INSIDE THE

WHITE
HOUSE

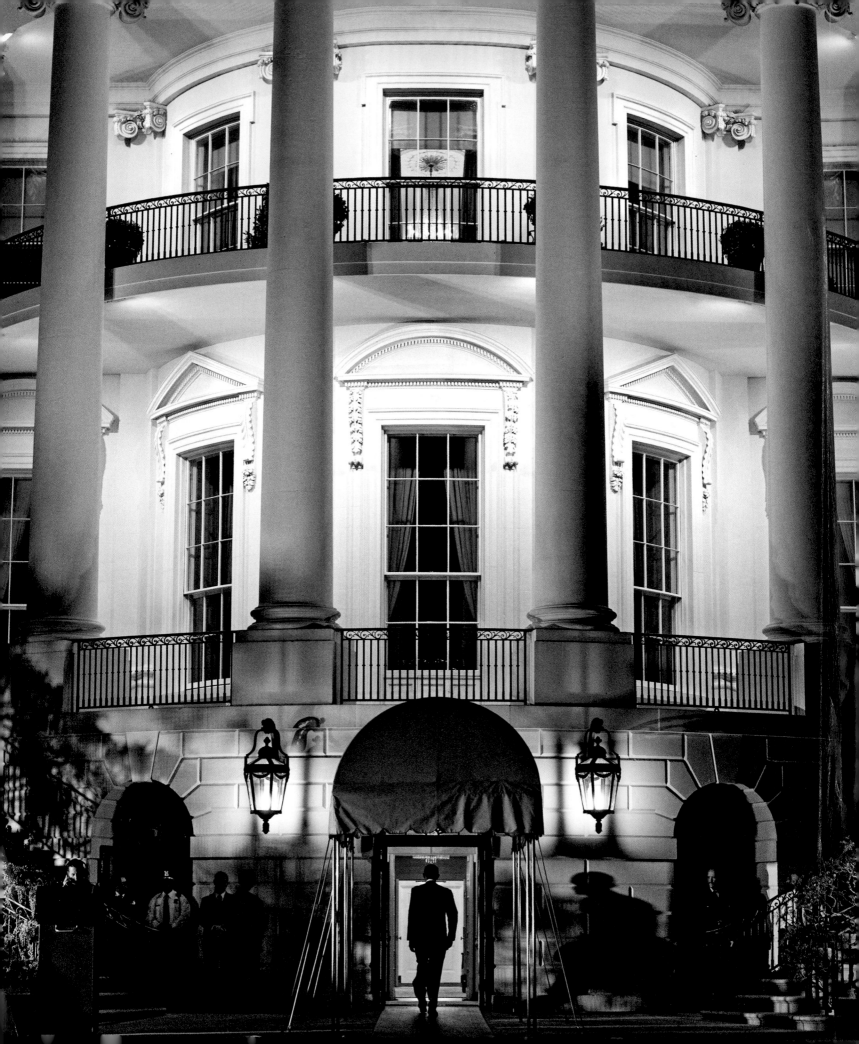

INSIDE THE
WHITE
HOUSE

STORIES FROM THE WORLD'S MOST FAMOUS RESIDENCE

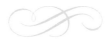

NOEL GROVE

WITH WILLIAM B. BUSHONG AND JOEL D. TREESE
FOREWORD BY FORMER FIRST LADY LAURA BUSH

NATIONAL GEOGRAPHIC

WASHINGTON, D.C.

CONTENTS

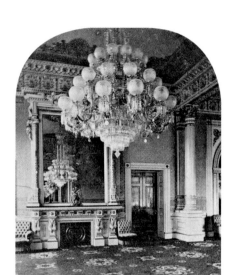

Preceding pages: (page 1) French Empire–style George Washington mantel clock, circa 1816; (page 2) President Barack Obama enters the South Portico of the White House, March 30, 2012. Opposite: Gilbert Stuart's 1797 portrait of George Washington was taken down and reframed to better preserve it in 2004. Above: Gas chandeliers that featured clusters of globe lights were installed in 1873–1874 in the East Room.

FOREWORD

By LAURA BUSH

WELCOME TO THE WHITE HOUSE. Past the famous gleaming columns and through the curved portico, you are entering an iconic house, well known to the world and home to the President of the United States and his family.

I first visited this landmark building when my father-in-law, George H. W. Bush, was president. One night, in the deep quiet after the day's many visitors and guests had departed, my mother-in-law, Barbara, and I turned on the lights and walked slowly through the Red, Blue, and Green Rooms, exploring each corner and remembering those who had walked here before us.

Until the 1960s, the presidents' families lived in these public rooms, having dinner in the old Family Dining Room off the State Dining Room and sitting on the Federal settee and Duncan Phyfe chairs. When President Lincoln lived in the White House, today's famous Lincoln Bedroom was in fact his office, and his family slept in the same bedrooms that we used just down the hall. President Theodore Roosevelt, who arrived with six boisterous children, moved the presidential office from the residence to the newly built West Wing.

The White House is the place where presidents and their families live their lives, in and out of the public eye. Under doctor's orders to relax, President Franklin Roosevelt escaped for lunch to the third-floor sky parlor, where young Caroline Kennedy would later have her tiny preschool. President Dwight Eisenhower liked to barbecue on the sky parlor's outdoor parapet.

Each room and each piece of furniture tells a story. Every day, when I lived in the White House, I walked by the room where young Willie Lincoln died. Generations of presidential grandchildren and children, including my own, played hide-and-seek in these rooms and flew down the stairway banisters.

Caring for the house and its residents are the men and women of the residence staff. They serve every family that lives within these walls, from presidency to presidency. On the night of September 11, 2011, when George and I returned home, many of the butlers, ushers, and chefs, who had evacuated the building less than 12 hours earlier, were back, placing their own safety at risk to welcome us. The bonds of family and friendship forged in the White House truly last a lifetime.

Mrs. Laura Bush, First Lady (2001–2009)

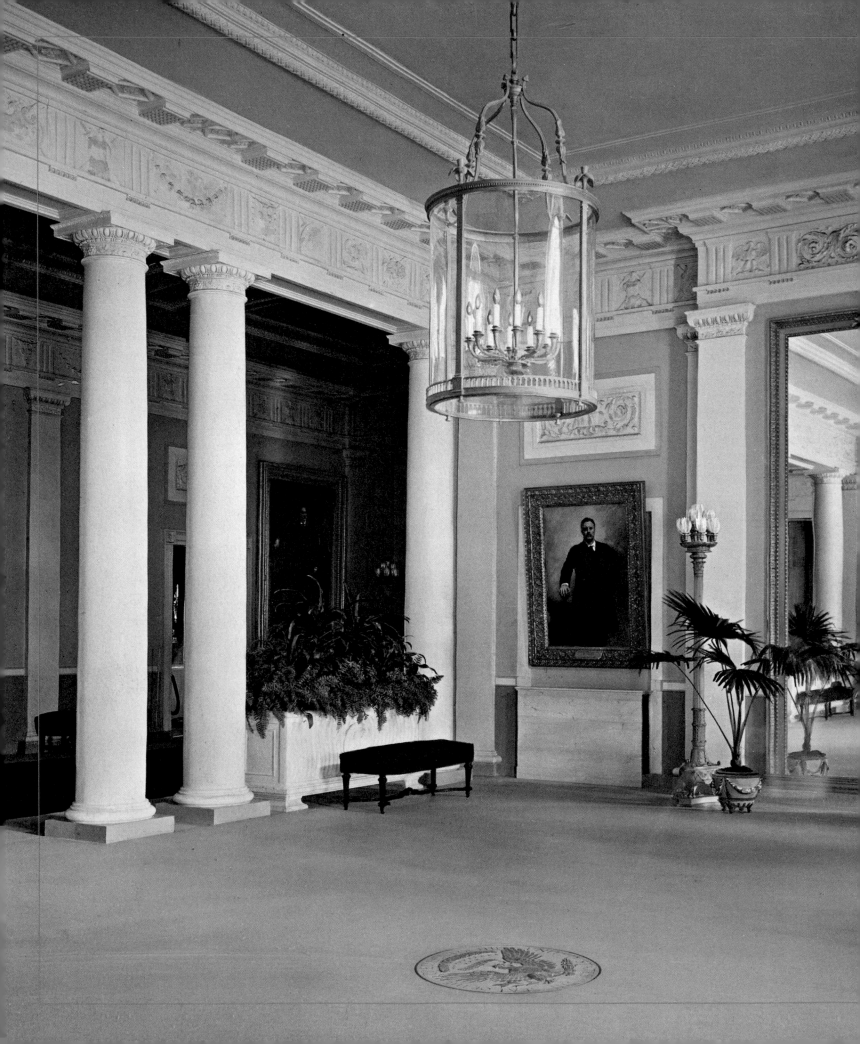

INTRODUCTION

By WILLIAM SEALE

TWO HUNDRED YEARS AGO, the White House was an ambitious house for a nation brand-new. Today it stands as a beloved symbol, big enough for the biggest dreams, the richest history, evocative in its architecture and history as no other house can be.

Ordered built by provision of the U.S. Constitution, the White House was begun in 1792, was occupied first in 1800, and still today is the home of the President of the United States. The historic stone building has been lived in longer than most official houses elsewhere in the world. Its humanity is vast. Every emotion, challenge, triumph, and even tragedy has appeared in the lives of those who called the White House home over two centuries. Its history is a chronicle of the nation, as well as that of a house and of many, many people.

In no other place can one find a more intimate touchstone of the American past. *Inside the White House* will transport you through more than two centuries of life and living in the White House. Here you will see where the principal characters of the White House then and now lived and worked, in the scenes of their everyday lives. At the pinnacle of the American governmental system, the presidents themselves, for four or eight years, are the most visible point of human contact in that system. They and their families live, figuratively, beneath a giant magnifying glass through which eyes at once curious, cynical, and admiring study them in every possible glimpse.

A whole staff of professional people continues to help build the American dream today, running the White House for the busy first family and facilitating the work of this great nation. They trolley food up from the basement kitchen. They clean the house and guard both house and grounds. They welcome guests, organize crowds, and maintain records and accounts.

The White House is first of all a home and the thick stone walls of the White House provide a retreat. Presidential families find privacy within the high-ceilinged rooms. They welcome guests into the East Room, Red Room, Green Room, and Blue Room; they retreat to the privacy of the "solarium," or sunroom, built high on the roof. They sit down to dinner in the family dining room (there are two), and for official

government events seat their guests, sometimes a hundred or more, in the great State Dining Room.

But the White House is also a place of work, from the laborers who built it to the residence staff who maintain it to the political advisers who work daily within its walls. After George Washington himself drove the stakes in the ground designating where the house would be built in the autumn of 1792, the stone walls rose in the hands of men from Scotland and Ireland and Africa. Skilled Europeans were the craftsmen, while the balance were laborers, including indentured white men and enslaved blacks, hired at great expense from their masters. This temporary village of builders, about a hundred people, transported, lifted, hauled, and laid materials such as stone from a quarry downriver on the Potomac, and wood from forests in North Carolina and Virginia. They mixed mortar and plaster from Maryland lime and affixed iron elements fashioned by local blacksmiths and fine hardware imported from England. They worked with rare crotch-mahogany wood from Latin America, and the cabinetmakers inlaid the doors with decorations of American holly.

When President Washington retired he visited the house on his way home and saw it about finished on the outside. The workmen stood on the walls and cheered him—the only president never to spend even one night there—firing a 21-gun salute, acknowledging their commander in chief, as well as the house he had helped to design "for all ages to come."

From the moment it was occupied the White House was a stage for history, and the curtain has never fallen. Jefferson announced the Louisiana Purchase from the front steps on the Fourth of July 1803; through the years after him, maps were unrolled in the upstairs office and presidents

dreamed of expansion farther west, achieving a boundary at the Pacific Ocean in 1848; Lincoln signed the Emancipation Proclamation in that office on New Year's Day 1862; in the East Room President Theodore Roosevelt convened the first national conference on conservation; in the library upstairs President Franklin D. Roosevelt first heard the news of Pearl Harbor, harbinger of America's entry into World War II; in a basement room, a former kitchen, President Dwight D. Eisenhower became the first president to address the nation on TV; in the East Room in 1964 President Lyndon B. Johnson signed the Civil Rights Act into law; before the columns of the North Portico President Carter announced the seminal Camp David Accord—and so the events go on and on, snowball-like, wrapping the White House ever more richly in the history of America.

Inside the White House takes you through this long and distinguished history, as well as accompanying you into the house as it is today. You will find chapters related to the house and life in it, accompanied by splendid illustrations.

It is the best taste of the White House you can get outside of being there. *Inside the White House* is a co-product of longtime colleagues the White House Historical Association and the National Geographic Society, and one that we hope will lead you to further study of the White House.

William Seale, historian and author of *The President's House: A History*

The BUILDING and ITS ARCHITECTURE

The PRESIDENT'S HOUSE, EARLY YEARS ★
The EXECUTIVE MANSION, 1814–1901 ★
The WHITE HOUSE, 1902–1952 ★ The MODERN
WHITE HOUSE, 1952 to the PRESENT ★

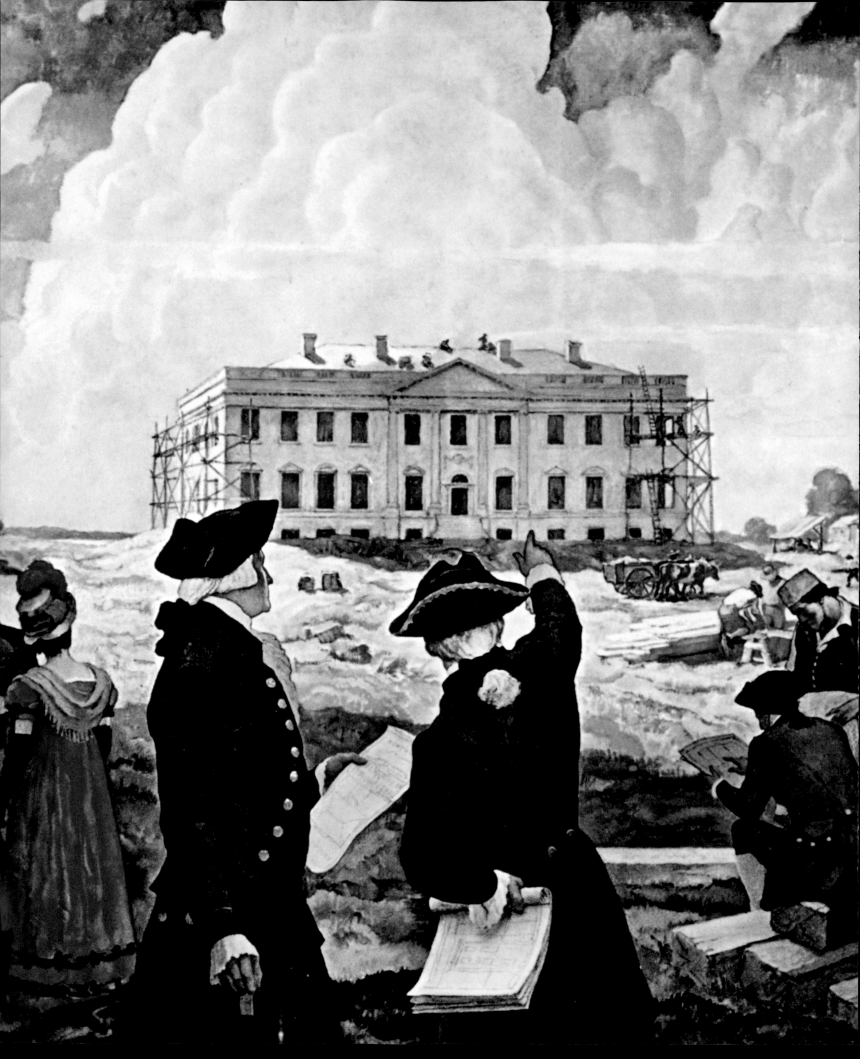

T HE STONE WALLS OF THE WHITE HOUSE ROSE in a wilderness. Congress authorized the new capital in the 1790 Residence Act. President George Washington selected the site. The Residence Act required that the federal government—the president, Congress, and the Supreme Court—move in 1800 from its temporary home in Philadelphia to the city that was to be named Washington. There were to be two public buildings ready for occupancy, a "House for the President" and a "House for the Congress." The president commissioned French-born architect and engineer Pierre Charles L'Enfant, who had fought on the side of the Americans in the Revolution, to design the capital city, the U.S. Capitol, and the President's House.

L'Enfant developed plans for the city, but his refusal to cooperate with the president's commissioners led to his dismissal in February 1792, before he had completed plans for the Capitol and President's House. Subsequently, a national competition was held to pick the designer of both buildings. President Washington sought out James Hoban, conferred with him, and in July 1792 quickly conveyed his preference for that architect's design as the best for the President's House. Hoban was selected as the architect for the White House—as it came to be called—and would return to rebuild it after the British burned it during the War of 1812. Hoban returned in 1824 to build the rounded portico on the south for President James Monroe, and in 1829, to add the portico on the north for President Andrew Jackson. Time and occupants with different needs have altered the White House in many ways. However, the White House image famous throughout the world is Washington's idea and Hoban's design.

The President's House, Early Years

PIERRE CHARLES L'ENFANT SELECTED THE SITE FOR THE PRESIDENT'S HOUSE and proposed a palace four times larger than the house that was built. L'Enfant had planned for the President's House and the Capitol to be the cardinal points of his 1791 plan for Washington city. It stood to reason that the President's House should be distinctive, but not a palace. The result was the White House, an Irish Georgian–style mansion modeled after Leinster House, which still stands in Dublin, Ireland. Through several major renovations and threats to move it, the house endured to become the iconic symbol of the American presidency.

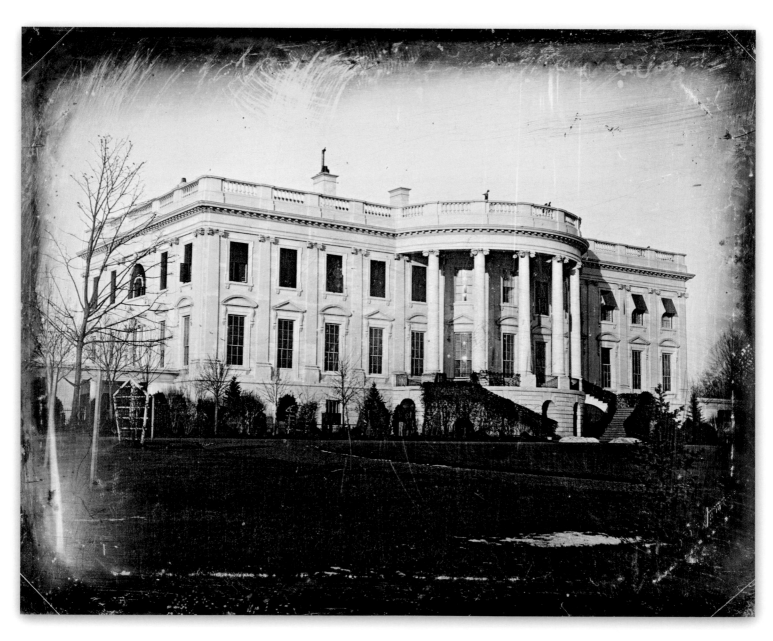

Few realize that the nation's capital was designed amid controversy. Thomas Jefferson in 1791 drew a plan for the Federal District that presented a compact and simple republican design much smaller than L'Enfant's capital. Secretary of the Treasury Alexander Hamilton and others wanted the capital elsewhere, in a northern commercial center. Southern leaders proposed that the Federal City be built in the agricultural South to avoid the dangers of concentrating financial and political power. Businessmen in Philadelphia and New York sought to lure the president by building great residences for him. George Washington, however, stuck to his rural site on the Potomac, believing that the location along the seaboard of the new nation would be the seed for a great city the equal of Paris or London.

At Washington's request, Secretary of State Thomas Jefferson announced an architectural competition in 1792 to produce design drawings for the President's House. On July 16, President Washington examined at least six designs submitted in the competition. James Hoban won, but a plan of a Palladian villa was a notable submission by a mysterious man known only as "A.Z." Historians have speculated that Thomas Jefferson was the mystery designer.

The President's Vision

Washington oversaw construction of the house, even though he never lived there, serving two terms as president in New York and Philadelphia. He insisted that the President's House be built of stone and embellished with extensive stone ornamentation. A quarry at Aquia Creek 40 miles down the Potomac from the site proved to be convenient. The creek was navigable from a quarry dock up to a wharf near the building site. The building material was sandstone (called "freestone" because it was so easy to quarry), which was porous and susceptible to cracking in freezing weather. Scottish stonemasons whitewashed the building in 1798 to protect the stone. The house came to be known unofficially as the White House,

and presidents traditionally continued to paint it white. In 1901, President Theodore Roosevelt made the name official.

Although Hoban's design won the contest, Washington requested alterations, adding the distinctive rose and acorn carved stone embellishments and cutting the building's height. Hoban's original design had two stories over a raised walkout basement, but some thought the house was too large. There was also a question of whether the sandstone quarries would hold out. Stone was needed to build the Capitol, where Congress would work. George Washington agreed that the President's House could be reduced to two stories by eliminating the raised basement. He knew that the design was basic enough to enable future presidents to make additions. As Washington said, the President's House and the other government buildings "ought to be upon a scale far superior to anything in *this* Country" and predicted that one day the original house would not be large enough.

Hoban was hired as the superintendent, not only for the White House but also for other public buildings. On the morning of July 19, 1792, three volunteer commissioners that Washington had appointed to oversee the building of the Federal City—Daniel Carroll, Thomas Johnson, and David Stuart—watched Hoban stake out the foundations of the President's House. He had trouble doing so, as L'Enfant's plan called for a much larger palace; the cellars already dug out swallowed Hoban's house. Hoban and the commissioners left it up to George Washington, the former surveyor, to locate the north wall. He placed it exactly where L'Enfant had planned. Hoban made the adjustments and directed laying out the wall foundations from a post designated by Washington that indicated the center of the North Front door.

Cornerstone and Construction

The cornerstone was laid on October 13, 1792, topped with an engraved brass plate with the names of dignitaries and the date set in the mortar. It has not been seen since. During the extensive renovation of 1949, army engineers attempted unsuccessfully to find the brass plate with a mine detector. When the 200th anniversary

continued on page 20

The South Front of the White House appears in the late winter or early spring of 1846 in a daguerreotype by John Plumbe, Jr.

around the world. In 1790, Congress passed the Residence Act. This established a permanent national capital on the Potomac River. The federal government—the president, Congress, and the Supreme Court—was ordered in 1800 to move from its temporary home in Philadelphia to the city that would be named Washington. Congress authorized President Washington (1789–1797) to select the site for the capital. From a ten-mile-square area on the east bank of the Potomac River, a French engineer and architect, Pierre Charles L'Enfant, planned the city streets of the new capital, and Washington himself selected the location for the President's House. L'Enfant set aside an approximately 80-acre park where he proposed to build a presidential "palace."

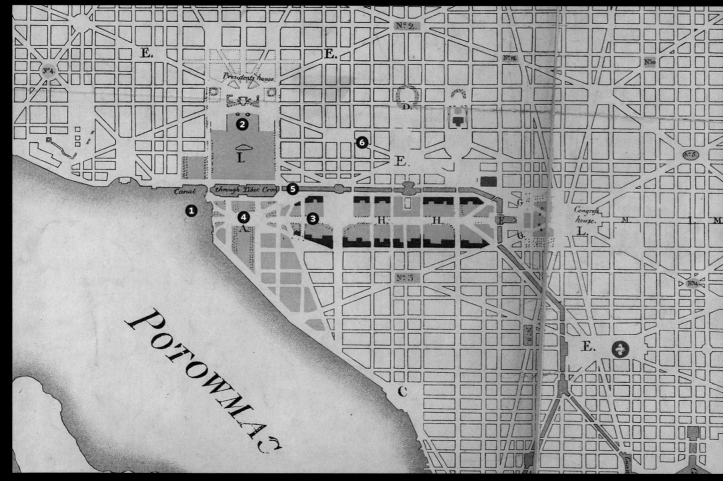

L'Enfant's original 1791 plan, as annotated by the United States Coast and Geodetic Survey Office, 1887

THEN AND NOW

① Until the late 1800s, the banks of the Potomac River were much closer to the White House than they are today. Heavy flooding in 1881 prompted a large infill project that created today's Potomac Park and Tidal Basin. **②** This area was designed to be the site of a vast presidential "palace," to be built on a ridge overlooking the Potomac River, with large surrounding grounds. **③** L'Enfant's plan included a "Grand Avenue" 400 feet in width extending due west from the "Congress House"; this would eventually become the National Mall. **④** At the western end, L'Enfant envisioned a monument of the equestrian figure of George Washington. The Washington Monument is now located near this site. **⑤** Per L'Enfant's plan, what had been Tiber Creek was turned into part of the Washington Canal, with a towpath for transporting supplies. Later

James Hoban's White House Design

James Hoban (1758–1831) rose from journeyman carpenter and wheelwright to become the architect of the world's most famous house. Born in Ireland, he studied at the Dublin Society's drawing school under Thomas Ivory, an advocate of the Georgian neoclassical style. He immigrated to the United States about 1785, and became well known in South Carolina for his ability as an architect and builder. George Washington selected his proposed design for the President's House in 1792. The White House image famous throughout the world is Hoban's, inspired by Irish Georgian–style country houses, notably Dublin's Leinster House. The only known image of James Hoban created from life is a wax bas-relief (from circa 1800, right) attributed to German-born artist John Christian Rauschner.

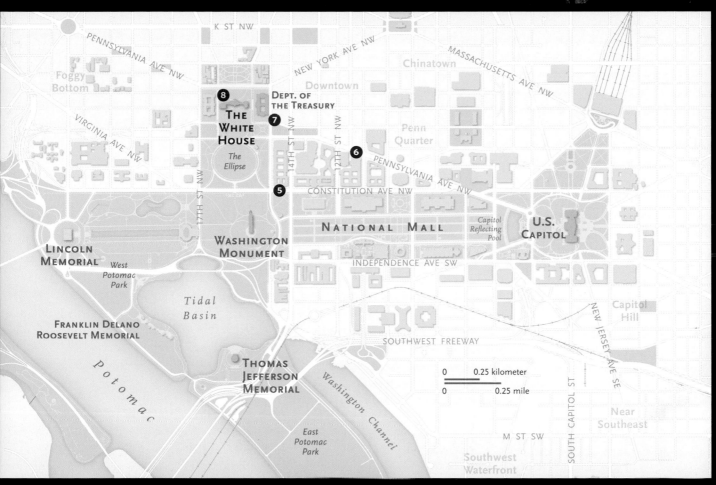

Present-day map of the area

deemed a health hazard, the canal was filled in by 1872; today, Constitution Avenue runs on top of the former waterway. ❻ The broad diagonal avenue running 1.2 miles between the President's house and "Congress House" became known as Pennsylvania Avenue, and was one of the first roads constructed in the city. This stretch is now the site of presidential inauguration and funeral parades, and other public events. ❼ The south wing of the Treasury Building—constructed from 1855 to 1860—blocks the view from the White House to the Capitol, deviating from L'Enfant's vision of a "splendid avenue without obstruction." ❽ Increased security following the 1995 Oklahoma City bombings and 9/11/01 attacks led to Pennsylvania Avenue being permanently closed to vehicular traffic in the area around the White House.

> *The president's house is certainly a neat but plain piece of architecture . . . The ground around it . . . remains in its ancient rude state, so that, in a dark night, instead of finding your way to the house, you may, perchance, fall into a pit, or stumble over a heap of rubbish.*
>
> <small>CHARLES WILLIAM JANSON, *The Stranger in America*, 1807</small>

of the construction was commemorated in 1992, the search for the cornerstone was intensified. X-ray machines were brought in to image the stone walls with short waves, but the effort yielded nothing but gauzy reflections.

The design for the President's House was not finalized until a year after the competition, although the foundation work had begun. Historians do not know the extent of Hoban's consultation with George Washington, but Hoban did make his drawings with the president's participation. The mansion was built on a ridge with a beautiful view overlooking the Potomac River toward Mount Vernon, George Washington's home. It is almost impossible to overemphasize how rural and bucolic the capital was when the President's House began to rise. The cornerstone of the Capitol that would house the House and Senate would not be laid until September 1793, and Pennsylvania Avenue was just a broad clearing. Open fields, pastureland, and produce gardens stretched west of the President's House, while cattle and hogs grazed and foraged.

Among the Workmen

Spread out over what is today Lafayette Square and the North Lawn of the White House were brickyards and kilns, the carpenters' hall, storehouses, the cookhouse, and the stonecutters' lodges. On the South Lawn were a sawmill and at least one pit for tempering bricks. There were several pits for sawing logs—one man standing above and another in the hole, sawing the log with a long saw in between. Sawyers listed on government payrolls, such as "Jerry," "Charles," "Len," "Dick," "Bill," and "Jim," were black laborers hired from their masters. Experienced carpenters and master stonemasons were rare in America, so most of the skilled builders were Scots, Irish, and English.

The D.C. commissioners, charged by Congress with building the new city, initially planned to import workers from Europe. However, response to recruitment was dismal, but they found good hands among African Americans—enslaved and free—to increase

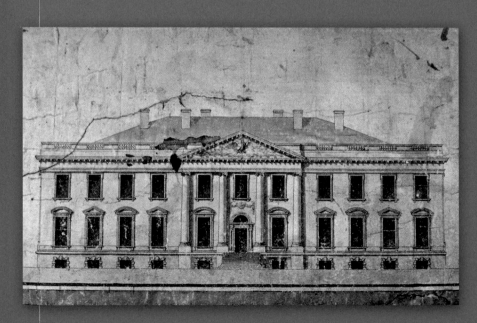

HOW THE WHITE HOUSE GOT ITS NAME

The building was first made white with lime-based whitewash in 1798, when its walls were finished, simply to protect the porous stone from freezing. The house acquired its nickname early on. Through much of the 19th century, however, the official title for the house, used on its stationery and in government documents, was "Executive Mansion." In October 1901, President Theodore Roosevelt changed that. Roosevelt believed the popular name "White House" was more appropriate to distinguish the president's official residence.

James Hoban's 1793 drawing of the north elevation.

the labor force that built the White House, the U.S. Capitol, and other early government buildings.

Labor disputes and arguments over pay with artisans were common. Four stonecutters threatened Hoban, and he asked the constable for protection. The toughs were run out of town. Vice became a concern as the hardworking men reveled in gambling and drunkenness. When Betsy Donohue, the wife of one of the carpenters, opened a house of "riotous and disorderly" conduct, she was fined, but by no means shut down, and her house, owned by Hoban, was moved and reopened off the public land. A routine developed in the workmen's village that grew up around the White House during its construction. Sunday was a day for hunting and fishing or perhaps a stage ride to big-city Baltimore to spend the week's wages.

The building begun in 1792 took eight years to be sufficient to receive the second president, John Adams, in the appointed year of 1800. The biggest room on the first or State Floor was the unfinished East Room, which occupied the entire east end of the building and was intended as an audience room for public events. An unfinished oval room (what is now the Blue Room) was at the center of the plan to facilitate levees— public receptions—where the guests traditionally stood in a circle waiting to

The intricate carving of roses and acorns on the North Door surrounding and above the north portal reflects the skill of Scottish stonemasons who worked on the White House, and the express wish of George Washington for a house of stone construction with elaborate ornamentation. The carvings were completed in about 1796.

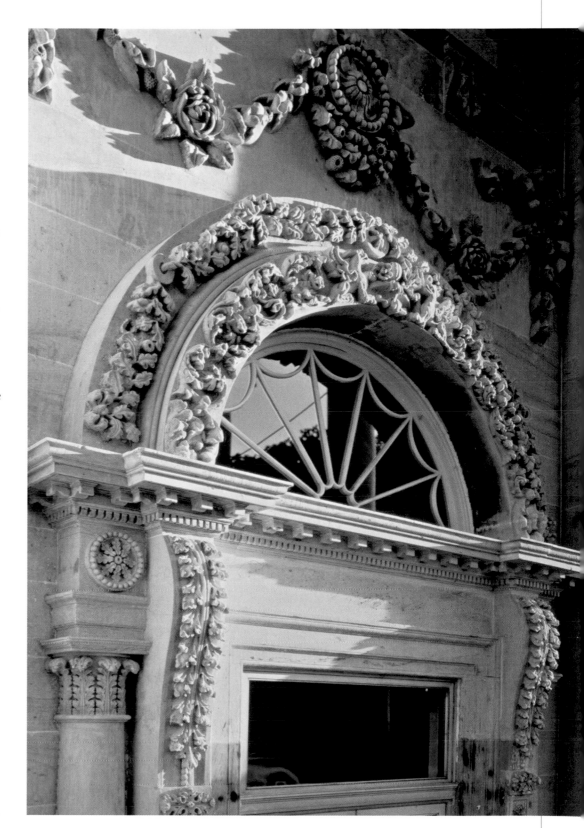

greet the president. The rooms readied for the Adams family on the State Floor were a levee room in the southwest corner, a dining room in the northwest corner, and a breakfast room (now the Red Room). On the west end of the second floor—the family floor—there were bedrooms for the president and the first lady, their young granddaughter Susanna, and an office for the president and his secretary, William Smith Shaw.

George Washington died on December 14, 1799, before the President's House was finished. On November 1, 1800, John Adams became the first president to occupy the building, as required by the Residence Act, but he lived there just four months before he lost office. Abigail Adams arrived two weeks after her husband, getting lost several times on the unmarked roads. Parts of the journey were so heavily

wooded that a man had to sit on the top of the coach and chop branches so the vehicle could pass through. The house was intensely cold and damp during the winter of 1800–1801; fires in the fireplaces barely heated the six habitable rooms. Abigail Adams complained in a letter on November 21, 1800: "I could content myself almost anywhere three months; but surrounded with forests, can you believe that wood is not to be had because people cannot be found to cut and cart it?" After a bitter defeat in the 1800 presidential election, Adams left Washington in the early hours of the morning of Thomas Jefferson's inaugural on March 4, 1801, skipping the ceremony. Abigail Adams had departed weeks earlier to prepare their home in Quincy, Massachusetts, and was not sorry to leave Washington.

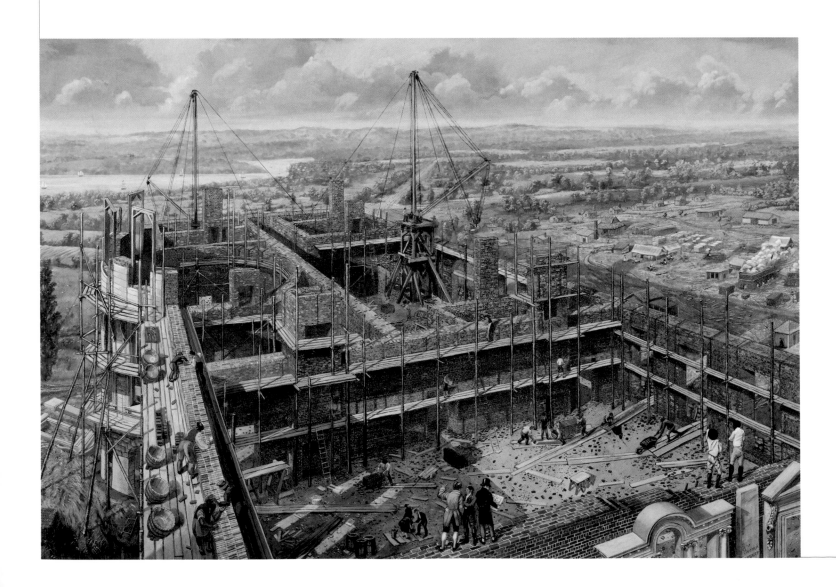

Jefferson and Latrobe

Thomas Jefferson became the third president of the United States in 1801. As a Democratic-Republican, he detested the formal etiquette of the Federalists, although his lifestyle and tastes were anything but simple. He immediately sold off President Adams's seven-horse stable, the silver-trimmed harnesses, and two carriages bought with funds intended for household furnishings. He preferred to travel on horseback and kept only a market cart. Jefferson ended the great levees, or public receptions, and turned the State Dining Room where they had been held into his office. He cleaned the grounds, erected a post and rail fence around the house, and established the main entrance on the north side, demolishing the temporary wooden south entrance stairs. Jefferson did not change the appearance of the house substantially. This was not the residence that he would have built, but he recognized it as part of George Washington's legacy and saw the need for continuity. Sensitivity to this sort of symbolism was to characterize the White House from that time on.

Jefferson's main concern with the public buildings was the lack of progress on the Capitol. For that and for any improvements to the President's House that he contemplated, he appointed architect Benjamin Henry Latrobe as the surveyor of the public buildings in 1803. Latrobe, born in England to an American mother and an English father, had practiced in the United States for seven years and had attracted attention for his buildings and engineering projects, notably the Bank of Pennsylvania, Philadelphia, and the Centre Square Water

Works in that city. Like Jefferson, he was multilingual and an accomplished musician. They shared an intense interest in architecture, science, invention, philosophy, and religion. For six years under Jefferson, Latrobe worked at the President's House, completing repairs to a badly leaking roof, installing a grand staircase, solving a drainage problem, constructing water closets, landscaping the grounds, and designing classical east and west colonnades, which still remain today.

Jefferson often contributed to Latrobe's designs and occasionally caused the architect some annoyance. Of Jefferson's ideas for adding wings to the White House, Latrobe wrote, "I am sorry that I am cramped in this design by his prejudices in favor of the old French books, out of which he fishes everything." Latrobe was contemptuous of his rival, Irish architect/builder James Hoban, continuing in his letter to construction supervisor John Lenthall that the colonnade collaboration was "exactly consistent with Hoban's pile—a litter of pigs worthy of the great Sow it surrounds, & the Irish *boar*, the father of her." Latrobe mistakenly addressed the letter to Jefferson, but the gentlemanly president returned it to him, saying he had not read it.

Jefferson also improved the presidential grounds from a barren site that had been left after construction of the White House. With the wing additions, built for domestic use, he separated the upper and lower lawns of the site and made an official entrance on the north. He began a stone wall around the house, planted trees and flower gardens, and built graveled driveways. Mistakes were made. He planned an arched carriage gate, designed by Latrobe, at the center of the East Wing, but the work was delayed and the mortar would not set in the winter cold. In the spring, the supporting timbers were removed and the stone arch toppled to the ground. The ruins were quietly taken away, leaving a vacant space and an East Wing with two parts for many years.

Opposite: *The White House Under Construction, 1796*, a painting by Peter Waddell, shows the walls rising within a barren construction site and worker village. Architect James Hoban discusses the plans in the foreground with a master carpenter. Above: Benjamin Henry Latrobe, surveyor of the public buildings, added the East and West Terraces.

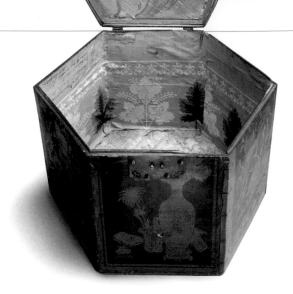

The Madisons Move In

The Washington city that Jefferson left in 1809 was vastly different from the one he had come to as president eight years before. It was still sparsely settled, but by the 1810 census, the population totaled 8,208 inhabitants; speculators, including local builders, had built a few substantial rows of houses. Both the government's artisans and its clerks erected rental houses and even taverns, which their families operated. Jefferson had fast-growing poplar trees planted along Pennsylvania Avenue following L'Enfant's suggestion; they were now tall and waving in the breeze. In 1809, President James Madison and his wife, Dolley Madison, moved into a completed and habitable President's House, which allowed them to focus on the interior decor. Latrobe obtained reappointment as surveyor of the public buildings, and because of a personal connection—Latrobe's wife Mary had known Dolley Madison since they were children—what followed was a close collaboration. Dolley Madison required elegant rooms for her weekly "drawing rooms" or "levees," much attended and talked about in Washington society and a valuable political tool for President Madison. Latrobe designed furniture to fill the Oval Drawing Room and acquired draperies, light fixtures, and mirrors for the other principal rooms with Dolley Madison's supervision. When the British burned the White House and Capitol in 1814, Latrobe's work was destroyed. ★

The pink ground French wallpaper lining this circa 1811 Chinese tea box (above) is believed to have been installed in the White House before the 1814 fire. The West Colonnade (right) connects the White House to the West Wing.

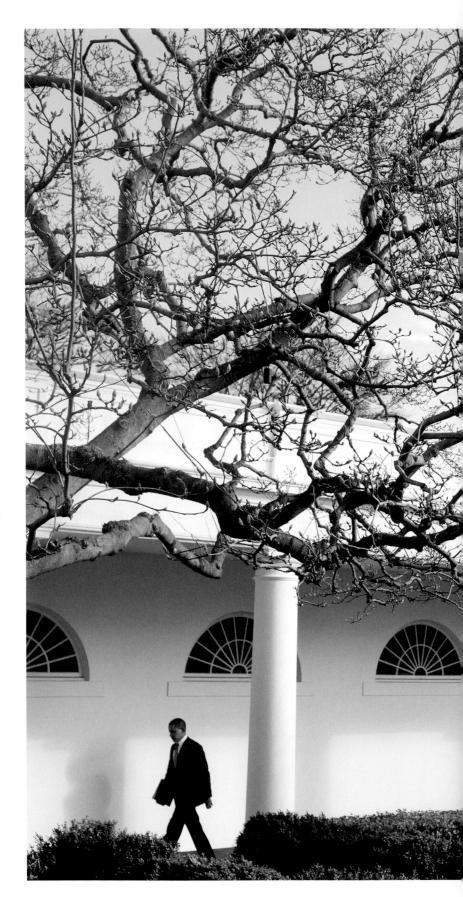

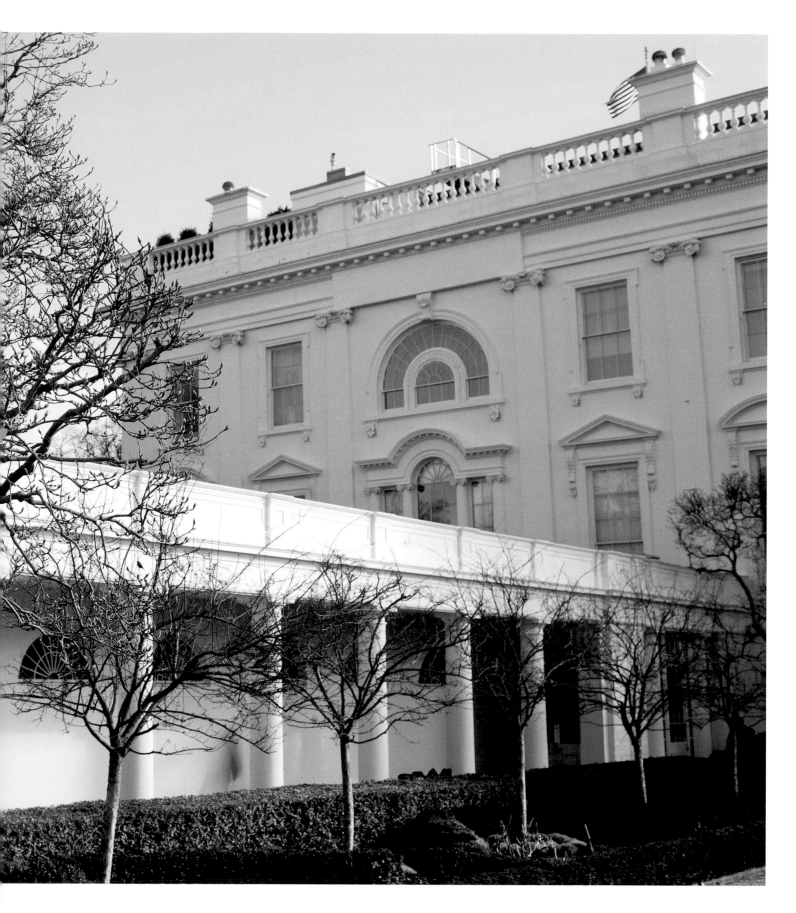

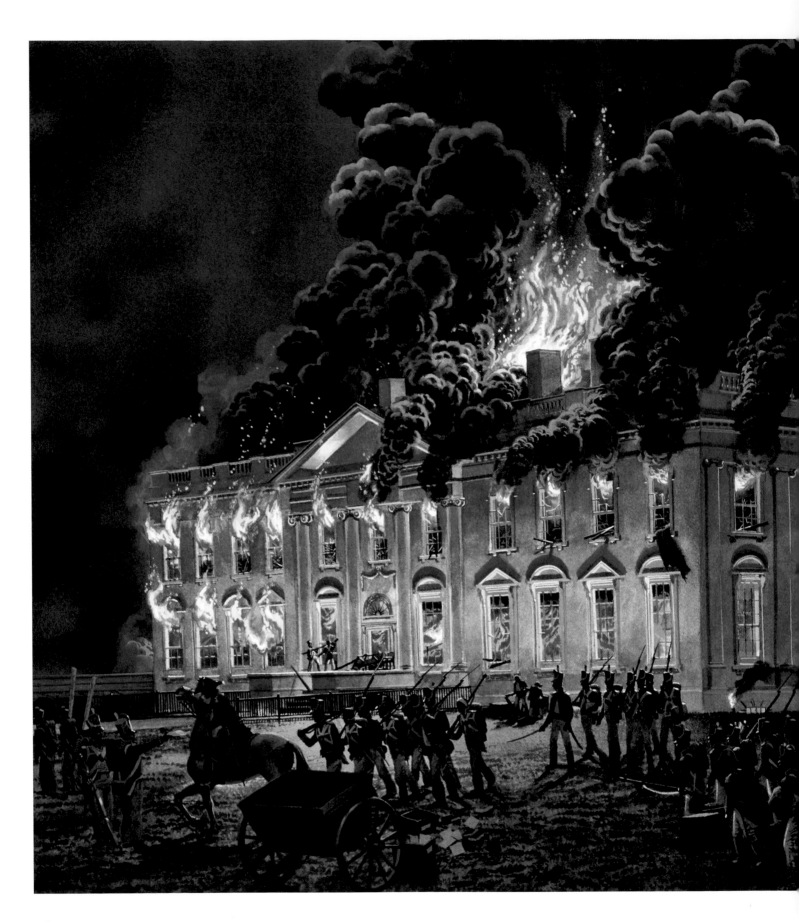

The Executive Mansion, 1814–1901

THE PRESIDENT'S HOUSE WAS LESS THAN 20 YEARS OLD when it was burned to a blackened stone shell. Completed during the administration of Thomas Jefferson, it was the pride of the new nation's citizenry, a place that symbolized the dignity of its government. But when the young nation went to war, that proud symbol was destroyed. The United States Capitol and other government buildings were torched by the British soldiers during the War of 1812, but the destruction of the Executive Mansion gave Americans a palpable sense of defeat.

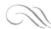

The United States declared war against Great Britain on June 18, 1812, as a matter of national honor. The British, involved in an ongoing war with France, seized cargoes from neutral American ships and impressed into the Royal Navy some 5,000 merchant sailors —most of whom were British-born and had deserted to the American merchant fleet because of higher pay and better conditions. The Royal Navy spent little time in the United States until Napoleon's defeat in April 1814, which freed the British to deploy a greater force against their upstart former colony. On August 19, 1814, 4,000 British veterans under the command of Rear Admiral George Cockburn and Major General Robert Ross landed on the Patuxent River in southern Maryland. Five days later, the invaders defeated a force of American militiamen at Bladensburg, Maryland, and entered Washington about 7:30 p.m. Many government documents, including the Declaration of Independence, already had been hidden at Leesburg, Virginia, and the Madisons had abandoned their home.

Tom Freeman's painting of the August 24, 1814, burning of the White House by British troops during the War of 1812. Dolley Madison fled the city just hours before the forces arrived, taking important state papers, pieces of silver, and Gilbert Stuart's famous portrait of George Washington.

Fire!

After burning the U.S. Capitol, a detachment of about 100 troops led by Cockburn and Ross marched to the deserted White House, where they

sat down to a dinner prepared earlier in the day by the domestic staff. After dinner, some 50 men surrounded the Executive Mansion holding poles with fiery rags soaked with oil at the end, and at a signal, hurled them like javelins through broken windows. An "instantaneous conflagration took place and the whole building was wrapt in flames and smoke," Mrs. William Thornton, an eyewitness, recalled. "The spectators stood in awful silence. The city was light and heavens redden'd with the blaze!"

Washington presented no target of strategic importance, as it was still a provincial village. But the British commander in chief, Admiral Alexander Cochrane, had promised to give the Americans "a complete drubbing." The White House burned brightly for several hours before a fierce storm broke loose and heavy rain dampened the flames. The British soldiers set other government buildings on fire the next morning, and then departed for the richer target of the Port of Baltimore.

Three days later, the Madisons returned to Washington and viewed the ruins of their house and the Capitol. The press said that Dolley Madison could have saved the building had she stayed, and blamed the president for fleeing. But the first lady feared that the British would exhibit her in London as a prisoner of war, as they had threatened, and James Madison had no military experience and could have done nothing to save his house. After the fire, the Madisons stayed at the Octagon, Colonel John Tayloe III's mansion. At the Octagon, President Madison signed the papers formally ending the war on February 17, 1815.

Rebuilding the White House

The British left the President's House, the U.S. Capitol, the Treasury, and the War Department in ruins. Angry residents scribbled on the Capitol's walls: "the capital and the Union lost by cowardice." Some suggested that

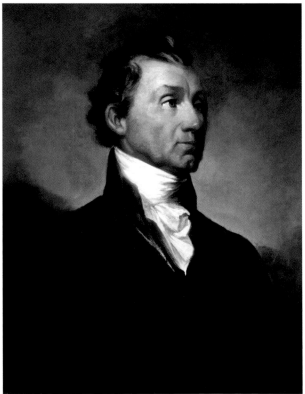

Scorch marks from the 1814 fire appeared 176 years later, in 1990, when white paint was removed from the walls (top). President James Monroe (left) moved back into the reconstructed White House in 1817, a time described as the "era of good feeling."

the Federal City be moved inland as the nation expanded west with the 1803 Louisiana Purchase, but the proposals failed to secure congressional approval. Cost for reconstructing the public buildings was put at $460,000, with Washington banks offering a loan of $500,000 to the government as an incentive to keep the national capital in the District of Columbia. Benjamin Henry Latrobe, who had already spent eight years in Washington as surveyor of the public buildings, was assigned to restore the Capitol. James Hoban, by then the principal contractor in the city, was retained to restore the President's House and the adjacent Treasury and War Department Buildings. The weakened walls of the President's House were dismantled to the basement level on the east and west sides and on the north except for the central section. Only the south wall survived intact. Most of the carved ornamentation, bearing the scorch marks of the fire, was reused. President James Monroe moved into a new house in 1817.

The Porticoes

As early as 1792, James Hoban had proposed a south porch with doors opening to it from the three south parlors. It was never built. Latrobe drew proposals for North and South Porticoes, but the 1814 destruction of the house and economic problems associated with the Panic of 1819 stalled construction until 1824 (on the South Portico) and 1829–1830 (on the North Portico). Under the supervision of James Hoban, both porticoes (the rounded one on the South Portico is really a "porch") were built of Seneca sandstone from Maryland. When the porticoes were finished, the White House as we see it today was complete.

Maintaining the Interior

From the 1830s until 1902, changes in the main block of the White House occurred principally to its interiors. Andrew Jackson had furnished the East Room for the first time in 1829, including elaborate cut-glass candle chandeliers. Succeeding

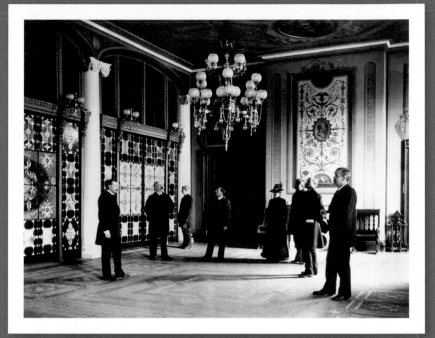

DESIGN AND DECOR ★

THE TIFFANY SCREEN

The Tiffany glass screen, gone for more than a hundred years, is still one of the great legends of the White House. When President Chester A. Arthur redecorated the White House in the Aesthetic style in 1882, he hired as designer Louis Comfort Tiffany, the 34-year-old son of Arthur's friend and New York City jeweler Charles Tiffany. Tiffany, a now legendary artist and decorator, installed one of the most beautiful features ever to adorn the building, a 338-square-foot mosaic screen in ruby, crimson, white, cobalt, and blue opalescent glass for the Entrance Hall that suggested the colors of the American flag. The screen, intended to cut off cold drafts to the main rooms, also filtered light softly through its opalescent glass, a technological advance. It is shown above as visitors to the building admired Tiffany's masterpiece. The *Washington Post* said of the glass screen, "The completed work is beautiful beyond even the most glowing descriptions made in advance . . . it changes the whole character of the entrance." It had the greatest effect in natural light, but Benjamin Harrison—two administrations later—added electric lighting (1891), which diminished its vibrant effect. The Tiffany screen was removed during the 1902 renovation of the White House and sold at auction as boxes of glass for $275. Part of it was installed in the Belvedere Hotel at Chesapeake Beach, Maryland, which was destroyed by fire in 1923.

The North Entrance Hall in 1889.

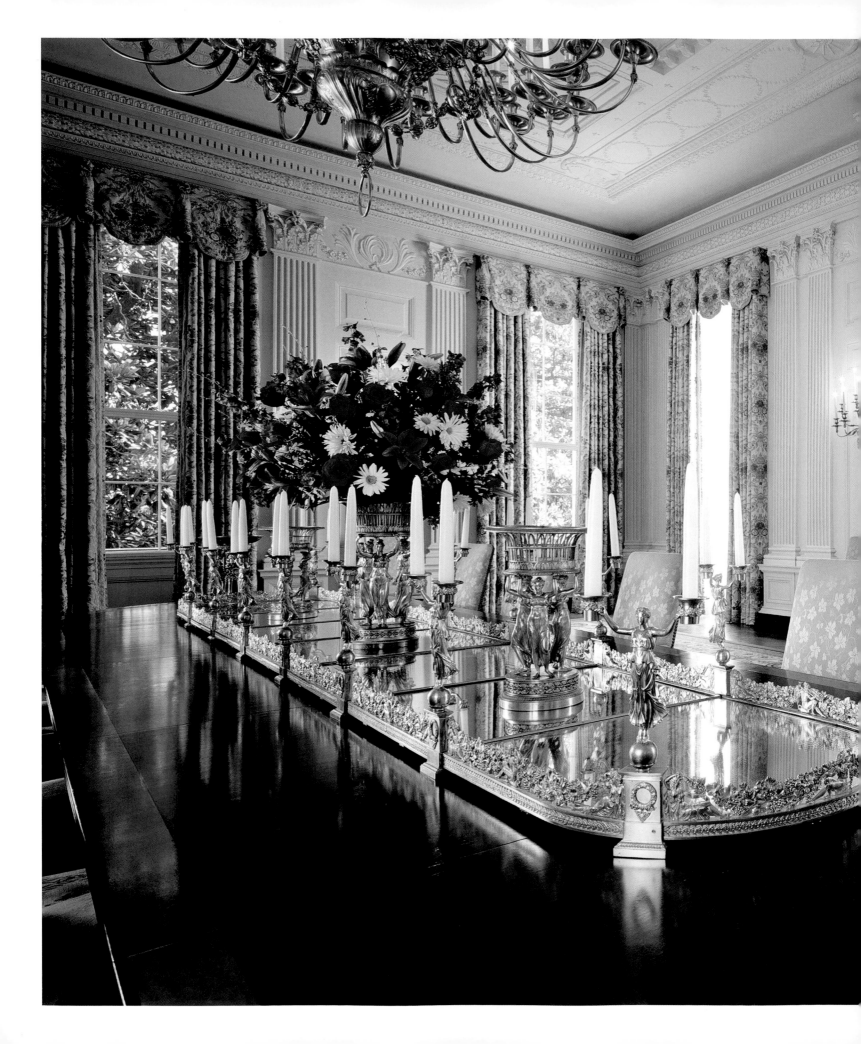

As part of the refurnishing of the White House after the fire of 1814, President James Monroe ordered for the dining room a large gilded bronze plateau—a removable table-top—that is still used today (left). Monroe acquired these side chairs (above) for "the large oval room" (Blue Room) as part of a suite of gilded beech wood furniture. The government auctioned 28 chairs (perhaps what remained of the original 38) along with sofas, stools, footstools, and screens in 1860. Seven chairs and a sofa have been returned to the White House.

presidents and their wives periodically refurbished the house to reflect changes in tastes and fashion.

When Abraham Lincoln moved into the President's House in 1861, the State Floor and private quarters were in a "miserable condition." With the approach of the Civil War, Lincoln paid little attention to decorating. He left the purchases to his wife, Mary Todd Lincoln, and despite a generous $20,000 appropriation for furnishings, the budget was exceeded. Two supplemental appropriations were needed to pay for her spending spree, which included an ornate, laminated mahogany bedroom suite for guests that included the Lincoln Bed we know today.

President Ulysses S. Grant renovated the East Room between 1873 and 1874 for the wedding of his daughter, Nellie. Immense mirrors topped new wooden mantels, two ceiling beams were added to continue the carved embellishments Hoban had made for James Monroe, and ornate new gas chandeliers featured clusters of globe lights. These replaced Andrew Jackson's chandeliers, long since converted from candles and oil to gas.

Chester A. Arthur, president from 1881 to 1885, revived plans to build a new Executive Mansion, but opposition was so strong he agreed to renovate. Arthur called on Associated Artists of New York, of which Louis C. Tiffany was a partner, a firm synonymous with the highest standards of craftsmanship and design. Practically every surface was transformed with Tiffany's decorative painted patterns, accented by his trademark stained glass. ★

The White House, 1902–1952

ONE OF THEODORE ROOSEVELT'S EARLIEST ACTS AS PRESIDENT was to issue an order establishing the "White House" as the building's official name. Previously, it had been called the "President's House" or the "Executive Mansion." This presaged further discussion regarding the house. First Lady Edith Roosevelt, with a large family of six children, asked New York architect Charles McKim for his advice on making the house more comfortable. He recommended a complete renovation, leading to major changes in the functioning of the building.

The renovation doubled the space allocated to the family living quarters, provided a new wing for the president and his staff, and a new entrance area on the east for receiving guests. Today's White House reflects the 1902 design of the McKim, Mead & White firm. Theodore Roosevelt was pleased with the new president's home when he and his family moved back. His sense of history was satisfied; even the most critical of observers could see the work preserved the White House as they had come to admire it.

McKim had removed the glass greenhouses from the west end of the Executive Mansion, and replaced them with the "temporary" offices of what would become the core of what we today call the West Wing. He restored the terraces and colonnades as Jefferson had built them, to accommodate domestic work and storage spaces. McKim changed the character of the interior of the house, and introduced new patterns of use. He stripped away the Victorian decor, replacing it with elegant neo-classical finishes. The North Portico became a ceremonial entrance. Nearly all guests now entered the East Wing entrance and walked through to the ground floor from which they ascended the stairs to the State Floor. Diplomats entered through a special ground floor entrance on the south through the old furnace room that became the Diplomatic Reception Room. Business callers went to the new Executive Office Building west of the White House. There was some grumbling from guests about entering the house through the ground

President Theodore Roosevelt enlarged the State Dining Room and mounted game trophies above the mantel on the natural oak panels. The woodwork, eagle-pedestal console tables, chairs, and lighting fixtures remain in this room from the 1902 restoration. The animal heads were removed during the Harding administration.

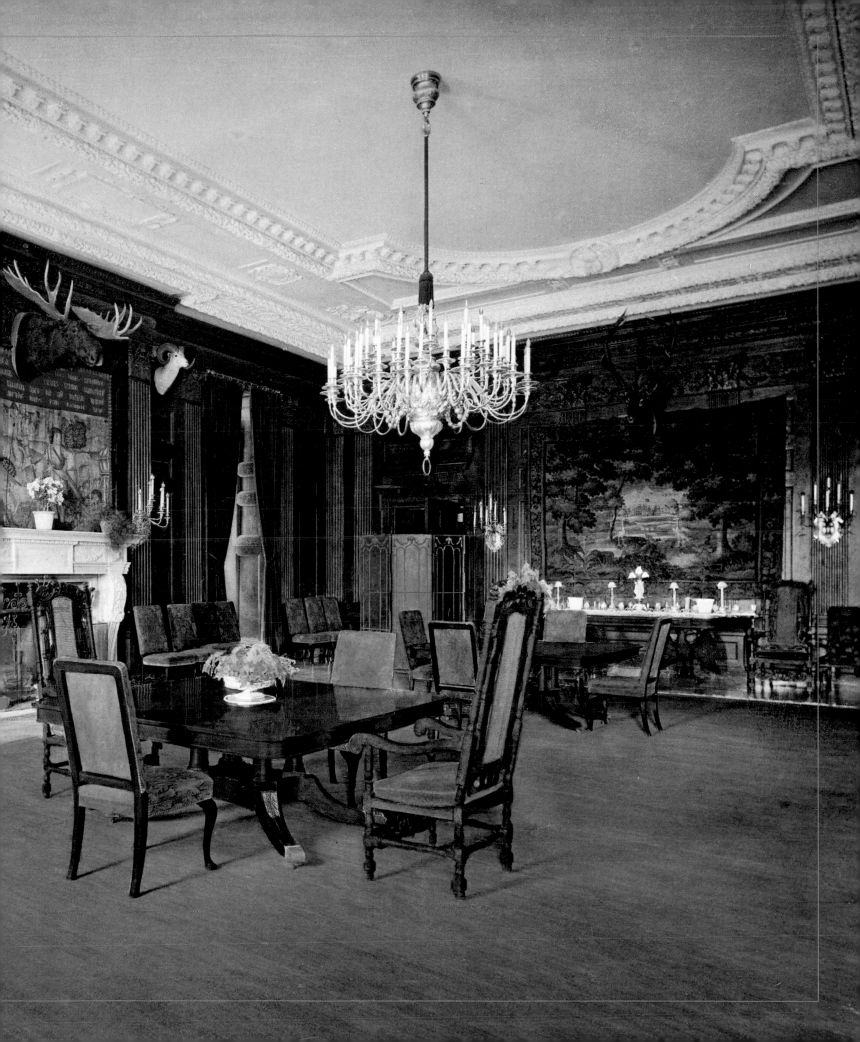

Washington has always called it [Executive Office wing] "the Wart." But now it is being transformed by radical alterations into a very handsome building . . . it bids fair to become an ornament . . .

"Mr. Taft's New Quarters," *Washington Post*, September 19, 1909

floor, but the arrangement improved security and was more convenient for everyone.

Between Theodore Roosevelt's time and that of President Harry Truman, the White House would endure a Depression and two world wars. Despite the office space created in 1902, the new annex would soon be too small to accommodate the needs of a nation expanding in population and global importance.

Adapting and Expanding

Although a "president's room" was now in the "temporary executive offices," Theodore Roosevelt did most of his work on the second floor of the White House, where presidents had always worked. President William Howard Taft added the first Oval Office in his major expansion of the West Wing in 1909. Herbert Hoover, universally recognized as the world's greatest humanitarian after rescuing thousands of Americans stranded in Europe at the start of World War I and directing famine relief programs for millions of Europeans, entered the presidency in 1929. Just seven months after his inauguration, the stock market crashed and the Great Depression began. That winter, on Christmas Eve of 1929, the West Wing burned to its walls. Firemen's hoses froze in the bitter night as the flames consumed furniture and documents. Hoover had the wing rebuilt in four months. He also had toy fire trucks delivered to the children who attended the abruptly canceled White House party.

The problem with rebuilding and remodeling the White House in the 19th and early 20th centuries was that the work had to be done in a hurry. To speed rebuilding after the 1814 fire, a wooden structural system for the walls replaced the original brick partitions. Engineers periodically replaced sagging wood floor joists with steel, intending to make the structure sturdy. Water and gas pipes, ventilation and heating ducts, and electric wires had been routed or threaded through the walls

and floors. New paint and wallpaper covered the damage, but it could not add to the structural integrity. Theodore Roosevelt's renovation in 1902 had brought order and an elegant neoclassical interior to the house, but beneath the serene-looking surface, the structural improvements had been hasty. By the 1920s, the White House roof was decayed and in danger of collapse, and President Calvin Coolidge realized he couldn't ignore the problem.

The White House had always had an attic for storage, but Ellen Wilson built guestrooms and a painting studio there for herself in 1913. A full third floor was not created until the Coolidge administration, when problems with the integrity of the old 1817 timber structure were discovered. Recommendations were made to replace the roof and to call upon an architect for advice. After studying Hoban's 1793 drawing, William Adams Delano of New York increased the pitch of the roof and lowered the floor to accommodate new guest and service rooms beneath a heavy steel and concrete roof structure. At Grace Coolidge's request, a sunroom, painted blue and called the "sky parlor" (predecessor of the current Solarium), was added.

Expanding the West Wing

President Franklin D. Roosevelt came into office in 1933, and implemented the economic programs known as the New Deal, greatly expanding the scope of the federal government. The president immediately requested additional space for his burgeoning executive staff, which was twice the size of Hoover's. He increased the office area from 15,000 to 40,000 square feet of a now permanent office wing. (The structure officially became known as the "West Wing" in 1949, to avoid confusion when the adjacent State, War, and Navy Building, now the Eisenhower Executive Office Building, was converted for use as executive offices). A "penthouse" story and

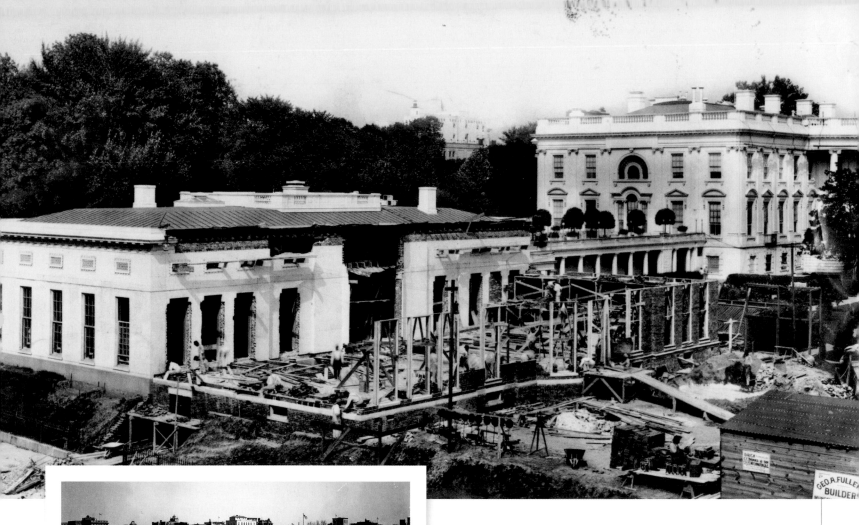

An expanding staff required doubling the size of the Executive Office Building in 1909. The addition, designed by Washington architect Nathan C. Wyeth, included the first Oval Office, built for President William Howard Taft. Inset: In 1934, Franklin Roosevelt expanded the West Wing from 15,000 square feet to 40,000, adding a basement and a penthouse, and moved the Oval Office to the southeast corner closer to the White House.

an enlarged subterranean office area with a light well were added to the West Wing. The Oval Office was relocated to the West Wing's southeast corner—its present location—to overlook the Wilson Rose Garden.

Franklin Roosevelt focused his attention on improvements to the West and East Wings. During World War II, in 1942, a new East Wing was built, creating a larger formal entrance for guests, offices on the first and second floors, and a secret air-raid shelter underground. Work within the old walls of the historic White House mostly concerned updates to the kitchen, installing an indoor swimming pool in the West Terrace, and upgrading the ancient electrical system.

The Roosevelts moved into the White House in the midst of the Great Depression with two vanloads of personal possessions. Eleanor Roosevelt ordered tables, a mirror, a stool, and bedsteads from the Val-Kill Furniture Shop, a company she co-founded in 1927 to provide employment for men in the Hyde Park, New York, region. Largely because of the Depression and World War II, the historic main building of the White House changed very little during the Roosevelt years.

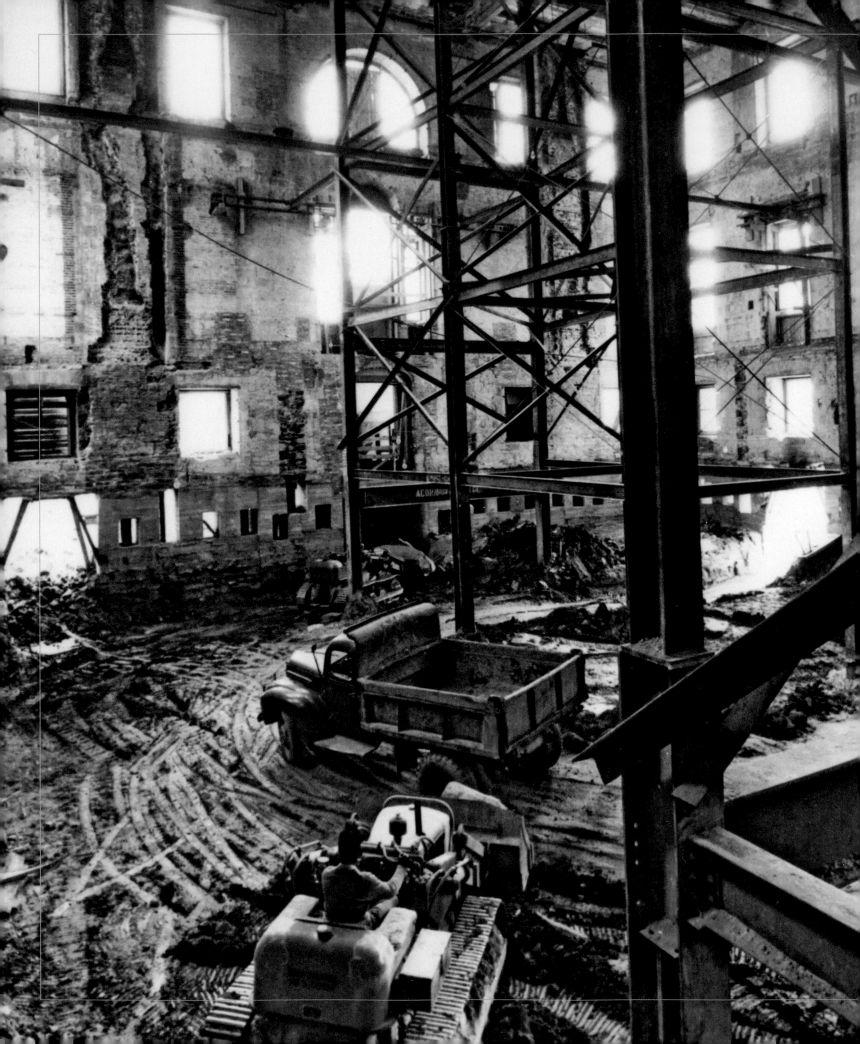

A housekeeper described one of the rugs in the living space as "so historic that you caught your heels in it."

The death of Franklin Roosevelt on April 12, 1945, less than three months after his fourth inauguration, took the world by surprise, although those close to him had known his health had been fragile for years. Replacing him was Harry S. Truman, a complex and determined man who loved daily brisk walks and whose language was not patrician, like that of his predecessor, but rather was direct and easily understood.

The Truman Renovation

Truman inherited a White House that was aging, had faulty wiring and cracked plaster, and was considered dangerous to live in. An assistant to the chief usher showed the new first lady her new home and was embarrassed. The White House looked, in his words, like an "abandoned hotel." A structural survey revealed major problems caused by stress from floor-bearing steel beams added in 1902 and the sagging weight of the 1927 third floor and roof improvements, all pressing against the inner brick walls.

The Trumans—the president, his wife, Bess, and daughter, Margaret—spent evenings together as often as they could, reading, playing instruments, or listening to music. Said a staff member, "The Trumans were the closest family who lived in the White House in the twenty-eight years I worked there." The new president was too busy with the challenges of ending World War II to bother with White House improvements. However, he did sponsor plans in 1945 to expand the West Wing for executive office space and to add a broadcast studio, an auditorium for press conferences, and work space for reporters. Congress gave nominal approval. But word spread that Truman was planning a large addition that would mar the residential character of the President's House, and Congress withdrew approval for funds for this ambitious

Temporary steel bracing and concrete underpinnings for the walls allow bulldozers and trucks to move earth within the gutted walls of the White House for digging a new basement for a modernized White House, May 17, 1950.

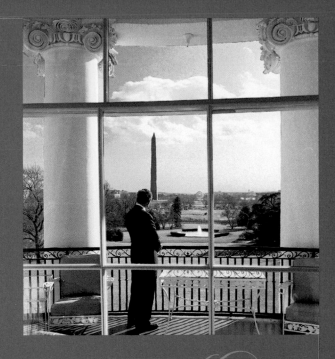

DESIGN AND DECOR ★

THE TRUMAN BALCONY CONTROVERSY

President Harry S. Truman decided a second-floor balcony on the South Portico would improve both the appearance of the White House and the livability of the family quarters. But critics, including members of the Commission of Fine Arts and the American Institute of Architects, opposed the addition, the first exterior alteration since Andrew Jackson built the South Portico in 1830, claiming it would disfigure the building. At Truman's request, White House architect Lorenzo S. Winslow and New York architect William Adams Delano drew up plans. Construction proceeded on January 26, 1948, and was completed in March at a cost of $16,050.74. Truman insisted that the balcony would eliminate the shabby awnings that were erected each spring to shade the South Portico. The balcony—a concrete floor reinforced by a steel frame, its exterior encased in plastic, with a slender iron railing—has been enjoyed by presidents, their families, and guests who can gaze across the South Lawn and its fountain to the Ellipse, Jefferson Memorial, and Washington Monument.

President George W. Bush looks out toward the Washington Monument from the Truman Balcony.

West Wing expansion. In 1948, an angry Truman completed a controversial balcony on the South Portico, paid for from the household budget, which changed the appearance of the south facade of the White House. Reaction to what is now known as the Truman Balcony was mixed, but it stayed.

Truman appointed a Commission on the Renovation of the Executive Mansion that studied the house's structural problems and recommended a renovation that retained the original walls, the 1925 third floor and the roof, while completely removing and then reinstalling the interiors within a skeleton of steel structural beams on a new concrete foundation.

In November 1948, the engineers studying the structural integrity of the house recommended that the Trumans move into Blair House across the street, and the president agreed. President Truman considered the experts' options concerning the fate of the 150-year-old presidential mansion. Permanently moving the president's residence was considered—as it had been in the past—but was dismissed. Truman made his feelings plain when he wrote: "The facts in the case are this. This old barn called the White House should be turned into a museum and a comfortable residence, inside a 160-acre farm in reach of Washington, should be arranged for the president so he could live like other people, but that, of course, is beyond the dreams of probability."

Ultimately, it was agreed that while the first family lived at Blair House across the street, a modern White House would be built inside the old walls. To the public, the outer walls of Aquia sandstone and the Seneca stone North and South Porticoes would appear unchanged. President Truman's renovation, the most ambitious rebuilding since the fire of 1814, began in the fall of 1949. In the end, little of the 19th-century or early 20th-century interiors were left. The interior of the White House was razed and a new interior built within the historic walls. Bulldozers dug out a basement two stories below the ground level where new service floors were built. Historic doors, mantels, and fixtures were retained and

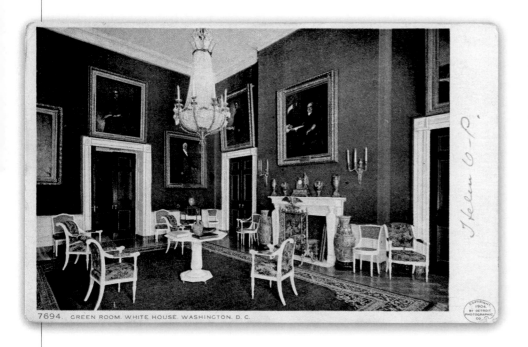

7694. GREEN ROOM. WHITE HOUSE. WASHINGTON. D. C.

A postcard view of the Green Room just after completion of the 1902 restoration by architects McKim, Mead & White. Opposite: A carpenter installs wood trim on the great lunette window in the West Sitting Hall during the Truman renovation, 1948–1952.

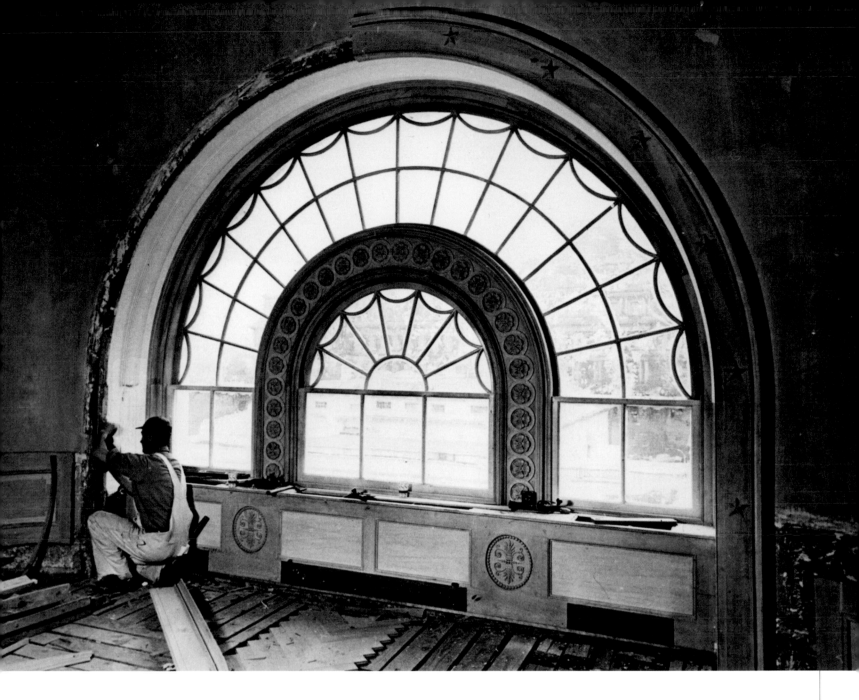

reinstalled later. Of the State Floor rooms, only the oak-paneled State Dining Room walls were reinstalled, but then they were painted a soft celadon green. Many modern conveniences were added, including central heating and air-conditioning. The project took three and a half years and cost $5.5 million. It destroyed the interior that had existed since 1902, but it saved the building as a symbol of the presidency.

The Commission on the Renovation of the Executive Mansion discussed furnishing the house in either late 18th-century Georgian style or early 19th-century Federal style to celebrate the house's early history. However, rising construction costs limited the budget for

new furniture, and many pieces removed before the construction were reinstalled with the addition of some neoclassical reproductions. Fabrics, rugs, and upholstery were provided at generously reduced prices, notably from B. Altman department store in New York.

On March 27, 1952, the Trumans moved back into the White House. President Truman's 1952 televised tour of the house showed his pride in the results of the renovation. Few people realize as they tour inside the White House now that although the house has changed to reflect changing times, technology, and building methods, they are looking at Truman's modernization of a neoclassical image established in 1902. ★

The Modern White House, 1952 to the Present

PRESIDENT DWIGHT D. EISENHOWER AND MAMIE DOUD EISENHOWER moved into the renovated
White House in 1953. Because changes were so new, Congress did not appropriate the customary
$50,000 for redecorating. In 1960, the Eisenhowers accepted from the Association of Interior
Designers a donation of early 19th-century furniture for the Diplomatic Reception Room.
This was the first successful attempt to furnish a room in the period of its earliest occupancy,
and set the precedent of obtaining museum-quality furnishings.

When President John F. Kennedy and his wife,
Jacqueline, came to the White House in 1961,
the first lady was dismayed to find so few historic fur-
nishings. She formed a Fine Arts Committee to advise
her on the acquisition of authentic period furnishings,
and Lorraine Waxman Pearce was hired as the curator.
Pearce wrote *The White House: An Historic Guide*, the
first guidebook published by the White House Histori-
cal Association. Jacqueline Kennedy also brought in
Henry Francis du Pont of the Winterthur Museum in
Delaware, an authority on American antiques and
period room decoration, as committee chairman.
Scholars Lyman Butterfield, editor of the John Adams
papers, and Julian Boyd, editor of the Thomas Jefferson
papers, drafted a paper entitled "The White House
as a Symbol." This document influenced Jacqueline
Kennedy to focus on conserving the evolving history
of the White House rather than trying to evoke only
the building's early period.

The Kennedy Restoration

A call by Jacqueline Kennedy for donations led to an
influx of authentic furnishings, among them three
original chairs from Monroe's Oval Room and a chair
made for the East Room in 1818. Congress in 1961
extended protection to these and all White House
objects. In a November 1965 issue of *Life* magazine,
Jacqueline Kennedy recalled the philosophy for the
restoration: "Everything in the White House must
have a reason for being there. It would be sacrilege
merely to 'redecorate it'—a word I hate. It must be
restored, and that has nothing to do with decoration."

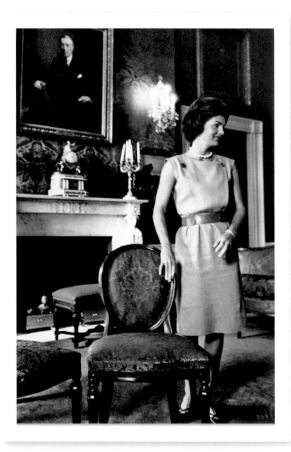

First Lady Jacqueline Kennedy posed in the Red
Room in 1961 to promote her plans to restore the
historic integrity of the mansion's public rooms and
make the White House a "living museum." Opposite:
Refurbished in 1971 under Pat Nixon's supervision,
the Green Room's walls were covered with green watered
silk fabric first chosen by Mrs. Kennedy in 1962.

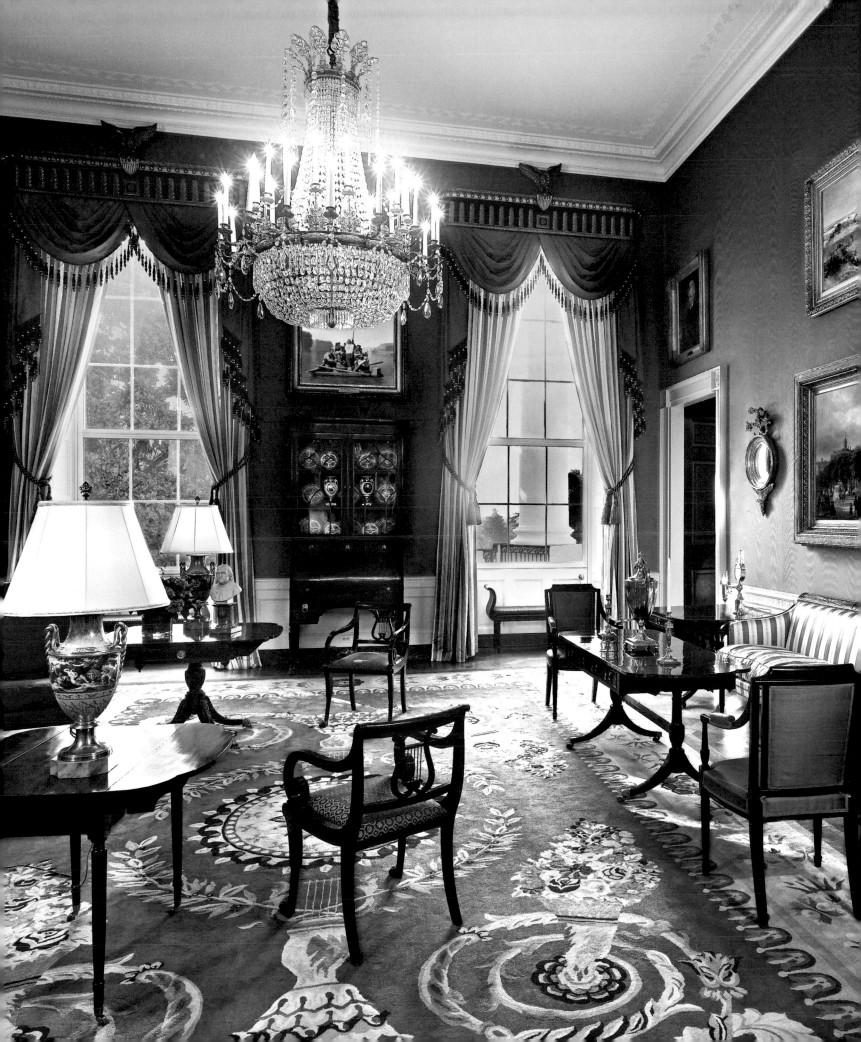

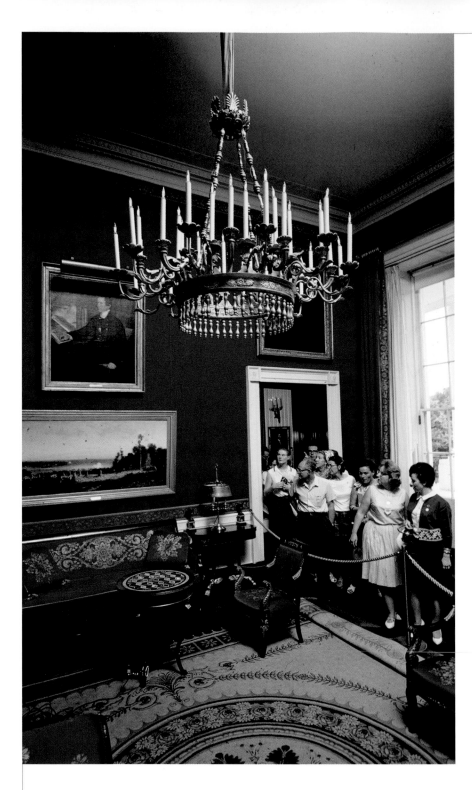

Visitors to the White House admire the Red Room on a morning tour featured in the White House Historical Association's *The Living White House*, 1966. The association sponsors projects that interpret the historic White House to the American people. Opposite: Elaborate stone carvings on the exterior were repaired in 1978, when paint coatings—in some cases, as many as 40—were removed.

Philanthropists, including Boston's Crowninshield family, Jane Engelhard, Jayne Wrightsman of New York, and the Oppenheimer family, donated fine and decorative arts to the project. Stéphane Boudin, the French interior designer who restored rooms at Versailles, was employed to supervise. Each major room was designed to reflect a period of history. The Green Room became a showcase for the Federal style, the Blue Room for the French Empire style, and the Red for American Empire. Upstairs, the style was Louis XVI for the Yellow Oval Room and Victorian Revival for the historic Cabinet Room, then used as the president's study, which was renamed the Treaty Room.

On February 14, 1962, Jacqueline Kennedy showed the results on the live television program *A Tour of the White House with Mrs. John F. Kennedy*. The program drew more than 80 million viewers and brought many offers of family heirlooms and antiques. Although most of the offers were of unsuitable objects, the committee did find a few treasures. The Kennedys made the White House a showcase of art, history, and culture that influenced the national identity in a way that had not been seen since the Roosevelt restoration of 1902.

As historian William Seale noted, "If President Truman's metamorphosis of the house had altered everything structurally, President Kennedy's brief years in the presidency were to see the house transformed forever in the world's understanding of it. The change was almost spiritual in character. It was not simply a matter of antique furnishings and period interiors that made the difference." Lady Bird Johnson secured

the Kennedy legacy when President Lyndon Johnson created by executive order a permanent Committee for the Preservation of the White House in 1964.

Adding Artwork

Later administrations have left important decorative arts impressions on the White House. Richard and Pat Nixon surpassed Jacqueline Kennedy in the acquisition of historic furnishings and in historical accuracy in the restoration of the State Rooms. Pat Nixon took special interest in acquiring fine works of American furniture, and working with curator Clement Conger, added more than 600 works to the collection, including major examples by noted early American cabinetmakers Duncan Phyfe and Charles-Honoré Lannuier. Gerald and Betty Ford were in residence during the U.S. bicentennial in 1976, and received James and Dolley Madison's French dinnerware. Rosalynn Carter's broad vision and love of history inspired the establishment of the White House Endowment Fund in 1978, which provides an endowment for acquisitions and for refurbishing. Ronald and Nancy Reagan added more than 150 collection objects and conserved the marble walls, wood doors, and floors in the public rooms. Nancy Reagan was a tireless advocate of redecoration of the private quarters and conservation of public spaces with private donations.

Barbara Bush appointed curators and art historians to a revived Committee for the Preservation of the White House and worked to increase Rosalynn Carter's White House Endowment Fund under the White House Historical Association. The goal was to raise an endowment for acquisitions, conservation, and refurbishing. Hillary Clinton strongly supported the fund-raising campaign, and its $25 million goal was met in 1998. Hillary Clinton, with the preservation committee's advice and her own participation, completed refurbishment of the Blue Room and the East Room in 1995. Two years later, the Entrance Hall, Cross Hall, and Grand Staircase were refurbished, and the State Dining Room in 1998. Laura Bush supervised a significant redecoration of the Lincoln Bedroom in 2004, refurbished the Green Room and the Queen's bedroom, updated the library's book collection, and renovated the Vermeil and Map Rooms.

Preservation Projects

Since 1952, attempts to provide a sense of the history of the President's House, coupled with new research, have resulted in decorative interior changes but no substantive architectural work. Beginning in 1978, a study approved by President Carter assessed problems with the exterior paint. Successive layers—in some areas as many as 40—had to be removed. Masons then began repairing deteriorated stone. As the stone restoration entered its late stage in 1988, the White House, in cooperation with the National Park Service and the Historic American Buildings Survey, began a documentation project. Conservation and repainting of the exterior took 20 years—from Carter to Clinton—representing patience and support of four presidents who endured endless noise and windows blocked from construction dust.

In 1990, the American Institute of Architects, in cooperation with the White House Historical Association, sponsored a Historic American Buildings Survey project to record the interior architecture of the White House. The results of these two completed projects combined to create a comprehensive record of the historic main house rendered in ink on linen, which will be used as base documents for future renovation, restoration, maintenance, and interpretation of the house. ★

The WHITE HOUSE GARDENS and GROUNDS

BREAKING GROUND ★ *GARDENS in TRANSITION* ★
The GILDED AGE ★ *The MODERN ERA* ★

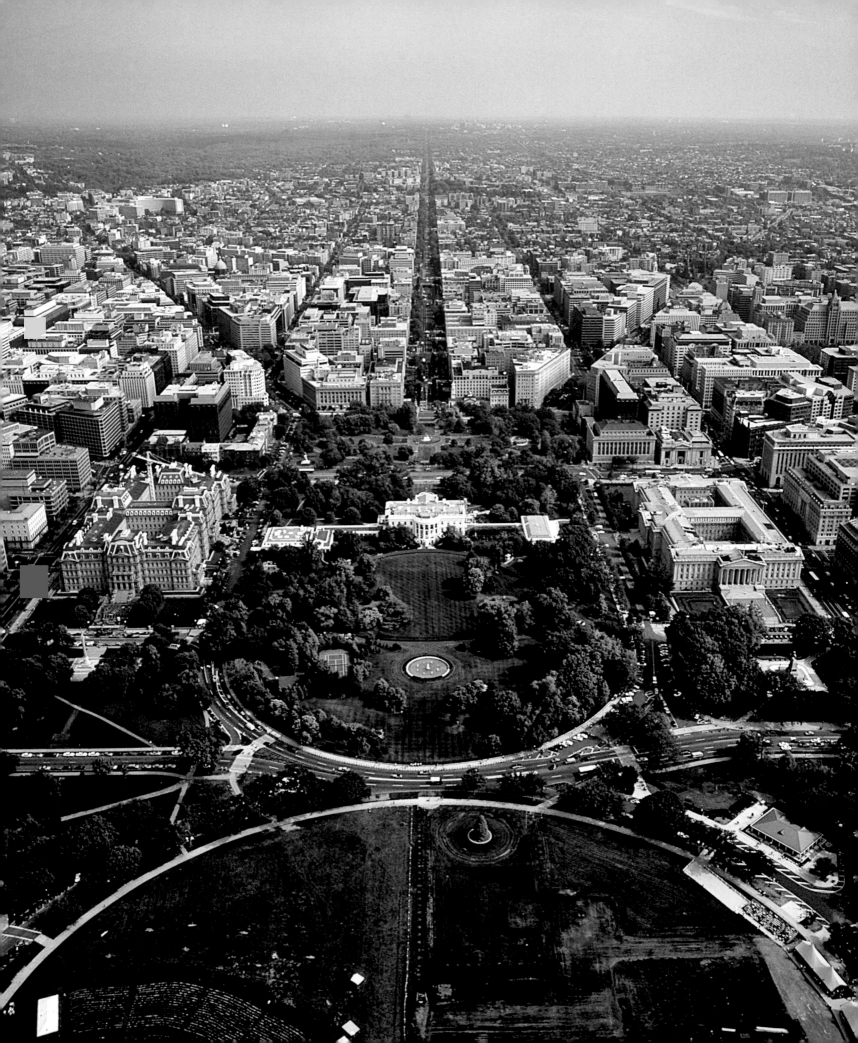

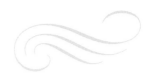

THE 18 ACRES OF GROUNDS SURROUNDING THE WHITE HOUSE are for the use of the president and his family, but they are shared with the public whenever possible at events such as the annual Easter Egg Roll, as well as spring and fall garden tours, when the flowers and trees are at their seasonal peaks. The White House grounds are the oldest continually maintained landscape in the United States. George Washington anticipated that this "country house" would be set within an approximately 80-acre "botanical garden," more than four times the present acreage. Thomas Jefferson cut the tract down to about eight acres, believing the plans too ambitious. In the early 19th century, an orchard, gardens, stables, cowsheds, and other structures offered essential and economical support for the president's table. The evolution of the grounds reflects both their use by the presidents and first families, and the growth of the profession of landscape architecture. Today, the approximately 85-acre President's Park includes the 18-acre grounds surrounding the White House and outside the fence, the sites of the Eisenhower Executive Office and Treasury Buildings, Lafayette Park, the Ellipse, and a section of Pennsylvania Avenue. The attractive grounds are the result of more than two centuries of presidential interest in the landscape. John Adams, an inveterate gardener, ordered a vegetable garden turned up in the fall of 1800. Before the seeds could be planted in the spring, he had lost the election to Jefferson and returned home to Massachusetts to plant his own garden. Jefferson kept an indoor garden of potted plants—flowers and seedlings in his office—with his tools in a nearby drawer.

Preceding pages: President Woodrow Wilson and First Lady Edith Bolling Wilson stand beside a lily pond in the East Garden in 1916. Opposite: An aerial view shows the White House, the North Lawn, Lafayette Square, 16th Street extending north, and the South Lawn with its prominent fountain. The Ellipse appears at the bottom, and the Eisenhower Executive Office and Treasury Buildings frame the grounds.

Breaking Ground

WHEN THE WHITE HOUSE WAS BUILT, THE PRESIDENT'S PARK looked nothing like it does today. Pierre Charles L'Enfant had imagined a presidential "palace" in a park, but the completed Executive Mansion stood as a stately house in the midst of wooden cottages, and a few brick houses and office buildings. Lafayette Square to the north was a part of a plantation known as Jamaica, once a thriving tobacco enterprise. That farm encompassed the old Pierce family cottage—cemetery at its door—an apple orchard, and fallow fields. On the south, most of the planted grounds of the White House were on land secured from David Burns's farm, including marsh to the south.

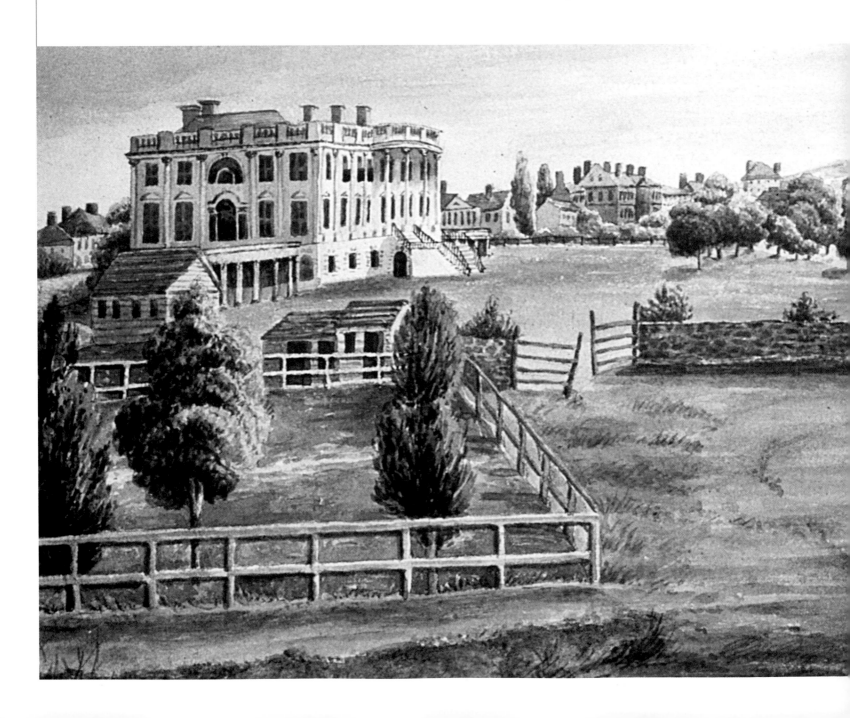

The grounds were undeveloped when John and Abigail Adams moved in. North and south of the White House were work areas for stonecutters and woodworkers. Sheep and cattle grazed where tourists now tread. Nonetheless, Abigail Adams optimistically described the potential of the site to her daughter as "a beautiful spot, capable of every improvement, and the more I view it, the more I am delighted with it."

Thomas Jefferson inherited a construction site when he came into office. During his two terms, he prepared plans to improve the grounds to include

The home of the president of the new United States stands amid a setting of dirt roads, wooden fences, and mostly wooden cottages in this anonymous watercolor painting from about 1827. The White House at this point was still the grandest residence in Washington. Shown are the East and West Terraces and the stone wall built by Thomas Jefferson, along with an orchard, vegetable garden, and a few worker shanties left from the restoration of the White House after the fire of 1814. Lafayette Park was still just a pasture, as was other land around the mansion.

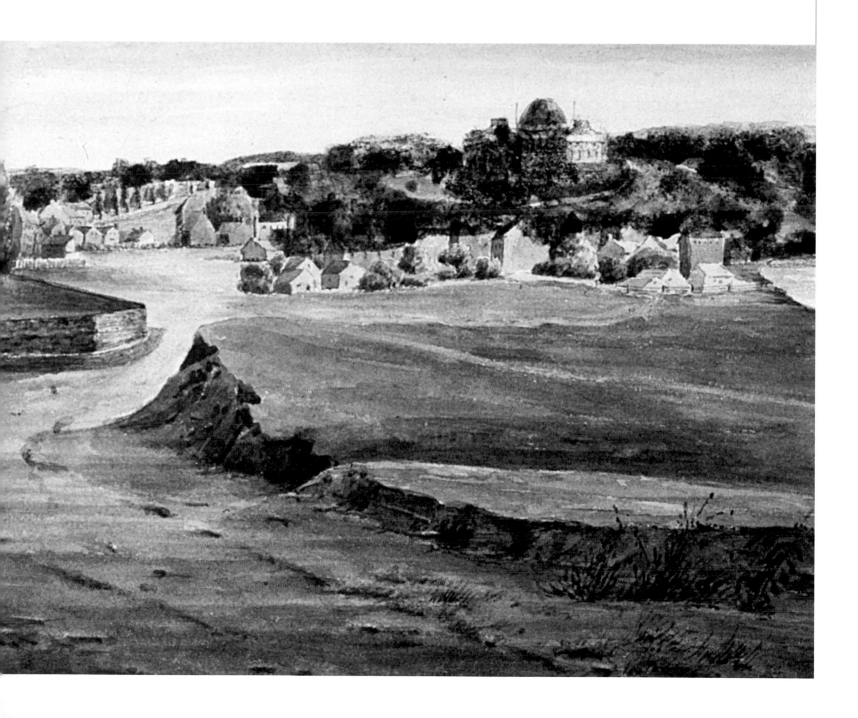

groves of trees, gardens, and graveled driveways, with a fence that enclosed eight acres around the residence. His plan was detailed and influenced the site's overall layout until the Civil War. Of major importance was his solution for the problems of wet ground immediately south of the house. He built a high retaining wall and moved earth behind it to level the grade of the South Lawn. With the completion of his East and West Terraces and wings in 1807, Jefferson had divided the grounds into two sides. The north became the public space leading to the main entrance for callers or visitors. He envisioned the South Grounds as a private garden with serpentine walks and a lawn, within the retaining wall edged by flower borders. The vegetable garden was placed out of sight on the southeast side of the house. Jefferson ordered groves of trees planted and walls built around his eight acres for privacy. The mansion was not hidden but always visible because it was situated on a high ridge. To maintain the view and the illusion of an unbroken landscape from the high ground, Jefferson had the southern portion beyond the wall dug out as a "ha-ha," a sunken ditch that kept livestock from grazing in the garden.

Jefferson's vision for the grounds was largely carried out in James Madison's administration, and the grading and plantings began to provide an attractive site for the house. The progress ended when the British burned the White House in 1814. During the administration of President James Monroe, from 1817 through 1825, little work on landscaping was accomplished as the White House was still being rebuilt and the earth ripped out for regrading or was trod down by workers. Monroe brought in Charles Bizet, the Madisons' gardener from Montpelier, but any immediate

planting had to be postponed by prolonged construction work. Jefferson's seedlings, however, had shot up, and attention was given to them. It was the beginning of the grounds as a grove of trees. A new semicircular driveway marked by eight stone piers and an iron fence and gates between 1818 and 1819 replaced Jefferson's high stone wall across the North Front of the house. Parts of the wrought-iron fence and stone piers still stand today on Pennsylvania Avenue, with replica gates made from reinforced metal installed in 1976 for increased security. The stone retaining wall on the south remained until 1873, and mischievous youths often painted their names on the wall.

President John Quincy Adams, who succeeded Monroe, was an enthusiastic gardener who planted trees, herbs, and vegetables, and created groves of fruit and forest trees. Adams brought John Foy, Henry Clay's former gardener working at the Capitol, to advise him on groves of fruit and forest trees. John Ousley, who with his family occupied a cottage on the grounds made from several builders' houses, planted and cared for the herb and vegetable gardens and the grounds.

Andrew Jackson's Magnolias, or Not

With the coming of "Old Hickory" in 1829, Andrew Jackson, the grounds underwent an overhaul, thanks

Opposite: Magnolias (top) possibly planted in the 1840s survive today. A romantic legend holds that Andrew Jackson set the trees in memory of his late wife, Rachel. A stone milk trough (inset) carved for Jackson about 1834 serves today as a garden ornament. Jackson in a portrait by Ralph E. W. Earl (above), about 1835.

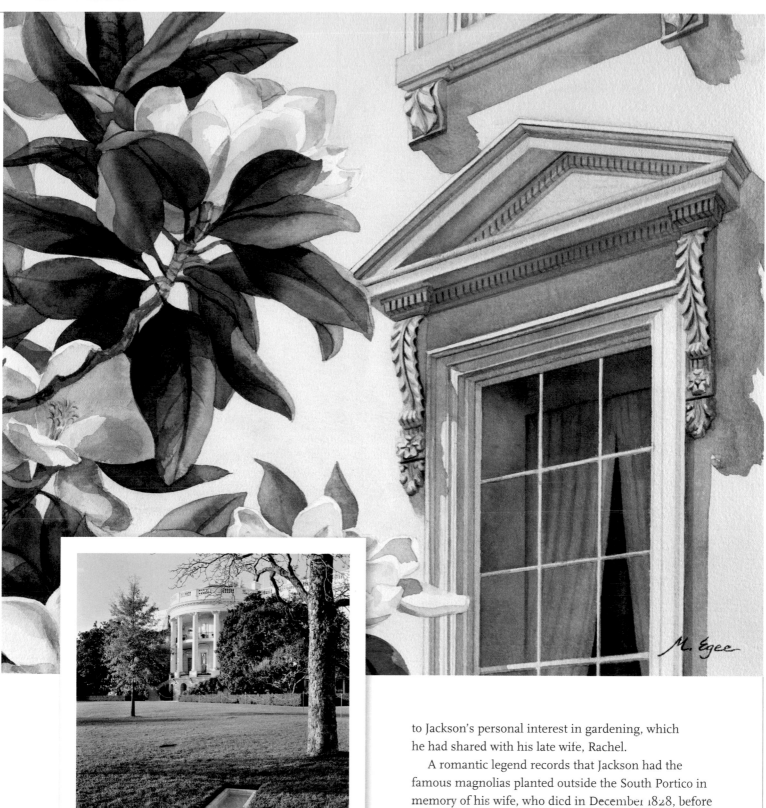

M. Egee

to Jackson's personal interest in gardening, which he had shared with his late wife, Rachel.

A romantic legend records that Jackson had the famous magnolias planted outside the South Portico in memory of his wife, who died in December 1828, before his first inauguration. No contemporary records place these trees in Jackson's administration, and the first known photograph of the south facade of the White House, taken in 1846, does not show a magnolia in that location. However, the magnolia is ancient so perhaps Ousley planted the tree soon afterward. ★

Gardens in Transition

IMPROVED TRANSPORTATION OF PLANTS WORLDWIDE AND THE DEVELOPMENT of portable hothouses in the 1830s made it commercially feasible to obtain and grow once exotic plants. For the White House, this meant ever more interesting plants could be shipped by steamer and rail. Documents of the 1830s and 1840s in the National Archives list wide varieties of indoor plants ordered for the White House from nurseries everywhere, but mostly on Long Island. Potted fruit trees and tubbed camellias were popular, but roses soon became the most prized.

When Jackson first took office, a stable built during the Monroe administration on the end of the West Wing sheltered presidential and government horses and cows. This stable was enlarged, but it was crowded and created both a chaotic scene and unwelcome fragrances under the windows of the State Dining Room. Cows, providing milk for the White House tables, were milked night and morning, and were led to pasture along the river by day, supervised by "cowboys." It all provided for an odiferous presidential mansion, with all that activity plainly visible from the State Rooms. Jackson, a consummate horseman, built a handsome two-story neoclassical brick stable trimmed with Aquia stone in 1834 to the southeast of the house, near the present site of the General William Tecumseh Sherman Monument. The cows were also moved there or to an adjacent shed. Stables would remain a fixture at the White House, and a series of new structures were built on the east and west side of the grounds over the years until automobiles replaced horses for official presidential travel in 1909. The last stable was a grand high Victorian structure built for Ulysses S. Grant on the west grounds in 1873, and was demolished in 1911. Automobiles today are garaged away from the White House.

Gardens Under Glass

While U.S. minister to Great Britain, Martin Van Buren acquired a taste for gardening and toured famous English gardens with author Washington Irving. As president from 1837 to 1841, he promoted the gardens at the White House and encouraged gardener John Ousley to create splendid grounds. He may have gone too far, because the garden became a political issue. During the campaign of 1840, Whig congressman Charles Ogle of Pennsylvania launched on the House floor a venomous criticism of Van Buren's White House indulgences while the country was in the midst of a depression. Ogle said, "It is time the people of the United States should know that their money goes to buy for their . . . President, knives, forks, and spoons of gold, that he may dine in the style of the monarchs of Europe." Although the speech became famous as the "Gold Spoon" oration, the gardens were not omitted. He described brick coping, fountains, paved footways, a profusion of flower beds and borders, trained vines, "sweet-scented grass," and "beautiful bouquets for the palace saloons." One harsh criticism was damaging and true: "As the President's garden is enclosed by a high stone wall, and the gates are generally secured with locks, very few persons, I have been informed, visit it, except by special invitation." In fact, President John Tyler opened the backyard to the public in 1841, and it soon became a social center of Washington high society for strolls and weekly concerts until after the Civil War.

By the 1850s, greenhouses with overhead glass began to replace orangeries, and the White House

An old apple tree photographed in 1920 was probably the gift of landscape designer Andrew Jackson Downing during Millard Fillmore's administration. Through splicing, the tree produced three varieties of apples annually, typical of the time when homegrown fruit ended up on the presidential table.

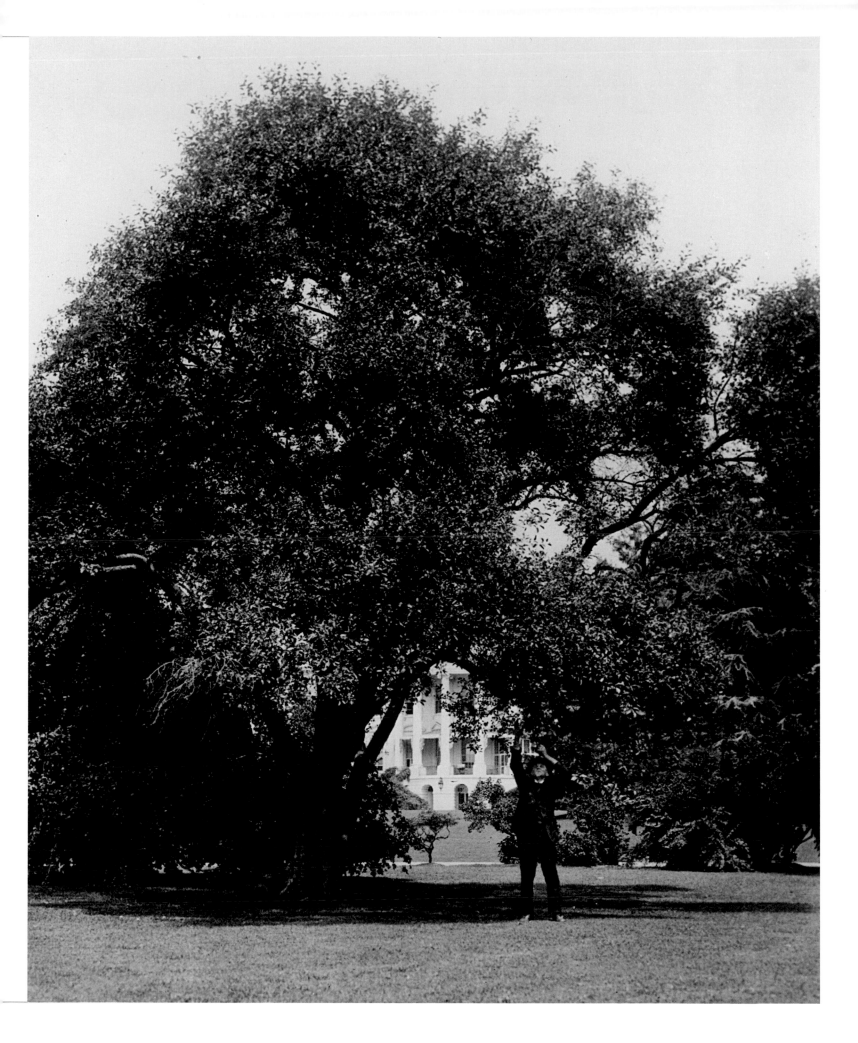

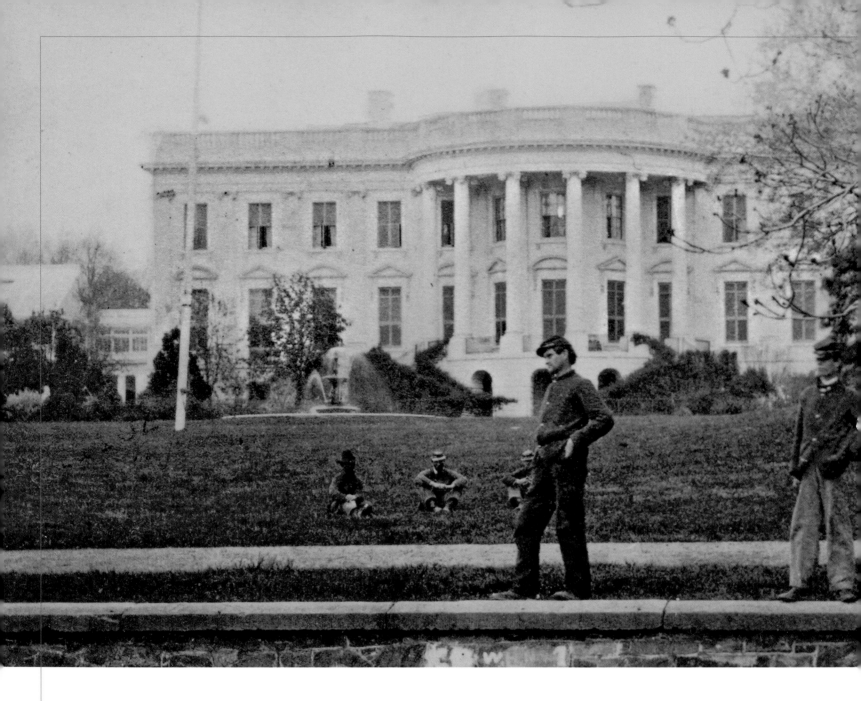

orangery was remodeled with glass shed roofs in 1853. Franklin Pierce, president from 1853 to 1857, modified the greenhouse, adding a semi-octagonal bay in the middle of the glass sheds as a sitting room. The south facade was principally glass. White plaster walls, cast-iron furniture, and surrounding banks of palms created a pleasant retreat for the first family.

In 1853, botanical specimens brought back by Commodore Matthew C. Perry's expedition to Japan flourished in the Pierce greenhouse. Congress had provided an appropriation for enlargement of the National Botanic Garden, and the president tried to divert the funds to expand the greenhouses at the White House. About the same time, it was realized that existing White House greenhouses were in the way of a much needed westward extension of the Treasury. So in a sense, Pierce got his way. The substitute for the orangery and its indoor garden was a new greenhouse mounted atop the flat roof of the West Terrace that could be entered from the central hall at the end of the house. There were occasional warnings through the 1850s about how flowers kept in a residence discharged dangerous "effluvia," but people began to disregard the claims. Flowers now meant more

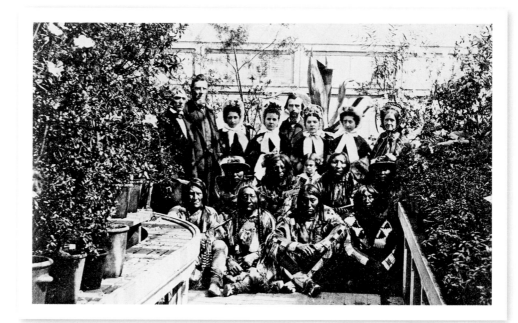

Union Army soldiers (left), in 1862, stand on a stone retaining wall built by Thomas Jefferson, in a photo by Mathew Brady. In 1863, a delegation of Native Americans (above) was photographed with the president's staff and guests during a visit to Abraham Lincoln. They include, front row from left, Standing in Water, War Bonnet, and Lean Bear (all Cheyenne), and Yellow Wolf (Kiowa).

at the White House than ever before, and that would be attested to by the growth of a rambling greenhouse complex over the next 40 years. The splendid arrangements that beautify the State Rooms are descendants of the floral bounty of the greenhouses.

Rural Architect

Already in the early 1850s, the federal government had hired the most prestigious "rural architect" in the nation, Andrew Jackson Downing, to redevelop the public grounds of the national capital, including President's Park and the Mall. Downing had ambitious plans that required major tree cutting and planting. For President Millard Fillmore, a gardening enthusiast, Downing envisioned defined groves of trees pulled away from the house and pruned upward to create a forestlike effect—his early plans sketched in rows of trees on the north side and in picturesque configurations on the south.

Millard Fillmore, president from 1850 to 1853, took a keen interest in Downing's plans and played an active role in the design review whenever he could. New gravel walks were put down, and the existing flagstone paving on the porches and driveway was taken up and relaid on a bed of sand. (The familiar horseshoe-shaped driveway in place today had been laid down in 1834.) The president and first lady planned a meeting with Downing in Washington to show his new plans to make the White House grounds an enviable garden. Tragically, Downing was killed on the Hudson River in July 1852, when the side-wheeler *Henry Clay* exploded and fire swept the ship. Deprived of their designer, officials who had enthusiastically endorsed Downing's ambitious plans were stalled. For half a century, however, landscaping around the White House and on the Mall was influenced in one way or another by Downing's unrealized design.

Changes were made. The Ellipse, for example, south of the White House grounds (within the President's Park) began as a circular "parade" after

continued on page 59

ORANGE DE LA CHINE.
Arancio Fino.
Tab. 4.

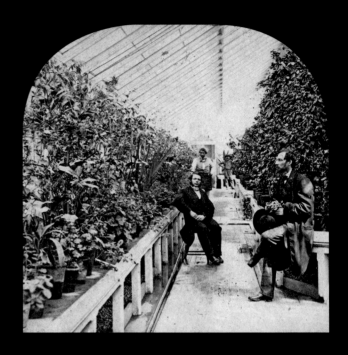

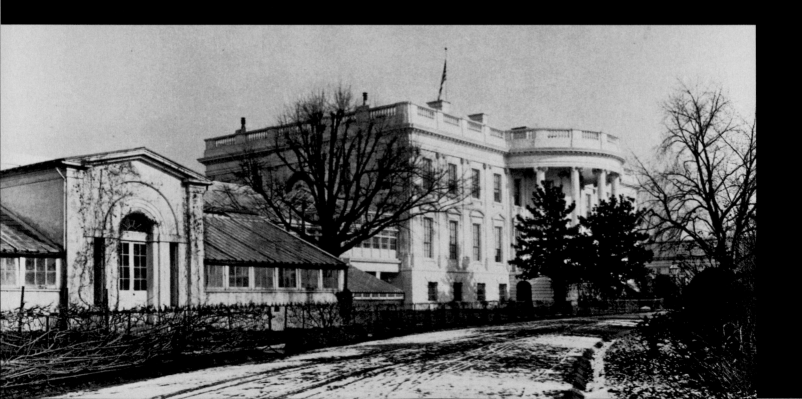

GREENHOUSES AT THE WHITE HOUSE

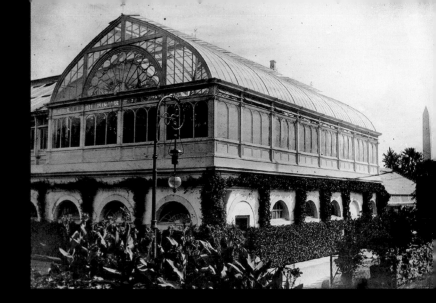

Hothouses, or orangeries, had been known since George Washington's day, and Thomas Jefferson delighted in growing plants in pots, including the edible China orange (far left). When a Treasury Building expansion east of the President's House required demolition of an older orangery/greenhouse, a new conservatory was built above the West Terrace in 1857. Lincoln's secretary John Nicolay (left, foreground) sits posed in the conservatory with an unidentified gentleman. A late 19th-century addition to what grew into a complex of greenhouses seen from the northwest (right). Warmed by a furnace and oil heater, these young ladies (below) enjoy a private world of plants and flowers during the Buchanan administration. The conservatory (below left) seen from the South Drive of the White House during the winter of 1875. The Jackson magnolias are visible in the distance. The greenhouses were torn down in 1902, during the Theodore Roosevelt administration.

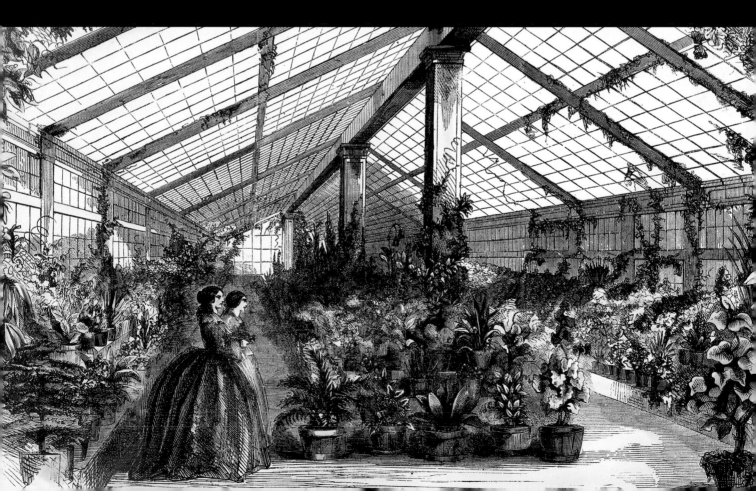

THE HEAD GARDENERS

The 18 acres of lawns, trees, and the Rose, East, and Children's Gardens are under the direction of the head gardener; the National Park Service tends the larger President's Park. Charles Bizet is usually considered the first head gardener, hired by James Monroe in 1818 and paid $50 at random intervals. John Quincy Adams replaced him with John Ousley, who remained in that position from 1825 until 1852. Millard Fillmore decided he needed a younger man to rebuild the grounds and brought on John Watt. Chief gardener Watt famously befriended Mary Todd Lincoln, abetting her with shifting allocations of public funds. Watt leaked portions of the president's 1862 State of the Union message to a dandy about town named Henry Wikoff who worked with the *New York Herald*. Lincoln summarily fired Watt. Superintendent Irvin Williams holds the record for the longest tenure as groundskeeper, caring for the White House landscape from 1961 until his retirement in 2010.

Superintendent Irvin Williams (top) tends to a bed of tulips on the South Lawn of the White House in 1966. Horticulturalist Charles Lee Patton (above), circa 1923, worked with Henry Pfister, chief gardener, 1871–1902, and later supervised the Olmsted plan of the 1930s.

Downing's plan. However, most improvements were modest. The flower garden gained a new white picket fence. On the walks, fresh gravel was placed, mounded, and rolled. An old, rotten arbor was torn down and an attempt was made to save old roses that had survived. The gardens were fresh and trim in the autumn of 1854, with plantings pruned and new material added. Off the East Colonnade, only the president, his family, and intimate friends had access to a private garden, secluded by trees and shrubbery. The iron main gates to the grounds were unlocked daily and the public allowed to enter the South Grounds until sundown, peering up toward the White House windows for a glimpse of the president or his family.

In 1853, Clark Mills's famous statue of Andrew Jackson on his "rocking horse" went up in Lafayette Park, where it still stands. Gas lamps were set up in the park, and metal fences enclosed the statue and the park. When spring came, wagons rolled in with young trees, which were planted on the Mall and city streets. On the White House grounds, little was done beyond maintaining the gardens in a condition suitable to the president's home.

By 1860, the South Lawn boasted the magnolia near the house, its first fountain, and an earthen berm, often called "Jefferson's mound," although documents indicate it was built long after his administration. The South Grounds had a gravity fountain, a terra-cotta configuration of dolphins, and graduated bowls that consistently refused to

President Thomas Jefferson cultivated potted geraniums on the sunny window sills on the south side of the White House. His favorite variety was the scarlet geranium (above), illustrated in Robert Sweet's five-volume guide on geraniums published between 1820 and 1826.

spray, despite the devoted efforts of the gardeners.

The house and grounds that greeted Abraham Lincoln in 1861 had changed little for more than a decade. The North Lawn with its horseshoe drive had an iron-fenced garden with a few rose bushes along its gravel paths. A bronze statue of Thomas Jefferson by David D'Angers stood in the center. James K. Polk had it erected there in 1848, to symbolize his kinship to Jefferson as an expansionist. It was removed during the Grant administration and today stands in the Capitol Rotunda.

The Torments of Summers

For respite, the Lincolns often went to the White House conservatory. However, the president and his family spent hot summers at a Gothic Revival–style cottage on the grounds of the Soldiers' Home, three miles north of the White House, and Lincoln commuted downtown by carriage, accompanied by a detachment of soldiers. There during the Civil War, he escaped the stench and insects that pervaded the White House from stockyards and a slaughterhouse southward on the Ellipse and the grounds of the Washington Monument. What had once been the Tiber Creek had been walled and deepened early in the century, becoming the slow-moving Washington City Canal. By the time of the Civil War, it was an open sewer where dead animals rotted in the sun.

Civil War Washington was a Union Army encampment, and troops bivouacked throughout the city, including on the South Lawn. Despite these difficulties, the White House grounds had grown in attractiveness and grace through the years. The view down the Potomac River was spectacular, with the lesser bodies of water catching silver reflections from the sky, and the many greens of trees and grasses combining in natural beauty. The railroad trestles and highways that today mar the view had not been built. The grounds of the White House were considered one of the most attractive spots in the nation's capital, and many people came to see them. ★

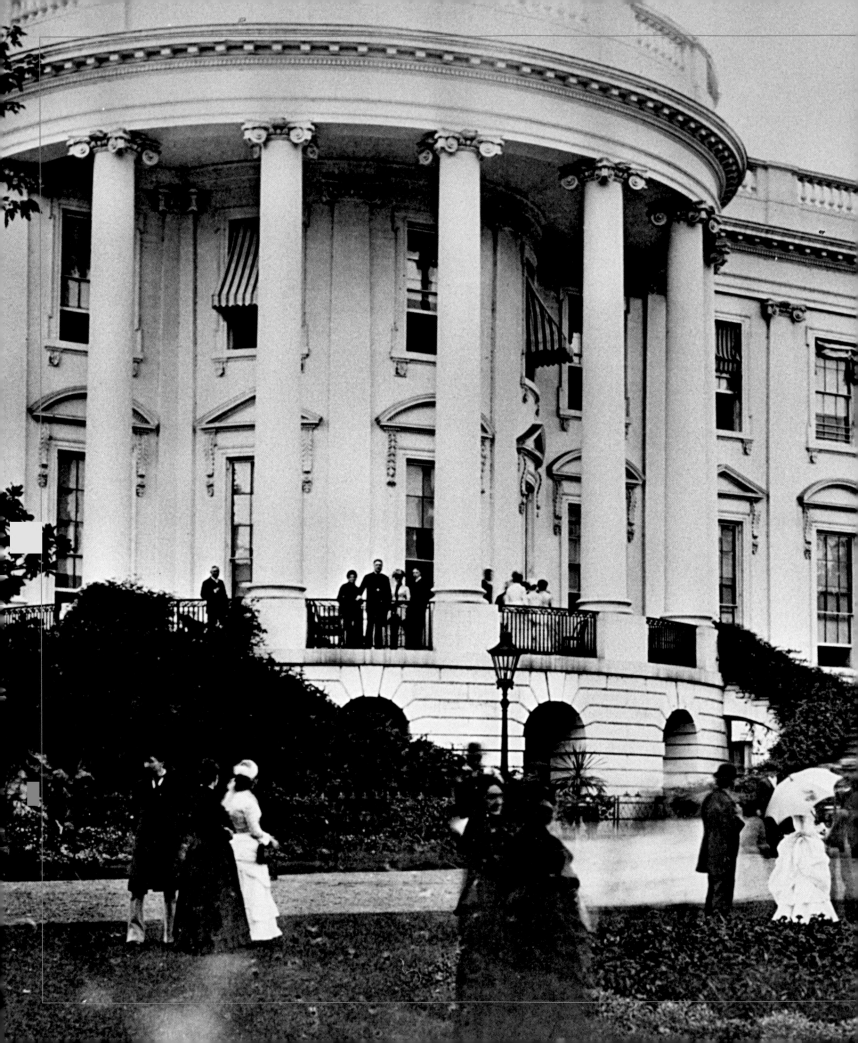

The Gilded Age

AFTER THE CIVIL WAR CAME THE PERIOD KNOWN AS the Gilded Age, coined in an 1873 novel, *The Gilded Age: A Tale of Today* by Mark Twain and Charles Dudley Warner, to describe a time of rapid industrialization masked by the cheap tinsel of corporate greed and political corruption. Americans who had made their fortunes in the West and North transformed Washington into one of the nation's social centers. Washington's newest affluent residents built mansions along 16th Street and Massachusetts Avenue.

President Chester A. Arthur (left) greets his guests from the South Portico during a garden party in 1884. Garden parties on the South Lawn became popular during the Gilded Age and remain so today. President William H. Taft (inset) greets society members at a White House party in 1911.

The timing would have been advantageous for President Ulysses S. Grant to build a new executive residence. Just after the Civil War, the Army Corps of Engineers had proposed to Congress in 1867 plans for a new presidential mansion within a future Rock Creek Valley public park. President Grant dismissed the idea. In his mind, the White House had been sanctified by Abraham Lincoln and the trial of the Civil War. Moreover, it was a symbol of history and perseverance. Grant and his family greatly enjoyed the house, its grounds, and its greenhouses—or conservatories as they were also called—as private retreats and as after-dinner entertainment spaces.

Expansion of the Grounds

Several important improvements to the grounds were made during the Grant administration, including constructing East and West Executive Avenues, separating the house from the expanded Treasury Building and the new State, War, and Navy Building, adding the pool fountains that still survive on the North and South Lawns, expanding the South Grounds, and initiating Downing's long-delayed plans for tree planting. One of the first projects that Grant directed was the restoration of the flower gardens on each side of the South Portico. During the Grant administration and in the years to come, these gardens became a feature of frequent lawn parties where guests could mingle and enjoy refreshments.

When Rutherford B. Hayes came into office in 1877, he found many of the Grant landscaping projects half

One of the sad features of the storm, was the destruction of the Lincoln tree . . . It was the end tree of a row nearly all of which have been planted a few months after President Lincoln entered the White House . . . those who secured limbs said they intended having canes made for presentation to those who would cherish a souvenir from Washington, and especially a cane from the tree planted by Lincoln . . .

"THE 'LINCOLN TREE' BLOWN DOWN," November 5, 1896

WHITE HOUSE LORE ★

THE LINCOLN TREE

Presidents have often planted trees, and Abraham Lincoln appears to be no exception. Newspaper accounts claim one of the trees he planted was a maple near the steps leading from the State, War, and Navy Building (now the Eisenhower Executive Office Building west of the White House) to the Executive Mansion. It blew down in a tornado that hit Washington, D.C., on September 29, 1896. The storm killed ten people in the city and injured many others with falling walls, bricks, awning frames, and trees. Extensive damage was also reported to government buildings, embassies, churches, theaters, schools, stores, and the summer residence "Red Top" of then President Grover Cleveland, in today's Cleveland Park suburb. After the storm abated, the White House received many requests for wood from the Lincoln tree to make canes, and White House gardeners did their best to fulfill them. They cautioned, however, that maple did not make good cane wood, with hickory and oak being preferred. Canes made from the supposed Lincoln tree became canes anyway, and are prized as souvenirs and artifacts.

completed, including the addition of a guitar-shaped oval driveway that ultimately developed into the Ellipse, a 17-acre oval public park beyond the White House fence that remains today. Such grand landscaping plans take time to fulfill. The land was raised seven feet above where it had been in 1800, and densely planted with elm trees. Hayes also began the tradition of planting commemorative trees on the White House grounds to represent each president and state. After Hayes departed in 1881, little was done to change the grounds at the White House for decades. Plan after plan went unfunded by Congress and thus unrealized.

Nonetheless, in the decades after the Civil War, the White House grounds once again became a part-time public park, and when the gates were opened, people flocked there to enjoy strolls and to listen to the Marine Band concerts. Apart from brief closures due to the illness of the president or a member of the first family, the public had daily access to the grounds at certain hours and came to regard respectful enjoyment of the lawns and gardens as a fundamental right. After Chester A. Arthur revived the 1850s custom of the president coming down from the South Portico to greet and mingle with people on the lawn, the summer concerts by the Marine Band on Saturday afternoons began attracting large crowds. The concerts became an ever more popular tradition among Washingtonians and a treat for tourists. Plain folk hobnobbed with the president, members of the diplomatic corps, army and navy officers, and the elite of self-defined Washington society. Couples strolled on the South Lawn while the band played waltzes and nocturnes. The events remained popular even when President Arthur was not in attendance.

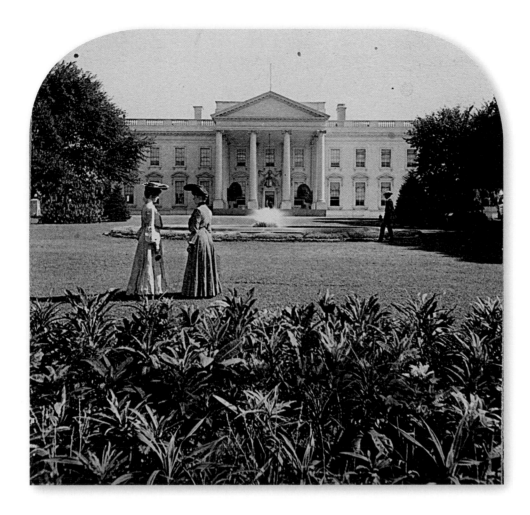

Tourists pose on the North Lawn in this detail from a stereocard view of 1903.

John Philip Sousa

The popularity of the Marine Band concerts in the 1880s was in large measure due to the high quality of the music. John Philip Sousa was the band's director between 1880 and 1892, and brought world fame to "The President's Own." While the band was already considered a beloved national institution, Sousa's dynamic leadership transformed the Marine Band's repertoire, emphasized symphonic music, changed the instrumentation, and made rehearsals exceptionally strict. The Marine Band delivered some of its most memorable outdoor concerts in this period, including a performance of the musical score from Gilbert and Sullivan's comic opera *The Mikado,* just three months after its premiere on the London stage and before it became a smash hit in American theaters. There might have been a hint of humor in the June 20, 1886, performance for the newlywed President Grover Cleveland and First Lady Frances Cleveland—bands across the country had

played a song from *The Mikado,* "For He's Gone and Married Yum-Yum," in the days after the president's May–December marriage earlier that month.

An 1891 account of the popular summer and fall concerts reported, "Administrations come and go, but the band plays on forever." Sousa conducted his last concert at the White House for President Benjamin Harrison in 1892, and went on to organize a civilian band that traveled the world. His accomplishments while director included the Marine Band's first sound recordings and its first national concert tour. During those years, he began to write the marches that earned him international acclaim and the title "The March King." He continued composing and conducting until his death in 1932. Through the years, the band has performed original band compositions, orchestral transcriptions, popular and patriotic music, folk music, and jazz. For nearly a century, Saturday public concerts on the White House grounds were a fixture of cultural life in Washington. ★

The Modern Era

AS PART OF THE WHITE HOUSE RESTORATION UNDERTAKEN by Theodore Roosevelt in 1902, the 19th-century conservatories were razed, and a new "temporary" Executive Office Building, later to be known as the West Wing, was erected. A photograph of Roosevelt standing in his office in the new building with his hand resting on a globe, partly turned toward the lens, unsmiling, as if he were at ease with power, symbolized his leadership of the United States onto the world stage.

First Lady Michelle Obama thanks the chefs for their work on the State Dinner for German Chancellor Angela Merkel held in the Rose Garden in 2011. President Barack Obama awarded the Presidential Medal of Freedom to Chancellor Merkel at the dinner. The intricate design on the west wall of the White House was created by colored lights projected above the guests.

After he became president following William McKinley's assassination in Buffalo, New York, in 1901, Roosevelt and his wife, Edith, began planning to remodel the White House. The East Room floor trembled, and to support large crowds had to be reinforced with timbers. The family had always shared the second floor with the offices of the president and his clerks. Bathrooms and bedrooms were too few for Roosevelt's large family, which consisted of five young children by his second wife, Edith, and 17-year-old Alice from his first marriage, to Alice Hathaway Lee who had died at age 22.

A major renovation was undertaken, with architect Charles McKim of the New York firm McKim, Mead & White in charge. McKim with difficulty persuaded the Roosevelts that the "glass houses" were an impediment to "restoring" the historical authenticity of the original White House. He argued that the structures marred the symbolic importance of the White House's historic architecture. The greenhouses also created a major impediment to the planned office expansion on the west that would clear the president's staff from offices on the east end of the second floor. The greenhouses were dismantled and for a time reassembled near the Washington Monument. Parts of the structure survive today in greenhouses maintained in Maryland by the National Park Service.

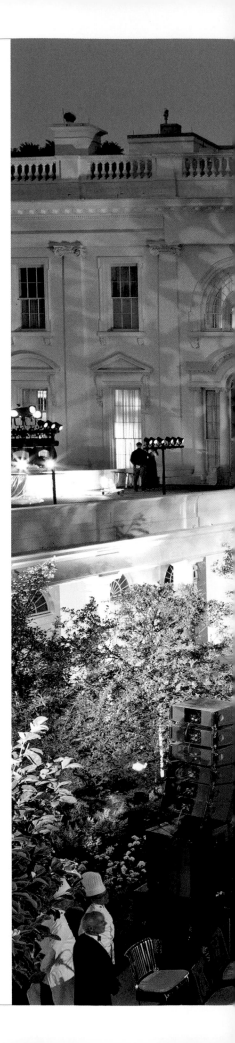

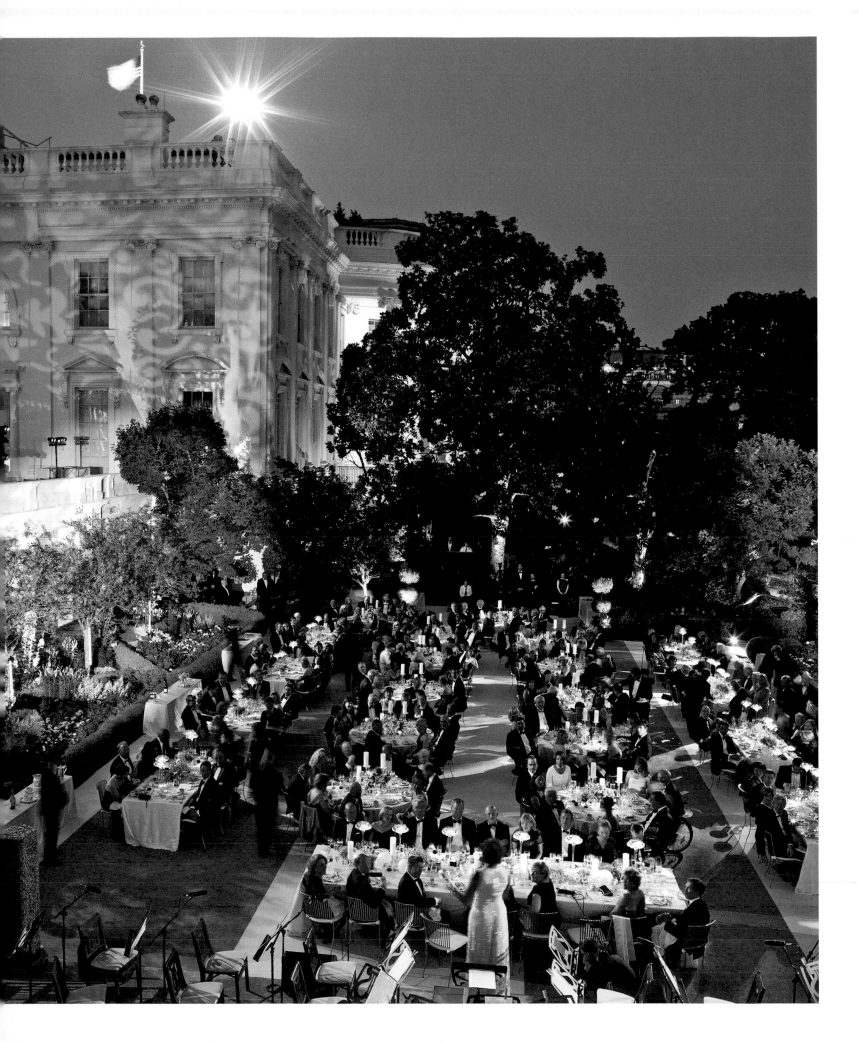

Gardens Replace Greenhouses

First Lady Edith Roosevelt planted her "colonial garden" following removal of the great greenhouses in 1902. Her official portrait by Theobald Chartran shows her seated there. Eleven years later, in the summer of 1913, First Lady Ellen Wilson created the first formal rose garden on the site with the assistance of landscape architect George Burnap. It was planted in the manner of 17th-century Italian gardens, with long hedges and a bordered "president's walk" along the Jefferson colonnade. The West Colonnade, built by President Jefferson, was repaired after the War of 1812, and restored in 1902. The garden in that location was redesigned for President John F. Kennedy in 1961, becoming today's Rose Garden. The plan suggests a traditional 18th-century American garden from designs by Rachel Lambert Mellon and landscape architect Perry Wheeler. Located adjacent to the President's Oval Office and the Cabinet Room, the Rose Garden is the scene of bill signings, award presentations, State Dinners, and historic diplomatic ceremonies. It functions as an outdoor space for gatherings and accommodates some 300 guests. Mellon remembered in 1966, "The one flower that unites all of the occupants through the history of the White House is the rose." Thus, for most of the 20th century, the Rose Garden

has been a rose garden. In 1961, President Kennedy wanted it restored in spirit but revised to become more than just a private garden.

Before her death from kidney disease in 1914, Ellen Wilson also had landscape architect Beatrix Farrand prepare plans for a formal garden on the east side outside the colonnade of the East Wing. Their general plan for the East Garden was implemented and remained essentially unchanged from the Wilson administration until the mid-1960s, when Mellon and Wheeler revised it. The East Garden is now known as the Jacqueline Kennedy Garden, and is often used by first ladies for receptions, teas, and official ceremonies. The Rose (West) and East Gardens are the main flower gardens of the White House and are formal, with central rectangular carpets of grass and hedge-lined beds of seasonal color relaxed with baskets of flowers. The colonnade provides a walkway around the perimeter of the West Garden. Open grass paths in the East Garden provide close contact with the seasonal plantings of the spring, summer, and fall.

Olmsted's Master Plan

President Franklin D. Roosevelt enjoyed the pastime of "amateur architect" and is well known for

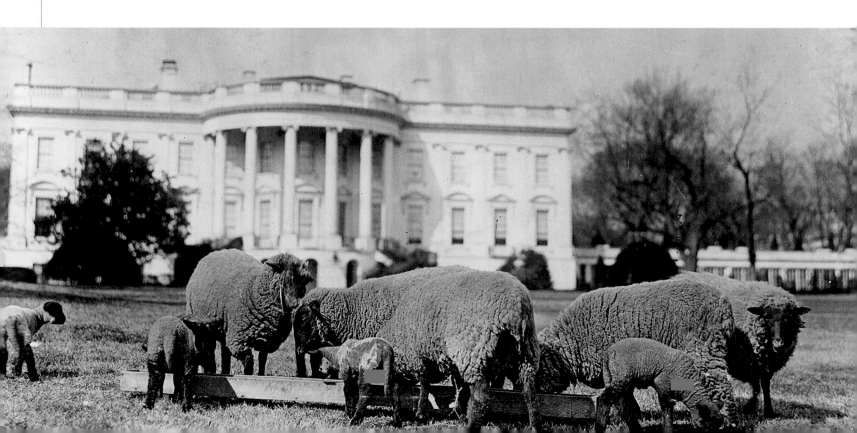

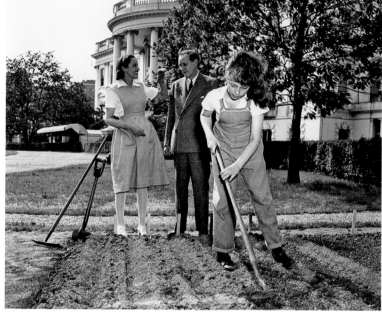

Diana Hopkins tends a victory garden on White House grounds in 1943, during World War II, as her father, Harry Hopkins, and his wife, Louise, look on. Her father was a close adviser to President Franklin Roosevelt.

designing the White House Library on the ground floor, taking part in expanding the West Wing in 1934, and erecting a new East Wing in 1942. Perhaps his most lasting contribution to the White House was ordering a master plan for the grounds. President Roosevelt invited Frederick Law Olmsted, Jr., son of the first U.S. landscape architect, to discuss the future of the White House grounds in 1935. Olmsted's father had designed major public parks and landscapes, including New York's Central Park and the U.S. Capitol grounds. The junior Olmsted was a major landscape architect in his own right, with a distinguished career as a designer and urban planner, including his contributions to the Senate Park Commission's 1902 comprehensive plan for Washington, D.C. For Franklin Roosevelt, he proposed an organic rethinking of the White House grounds to make them more private

and more secure, as well as opening up the South Lawn to become a rich carpet of green.

Olmsted totally revised the historic character of the landscape. The north side retained its elms and oaks and remained a shady lawn, a front yard for the White House. The South Grounds were to be cleared except along the sides. Old and enhanced groves of trees were to be shaped to screen views from the flanking streets. Gardens and plantings and other interruptions to the southern vista were to be removed. Driveways that crossed the South Lawn were to be sunken out of sight, and parking was taken off all driveways. Looking from the south was a splendid vista of the White House framed by groves of trees. From the White House, one had an open, green vista terminated by the Jefferson Memorial, completed in 1943. Olmsted created a simple and elegant solution to many problems, one that was flexible and open to innovations.

Olmsted's Continuing Influence

Over the years, administrations have made changes, largely in the form of additions. Examples of changes that have been made are the East and West Gardens redevelopments during the Kennedy and Johnson administrations and the gift of the Children's Garden from the Johnsons. Eisenhower built a putting green, the Fords added an outdoor swimming pool, the Carters

WHITE HOUSE LORE ★

SHEEP ON THE LAWN

The sight of sheep grazing on the lawn of Woodrow Wilson's White House was a symbol of support of troops overseas during World War I. The original flock of 12 sheep and 4 lambs, purchased at a Bowie, Maryland, farm in May 1918, grew to 48, saved manpower by cutting the grass, and earned $52,823 for the Red Cross through auction of the wool. During the war, President Wilson suspended entertaining, and his daughter Margaret Wilson sang to troops at army camps. First Lady Edith Wilson organized war bond meetings, with Hollywood stars autographing bonds on the steps of the State, War, and Navy Building.

Woodrow Wilson's sheep on the South Lawn in 1919.

The Rose Garden has seen administrations come and go.
It is now known the world over . . . the subtlety of its ever changing
patterns, would suggest the ever changing pattern of history itself.

RACHEL LAMBERT MELLON, *White House History*, 1983

Amy Carter and her father President Jimmy Carter
help his grandson Jason into the tree house built for
Amy on the South Lawn in 1977.

a tree house, and Hillary Clinton installed an exhibition
of sculpture in the East Garden. Whether permanent or
temporary, these features were sensitively designed and
did not intrude on Olmsted's and Franklin Roosevelt's
renewed grounds.

Since 1961, the South Grounds have been stages
for outdoor arrival ceremonies for heads of state,

landmark bill and treaty signings, and presidential
speeches. A large variety of special social events, includ-
ing congressional picnics, a country fair hosted by
President Carter, tented or open-air State Dinners, and
concerts have taken on a greater role. The grounds that
had been public space in the 19th century became pri-
vate space in the 20th century and now have become
an important extension of official space for
the executive branch.

The grounds of the White House have held a number
of notable dinners in the past century. Richard and Pat
Nixon honored 591 Vietnam-era military personnel who
had been prisoners of war. The May 1973 gala, simply
titled "P.O.W. Dinner," was the largest dinner held
up until that time. It was held under an immense
yellow-and-white-striped tent that protected the dinner
guests from a rainstorm that night. The Nixons also
held the 1971 wedding of daughter Tricia to Edward
Cox in the Rose Garden, decorated with a profusion
of border plantings—white tree roses, Madonna lilies,
heliotropes, pink geraniums, and white petunias. The
ceremony was broadcast live across the nation to satisfy
the public's keen interest in the event. Pat Nixon also
reopened the White House grounds for public tours
during one weekend in the spring and fall so people
could enjoy the East and Rose Gardens in their seasonal
splendor. This tradition continues to the present,
and more than 10,000 visitors turn out for the special
tours each year.

In 1976, Gerald and Betty Ford hosted a dinner out-
doors in the Rose Garden to commemorate the 200th
anniversary of United States independence from Great
Britain, with Queen Elizabeth II and Prince Philip as the
guests of honor. Jimmy Carter played host to a
jambalaya and jazz festival for 600 guests in 1978, to
honor the 25th anniversary of the Newport Jazz Festival.
Performers included Dizzy Gillespie, Eubie Blake, and

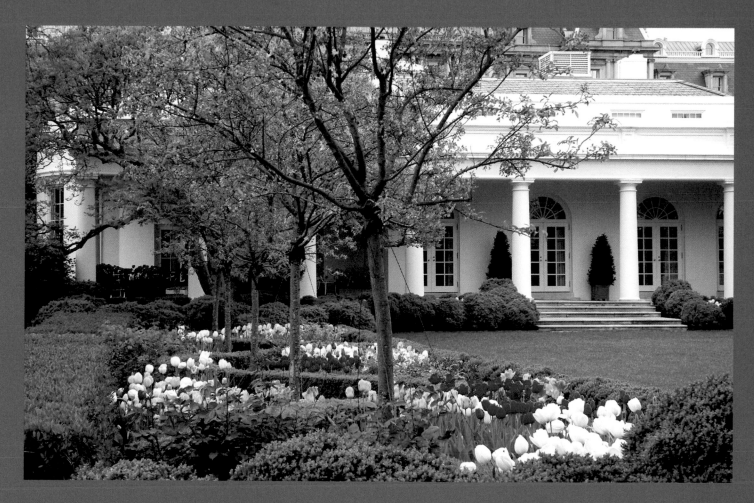

THE EAST AND ROSE GARDENS

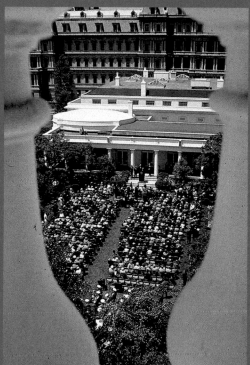

The Rose Garden and East Garden existed long before President John Kennedy and First Lady Jacqueline Kennedy created the modern versions. Edith Roosevelt created a "colonial garden" at the site of the present Rose Garden in 1902, and Ellen Wilson had landscape architect George Burnap formalize it as an Italian garden with long hedges, introducing an array of roses. She also planned an East Garden to balance it, completed after her death. The gardens had changed little since the Wilson administration, and when President Kennedy came back from a trip to Europe, impressed by the gardens he had seen, he asked Rachel Lambert Mellon to redesign the Rose Garden outside the Oval Office. With landscape architect Perry Wheeler, a plan was devised that would be useful and attractive, including a lawn that could hold 300 seated people. In the East Garden, also redesigned by Mellon and Wheeler, flowering trees, shrubbery, and plantings that change color with the seasons surround a rectangular lawn. The garden serves primarily as an informal reception area for the first lady.

The Rose Garden in spring (top) and as seen during an event through a White House balustrade.

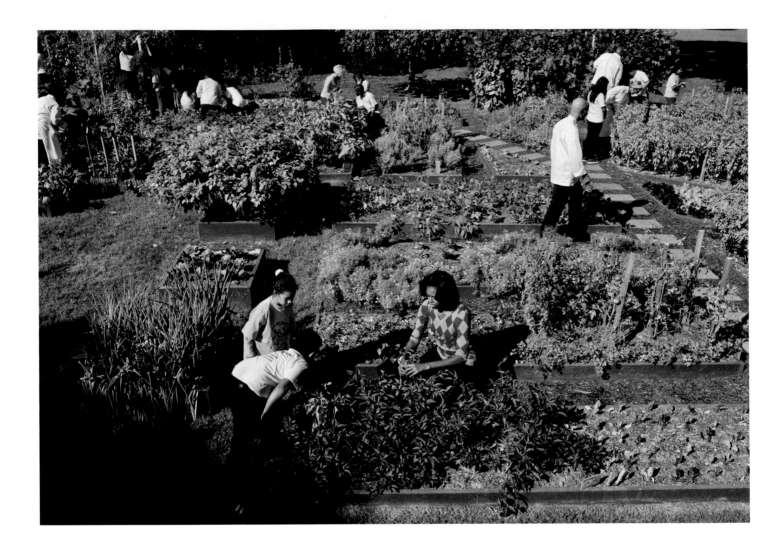

Earl "Fatha" Hines. Ronald Reagan, Ted Kennedy, Superman, and the Beach Boys, plus 1,000 guests, rocked out on the South Lawn to raise money for the Special Olympics in 1983. Barbecues for members of Congress and their families have become an annual event, and concerts and fairs have taken place right alongside formal state arrivals and dinners on the South Lawn and Rose Garden since the 1970s.

One of the most original additions to the South Lawn in recent times was the 2009 planting of an L-shaped kitchen garden next to the White House tennis court. As was the case with Eleanor Roosevelt's victory garden planted in vegetables in 1943, the Obama vegetable garden was meant to inspire the nation to take up the trend. Michelle Obama believed that a vegetable garden could be an educational tool that would expose children to the importance of

eating fresh fruits and vegetables. The garden also provides produce for the president's table and food for the homeless in Washington, D.C., and was a reminder of the White House vegetable gardens of the past. Heirloom varieties were planted that were a sampling of presidential favorites, notably Thomas Jefferson's "Brown Dutch" and "Tennis Ball" lettuce, "Prickly Seed" spinach, and "Savoy" cabbage. The charitable use of the vegetable garden also recalls Mary Todd Lincoln taking produce from her White House garden to help feed and comfort the sick and wounded in hospitals in Washington, D.C., during the Civil War.

Trees are the unsung glory of the White House grounds, the long-lasting giants that give the landscape its structure. Their propagation and survival are a major concern of the Olmsted landscaping plan.

A child holds a wooden souvenir Easter egg (right) from the Easter Egg Roll of 2001, hosted by President and Mrs. George W. Bush. The tradition of rolling eggs at the White House goes back to 1879, under President Rutherford B. Hayes. Opposite: First Lady Michelle Obama and White House chefs join children from D.C. schools to harvest vegetables in the White House garden in 2011.

Presidents and first ladies from the time of President Hayes have enthusiastically planted commemorative trees. Dozens of commemorative trees have been planted to honor the presidents themselves or a historic event. Many are the most venerable of the generations of trees that have been planted, grown, and died. "Trees tie it all down," grounds superintendent Irvin Williams said of the grove of great trees that define the White House grounds and express the continuity of this place over time.

Security and Access

Significant changes have been made to the White House grounds for security since First Lady Frances Cleveland ordered the grounds closed to the general public to protect her young children from being swarmed by tourists when they enjoyed the South Grounds with their nanny. William McKinley reopened the grounds, but following his assassination, the gates closed again. For a brief interlude after World War I, the public was welcomed, but by the beginning of World War II, the use of the grounds had evolved formally from a public park into a private estate. President Franklin Roosevelt would object to security plans by the military to paint the White House in camouflage, to place machine gun turrets on the roof, or to build barricades around the mansion, feeling that the public would be alarmed unnecessarily. He did secure the White House grounds with a military guard during the war, but social events continued to be held and concessions made, especially for soldiers on leave to enjoy the gardens. The house would be heavily guarded by patrols and sentries, setting a precedent for a perimeter security maintained to this day. Site security has become ever more vigilant as events, such as the bombing of the Alfred P. Murrah Building in Oklahoma City in 1995 and the September 11, 2001, terrorist attacks on New York City and the Pentagon, have brought heightened security at the White House.

The landscape of the White House grounds over the last 50 years may appear static in comparison with the large-scale changes that occurred in the 19th and early 20th centuries. It might seem that presidents and their families hardly venture outdoors anymore, but that is far from the case, as first families have greatly enjoyed and entertained on the verdant lawns and shaded groves of the grounds. The test of a great landscape plan for a house is stability and meeting the needs of the inhabitants. The White House grounds have been well managed and have grown august in the modern era. ★

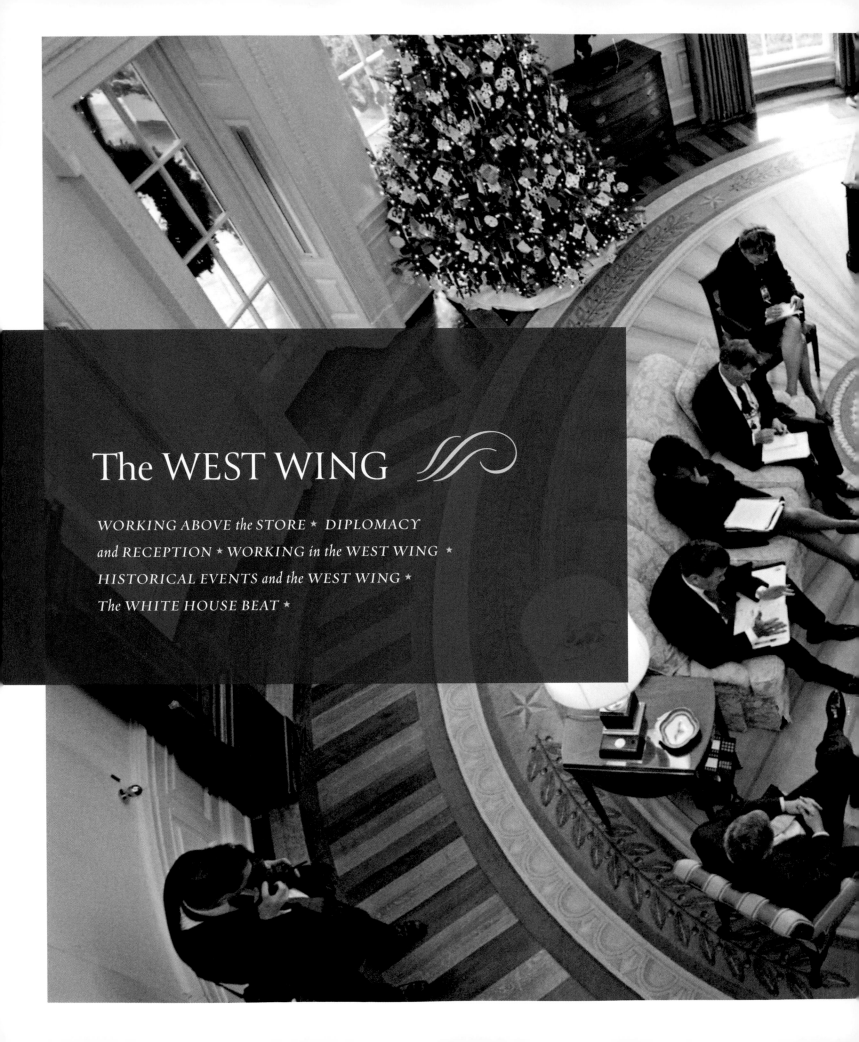

The WEST WING

WORKING ABOVE the STORE ★ DIPLOMACY
and RECEPTION ★ WORKING in the WEST WING ★
HISTORICAL EVENTS and the WEST WING ★
The WHITE HOUSE BEAT ★

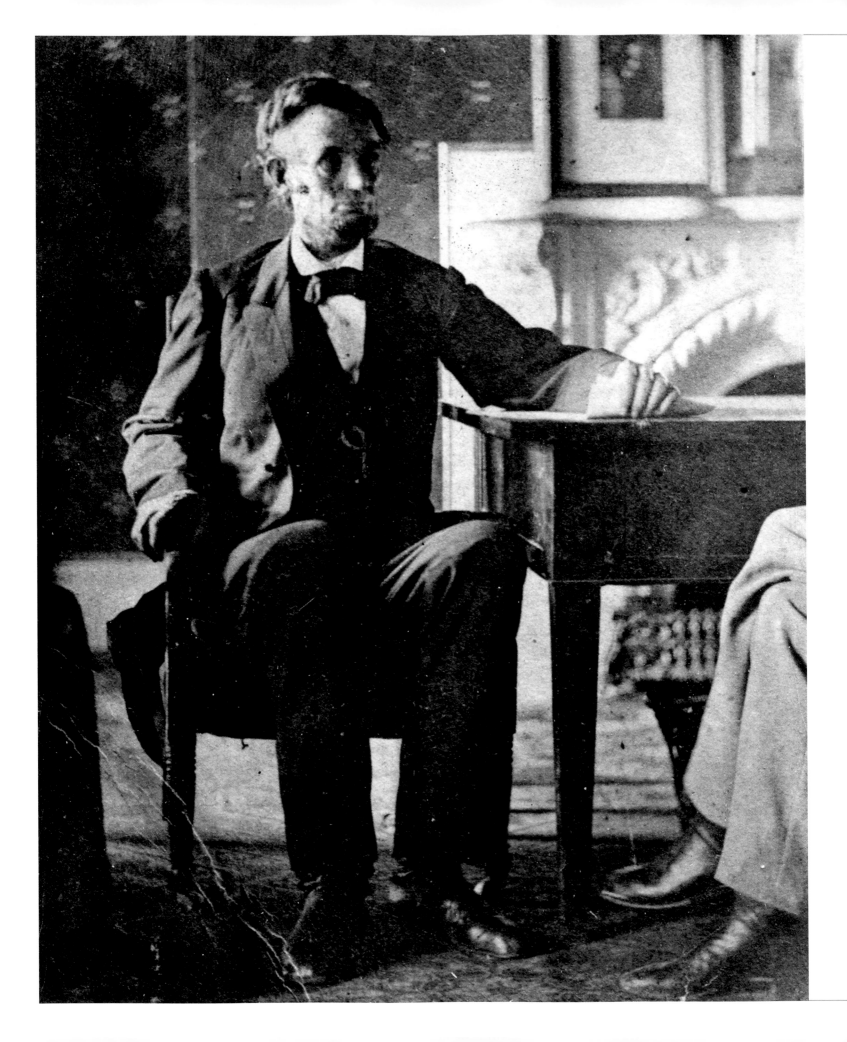

MORE THAN A CENTURY AGO, President Theodore Roosevelt directed a renovation of the White House that reconstructed the building's interior and established, with a few exceptions, the functional design of the complex that we know today. The bold Beaux-Arts makeover reflected the rise of the United States as a world power and the emergence of the president as an international figure. Importantly, Roosevelt's presidency also ended a chaotic mixture of family and business activity in the White House. For many years, the chief executive's ever-growing staff worked at the east end of the second floor, just down the hall from cramped private family quarters. The 1902 Roosevelt restoration created more comfortable family living arrangements and efficient new work spaces for the presidential staff in a new executive office wing on the West Lawn. *Harper's Weekly* called the understated "temporary" wing the "White House Workshop." Today, the "West Wing" has become shorthand for presidential policy and politics. William Howard Taft built the first Oval Office in 1909, and used it for both routine and ceremonial business. Franklin D. Roosevelt, whose staff expanded rapidly with New Deal programs, doubled the size of the West Wing in 1934, and added the present Oval Office on the southeast corner of the building. The adjacent French Second Empire–style, multistoried State, War, and Navy Building (today named the Eisenhower Executive Office Building), completed in 1888, officially became part of the executive office complex in 1949. To avoid confusion, the White House Executive Office Building, built and enlarged from 1902 to 1934, became known officially as the West Wing.

Preceding pages: Staff of the Office of Homeland Security and assistants to the president meet in the Oval Office on December 21, 2001. Opposite: President Abraham Lincoln sits beside a table in his office on the second floor of the White House (today the Lincoln Bedroom). Every president who lived in the White House worked there with his cabinet until the first Executive Office Building was built in 1902.

Working Above the Store

WHEN THE FIRST PRESIDENT, GEORGE WASHINGTON, lived in Philadelphia and New York while the President's House was being built, he had five secretaries, including his loyal senior secretary, Tobias Lear. He met regularly with his cabinet, striking a balance between the competing visions of Alexander Hamilton and Thomas Jefferson. Washington had become a hero of the American Revolution and "first in the hearts of his countrymen," and his leadership and the adulation with which he was viewed enabled him to set a standard for future presidents in many things, including a close executive staff.

John Adams moved into the partially finished White House in 1800, and brought with him his secretary, William Shaw. Adams resided in the President's House for only four months and did not have the personal wealth of Washington, nor did he have time to gather clerks around him. Under Thomas Jefferson, the mansion was completed. He added East and West Terraces for servant quarters and household functions, but did not plan offices. Jefferson brought Meriwether Lewis to the President's House for a few months as his personal secretary, more as a pupil than an aide, as he prepared his secretary to explore the West and lead the Lewis and Clark expedition after the 1803 Louisiana Purchase. Otherwise, Jefferson had no permanent office staff.

The Cabinet

Every president in the 19th century set aside a room for the work of his cabinet and employed a private secretary, clerks, and copyists, as needed, paying the salaries of these staffers from his own pocket.

The cabinet dates back to the beginnings of the presidency, and its advisory role is established in the Constitution. Members of the cabinet are the president's official advisers and confer frequently and assist the chief executive with decisions, messages, and proclamations. Some presidents have used the cabinet as a group of advisers on diverse collections of issues facing an administration or the nation as a whole. The first photograph of a president and his advisers was taken by John Plumbe, Jr., of James K. Polk and

his cabinet assembled in the State Dining Room at the start of the Mexican War, in May or June 1846. This dim daguerreotype is also the earliest known photograph taken inside the White House. Although the president would dine or have meetings in rooms throughout the house, a room for the cabinet, appropriately called the Cabinet Room, was set aside on the second floor of the White House after the Civil War. At times, the cabinet's working space was makeshift. During the Madison administration, the temporary canvas frame rooms, built for Jefferson's secretary Meriwether Lewis at the south end of the unfinished East Room, were expanded, plastered, and wallpapered for the cabinet's use.

The office suite first began to look like an office and no longer residential in the administration of Andrew Johnson. The reception room was in the east end of the central hall; next door on the north side were a private office for the president's secretary and a large room—Queens' Bedroom today—that accommodated desks for six clerks. Across the central hall on the south side were the Cabinet Room, Johnson's office, and a flanking room on the southeast corner that became the first telegraph room, installed in 1866. The Cabinet Room for the remainder of the 19th century would be located between the oval room (today's Yellow Oval Room) and the president's office (Lincoln Bedroom). Meetings in the 19th century were held every Tuesday and Friday morning when the president was in

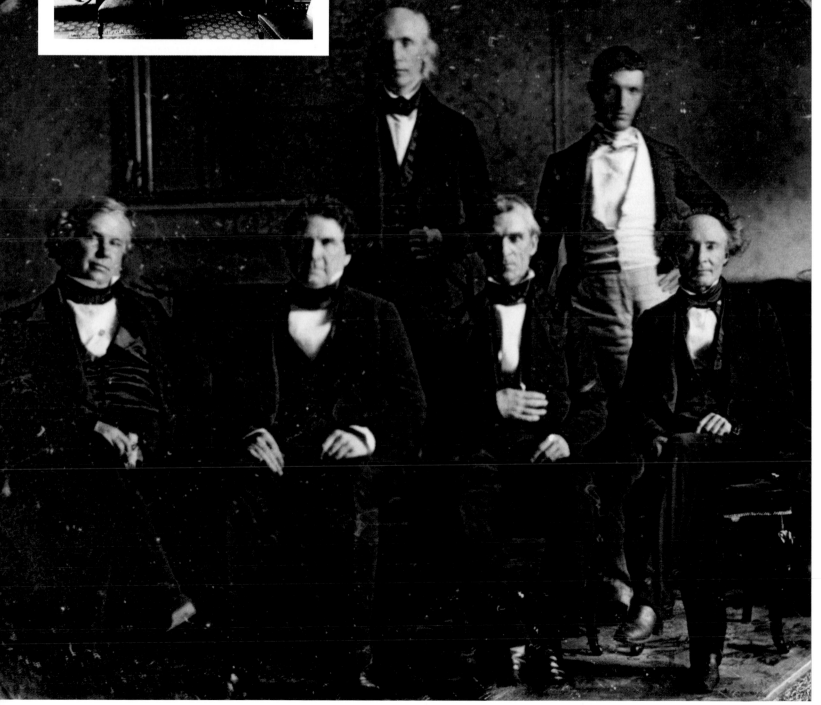
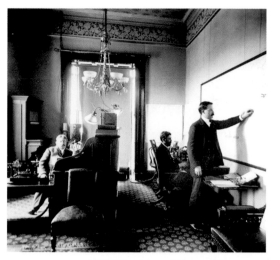

Photograph of President James K. Polk and his cabinet (below) in the State Dining Room in 1846, seated, from left, Attorney General John Y. Mason, Secretary of War William L. Marcy, President Polk, and Secretary of the Treasury Robert J. Walker. Standing are Postmaster General Cave Johnson and Secretary of the Navy George Bancroft. President McKinley's staff (left) tracks troop movements on a map in the war room during the Spanish-American War.

A modern painting of President Lincoln's office depicts the day in November 1862 that he met with Mary Livermore, abolitionist and civil rights activist, after Lincoln announced he would sign the Emancipation Proclamation. Lincoln donated the original document to raise funds for hospitals. Opposite: The hat that Lincoln supposedly wore when he went to Ford's Theatre the night he was shot.

town and were usually cordial and informal gatherings. Grover Cleveland began the meetings by sharing humorous stories of day-to-day official life and then moved on to serious business, expecting each of his cabinet secretaries to express their opinion in rotation. Some of the greatest U.S. statesmen served in the cabinet. Six secretaries of state in the 19th century alone became president, including Thomas Jefferson (secretary of state for Washington), James Madison (Jefferson), James Monroe (Madison), John Quincy Adams (Monroe), Martin Van Buren (Jackson), and James Buchanan (Polk). Other notable figures that served as secretaries of state were William H. Seward (for Lincoln and Andrew Johnson), Daniel Webster (William Henry Harrison), John Calhoun (John Tyler), and John Hay (William McKinley and Theodore Roosevelt).

When the eastern end of the second floor was used for executive business, the Center Hall was partitioned off as a waiting room to keep the public from wandering into the family apartments. Access to the waiting room was by a long stairway and through ground glass doors. The Cabinet Room (now the Treaty Room) became a popular space for a presidential study.

The room served as the Cabinet Room between 1867 and 1902, and is on the south, or garden, side of the White House, overlooking the bucolic landscape seen through the window. Theodore Roosevelt continued to use the Cabinet Room to meet with senators and representatives who could visit the president without an appointment between 10 a.m. and 1:30 p.m. The president would often circle the room, "gesturing freely" and speaking with each distinguished visitor. First Lady Lou Hoover converted the room into a parlor, decorating it with reproduction French 1790s furniture and calling it the James Monroe Room. During the Kennedy administration, the name "Treaty Room" was chosen to reflect the many important deliberations made in the room, including the Partial Nuclear Test Ban Treaty that John F. Kennedy signed on October 7, 1963. The "Treaty Table," a magnificent Victorian library table used originally for cabinet meetings by Ulysses S. Grant, first served for the peace protocol that led to the end of the 1898 Spanish-American War.

Position of Prominence

Congress first authorized a government-paid position of "private secretary at the White House" in 1857. The first person to hold the post was President James Buchanan's secretary and nephew, J. B. Henry, nicknamed "Little Buck." Presidents in the 19th century had slim staff resources and often had clerks detailed to the White House from the executive departments. Abraham Lincoln had two bright secretaries—John G. Nicolay and John Hay—to assist him. The hours were long and the men actually slept next to the offices in the White House. The president sometimes awoke them in the middle of the night to share an idea or work through a problem. First Lady Mary Todd Lincoln was said to be jealous of the two because her husband spent so much time with them and thought so much of their opinions. It may have been a factor in why Lincoln's secretaries called Mary Lincoln the "Hellcat."

The president's private secretary held a position of prominence and importance that required ability and usually a close personal relationship with the first family. Several private secretaries were married into the president's family, including Samuel L. Gouverneur, who wed James Monroe's youngest daughter, Maria, in the White House in 1820, and secretary J. Stanley-Brown, who wed Mary Garfield in 1888, some years after his service to James Garfield. It was also common for the president's son or a nephew to become his private secretary. John Adams served his father, John Quincy Adams; Abraham Van Buren, the son of Martin Van Buren, worked for his father. Many private secretaries rose to distinguished careers, including John Hay, McKinley's secretary of state, and George Cortelyou, who served as secretary of labor and commerce, postmaster general, and secretary of the treasury in Theodore Roosevelt's cabinet. Grant's secretary, Horace Porter, became ambassador to France, and Cleveland's secretary, Daniel Lamont, established a lucrative career in business.

By 1900, the White House offices were crowded with 23 men working in five rooms at the east end of the second floor. In addition to the secretary to the president, two assistant secretaries, two executive clerks, a stenographer, and seven other office clerks, the offices were used by military personnel attached to the White House, as well as coachmen, stablemen, and laborers who spent time in the office area. George Cortelyou proved an integral adviser to the administrations of Grover Cleveland, William McKinley, and Theodore Roosevelt. Cortelyou was the first to hold the title "secretary to the president," a post not unlike today's chief of staff, established during the McKinley administration. Several other men in the office in 1900 had been mainstays, including paymaster William H. Crook, who had joined the White House staff as a bodyguard for Abraham Lincoln. Trusted chief doorman Thomas Pendel was another Lincoln-era hire. And Charles Loeffler, keeper of the president's door for more than 50 years, had at least a few

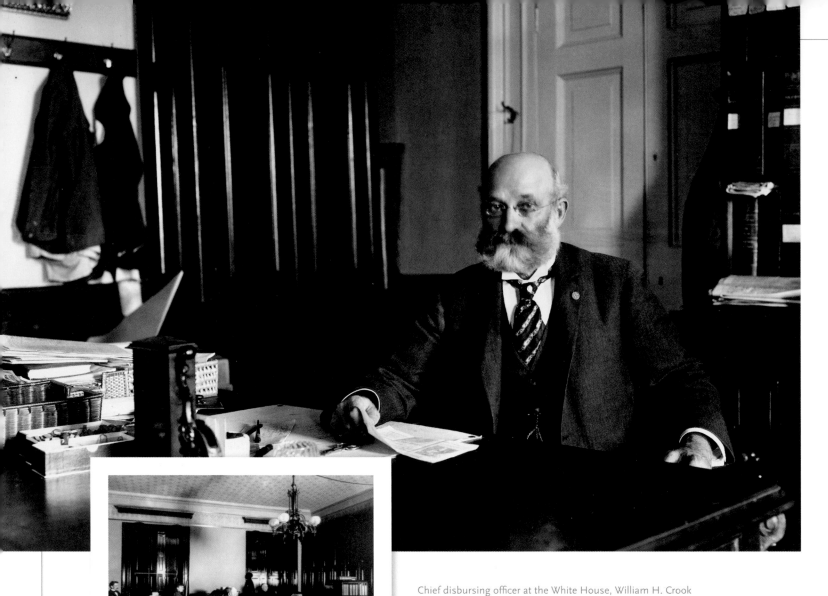

Chief disbursing officer at the White House, William H. Crook (above) came onto Lincoln's staff as a bodyguard and stayed on through Theodore Roosevelt's administration. Alice Sanger (inset), the first woman to serve on a president's executive staff, in Benjamin Harrison's Executive Mansion, about 1890.

years of seniority over either Crook or Pendel, and served until at least 1908.

Cortelyou had the experience and organizational skills that brought about the consolidation of the executive offices and its operations within the new West Wing. The offices represented a significant change from the crowded rooms on the second floor of the White House. Rooms for the staff, press, telegraph operators, and messengers flanked a large entry hall. As secretary to the president, Cortelyou worked in an office that was centrally placed with direct access to the main lobby and the front door of the West Wing. The room to the east of the secretary's office was the president's workroom, with sliding pocket doors connecting it to the adjacent Cabinet Room. The new offices suited the complete revision of the administrative procedures of the presidency. Theodore Roosevelt charged Cortelyou with putting the organization of the president's executive offices on a businesslike basis. Cortelyou developed procedures and rules that guided White House protocol and established a formal organizational structure where there previously had been only personal prerogative.

An unwritten office rule: *"in no circumstances may any caller of whatever position quote any words the President has spoken in an interview at the White House, except by special permission."*

GILSON WILLETS, *Inside History of the White House*, 1908

In 1902, *Harper's Weekly* described the president's offices in a separate building on the west grounds as a "White House Workshop" because for "the first time since the United States has been a nation the head of the nation does not live in his shop." When the offices were actually placed on the second floor is uncertain. However, by the administration of Andrew Jackson, a suite of three rooms on the South Front located at the east end of the second floor had been established for the president's offices. The physical separation of the president's office from within the historic White House to Roosevelt's separate building had taken more than a century. The new structure was born of compromise, included a "president's room," not an Oval Office, and was denoted in the official construction report as the "temporary" Executive Office Building. Today, this wing functions at the core of the executive branch, and it seems impossible to imagine the White House without it.

Adding Office Space

By 1909, President Taft's staff already needed more space, so the Army Corps of Engineers employed architect Nathan C. Wyeth to prepare plans that doubled the wing, and created the first Oval Office. Congress added further permanent executive staff positions to the White House staff during Herbert Hoover's presidency, notably including a "press secretary." President Franklin Roosevelt completely renovated the West Wing in 1934, when his New Deal programs greatly expanded the executive staff. New York architect Eric Gugler effectively redesigned the wing, adding mezzanine and basement levels, and moving the Oval Office closer to the house, to its present location on the southeast corner of the West Wing. Partly due to the expansion of the scope of the federal government's policies and powers in response to the Great Depression and the need for modern reorganization, the executive office of the president was established in 1939, dramatically changing the structure and operations of the executive branch of government. ★

WHITE HOUSE OFFICES ★

WHY THE OVAL OFFICE IS OVAL

The president's office was not oval when it was built in the first Executive Office Building in 1902. During William Howard Taft's administration, Washington architect Nathan C. Wyeth added an Oval Office patterned after the oval-shaped Blue Room. This was to give it a White House identity. James Hoban's original Blue Room may have been influenced by George Washington's bow-ended room for receptions in Philadelphia. To attend to the ceremony of the office of the presidency, Washington rounded the circle of guests, bowing to each but not shaking hands, and then returned to his place at the head of the room. The guests then came before him, greeted him one by one, bowed, and left the room.

Hand-tinted postcard of the first Oval Office

Diplomacy and Reception

TELEVISION NEWS SEGMENTS OFTEN HIGHLIGHT diplomatic meetings in the Oval Office or an awards ceremony from the Rose Garden. The ceremonial role the president plays as the nation's host is now a significant part of the chief executive's daily schedule. The Oval Office meeting for a visit by a head of government usually lasts less than an hour and often sets the stage for a state visit. A small press conference and photo opportunity in the Oval Office usually concludes such White House events. A state visit then often culminates in a grand dinner.

The president represents the nation and spends a significant amount of his time in and around the West Wing, meeting with foreign dignitaries, political figures, celebrities, sports figures, or average American citizens who are being honored for their achievements. The collections of the presidential libraries hold tens of thousands of photographs and videos of these meetings. With the rapid growth of news photography in the 20th century, the production of images of the president in his role as the nation's host has proliferated. In 1921, the White House News Photographers Association was founded. Yoichi Okamoto, a professional photographer, became the first official presidential photographer during the Johnson administration.

Before the era of photography, meetings with international guests were illustrated in woodcut engravings in magazines and newspapers. Before the 1850s great events, such as President John Quincy Adams honoring the Marquis de Lafayette, the hero of the American and French Revolutions, with a 68th birthday dinner at the White House in 1825, could be described only in print.

Iconic images of Franklin D. Roosevelt and British prime minister Winston Churchill together in an Oval Office press briefing captured the tense years of World War II; John F. Kennedy receiving a gift of shamrocks from Ambassador of Ireland Thomas J. Kiernan reflected the friendship between the nations

President George W. Bush and Prime Minister Tony Blair of Great Britain walk through Cross Hall en route to the East Room in May 2006, for a joint press availability during which the president said of Iraq's new government, "The United States and Great Britain will work together to help this new democracy succeed."

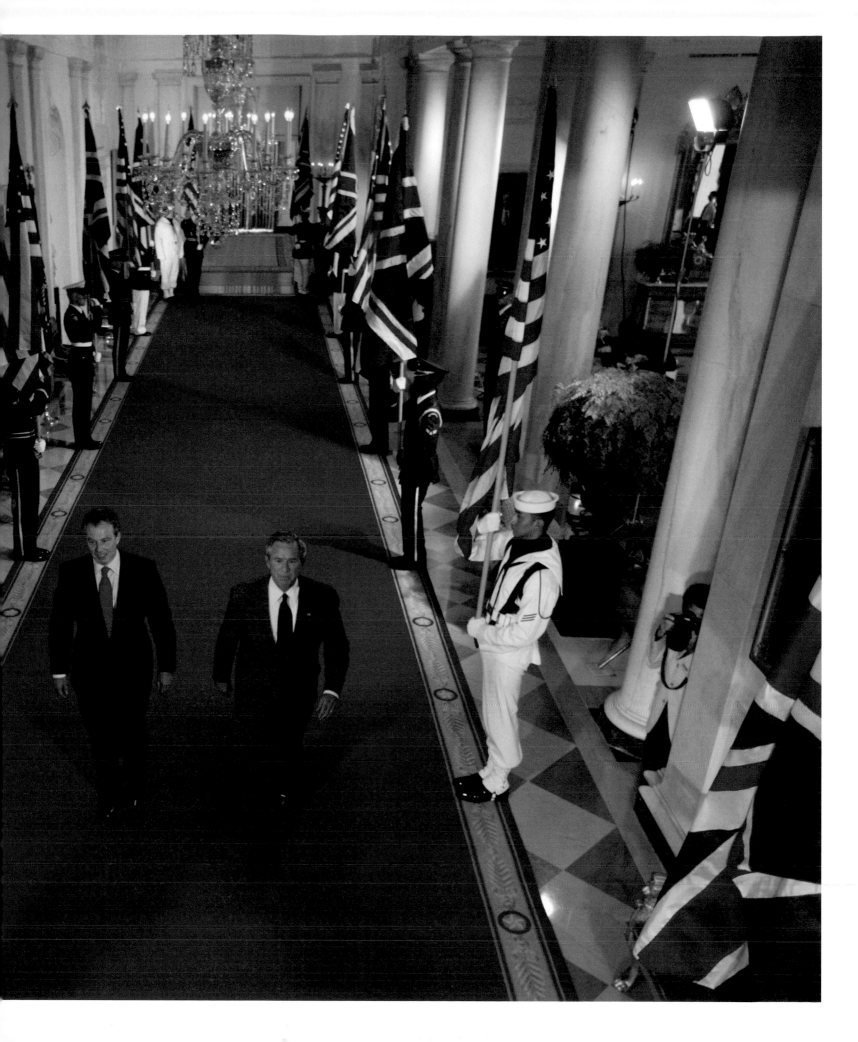

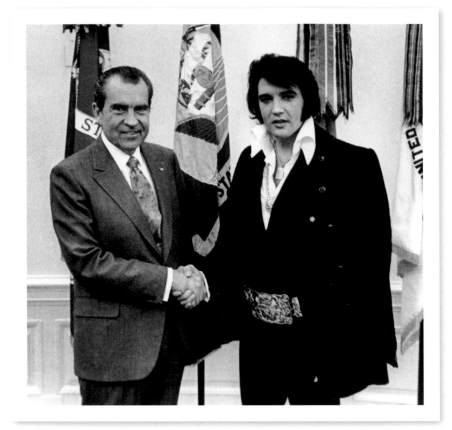

President Richard Nixon greets singer Elvis Presley, who in 1970 asked to be a "Federal Agent-at-Large" for the Bureau of Narcotics and Dangerous Drugs. At a meeting in the Oval Office, Nixon granted Presley his badge and received the gift of a Colt .45. Opposite: In 1919, Woodrow Wilson met with members of the Alabama Good Roads Association (below), who sold roosters to fund road improvements. The Army Medal of Honor (above)

in an established Saint Patrick's Day tradition; and the image of Ronald Reagan and British prime minister Margaret Thatcher in deep conversation outside the Oval Office captured the mutual respect and friendship of allies. In recent times, White House photographers have memorialized many landmark events, such as Jimmy Carter's meeting with former Israeli prime minister Golda Meir in 1977, Pope Benedict XVI's visit with George W. Bush in the Oval Office in 2008, or Barack Obama's first Oval Office meeting in 2009 with Japanese prime minister Taro Aso.

These visits also showcase the role of the United States as a world power. In 1987 in the East Room, President Reagan and Soviet president Mikhail Gorbachev signed the Intermediate-Range Nuclear Forces Treaty, the first arms control agreement in history that reduced the number of nuclear weapons both countries held.

Visits From the Stars

Musicians, scientists, actors, and comedians are frequent White House guests. The legendary visit of Elvis Presley to see Richard Nixon is one of the best known encounters. Other luminaries include George Harrison of the Beatles, who met with Gerald Ford, and Michael Jackson, who met with both Ronald Reagan and George H. W. Bush. There have been many, many more musicians who have performed or received awards, including Bono of U2, jazz great Dave Brubeck, and Led Zeppelin's John Paul Jones, Jimmy Page, and Robert Plant. The Kennedy Center Honors recipients have been guests at the White House since the program's inception in 1978. Scientists Marie Curie and Albert Einstein famously posed with President Harding. Actors Cesar Romero, Paul Henreid, and Angela Lansbury were members of a large Hollywood contingent that visited the Trumans in 1946.

Sports figures and celebrities have also long been a part of the White House scene. The 1924 pennant-winning Washington Senators came to the White House to stand with President Calvin Coolidge for a picture on the White House lawn. Many of the sports heroes that came to the White House before the Reagan administration came as individuals. That may

have much to do with the national popularity of individual sports such as tennis, golf, boxing, and track before they were eclipsed by professional team sports in the 20th century.

Secret Service agent Edmund W. Starling, a member of the White House detail from the Woodrow Wilson to Franklin D. Roosevelt administrations, recalled Harding's friendships with sports celebrities and journalists: "You never knew what to expect when you went around back in those days. One day I found [tennis stars] Bill Tilden, Little Bill Johnston, R. Norris Williams, and Dick Washburn playing tennis on the White House courts, while the President [Harding] watched. Once I brought the car around to the front door to take him golfing, and he appeared with two utter strangers, one of them was a dark-visaged man who looked like a Balkan spy. He was Ring Lardner. The other man was

Grantland Rice," two of the best known sportswriters of the time.

The tradition of greeting teams and famous athletes can be traced back to Andrew Johnson, who invited a baseball team to the White House and was the honored guest at the opening of a new ballpark for Washington's National baseball team in 1867. Ronald Reagan, a devoted sports fan, can be credited with starting the modern tradition of honoring championship teams at the White House. He was athletic in his youth and played football, swam, ran track, and was a lifeguard. He was also a sportscaster in the 1930s, and starred in several memorable sports movies. His role as the Gipper in *Knute Rockne All American* in 1940 stuck with him as a nickname into his political career. Reagan established the now familiar ceremony of the president honoring a championship team by opening the event with

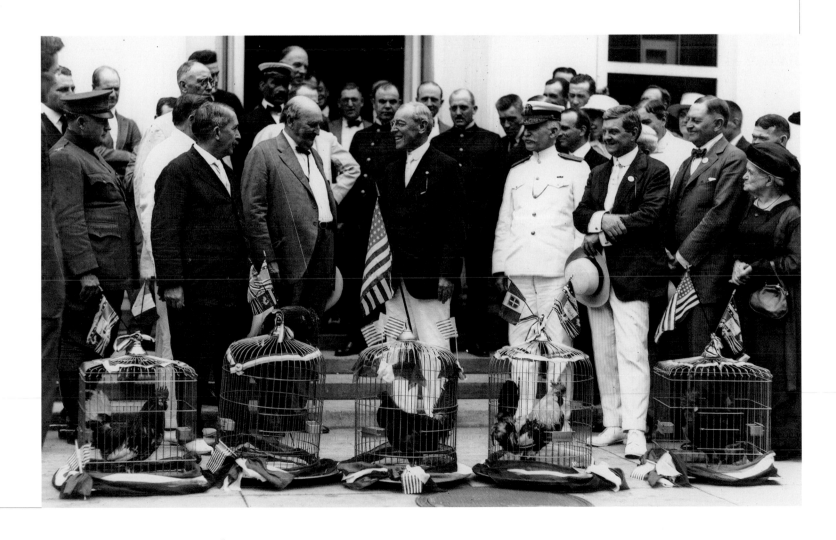

remarks, the coach and players saying a few words, and then the presentation of a team jersey or uniform. Reagan famously added action to the occasions, taking a slap shot after honoring the U.S. Olympic hockey team in 1987, and tossing a pass to wide receiver Ricky Sanders when the Washington Redskins celebrated their Super Bowl victory with him in 1988.

Since the 1980s, parades of college and professional teams have been invited to a Rose Garden ceremony. President George W. Bush alone listed 48 events honoring sports teams or individual athletes during his eight years in office. Sports ceremonies have become an expected and anticipated event at the White House. President Barack Obama joked in April 2013 that he is beginning to feel like a benchwarmer for the University of Alabama football team. The Crimson Tide has been honored as NCAA champions for three of the last four years.

Medal of Honor Ceremonies

Among the most poignant ceremonies are the Medal of Honor awards held at the White House in the West Wing, the Rose Garden, or the East Room. A Medal of Honor award ceremony held at the White House by President Theodore Roosevelt for Spanish-American War hero James R. Church in 1904 and a 2001 ceremony posthumously awarding Roosevelt the medal for his heroic actions in the decisive Battle of San Juan Hill made him the only president to both present and receive the Medal of Honor.

Various presidents, in the name of Congress, have awarded more than 3,400 Medals of Honor, the nation's highest award for valor in action against an enemy force, since the decoration was created in 1861. Each branch of the service has its own medal and symbolism. The Army Medal of Honor includes an eagle, symbolizing the United States of America, perched on a cannon with a saber grasped in its talons. Each of these ceremonies today is attended by several hundred people, including the family of the recipient, lawmakers, military leaders, and men and women who served with the honoree.

In May 1963, President Kennedy publicly saluted the valor of the U.S. armed forces and held a large reception on the South Lawn that included 240 Medal of Honor winners. The president concluded his remarks by noting, "While all Americans can't win the

The cast of the TV series *The West Wing*, which revolved around a fictional president, his family, and staff.

THE WEST WING IN POPULAR CULTURE

There is a natural curiosity on the part of the public regarding what goes on behind the scenes in the Oval Office and about the main West Wing players. Television programs and Hollywood films present us with fictionalized versions of the presidency and how the president works. One of the most popular American television series was *The West Wing*, which was broadcast from 1999 to 2006 and won numerous awards. It starred Martin Sheen as President Josiah "Jed" Bartlet and explored the lives of Bartlet's staff and family. There have been dozens of other depictions of fictitious presidents on television, and hundreds in films. Presidents have been featured in biographical films, some played several times by the same actor. Abraham Lincoln has been depicted on film more often than any other president, followed by George Washington, Ulysses S. Grant, Thomas Jefferson, Richard M. Nixon, George W. Bush, and Theodore Roosevelt.

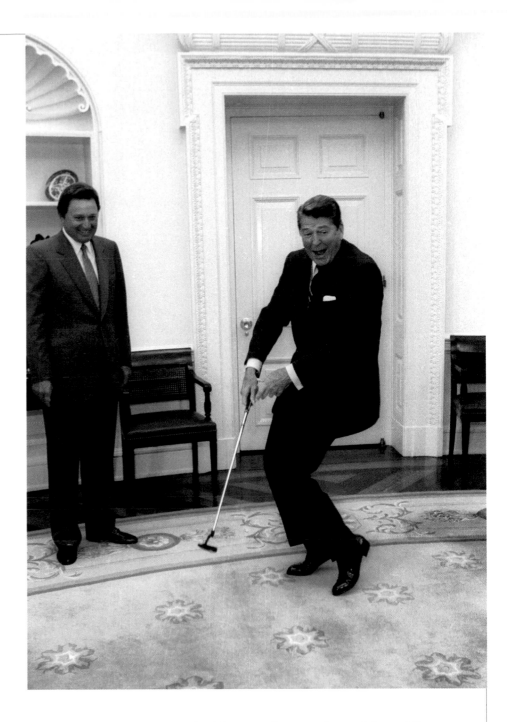

Medal of Honor and while all of them can't fight in far-off places, I hope that all are big enough and strong enough and courageous enough to support them."

President Barack Obama presented the Medal of Honor for Captain (Chaplain) Emil Kapaun posthumously to his nephew Ray Kapaun on April 11, 2013, for his heroism during combat operations against an armed enemy at Unsan, Korea, from November 1 to 2, 1950, and as a prisoner of war. The ceremony was emotional, and the audience in the East Room wept as President Obama recalled the extraordinary bravery of Father Kapaun. "Then, as Father Kapaun was being led away (as a prisoner of war) he saw another American—wounded, unable to walk, laying in a ditch, defenseless. An enemy soldier was standing over him, rifle aimed at his head, ready to shoot. And Father Kapaun marched over and pushed the enemy soldier aside. And then as the soldier watched, stunned, Father Kapaun carried the wounded American away." Sergeant Herbert Miller, who had been saved by Kapaun's bravery that day, was in attendance, as were eight other servicemen who had been held in a prison camp with the chaplain.

Receiving the People

During the early decades of the 20th century, presidents set aside a few hours on Thursday afternoons to greet citizen groups in the West Wing. A "posing ground" was set up on the South Lawn with the West Colonnade and White House as a backdrop. Local tour guides used this public receiving time as a means of guaranteeing their customers they would meet the president. Thousands of images of Presidents Wilson, Harding, Coolidge, and Hoover posed with civic and business groups, Native American delegations, or representatives of charitable organizations can be found in the National Photo Company Collection at the Library of Congress. This agency supplied photographs of newsworthy events in Washington as a daily service to its subscribers. The Thursday afternoon tradition ended in 1931, when the number of visitors overwhelmed President Herbert Hoover. ★

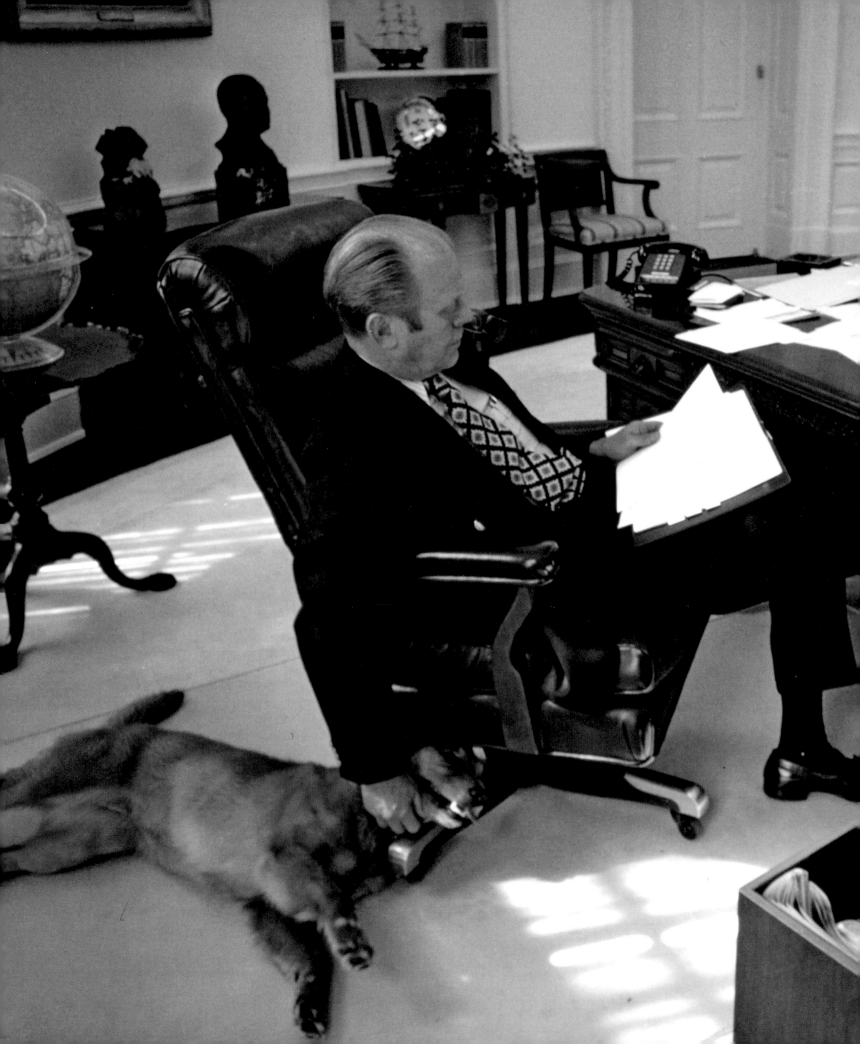

Working in the West Wing

WHEN THE PRESIDENT IS AT WORK IN THE WEST WING, it is the center of intense activity. In times of crisis, the atmosphere may be frenzied as clusters of staffers and members of the news media swirl in and around the building. Even on routine days, the work of formulating foreign policy and domestic programs, steering legislation through Congress, writing speeches, handling the news media, or deciding which letters and memos the president should read can create long 12-hour workdays for many of the president's aides and their assistants who labor in the West Wing. Nonetheless, these are some of the most highly coveted jobs in Washington.

Every president before Theodore Roosevelt, with the exception of George Washington, worked in an office in the White House or the West Wing. Their working habits varied as the job's demands and the United States' position in the world changed. President Ulysses S. Grant's daily routine was simple in comparison to presidents in the 21st century. Rising early, he read the morning newspapers, went for a brisk walk, and then began his official business, working until 3 p.m. He usually visited his prized horses at the stables after work and went for a carriage ride or another stroll before dinner. Grant then spent most evenings relaxing with family and friends.

The schedule of the president today is meticulously planned. It can be downloaded as a smartphone application to track events with scrutiny a 19th-century president could not have imagined.

The physical environment of the West Wing interior differs from that constructed for Franklin Delano Roosevelt in 1934. Once there was a large and airy lobby and vestibule that held the press, visitors, and White House staffers waiting for appointments. Generally, the offices were also more spacious. The lobby and vestibule and larger office spaces have been cut up over the years to create a honeycomb of work areas to accommodate the ever-growing staff around a hub of formal rooms, the Oval Office, the Cabinet Room, and the Roosevelt Room.

The Cabinet Room overlooks the Rose Garden and is where meetings with the cabinet, congressional leaders, and presidential advisers are held, as well as sessions of the National Security Council. The Roosevelt Room, known as the Fish Room during the time of Franklin D. Roosevelt, contained an aquarium and mementos of the president's fishing trips. It is where staff meetings and occasional press conferences take place.

"The Buck Stops Here"

President Harry S. Truman had a famous sign on his desk in the Oval Office: "The buck stops here." And indeed it does. No matter the support of his family or advisers, nothing can relieve the president of the responsibility of decision making. "No easy matter will ever come to you," President Eisenhower said to President-elect Kennedy on the eve of the 1961 inauguration. "If they're easy they will be settled at a lower level." As the representative of all the people, the president must balance the advice of his staff and cabinet with the conflicting interests of many groups. He can never forget that individual Americans look to him as the holder of the office that—in Herbert Hoover's words—"touches the happiness of every home."

Seldom, if ever, can the chief executive escape the pressures of his job in the West Wing by engaging in his favorite sport or relaxing with his family. His election has given him powers that in scope are unique.

President Gerald Ford pets his golden retriever, Liberty, while reading briefing documents in the Oval Office in 1974. The Ford family received Liberty as a puppy shortly after they moved into the White House.

He is at once the ceremonial head of government, leader of a political party, administrator of the nation's laws and domestic affairs, director of foreign policy, and commander in chief of the armed forces. How this power has been used has depended on the era. As Woodrow Wilson said five years before he became president, the president is "at liberty . . . to be as big a man as he can. His capacity will set the limit."

Today, the president's executive staff is overseen by a White House chief of staff. The Executive Office of the President (EOP) has been organized into numerous units since 1939, and today includes important policy and advisory councils, such as the Council of Economic Advisers, National Security Council, the Office of Communications, the Office of Management and Budget, and many more. The EOP staff members are organized in a hierarchy; those closest to the president have the title assistant to the president, the next tier are deputy assistants, and the third group are special assistants. Today, more than 400 people work in the West Wing, including the president's staff and assistants, the permanent employees who maintain the building or provide food service in the mess, and the security forces

of the Secret Service. Advisers, speechwriters, communications staff, and military and social aides all contribute to the operation of the West Wing and make it possible for the president to govern.

Inside the Oval Office

Presidents have traditionally decorated the Oval Office to suit their individual needs and reflect their personal tastes. Because of this, the Oval Office tends to echo the personality and governing style of the incumbent chief executive. During the Taft administration in 1909, newspaper reports joked that the dimensions of the newly completed Oval Office, the formal office in the heart of the West Wing, had been determined by the Army Corps of Engineers by laying the rotund president down on the South Lawn and drawing a circle around him. (In actuality, the office is much bigger than that. On its long axis, it measures 35 feet, 10 inches; the short axis measures 29 feet. The ceiling rises to 18 feet, 6 inches.) For President Taft, the first Oval Office symbolized the center of his administration and the place a president worked full time. He established the day-to-day operation of the presidency in the West Wing.

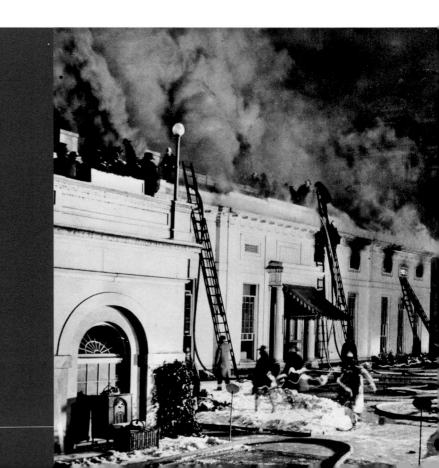

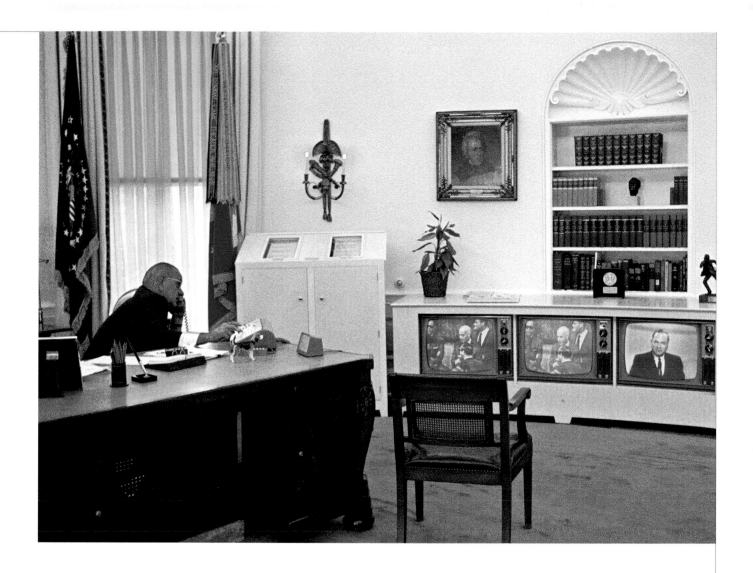

President Lyndon B. Johnson converses on the phone while watching news coverage from the three major networks and monitoring two teletype machines that print dispatches from the major newswire services.

During the 1934 West Wing expansion, architect Eric Gugler retained the character of the Oval Office of Taft and Hoover, preserving and installing the 1909 marble mantel and some woodwork from the original office in the new space built for President Franklin D. Roosevelt. Gugler enlarged the office and gave it his own slightly moderne-style flair, while keeping the Georgian design of the original room. He incorporated pediments over the doors and fluted seashell coves crowning built-in bookcases. Franklin Roosevelt selected the colors, then gray-green walls and white woodwork. Gugler also created office space in the basement with a bright open courtyard, plants, and a fountain to accommodate the president's correspondence staff. Enclosed during World War II, today this space holds the situation room and its adjoining offices.

The Oval Office was changed very little until the Kennedy administration, when televised addresses from the Oval Office became more regular. Succeeding presidents since Kennedy have changed the wall coverings, rugs, chairs, and more. For instance, the rug custom-made for Barack Obama's office features a presidential seal in the middle, typical of presidential rugs, while the border is ringed uniquely by quotes from previous presidents and from Martin Luther King, Jr. Some elements, however, remain fixtures. The elaborately carved Resolute desk, built from wood salvaged from the British ship H.M.S. *Resolute,* was given to President Rutherford B. Hayes by a grateful Queen Victoria. Numerous presidents have used it, including all the recent presidents from Jimmy Carter to Barack Obama. President George H. W. Bush, however, used it in the Oval Office for only five months in

1989, before having it moved to his residence office in exchange for a partner's desk that he had used in his West Wing office as vice president.

Journalist Haynes Johnson gained close access to the Ford administration and produced *The Working White House* (1975), a book that described the inner workings and demanding job pressures of the West Wing and its staff. His observations could apply to any administration: "The hours are long, the attention to detail exacting, and the cumulative strain immense . . . The White House has been operating so long, in so many times of crisis and challenge, that the working side of the West Wing conveys an atmosphere of calm and unhurried deliberation. At the same time one cannot help but be struck by the remarkable efficiency and volume of the work accomplished there. It seems effortless. Of course it is not."

Enhanced Security

It is no longer possible for the public to use the grounds of the Executive Mansion freely as in the past, let alone walk unannounced into the White House or the West Wing to meet the president. The possibility of an attack on the White House during World War II changed security forever. Guardhouses, built at the corners of the lawn, monitored the White House gates. Without a special appointment, no one but staff with badges could enter. In times of war, Washington Metropolitan Police or military details protected the presidents until the U.S. Secret Service, founded by the Treasury Department to

White House police line up for roll call in 1965 (left). Archie Roosevelt (below) salutes the presiding officer, and his younger brother Quentin yawns as roll call takes place among the White House police detail about 1903. In 1977, the White House uniformed protection services became part of the Secret Service.

deal with counterfeiting, was given responsibility in 1902 for protecting the president. This followed the assassination of William McKinley in Buffalo, New York, by a deranged anarchist. A special White House police force was created in 1922, and was placed under Secret Service supervision eight years later. This force eventually became part of the Uniformed Division of the Secret Service in 1977. Uniformed and in plain clothes, the Secret Service today is in charge of White House security. Highly professional and innovative in technologies, this division focuses all its efforts on the protection of the chief of state.

The first presidents had few if any guards, usually just a doorkeeper concealing a pistol. In wartime, a detachment of troops usually camped on the grounds. In the first century after John Adams occupied the mansion, it was considered undemocratic to guard the president. James Monroe was the first to have plainclothes guards roam the White House and armed guards patrolling during receptions. Andrew Jackson did not

favor hiring guards, almost resulting in his demise in January 1835. A gunman attempted to assassinate Jackson at the east front of the Capitol, but both of the assailants' pistols misfired. Abraham Lincoln had many threats against him, but the night he was shot at Ford's Theatre, the guard at the entrance to his box was not at his post. It would take another 36 years and the assassination of two more presidents—James A. Garfield in 1881 and William McKinley in 1901—before Congress added protection of the president to the list of duties for the Secret Service. That protection grew through time, yet the assassination of President Kennedy, seemingly impossible because he was under heavy guard, came as a shock.

Incidents since Kennedy's death in 1963 have only intensified security measures. Danger seems to move ever closer to the White House, and the Secret Service maintains ever closer guard. Following the April 1995 bombing of the Alfred P. Murrah Federal Building in Oklahoma City that took 168 lives, President Bill Clinton reluctantly but wisely agreed to have Pennsylvania Avenue in front of the White House closed to automobile traffic. Today, special permission must accompany any visitor to the grounds of the President's House or executive offices, and uniformed guards and special agents in civilian clothes protect the White House at all times. ★

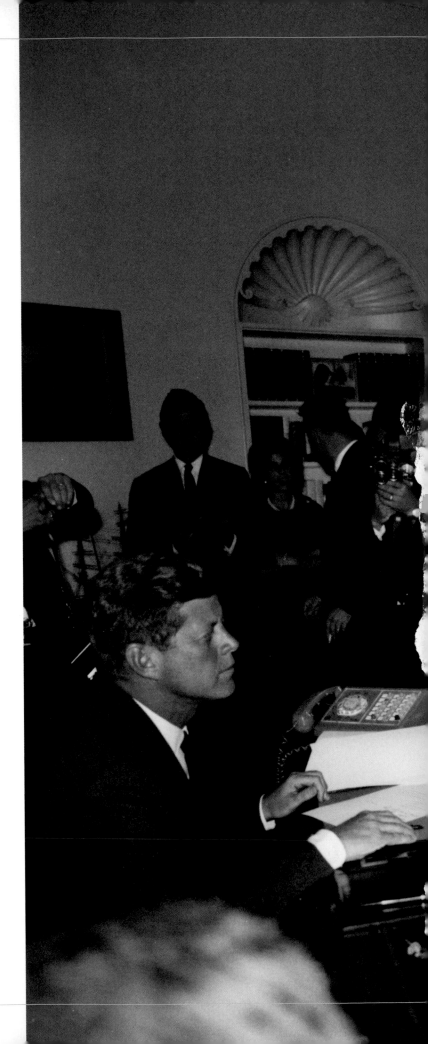

Historical Events
and the West Wing

THE PRESIDENT'S OVAL OFFICE has become famil-
iar to people all over the world, with pictures of
the toddler John Kennedy, Jr., peering through
the front panel of his father's desk, or Richard
M. Nixon talking with astronauts by radio-
phone after a moon landing. The Presidential
Libraries store millions of historic still and
moving images that capture how the rooms
of the White House have become synonymous
with the power of the presidency. From here,
presidents have made the most momentous of
private decisions and public announcements.

Woodrow Wilson spent many sleepless nights
assessing the consequences before he called
for a declaration of war against Germany in April 1917.
After all, he had built his successful 1916 reelection
campaign on the slogan, "He kept us out of war."
But Wilson felt that Germany's unrestricted submarine
activities plus its attempt to enlist Mexico as an ally
forced his hand.

Franklin D. Roosevelt signed the Social Security
Act in 1935 in the Cabinet Room during the Great
Depression; in 1938, he signed the Fair Labor
Standards Act, a federal law to establish a national
minimum wage, time and a half for overtime pay,
and a 44-hour workweek. Roosevelt did not live to see
the end of World War II; instead, Truman made the
announcement in the Oval Office of VJ Day—the
unconditional surrender by Japan on August 14, 1945.

Photographers crowd President Kennedy for a close-up during
a briefing in the Oval Office in 1962, at the time of the Cuban
missile crisis.

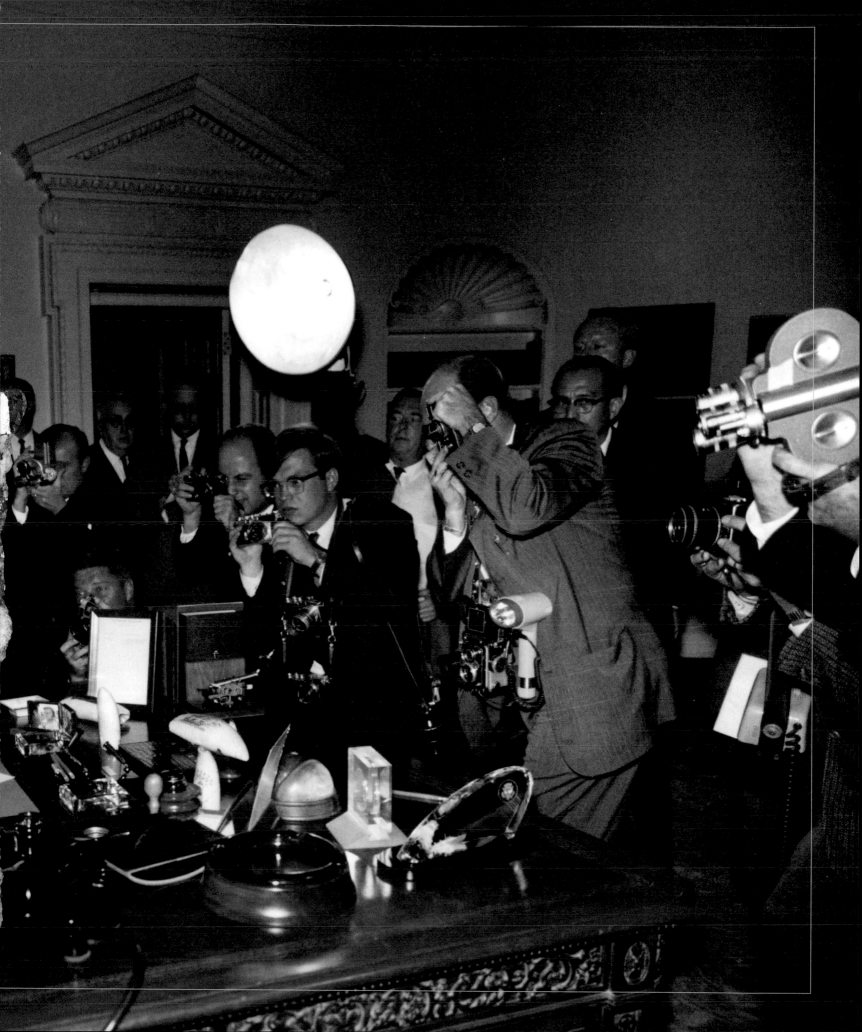

PRESIDENTIAL BILL SIGNINGS

Legislation that has received congressional approval winds up on the president's desk in the Oval Office. This is where history happens, when the president either vetoes a bill or signs it into law. Ceremonial bill signings have often been held in the Oval Office since it was built in 1909. Other locations for bill signings—depending on the number of attendees and other factors—have included the Roosevelt Room (a conference room located across the hall from the Oval Office), the East Room, the North Lawn, the South Lawn, and the Rose Garden. Invitees usually include the bill's sponsors, members of the committees who have worked on the bill, and sometimes American citizens who have advocated for or are representative of the legislation created by the bill. The whole group gathers around the president's desk while he signs, providing the press ample opportunities for photographs.

When President Franklin D. Roosevelt signed the Social Security Act into law on August 14, 1935, there were so many attendees that the signing was not held in the Oval Office but in the Roosevelt Room.

Even in the slightly larger room none of the photographers were able to capture all of the participants in a single image. Twenty participants observed the President as he signed the bill. Directly behind him stood the only woman present, Secretary of Labor Frances Perkins; she chaired the Committee on Economic Security, which had submitted proposals from which much of the Social Security legislation had been fashioned.

President Franklin Roosevelt signs the Social Security Act, 1935.

President Truman shouldered the awesome burden of using the atomic bomb against Japan to end World War II. He wrote in his memoirs that he "regarded the bomb as a military weapon and never had any doubt that it should be used."

On the Nuclear Brink

In 1962, nuclear weapons figured into President Kennedy's decision to thwart the Soviet Union's secret installation of intermediate-range nuclear missiles in Cuba. Both nations had terribly destructive nuclear arsenals, and Kennedy decided to block Soviet ships from delivering both missiles and material to develop missile facilities just 90 miles off American shores. The news media's dramatic images of the president and his staff at work in the West Wing captured the tension and brinksmanship of the 13-day Cold War confrontation until back-channel diplomacy resolved the crisis. The Soviets dismantled the missile sites in exchange for a public statement that the United States would not invade Cuba, along with the secret removal of American nuclear warheads from Turkey and southern Italy.

Words of Comfort

President Ronald Reagan broadcast a consoling speech after the 1986 explosion of the space shuttle *Challenger,* leaving lasting impressions of both the office and its occupants in the minds of Americans. Comfort also came from the Oval Office when George W. Bush spoke on the evening of September 11, 2001, after terrorists hijacked airliners that crashed into the twin towers of New York's World Trade Center, the Pentagon, and a field in Pennsylvania, killing thousands. "Terrorist attacks can shake the foundations of our biggest buildings, but they cannot touch the foundation of America," Bush said.

Presidents have also used the Oval Office to advise Americans of major political changes. The Vietnam War and the loss of American

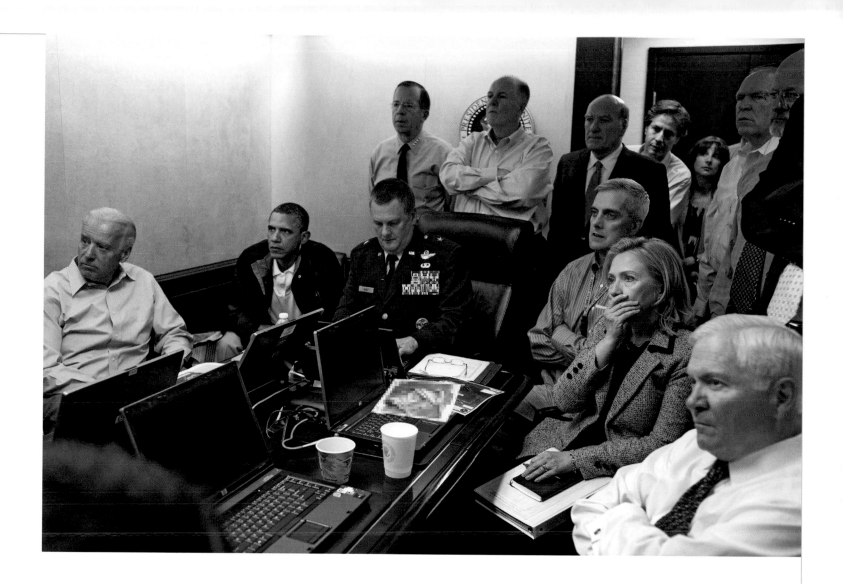

In 2011, President Barack Obama, Vice President Joe Biden, and the national security team monitor the mission against Osama bin Laden in real time.

lives weighed so heavily on President Lyndon Johnson that he addressed the nation from the Oval Office to tell his audience that he would not run in the election of 1968. Five years later, President Nixon would face an unprecedented domestic crisis when a break-in occurred in Democratic National Committee offices in the Watergate complex. In 1974, Nixon became the first president to resign, and made the announcement from the Oval Office on prime-time television when he faced certain impeachment for his cover-up of the break-in and other illegalities. "I would have preferred to carry through to the finish whatever the personal agony it would have involved, and my family unanimously urged me to do so," Nixon said. "But the interest of the nation must always come before any personal considerations."

Many presidents experience a crossroads of history from the West Wing. Gerald Ford, criticized for his pardoning of Nixon, inherited the worst economy in four decades, as inflation and recession ravaged simultaneously. Jimmy Carter dealt with an energy crisis and the seizure of embassy staff in Iran. Ronald Reagan was confronted by the loss of American lives in the bombing of the Marine barracks in Beirut, and signed a treaty in the East Room with Soviet president Mikhail Gorbachev that limited intercontinental missiles.

Since 1991 presidents have dealt with the end of the Cold War, the reemergence of the nation of Russia, and the threats of terrorism. The West Wing is now a permanent and integral part of the White House complex in its own right. The government of the country now revolves both symbolically and in palpable ways around the West Wing, where history has been and continues to be made. ★

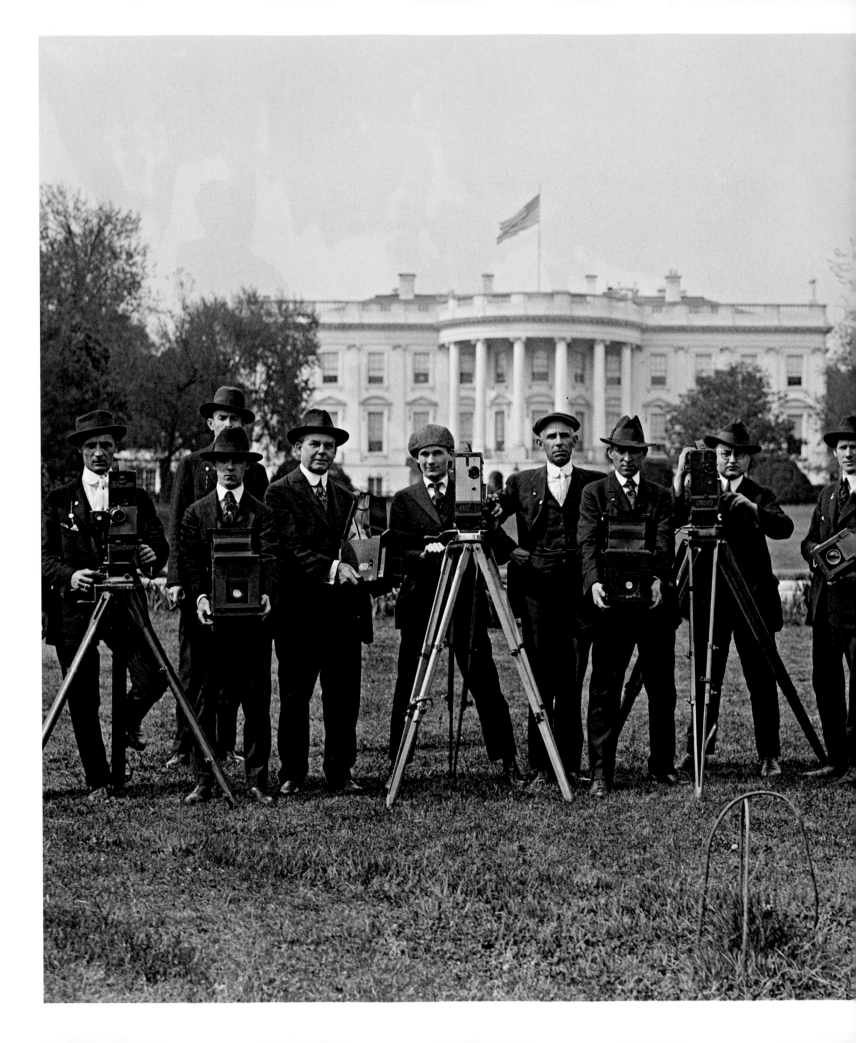

The White House Beat

IN OUR INFORMATION AGE, TELEVISION, RADIO, WEBSITES, smartphones, and print media serve as the main vehicles for presidential policy statements, the explanation of daily decisions, and discussion of foreign and domestic affairs both for the administration and its opposition. World events now have real-time immediacy, and the White House must react instantaneously. It's a long way from weeks-old coverage conveyed in dispatches by newspapers.

The "White House gang" of still and motion-picture photographers pose for a group photograph on the South Lawn in 1918. In 1921, a group of 17 photographers organized as the White House News Photographers Association, with the mission of ensuring access to government newsmakers. Among the members over the years: President Harry S. Truman, who helped judge the association's photo contest.

Early presidents relied on newspapers to communicate with the nation and to publicize their priorities. As newspapers became widely established in communities across the United States in the 19th century, reporters increasingly congregated at the White House under the North Portico. There they staked out interviews or claimed space in the second-floor waiting areas. However, it was not until 1902 and the construction of the Executive Office Building that the press had a work space of its own.

Recognition of the press's presence at the White House coincided with the emergence of the presidency as a distinct beat in the early 20th century. Theodore Roosevelt became the first president to hold regular meetings with reporters and to respond to their questions. By 1930, the formal position of presidential press secretary was established. President Franklin D. Roosevelt opened the modern period in president–media relations, holding more than 900 Oval Office press conferences and delivering numerous "fireside chats" on the radio from the residence during his 12 years in office.

When News Moved Slowly

In the early days of the presidency, news traveled slowly, taking days to arrive by horse or by ship. With the invention of the telegraph, communications picked up, although news from remote locations still traveled by

horse to a telegraph point and on to New York City, which had a line to Washington, D.C. The Civil War was the first war to be reported instantaneously, and Mathew Brady's photographs of battlefield corpses during the war shocked Americans. James K. Polk was the first president to be photographed in the White House. Zachary Taylor and Franklin Pierce and others had portraits taken. Abraham Lincoln was the first president to realize the importance of his public persona and that he should be available to photographers. He had more than a hundred taken while he was in office. The rules seemed to change at the White House after the Civil War, as journalists thought they had a democratic right to know about daily life within its walls. Writing under the pen name "Olivia," Emily Edson Briggs in the 1860s became the first woman journalist assigned to the White House; her columns appeared in Washington and Philadelphia newspapers. The White House, she said, "Belongs to the people. When we go to the Executive Mansion we go to our own house."

As mass readership and illustrated publications increased, human interest, gossip, and sensationalism increased, too. President Grover Cleveland became irritated with the press when they badgered him and his new bride, Frances Folsom Cleveland, on their 1886 honeymoon at a hotel in western Maryland. The Clevelands were followed by some 25 to 30 reporters, who hired cottages near the newly wedded pair.

Three presidential secretaries—Cleveland's Daniel Lamont, McKinley's John Addison Porter, and Theodore Roosevelt's George B. Cortelyou—were instrumental in bringing about creative press relations and management in the late 19th and early 20th centuries. Cortelyou conceived the idea of providing the president with a daily news summary of press clippings and commentary.

Press Conferences

In March 1913, Woodrow Wilson held the first press conference to explain his programs, and in 1914, the White

WHITE HOUSE LIVES ★

WHITE HOUSE PHOTOGRAPHERS

Photographers have been around the White House since the 1840s, when John Plumbe took daguerreotypes of President James K. Polk and his family. Frances Benjamin Johnston, one of the first female American photojournalists, was considered the White House court photographer from 1889 to 1909. The White House News Photographers Association, founded in 1921, formalized the role of news photographers covering events at the White House. For more than 50 years, presidents have also employed staff photographers. President Obama's photographer, Pete Souza, says the job "is not so much photojournalism as photo-history."

Photographers at President Ford's press conference in 1975.

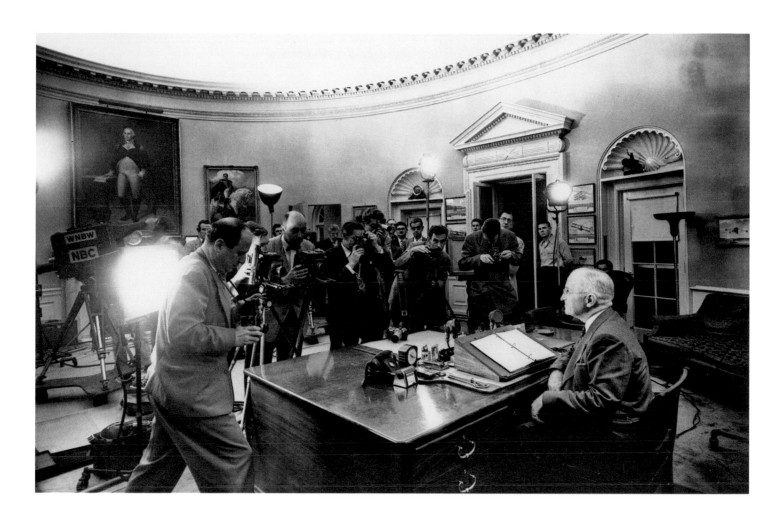

President Truman faces the hot lights and cameras to address the nation from his desk in the Oval Office in 1951.

House Correspondents' Association was formed to promote the interests of journalists covering the president. Warren Harding had been a newspaper publisher (he always carried a printer's makeup rule in his pocket for luck) and gave the press access to all his public events and some private ones. Franklin Roosevelt was friendly to the press and held two press conferences a week, always off the record, with reporters hanging chummily around his desk. Harry Truman was more cautious, and to accommodate the growth of the press corps held conferences in an auditorium in what is now the Eisenhower Executive Office Building.

Television revolutionized news coverage at the White House. Truman conducted the first televised tour of the White House after the 1949–1952 renovation, which some 30 million viewers watched. Dwight D. Eisenhower was considered the first television president as sets became more common. Under the tutelage of television pioneer Robert Montgomery, he held the first televised presidential press conference on January 19, 1955. President Kennedy began live daytime and early evening televised press conferences. By 1961, 87 percent of the public had television sets, and his sessions were uncut and live—as opposed to Eisenhower's conferences, which had been edited for later broadcast. With Kennedy, the public saw him as he spoke.

There has been no going back. Computer technology and 24-hour worldwide, live televised news have again revolutionized coverage. History shows that the presidency is an institution that makes use of the latest communications. The goal is to demonstrate command of the facts of policy, and to explain actions with clarity and at times a sense of humor, and thus display strong leadership. ★

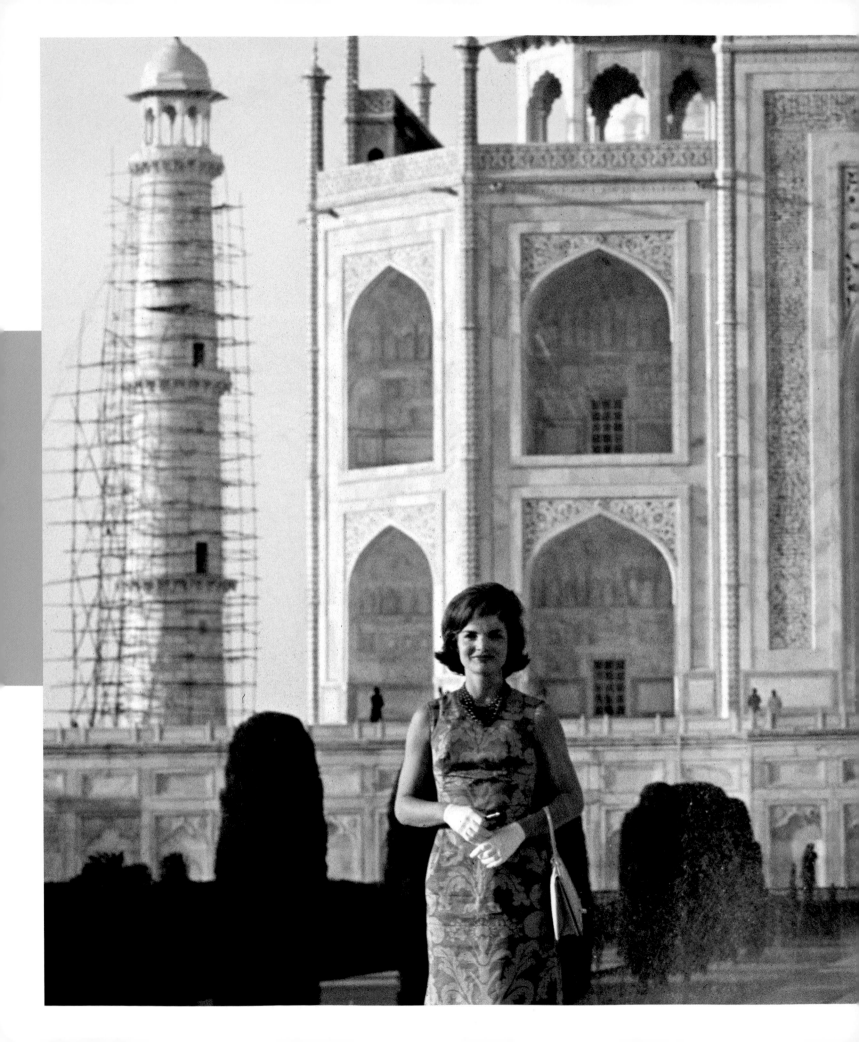

The FIRST LADY

WHITE HOUSE HOSTESS ★ ADVOCATES for CAUSES ★
INFLUENCING POLICY ★ The SOCIAL SECRETARY
and the OFFICE of the FIRST LADY ★

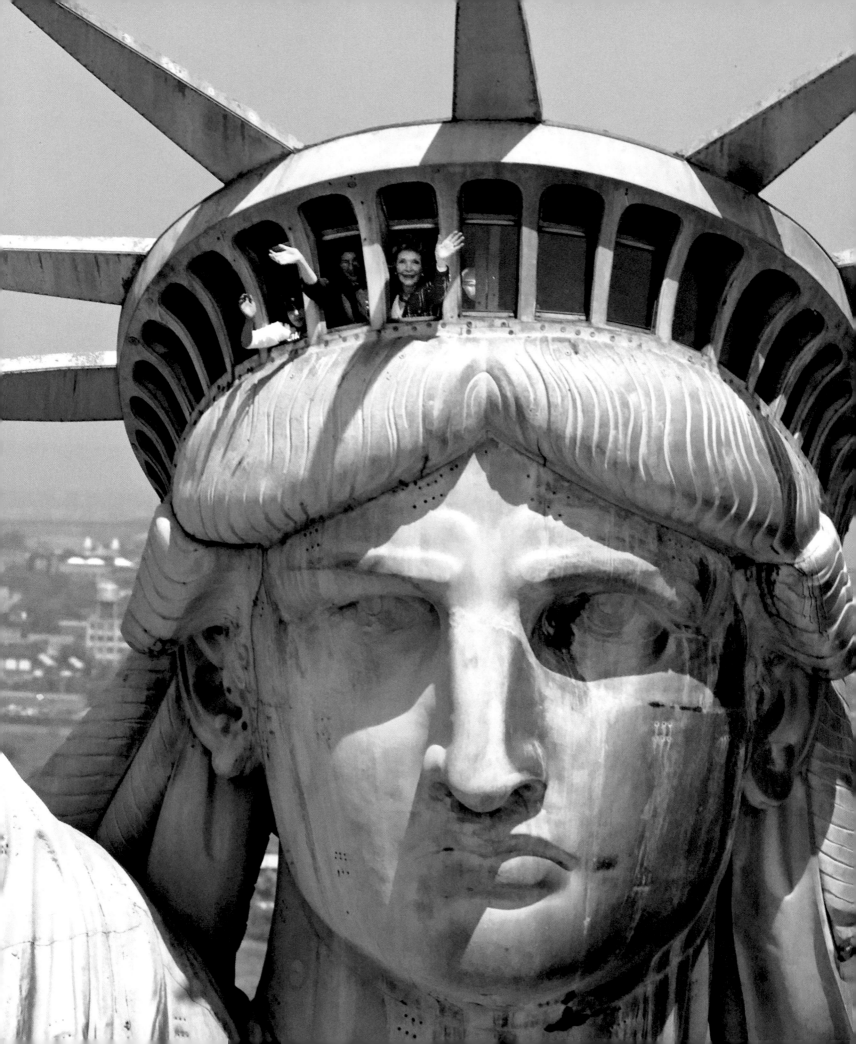

F IRST LADY JACQUELINE KENNEDY CAPTIVATED THE WORLD with her youthful beauty, glamour, and graceful sophistication. In the modern era, "Jackie," as the world called her, epitomized the star power of an American first lady. Previous first ladies usually had not been in the spotlight. As a wife and political partner of a president before women could vote in 1920, first ladies were discouraged from involvement in politics. This is not to say they complied.

The public has always been fascinated by the first ladies for what they represent—they are a living statement of the role of women in American society and culture, as well as personalities in their own right. How they behave, dress, entertain, and manage the White House conveys a national image, and it is not easy living up to expectations. Fulfilling the image of an ideal and supportive spouse is a stress-filled job with not a penny of salary. First ladies are inevitably on the receiving end of societal judgments that may be veiled partisan attacks against the president. Living under intense public scrutiny, style and appearances are important. Eleanor Roosevelt said that she sometimes felt that she was not only clothing herself "but dressing a public monument." A first lady's role as a fashion setter has been evident from the 18th century to the present. From Martha Washington's brown silk taffeta gown preserved at Mount Vernon to Michelle Obama's yellow silk Jason Wu–designed inaugural gown, fashions resonate with the public and can be seen to reflect the economic and political climate of their time. Each first lady has responded to the pressures of the position in her own way, most thriving but some finding their role a heavy burden.

Preceding pages: First Lady Jacqueline Kennedy poses in front of the Taj Mahal in Agra, India, during a diplomatic goodwill trip in 1962. Opposite: Waving out of the observation window of the Statue of Liberty in New York City, First Lady Nancy Reagan and visitors participated in Liberty Weekend, a four-day celebration of the statue's restoration and centennial, July 3 to 6, 1986.

White House Hostess

THE MOST TRADITIONAL DUTY OF A FIRST LADY is serving as a hostess at the Executive Mansion, just as she would in her husband's home. Guests and the press scrutinize everything from the gowns first ladies wear to their adherence to protocol, perhaps more closely than they do the president. Any slips are swiftly reported through multiple outlets, from major newspapers to blogs to Twitter. Conversely, a reputation for graciousness and style will enhance the success of the president. It is key to the symbolic presence of the American presidency.

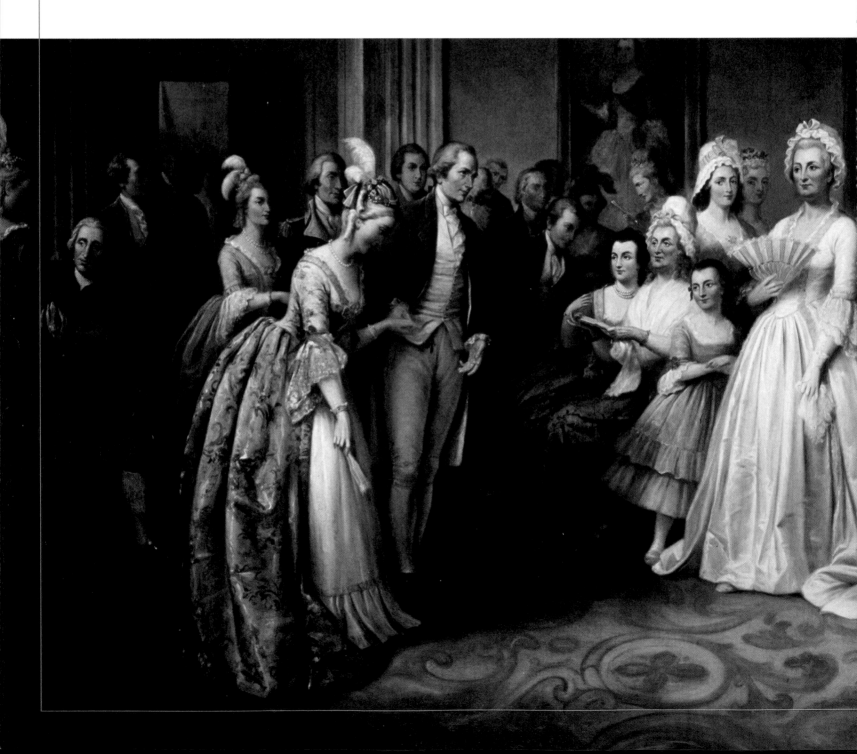

Being First Lady looks like a glamor role.
Actually, it is a tough job that is going to get tougher.

RUTH COWAN, *Washington Post*, November 2, 1948

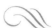

Just as George Washington set the precedents to make the presidency powerful but not "royal," Martha Washington created the role of first lady. The president and "Lady Washington," as some called her, held regular gatherings starting in 1789, as soon as they settled into the nation's first capital of New York City, where they lived in a rented house at 3 Cherry Street. Every two weeks, the president held formal receptions called "levees" for gentlemen only, replete with ceremonial bows and rehearsed greetings. Martha Washington held more relaxed Friday evening receptions known as "drawing rooms."

Entertaining in Washington

When John Adams succeeded George Washington as president in 1797, Abigail Adams realized that stepping into the role of first lady and maintaining Martha Washington's example of simple dignity would not be easy. The Adamses were not as rich as the Washingtons were. That made it difficult for the Adamses to meet the expectations of entertaining already established in Philadelphia and then in the unfinished President's House in Washington. Abigail Adams was a gracious hostess conversant on literary, scientific, and artistic subjects, and possessed a razor-edged wit.

George and Martha Washington are depicted at an American court in this fictionalized 19th-century illustration. Dolley Madison (above) set the standard for hospitality at the White House.

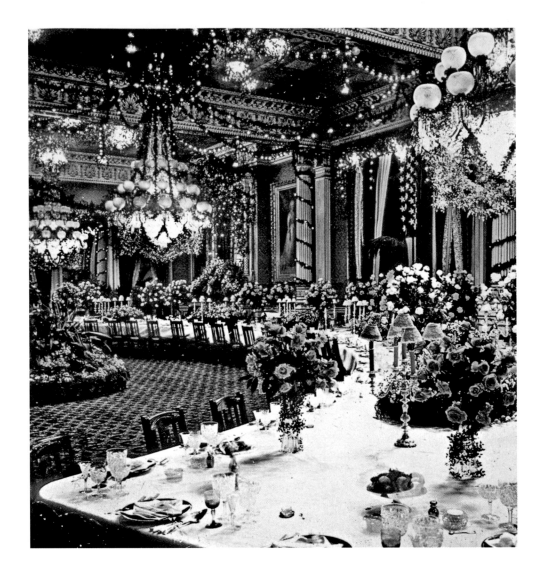

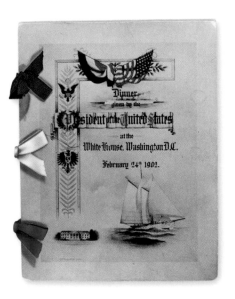

Thomas Jefferson's wife, Martha, died in 1782, long
before he became the country's third president in 1801.
His married daughters Martha Randolph and Maria
Eppes, along with Dolley Madison, then the wife of his
secretary of state, acted very occasionally as Jefferson's
hostesses during his two terms. President Jefferson
more often entertained by himself. Nearly all his guests
were men, and he cast out previous formalities, as well
as introducing a heretofore nonpresidential handshake.

Dolley Madison was already a leader in Washington
society when her husband, James Madison, entered
office in 1809. As first lady, Dolley Madison was consid-
ered by many to be nearly perfect. She was funny,
charming, and steered clear of controversial subjects.
She presided over her husband's first inaugural ball in
a buff-colored velvet dress with a striking purple velvet

bonnet trimmed with white satin and tall white feather
plumes. Author Washington Irving, who attended
one of the Madison receptions, recalled she was "a
fine, buxom dame who had a smile and a pleasant word
for everyone." She held popular Wednesday evening
receptions for anyone who wished to meet the presi-
dent. The motive was as much or more political than
social—a war was approaching—but who cared
to question?

The War of 1812, America's second war with Great
Britain, led to an invasion of Washington in August
1814. Just hours before the British occupied the city
and burned the White House, Dolley Madison showed
great courage awaiting her husband's return from the
Bladensburg, Maryland, battlefield where he had gone
to observe the troops. She directed the rescue of

Mrs. Hayes would have been considered an unusual woman wherever placed . . . One would know, from the way she carried herself . . . she was a woman of much character; the deference shown by her husband would have proved it if nothing else did.

William H. Crook, *Through Five Administrations,* 1910

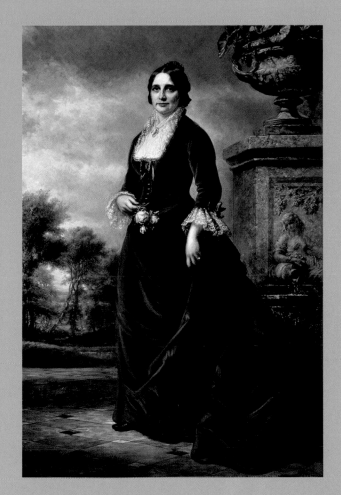

"Wild Turkey" dinner platter from a china service commissioned by Hayes in 1880.

LEMONADE LUCY

History now remembers Lucy Webb Hayes as "Lemonade Lucy," even though it was her husband who banned liquor and wine from the president's table. Rutherford B. Hayes won a hotly disputed election and felt the pressure from powerful temperance advocates to make the White House dry. To the delight of the Woman's Christian Temperance Union (WCTU), Lucy Hayes carried out her husband's orders to banish wines and liquors from the White House. The first lady became the idol of the temperance movement and was much admired in her time, generally as a sincere and compassionate woman with interests in charities assisting orphans and the poor. She donned a burgundy gown when the subject of a full-length Daniel Huntington painting, paid for by the WCTU. On his last day in the White House, President Hayes saw the painting hanging in the Green Room and wrote a note of thanks to Huntington for the accuracy of the likeness of his beloved wife.

valuable documents, silver, and the full-length 1797 "Lansdowne portrait" of George Washington by artist Gilbert Stuart. That same painting hangs in the East Room today, thanks to her. The Madisons fled separately into the countryside, and upon returning to the capital, found the Executive Mansion a smoky ruin. Hurried into temporary quarters, Dolley Madison entertained as skillfully as ever. She moved back to Washington from Montpelier, Virginia, in 1837, after James Madison's death. Living on Lafayette Square across the street from the White House, she became an adviser to first ladies. Dignitaries visiting the president often paid their respects at her home. In fact, the earliest presidential use of "first lady" occurred in Zachary Taylor's informal eulogy to her upon her death in 1849, when he said, "She will never be forgotten, because she truly was our first lady for a half century." Dolley Madison created a model for the role of first lady. She was always herself, and the most successful first ladies have done the same.

The wife of James Monroe was beautiful Elizabeth Kortright Monroe, a New Yorker, who was 17 when the 27-year-old Monroe married her in 1786. They led their whole lives in politics and diplomacy. A youthful Monroe had been George Washington's minister to France toward the end of the French Revolution.

Depending on the event, greeting guests to the White House can be informal or formal, requiring high protocol. In 1888, President and Mrs. Grover Cleveland (above) welcomed guests at an army and navy reception. In 1969, First Lady Pat Nixon (right) greeted visiting Girl Scouts and their mothers at a gathering in the East Room.

The loss of a child, her only son, darkened Elizabeth Monroe's once outgoing personality and she became aloof, which the public mistook for snobbery. She often chose not to attend White House dinners, and thus the protocol of the day prevented the wives of congressmen and other officials from attending the dinners in her absence. In the end, in the eyes of the social world, Elizabeth Monroe could not live up to the amiable Dolley Madison.

London-born Louisa Adams, the wife of John Quincy Adams, the sixth president, led an adventurous and eventful life in Berlin, St. Petersburg, and London during her husband's years as a diplomat.

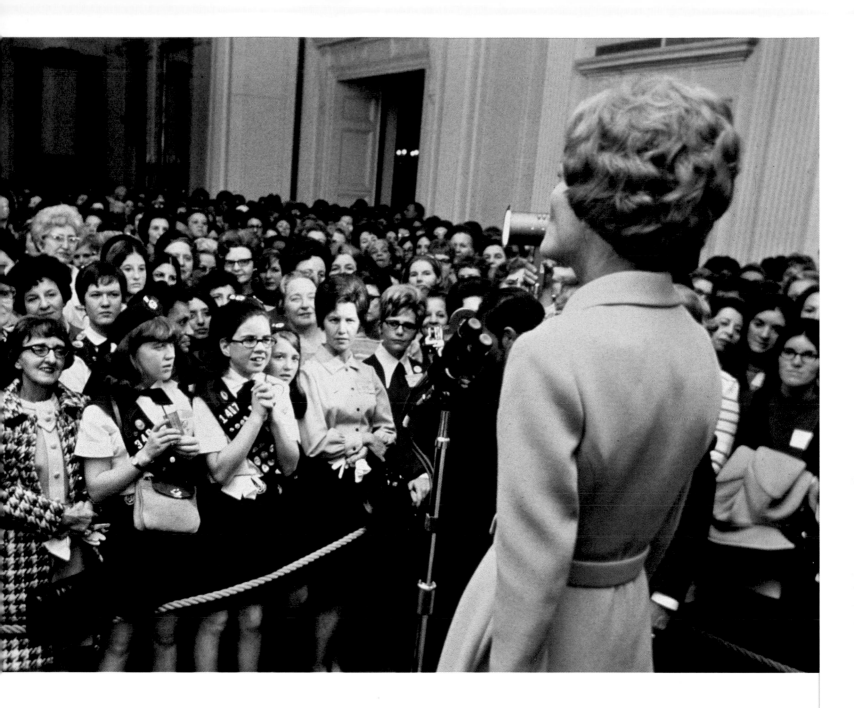

Her memoirs vividly recall a harrowing coach journey in 1815 from Russia to France in the tumultuous period after Napoleon's return from Elba. Life in the Adams White House proved far less glamorous as the administration was fraught with political conflict after the bitter campaign of 1824.

Widowers and Bachelors

By the late 1820s, it was well established that first ladies, as hostesses for the nation, welcomed the diplomats, statesmen, legislators, and honored guests of the president. But not all first ladies were the wives of presidents. Four 19th-century presidents were widowers:

Thomas Jefferson, Andrew Jackson, Martin Van Buren, and Chester A. Arthur; two—James Buchanan and Grover Cleveland—entered office as bachelors. The wives of John Tyler, Franklin Pierce, Andrew Johnson, and William McKinley, handicapped by sickness, largely withdrew from White House social life. Female relatives—daughters, daughters-in-law, or nieces—usually pinch-hit in social obligations.

The best known of these 19th-century substitute hostesses were Angelica Van Buren, the wife of Abraham Van Buren, the president's son and private secretary; and Harriet Lane, the niece of President James Buchanan. They had their own ideas of how

things should be done. When Van Buren sent his son and Angelica to Europe on a tour of the courts as goodwill ambassadors in the spring of 1839, Angelica was so impressed with the customs at the courts of Britain's Queen Victoria and of France's Louis Philippe that she briefly introduced some of the practices at the White House, notably receiving guests on an elevated platform and nodding to them without speaking. A Whig congressman, outraged, branded her a "Democratic peacock in full court costume, strutting." She abandoned the practice. Harriet Lane, in her 20s, had served as President Buchanan's hostess while he was American minister to the British Court of St. James's in 1854, and dined often with Queen Victoria and Prince Albert. The queen fondly referred to her as "the dear Miss Lane," and awe-struck social observers in the United States called her "Our Democratic Queen." Yet somehow the light-hearted Harriet drew admiration, not criticism, for her royal connections. Lane presided over the White House during the increasingly tense years after 1856, when the nation was deeply split over slavery, and despite the times, her uncle's White House experienced a gaiety it had not seen since the days of Dolley Madison.

Socializing during the Civil War was subdued, but in the years after, Julia Grant entertained with panache. Early in the first Grant administration in 1870, she was the hostess for an evening reception for a Native American delegation, bringing Washington society to the White House to meet her visitors. In 1877, she gave the first dinner ever held for a foreign head of state at the White House. King David Kalakaua of the Sandwich Islands (Hawaii) entered in splendid

Betty Ford, once a professional dancer, said she had always wanted to dance on the Cabinet Room table, and she did so to cheer up the staff on January 19, 1977, the day before the inauguration of Jimmy Carter.

procession, and at the dinner table, two aides tasted his food to make sure it was not poisoned.

The early Grover Cleveland White House was a bachelor's household; the president worked long hours and rarely entertained. Rose Cleveland, his sister, acted as first lady, managed the affairs of the residence, and also spent much of her time studying and writing. No sooner did the public become accustomed to the image of a lonely White House than the picture changed: Grover Cleveland had been secretly courting Frances Folsom, the daughter of Oscar Folsom, his late law partner. The announcement of a White House wedding created a sensation. The bride was 21, the groom 47.

As a White House hostess, Frances Cleveland broke new ground, holding Saturday receptions to make it possible for workingwomen to attend regardless of social standing. The Clevelands vacated the White House on March 4, 1889, after a close election won by Benjamin Harrison. They returned just four years later with baby daughter Ruth; soon Esther, born in the White House, and Marion were added to the family. As a busy young mother, Frances Cleveland spent less time and energy on official entertaining, but her motherhood made her ever more popular. In fact, the Clevelands were in the White House very little, for the president bought a home in the suburbs where "Frankie" and his children would be undisturbed.

With the assassination of President McKinley in 1901, Theodore Roosevelt, not quite 43, became the youngest president in the nation's history. Edith Roosevelt protected the privacy of her family as well as she could, but indulged media interest on several occasions, particularly in the wedding of "Princess Alice," her stepdaughter, in 1906, and her daughter Ethel's debut in 1908. Edith Roosevelt also recognized the historic significance of presidential wives, establishing a gallery of portraits of first ladies on the ground-floor corridor and arranging for a display for tourists of the presidential china collection begun by Caroline Harrison. ★

Portraits of the First Ladies

Fashions have changed, but the official portraits of first ladies reflect their style and grace through the years. From bottom left, clockwise: *Frances Cleveland* by Anders L. Zorn, 1952; *Sarah Polk* by George Dury, 1883; *Helen Taft* by Karl B. A. Kronstrand, 1910. At right, clockwise from top: *Rosalynn Carter* by George Augusta, 1984; *Nancy Reagan* by Aaron Shikler, 1987; *Hillary Clinton* by Simmie Knox, 2003; and *Patricia Ryan Nixon* by Henriette Wyeth, 1978. It was not until the founding of the White House Historical Association in 1961 and its commitment to fund the acquisition of portraits of both presidents and first ladies for the White House that life portraits were consistently commissioned for the collection.

Advocates for Causes

SOME FIRST LADIES WERE ADVOCATES OF CAUSES in the 19th century, notably Louisa Adams in the 1820s, who abhorred slavery, and Lucy Hayes in the 1870s, who became a symbol for women reformers. Abigail Fillmore, a former schoolteacher, was the first wife of a president to have been employed before she became first lady. As first lady, she immediately remedied the lack of a White House library, buying books with a small congressional appropriation. However, it was in the 20th century that the first ladies really became news for their good works.

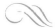

Lucy Hayes, the wife of Rutherford B. Hayes, was the "first" first lady to graduate from college and became a symbol of the "new woman" after her move to the White House in 1877. Her support of the temperance movement was dramatically expressed in the banning of alcoholic beverages from all White House entertaining. For this, history has remembered her as "Lemonade Lucy." Her popularity with the public was fanned by advances in national travel and communications. In 1880, she became the "first" first lady to travel coast to coast. A wave of illustrated magazines and newspapers that carried articles about Lucy Hayes portrayed her as an ideal matron of the presidential family. She also gained a special mention in White House history for inviting the children's Easter Egg Roll to move from the Capitol to the White House in 1878. Congress had banned the popular event on the U.S. Capitol grounds because of the damage to the lawn.

Caroline Harrison, wife of Benjamin Harrison, was a gifted artist who had grand plans to enlarge the President's House and proposed a plan that would have created an official residence akin to a European palace. The plan did not receive funding, but it spurred debate about the run-down condition at the White House that would influence support for extensive renovations within a decade. "Carrie" Harrison was a prominent backer of the National Society of the Daughters of the American Revolution and served as its first president general. The organization, the idea of women who felt unfairly overlooked by the male-only societies springing up in the 1870s and 1880s to

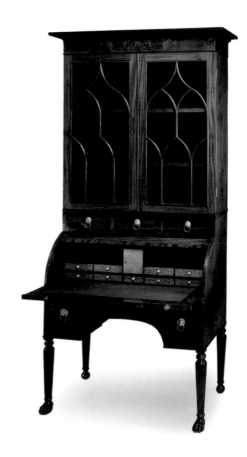

Opposite: A daguerreotype copy of a portrait of Abigail Fillmore, credited with starting the first White House Library. Pat Nixon played a major role in acquiring more than 600 paintings and furnishings for the White House collection, including this Duncan Phyfe desk and bookcase (above), circa 1815–1820, located in the Green Room.

mark the centennial of the American Revolution, took on a political character under Harrison.

In the first public project undertaken by a first lady, Helen Taft, inspired by fond memories of evening carriage rides through the lovely, tree-lined streets of Manila, supported construction of the paved "Speedway" in Potomac Park along the river. The road, which could be used by newly popular automobiles, officially opened as Potomac Drive in April 1909, and became an immediate success, the most fashionable place to go and be seen in Washington from April until late October. She also sponsored Washington's famous cherry blossoms. The plan to plant Japanese cherry trees along the drive came to fruition in 1912, when Helen Taft and Iwa Chinda, wife of the Viscount Sutemi Chinda, the Japanese ambassador, planted the first two of more than 3,000 Yoshino cherry trees on the northern bank of the Tidal Basin, where they and their descendants continue to be enjoyed by thousands of visitors each spring.

Social Causes

Over the years, the press sought ways to focus stories on the first ladies, their personalities, and their causes. Ellen Wilson, the first wife of Woodrow Wilson, was notably concerned about the dreadful circumstances of Washington, D.C.'s dilapidated alley dwellings, and tried to bring an effort to improve conditions to the forefront of congressional and newspaper attention. Her death in 1914 would spur passage of "Ellen Wilson's bill," to clean up the alley slums.

The second wife of President Wilson, Edith Galt Wilson, the widow of Washington jeweler Norman Galt, was a contrast to the shy and reserved Ellen and thrived on public attention. After a whirlwind courtship, she married Wilson on December 18, 1915. The president implicitly trusted Edith and shared all details of his work with her. The two were inseparable, golfing, walking, working, or hosting guests together. Edith Wilson assisted the president with policy

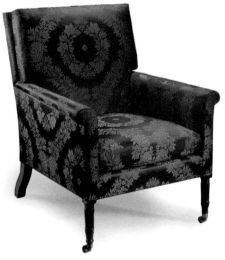

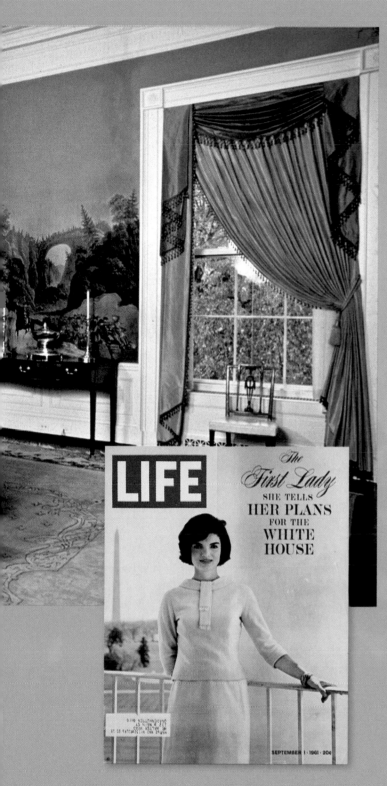

Jacqueline Kennedy created a second-floor President's Dining Room (top), converting a bedroom into a showcase Federal period room. Armchair (opposite) acquired by Mrs. Kennedy, possibly by Thomas Affleck, circa 1765–1775.

ACQUISITIONS AND CONSERVATION

Congressional appropriations and private gifts provided the money for furnishing the White House between 1800 and 1961. Congress also authorized the president to auction and sell obsolete or worn household goods. The most notable auction occurred in 1882, when Chester A. Arthur cleaned out the White House, selling off 30 barrels of china and 24 wagonloads of furniture and "junk."

A significant change occurred in 1961, when Congress enacted legislation declaring that the furnishings of the White House were the inalienable property of the White House. However, Congress did not provide adequate funding for the preservation or acquisition of art or historic furnishings. That year, Jacqueline Kennedy initiated a program to restore the historic integrity of the public rooms. That included establishing an advisory group to acquire a collection of fine and decorative arts and establishing the White House Historical Association as a private, independent, nonprofit educational organization to support her efforts financially and to interpret the White House for the American people. From private funding and the sale of educational products, the association has supported acquisitions for the White House and has contributed to its conservation since then.

Caroline Harrison (above) had plans for a major White House expansion.

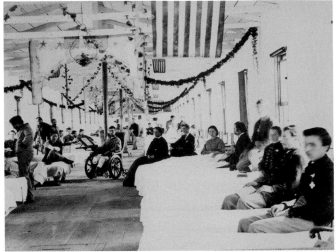

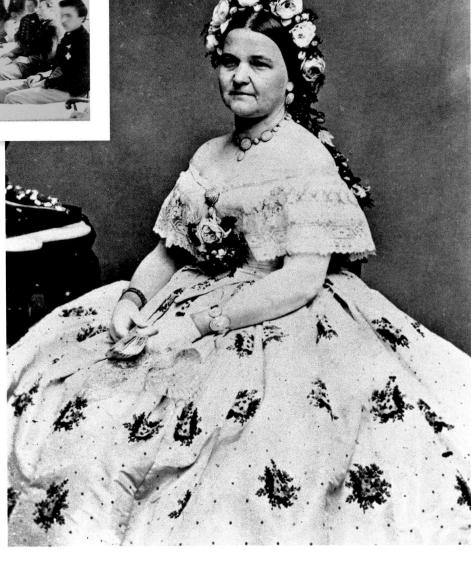

responses and often screened his visitors. After the United States entered World War I in 1917, Edith Wilson submerged her life in her husband's, trying to keep him fit under tremendous strain. She suspended entertaining at the White House and actively participated in war-support programs, publicizing White House home-front compliance with meatless and wheatless days and other food and fuel conservation efforts. After her husband suffered a stroke in 1919, she was labeled the "Secret President," because her role as first lady gained both controversy and significance during Wilson's prolonged and disabling illness.

Setting Examples

When Florence Harding moved into the White House, she came as a woman who had helped run a newspaper business and contributed mightily to her husband's campaign. Loud and demanding, she made many "democratic" changes—she ordered the White House and its grounds, closed while President Wilson had struggled with

A portrait of Mary Todd Lincoln by Mathew Brady in 1861 (above) reflects her social ambitions as she entered the White House. Her years as first lady were a mix of misery and triumph as her extravagant spending stirred resentment. Mrs. Lincoln curtailed her entertaining after her son Willie's death in 1862, and became a volunteer nurse visiting Union soldiers at Washington hospitals, including Carver Hospital (top).

debilitating illness, to be opened to the public once more, and revived traditions like Marine Band concerts, musicales, and the Easter Egg Roll. She hosted numerous garden parties for veterans. Florence Harding often traveled with her husband, and in the summer of 1923, she was with him when he died unexpectedly in San Francisco, shortly before the public learned of the major scandals facing his administration.

After President Harding's death, Grace Coolidge would plan the new administration's social life as her conventional husband wanted it: unpretentious but dignified. Even her son Calvin's tragic death at age 16 from tetanus caused by an infected blood blister developed while playing tennis on the White House court did not interfere with her duties as first lady. Often photographed with one of the members of the family's pet menagerie, Grace Coolidge was a well-liked hostess who often invited women's and charitable groups to the White House, knowing the press were sure to record the event and give the causes national recognition. Her elegance and gaiety offset the dour Calvin Coolidge, and she left Washington in 1929 beloved by the country.

Herbert and Lou Hoover moved into the White House in 1929, and the first lady welcomed visitors with poise and dignity. Her staid and matronly appearance was deceiving. She had earned a degree in geology at Stanford University and had an adventurous life accompanying Herbert Hoover to isolated mining areas around the world. As first lady, she sparked a nationwide controversy by inviting Jessie DePriest, the wife of Republican Oscar Stanton DePriest, the first African American member of Congress since 1901, to a White House tea. It was a social occasion wrapped in a political cloak, and it embodied Lou Hoover's

sense of justice and efforts to combine activism with tradition.

When Eleanor Roosevelt moved to the White House in 1933, at the height of the Great Depression, she transformed the role of first lady and spurred her social activism to a national level. She shattered standard practice by holding weekly press conferences restricted to female journalists. She traveled by train, plane, and automobile to visit New Deal projects; she lectured extensively throughout the country and appeared on radio programs, all the while serving her husband's interests. Eleanor Roosevelt understood social conditions of her time and candidly expressed her opinions in a syndicated newspaper column, "My Day." The column discussed her activities and addressed such national issues as civil rights, immigration, and the right of labor to organize. During World War II, she used "My Day" to support women in defense industries and the military, advocate for service personnel generally, and discuss the shape of the postwar world at home and abroad. She became a natural target for political enemies, but her integrity, her gracious passion, and her sincerity of purpose endeared her to many. Her outspoken support for controversial causes such as civil rights and civil liberties made her many friends—and many enemies. She remains a role model for modern first ladies.

No first lady could have been more different from Eleanor Roosevelt than her successor, Bess Truman, wife of President Harry S. Truman. Intensely private and shunning the press, Bess Truman kept complete silence on public issues. Americans admired her for being old-fashioned and genuine. She conscientiously fulfilled the social obligations of first lady, appearing at charity events and greeting White House visitors, but she did only what was required.

When Dwight D. Eisenhower was inaugurated in 1953, the American people warmly welcomed Mamie Eisenhower as first lady. The rapid development of commercial air travel in the years following World War II enabled the Eisenhowers to entertain an unprecedented number of heads of state and leaders of foreign governments at the White House, and Mamie's down-to-earth style and enjoyment of her role endeared her to guests and the public.

Through the years, first ladies have taken on activist roles that required increasing their staff. Pat Nixon, who traveled widely, added an advance staff for foreign travel; Betty Ford added speechwriting; Rosalynn Carter added a chief of staff. In 1978, during the Carter administration, Congress for the first time authorized personnel assistance for the spouses of the president and vice president when "assisting the President or Vice President in carrying out their duties." The number of women in substantive roles— including positions of power—in the executive branch began to increase slowly yet significantly in the mid- to late 20th century. Eleanor Roosevelt, Rosalynn Carter, and Hillary Clinton all testified before congressional committees on public policy issues, and Rosalynn Carter's attendance at cabinet meetings, although very controversial at the time, signaled the institutionalization of an advisory role for the first spouse, although that has yet to be widely accepted. ★

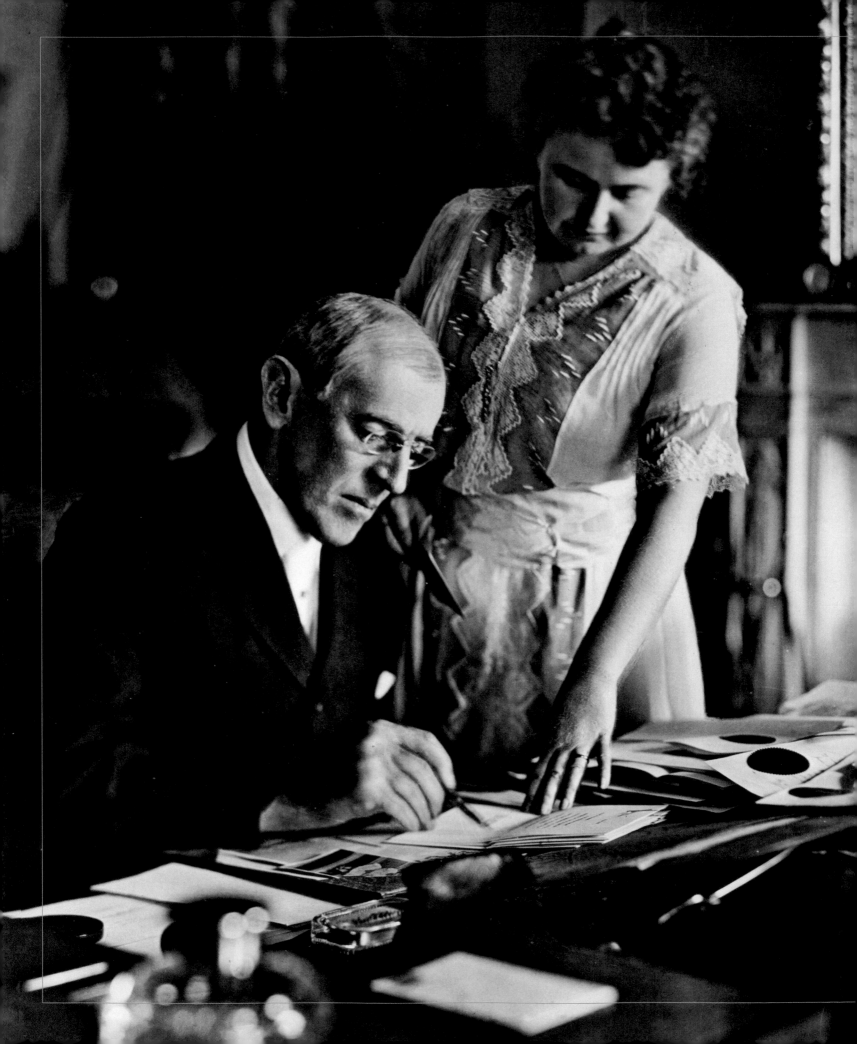

Influencing Policy

FIRST LADIES AS WIVES, MOTHERS, AND POLITICAL PARTNERS have naturally influenced the public policy decisions that their husbands had to make. But in modern times, it has become expected that a first lady sometimes express a public opinion on social norms or national culture and politics, and often appear on television and at public events around the country and the world. Betty Ford described the role of first lady as "much more of a 24-hour job than anyone would guess," and said of her predecessors, "Now that I realize what they've had to put up with, I have new respect and admiration for every one of them."

A number of 19th-century women expanded the public visibility of the first lady. Abigail Adams's political rivals sarcastically referred to her as "Mrs. President," implying that she was pulling the strings of her puppet husband. The venom of the remarks established Abigail Adams's credentials as an able political partner. Sarah Polk, the wife of James K. Polk, was probably much like Abigail Adams in being her husband's political partner. She was a new type of political wife, involved with every aspect of her husband's daily life, acting as confidante, political adviser, and social secretary. Her influence and involvement in political decisions set her apart from previous presidential wives. A devout Presbyterian, Sarah Polk kept entertaining at the White House sedate and respectable and would not allow cards, dancing, or billiards. Mary Todd Lincoln fulfilled her social ambitions when she became first lady, but found trouble by attempting to secure government jobs for her friends' husbands and brothers.

The Modern Era

Jacqueline Kennedy—a first lady with elegance, a sense of history, and a disposition to expand accepted constraints of taste and style—ushered in a modern era.

Her much publicized interest in historic preservation and the arts was showcased in her famous 1962 televised tour of the White House, and turned national attention to history and culture. Her interiors program at the White House and development of a conservation program for the fine and decorative arts collections made the residence a museum as well as the president's home and office.

Moving to the White House after John F. Kennedy's assassination, Claudia "Lady Bird" Johnson did her best to ease the painful transition. Lady Bird Johnson created a First Lady's Committee for a More Beautiful Capital, and then expanded her program nationally. She took an active part in her husband's War on Poverty, especially the Head Start program for preschool children, and became a tireless environmental advocate, working with conservationists, businesses, government officials, and private citizens to restrict billboards and automobile junkyards, encourage flower and tree planting, and promote highways lined with wildflowers.

Thelma Catherine "Pat" Ryan Nixon wanted to perform important, valuable work as first lady, both domestically and by representing U.S. interests abroad, and became the most traveled presidential spouse up to that time, visiting 32 nations, several more than once. In January 1972, she became the first wife of a sitting president to serve as an official U.S. representative to a foreign nation. She visited numerous schools, hospitals, and homes for the aged in the United States and throughout the world. She

spearheaded a renovation of the White House, hiring former deputy State Department protocol officer Clement Conger as White House curator in 1970, and directing the acquisition of heirlooms, antique furniture, and period pieces for the mansion. She also initiated White House garden tours and candlelight visits to the mansion during the holiday season.

Although Betty Ford was thrust into the role of first lady by the resignation of President Nixon, she won the press and the American people over with humor and honesty. Betty Ford spoke frankly about controversial topics, including her support of the Equal Rights Amendment, the legal status of abortion, and premarital sex. She underwent radical surgery for breast cancer in 1974, and she reassured many women by discussing her ordeal openly, and probably saved many lives with her insistence that women have mammograms.

Rosalynn Carter attended cabinet meetings and briefings, led a delegation to Thailand to address problems related to helping refugees from Laos and Cambodia, and represented the president on a trip to seven Caribbean and Latin American nations in May 1977. As first lady, she served as the honorary chairperson of the President's Commission on Mental Health. She also devoted time to projects and legislation focused on medical assistance to the elderly, childhood immunization, and aid to schoolchildren with learning disabilities.

Nancy Reagan lent her support to the Foster Grandparents Program, subject of her 1982 book, *To Love a Child*. She also fought against drug and alcohol abuse among young people, becoming known for the slogan "Just Say No." In 1985, she held a conference for first ladies of 17 countries to focus international attention on this problem. Nancy Reagan continued the tradition of showcasing young artistic talent in the PBS television series "In Performance at the White House."

Two months after becoming first lady, Barbara Bush established the privately run, volunteer-based Barbara Bush Foundation for Family Literacy, designed to train volunteers and promote family literacy programs for people of all ages. She also supported mentoring programs that matched adult volunteers with young students to help students improve their school academic performance, and volunteer associations delivering medical and social services for the homeless. In the early 1990s, she helped revive the Committee for the Preservation of the White House, which President Lyndon Johnson had established to advise on preservation and conservation of the public rooms and the collection of fine and decorative arts and acquisition of artworks for the permanent White House collection.

Public Service and Private Life

Hillary Rodham Clinton, a lawyer, continued to balance public service and private life. Chairing the President's Task Force on National Health Care Reform, she convened hearings around the nation, testified before Congress, and helped craft legislation. She led the fight to obtain health care for millions of children through the Children's Health Insurance Program and supported the National Institutes of Health efforts to seek cures for victims of cancer, osteoporosis, and juvenile diabetes. She also traveled to many countries as a representative of the United States and a champion of

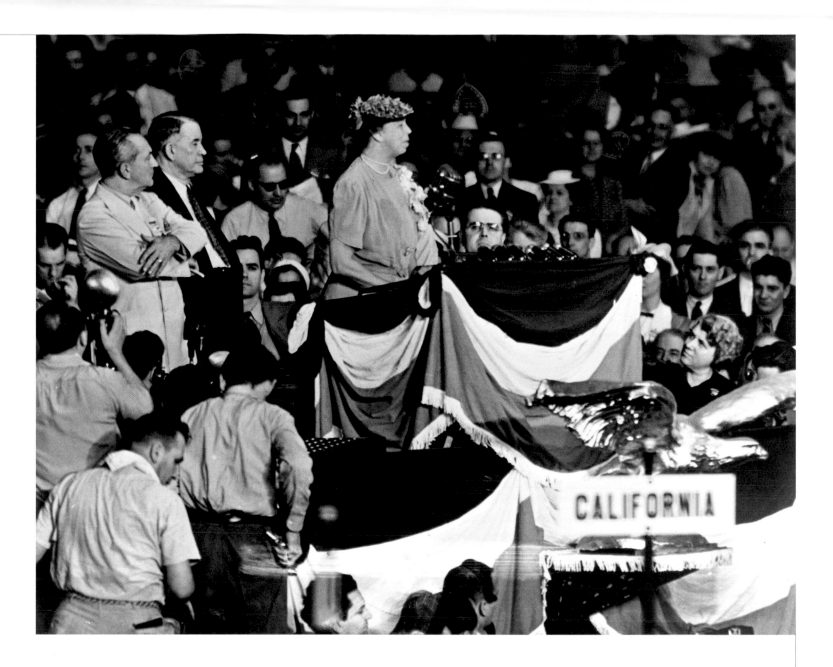

Eleanor Roosevelt addresses the Democratic National Convention (above) in Chicago, July 18, 1940. Abigail Adams (opposite) was an active partner in politics and policy to her husband, John Adams.

human rights, democracy, and civil society. The respect she earned for these efforts led New York State—after she left the White House—to elect her senator, and then President Obama to appoint her secretary of state.

When George W. Bush ran for president, Laura Bush hit the campaign trail with him—a bit reluctantly at first. "When George asked me to marry him, he promised me I'd never have to give a speech. So much for political promises," she quipped. Laura Bush, a librarian, spent eight busy years as first lady championing education and health initiatives. Her passion for the cause of advancing education and global literacy was evidenced by her staunch support of the "Ready to Read, Ready to Learn" initiative, partnering with the Library of Congress to launch the annual National Book Festival, and becoming an honorary ambassador for the United Nations Literacy Decade in 2003. After the attacks of September 11, 2001, Laura Bush became an ardent supporter of Afghan women speaking out against the oppression by the Taliban.

As first lady, Michelle Obama has worked on issues including supporting military families, encouraging national service, and her most visible campaign is "Let's Move." ⋆

The Social Secretary and the Office of the First Lady

WHETHER ATTENDING TO THE INTRICACIES OF PROTOCOL or to routine office work, the White House social secretary must possess unfailing tact in communicating with people—especially because responding so often means finding a diplomatic way to say no. Coolidge social secretary Mary Randolph once described the qualities needed for the position: "The White House secretary should combine keen perceptions and sensibilities with the strength of Hercules, the hide of a rhinoceros, great endurance, and a sense of humor." The social secretary works for both president and first lady and today holds the title special assistant to the president.

Opposite: The first male social secretary, Jeremy Bernard, discusses plans in 2012 with Michelle Obama in Hawaii. Above: Letitia Baldrige, social secretary from 1961 to 1963, and an etiquette expert, talks on the phone as she makes arrangements during the Kennedy administration.

For more than a century, White House social secretaries have been individuals with a tenacity of purpose, loyalty to the president and first lady, and a profound knowledge of protocol and society in Washington. The position of White House social secretary traces back to the engagement of Isabella Hagner as a salaried executive clerk employed by First Lady Edith Roosevelt in 1901. Before then, male clerks in the president's office assumed the duties of correspondence, invitation lists, seating charts, floral decorations, and menus, usually under the direction of a presidential aide. At the end of the 19th century, Colonel Theodore Bingham, an aide and the Army Corps of Engineers officer in charge of public buildings and grounds, had become the major player in running the White House and keeping the social lists. In 1903, newspapers declared a "social war" had broken out at the White House, and, with Edith Roosevelt's strong backing, Hagner "went after Bingham with a meat ax" and "he got his walking papers."

The newspapers in the early 20th century often portrayed Belle Hagner as "arbiter of White House social affairs" or the "real social ruler at the White House." In reality, the changes to the social functions at the White House were a part of a larger reorganization of the house. President Theodore Roosevelt established the position of chief usher, with an organizational chart for the 57 people working in and around the White House, and assigned a military aide to assist the president and first lady for more complex tasks.

The Roosevelts set precedents for glamour and spectacle in state entertainment. Teas, musicales, and garden parties became a regular part of the White House social scene. Belle Hagner created the guest lists, sometimes for as many as 600 people, but Edith Roosevelt had the final say and set the city's social pace. With time, first ladies expanded the number of staff working on social events. First Lady Grace Coolidge retained Laura Harlan, social secretary in the Harding administration, and added Mary Randolph to her staff to work on event planning. First Lady Eleanor Roosevelt handled the vast social side of the Franklin D. Roosevelt White House with the assistance of her personal secretary, Malvina "Tommy" Thompson, and Edith Benham Helm. Eleanor Roosevelt wrote a foreword to Edith Benham Helm's *The Captains and the Kings* (1954) noting, "I am sure I was at times a trial until Mrs. Helm came to know me better, for her social conscience where dinners and official functions were concerned was far more pronounced than mine."

Helm was social secretary under the Wilsons, Roosevelts, and Trumans. She had made trips to peace conferences in Europe with Woodrow Wilson after World War I, and had been a part of both gala peacetime entertaining and the austere times of war. She married Rear Admiral James Helm and left public service in 1920, but returned to the White House after his death to "help out" Eleanor Roosevelt.

Before the dinner commemorating the 200th anniversary of the occupancy of the White House in 2000, Clinton administration social secretary Capricia Marshall briefs the Bushes (left), Fords, Carters, and Clintons on arrangements for the event.

Bess Truman asked Helm to stay on the staff after President Roosevelt's death and considered her the "indispensable woman." After President Truman assumed office in 1945, the first lady decided that she would not hold press conferences, reverting to the custom of presidential wives before Eleanor Roosevelt. The women's section of the male-dominated White House press corps complained that they would lose access to news because their beat included the activities of the first lady. Bess Truman resolved the issue by delegating responsibility of attending press conferences to the social secretary and her assistant.

Helm recalled: "Now, holding press conferences for the wife of the president is no light responsibility, though it must be made plain, of course, that our meetings with the press were minor events compared with the give-and-take of Mrs. Roosevelt's press conferences . . . So the first time we met the press . . . Miss [Reathel] Odum and I felt and looked like condemned criminals. Frankly, we were terrified. One of the newspaper women, Doris Fleeson, summed up the way we looked, as I recall, with these words: 'While they showed no trace of personal resentment against anybody, their attitude toward this part of their duties clearly was that there must be an easier way to make a living.'"

For years, first ladies have had a social secretary and clerks on the government payroll, but the positions were not recognized as part of the institutionalized presidency until the Eisenhower administration. Social secretary Mary Jane McCaffree was listed in the Congressional Directory's top White House personnel as "Acting Secretary to the President's Wife." Today, the social secretary also holds a position as a special assistant to the president. It has become a tradition for the current secretary to host a welcoming luncheon attended by all the former secretaries to get acquainted, exchange ideas, answer questions, and give advice. The chief usher and his staff also provide an invaluable support system and knowledge gained by years of experience.

WHITE HOUSE LIVES ★

ISABELLA HAGNER, FIRST SOCIAL SECRETARY

Born in 1876 in Washington, D.C., Isabella Hagner was the only daughter of a prominent doctor, Charles Evelyn Hagner, and Isabella Davis. In her teens, she became part of a social coterie of elite young Washingtonians. This happy whirl ended abruptly when her parents died in 1892. At 16, she found herself responsible for supporting her three younger brothers, so she took on secretarial work for wealthy families. Sending out invitations for large weddings was the most lucrative work. The newspapers in the early 20th century detailed her continued ascent as a social secretary for various well-connected ladies, including Anna Roosevelt Cowles, Theodore Roosevelt's sister. Undoubtedly, at Cowles's suggestion, Edith Roosevelt first employed Hagner to manage Alice Roosevelt's coming-out party and then brought her to the White House as social secretary in 1901. Hagner served as social secretary through Roosevelt's terms and was the first Wilson administration appointee. She resigned when she married in 1915.

Isabella "Belle" Hagner became the first salaried White House social secretary in 1901.

Linda Faulkner, social secretary to the White House from 1985 to 1988, briefs aides in the Family Dining Room, July 1987.

Event Planning

The social secretary works with the first lady in the overall planning, arrangement, coordination, and direction of all official and personal social events given by the president and his family. This includes the form and wording of invitations, the compiling of guest lists, the setting of menus, the seating, the choice of decorations, and the selection of entertainment. Letitia Baldrige, social secretary in the Kennedy administration, who went on to be called the "Doyenne of Decorum" by the press in her later career as a protocol expert and consultant, noted in an interview: "The solid, lasting values that shape one's life are a gift of experience, the result of a very precious process of continuous selection . . . To be a part of a precious moment of history is perhaps one of the greatest privileges in life."

One of the greatest responsibilities of the social secretary is helping the president and first lady plan State Dinners. After being notified of an official state visit by the president's national security adviser, the social secretary issues a memorandum to senior White House staff asking for ideas for the State Dinner guest list. These are added to the official party, a list of the visiting head of state's entourage provided by the State Department. The president's and first lady's suggestions are included, as well as those of congressional and military leaders. After assembling these names, the social secretary suggests additions to diversify the list, including cultural and academic figures, athletes, entertainers, and other people of interest.

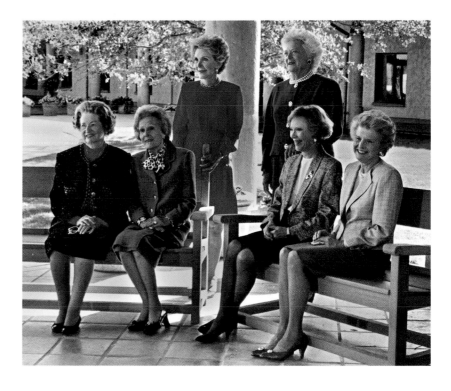

First ladies attend the opening of the Ronald Reagan Library, November 1991. (Seated left to right): Lady Bird Johnson, Pat Nixon, Rosalynn Carter, and Betty Ford. (Standing): Nancy Reagan (left) and Barbara Bush (right).

The pressure of the job can be great, but it also brings great satisfaction. Bess Abell, social secretary in the Lyndon Johnson administration, 1963 to 1969, kept a positive approach, "It's the best job in the White House, next to being first lady." The White House has its own power as a place. Maria Downs, social secretary in the Ford administration, 1974 to 1977, explained, "[The White House] affects you. Every morning as I walked through the East Wing gates to my office I had a very special feeling—a 'wondrous strange feeling.' Over the years many guests have mentioned that feeling to me—the transformation that happens when they come to the White House."

Care Package

Changes in technology over the past century have greatly affected the responsibilities of the social secretary. In the early 20th century, the social secretary was responsible for answering handwritten correspondence and telephone calls. Since the advent of the Internet, cell phones, and digital communication, the social secretary's job has become less encumbered with details, and instead tied to the 24/7 news cycle and the increased prominence and scrutiny of the White House and the first family. The pace can be hectic, as attested to by Ann Stock, social secretary in the Clinton administration, 1993 to 1997. "I always send a care package to the new social secretary. It's got vitamins, it's got aspirin, it's got nylons, it's got a comb, it's got hairspray, it's got all the things you need to exist."

The East Wing office of the first lady has evolved over time, from a single social secretary to more than two dozen professional staff members. It is an office unlike any other in the executive branch, because the first lady is viewed as a public official, but she is not elected or appointed, has no constitutional or statutory authority, and receives no salary. However, her role as partner to the president is essential to the presidency, and requires support staff including a social secretary, director of communications, chief of staff, legal counsel, and many others to help with her duties, both as hostess of the White House and participant in numerous public and ceremonial events. State Dinners, the Easter Egg Roll, Christmas season decorations, and tours are just a few of the myriad of events organized under the first lady's direction. ★

The WORKING WHITE HOUSE

*The DOMESTIC STAFF ★ MIRROR on AMERICA ★ KINSHIP
and COMMUNITY ★ LEARNING the ROPES ★ FIRST FAMILIES
and WHITE HOUSE RESIDENCE STAFF ★*

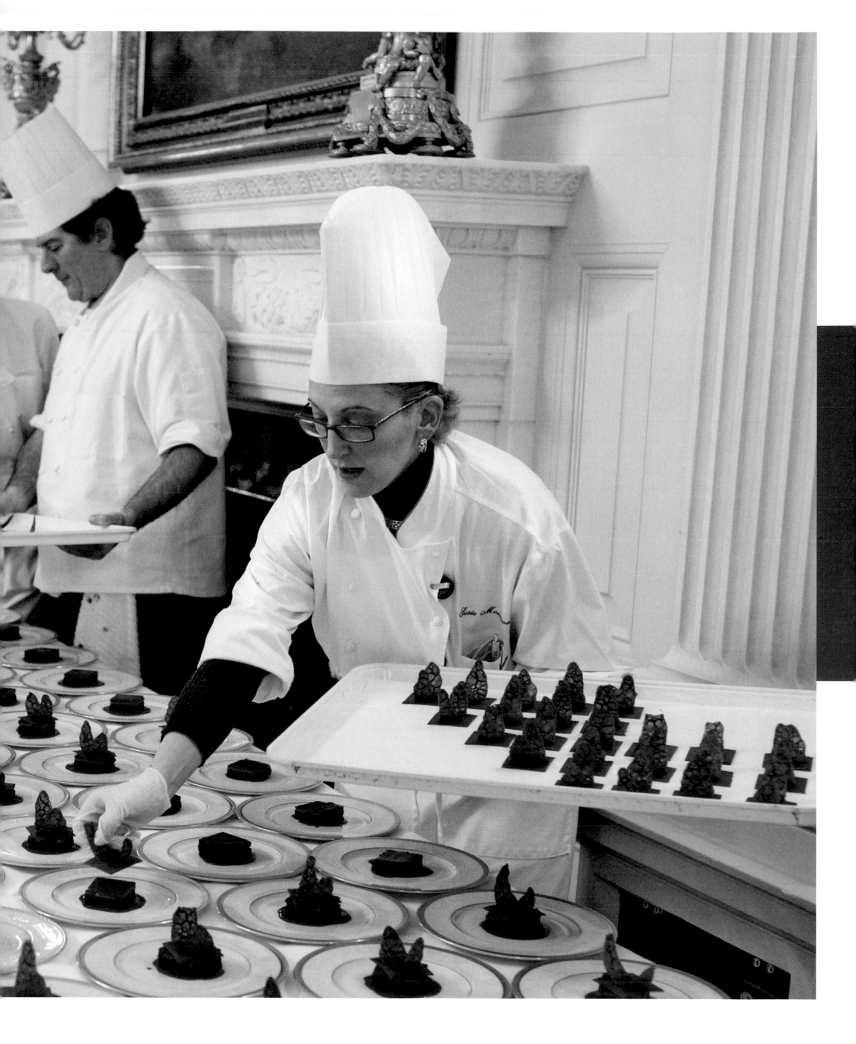

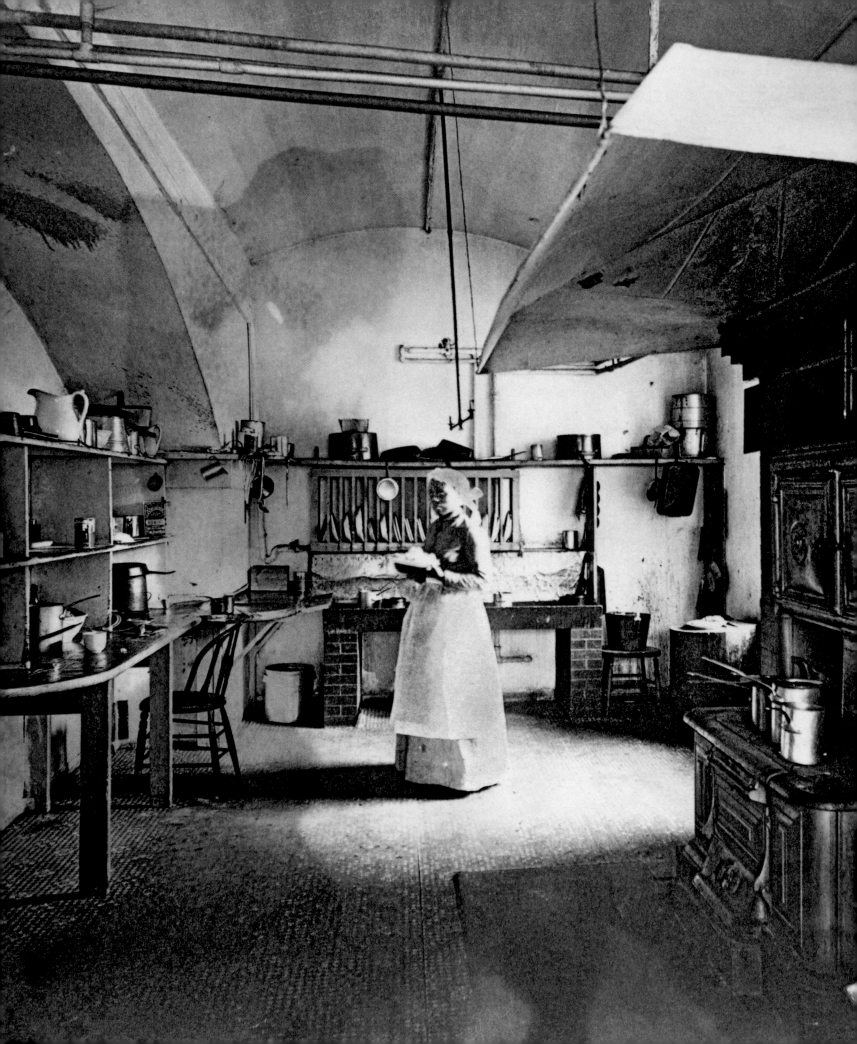

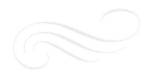

A SMALL ARMY OF DOMESTIC STAFF KEEPS the White House running smoothly. These employees greet visitors, carry trays, open doors, make beds, wash clothes, paint interiors, fix leaking pipes, and prepare meals and more—all with utter dedication. Each has a particular job description, but each can do just about anything. Mail messenger and butler Norwood Williams, who served from the Truman administration to the Clinton administration, observed of a State Dinner, "Everyone works like a team. You have a crew that comes in and moves furniture and sets up tables; you have the cleaning staff, the storeroom person, the chefs, the flower shop; even the carpenter's shop—they had to make some of those tables. You know how everyone pitches in at a circus? That's the way it's done!"

Servants in the early President's House considered themselves as working for the family, not the public. The early presidents paid their household staff out of their own pockets. Abigail Adams joined her husband, John, in the President's House on November 16, 1800. The Adamses, being the first family to live in the White House and to anticipate the needs of such an unusual house, brought manager John Briesler, John's wife, Esther, two young Irish maids, and several young men from Massachusetts. Even so, the public considered the White House staff skimpy—and they were right. At the time, the unfinished East Room had unplastered brick walls, and in this space, Abigail Adams strung her wash up to dry. Where a private citizen might stretch a clothesline outside, it was considered indelicate for the public to see the president's private laundry. The family lived in about six rooms because the other spaces were still unfinished. It was a rough beginning to a house that in time was to symbolize the American presidency.

Preceding pages: Assistant pastry chef Susie Morrison directs the placement of desserts on plates on a table in the State Dining Room on March 4, 2009. Opposite: Kentucky-born cook Dolly Johnson photographed in the small family kitchen circa 1893. Johnson came to the White House in 1889, with the Benjamin Harrison family, and stayed through four presidential administrations.

The Domestic Staff

ABIGAIL ADAMS SPECULATED IN A LETTER TO HER DAUGHTER that it would take "about thirty servants to attend and keep the apartments in proper order, and perform the ordinary business of the house and stables." Today, nearly a hundred people maintain the president's home, all with a dedication and expertise that goes beyond the staff of any other big house. They aren't just serving the exceptional requirements of a busy family and a large home; members of this residence staff are working for one of the world's most influential families, one that lives in what past residents have described as a "fishbowl."

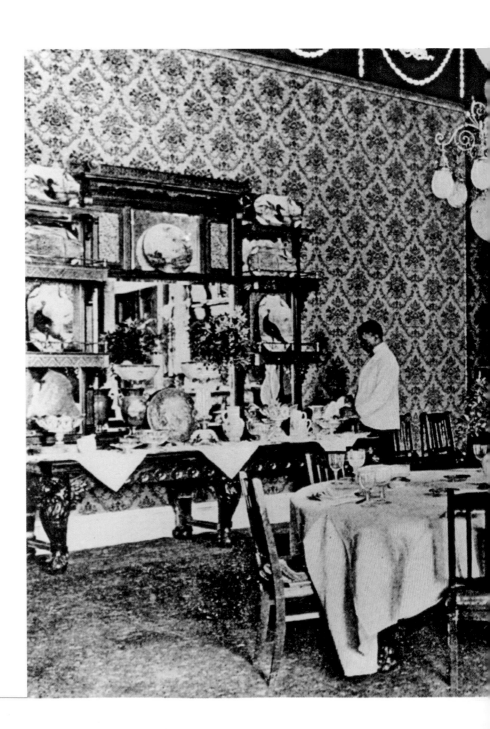

When John Adams moved in, the President's House was a barnlike assemblage of unfinished rooms with freshly plastered walls, vast wooden floors, and rattling windows. The yard around the President's House was a hardscrabble landscape of construction debris and abandoned workmen's shacks. Abigail Adams had responsibilities of her own back home in Quincy, Massachusetts, so she was a late arrival in Washington. However, upon the president's invitation to join him ("The building is in a state to be habitable, and we now wish for your company"), she traveled from Quincy to Washington, a two-week journey by coach, made more difficult by rutted roads and confusing directions. At the White House, she engaged in what she called the "splendid misery" of being the second first lady, and the first one to live in Washington. (George and Martha Washington had lived in Philadelphia while the White House was being built.) Eager to see the city under way, Washington especially pushed the work on the Executive Mansion, for it seemed far more likely than the other public buildings to make the deadline of November 1, 1800, required by the 1790 Residence Act for removal of the seat of government from the temporary capital in Philadelphia to Washington, D.C.

Adams's stay in the White House was very brief—only a little over three months. Voters

Residence staff set the table in the Family Dining Room as it appeared with Colonial Revival decor in about 1900. White House families took their private meals in this room adjacent to the larger State Dining Room.

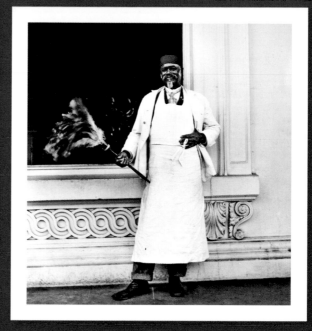

"KNIGHT OF THE FEATHERDUSTER"

Jeremiah "Jerry" Smith started working at the White House as a footman during the Ulysses S. Grant administration in the late 1860s, and served as footman, butler, cook, doorman, and "official duster" until his retirement approximately 35 years later. He often stood at the North Entrance with his signature featherduster. Newspapermen dubbed him the "Knight of the Featherduster," as reflected in his formal pose in the photograph above.

A popular character, reporters could always count on Smith for a story on a slow news day. Some famous White House ghost legends may have originated with him in the late 1880s. Smith claimed to have seen the ghosts of Lincoln, Grant, and McKinley, who tried to speak to him but could produce only a buzzing sound.

When McKinley was mortally wounded while standing in a receiving line at an exposition in Buffalo, it was Jerry Smith who shouted the news down a White House stairwell: "The President is shot!" Shortly before Smith died of throat cancer in 1904, he was visited at his home by President Theodore Roosevelt.

Jerry Smith, at the North Entrance in about 1889.

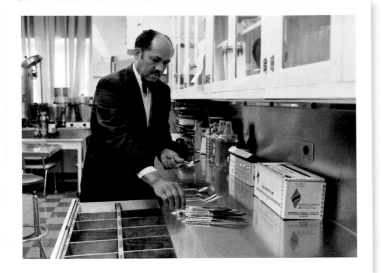

put Thomas Jefferson in office in 1801, after Adams had completed one term. Jefferson, considered a wealthy man, brought his own servants from Monticello. The White House was still unfinished, and Jefferson enlarged domestic work areas by building terraces, low wings to the east and west, and improved the grounds around it.

James Madison, who followed Jefferson, was renowned for his wife Dolley Payne Madison's well-attended weekly "drawing rooms" or receptions, which quickly grew to several hundred guests. Local people came to supplement the domestic servants brought from the Madisons' Virginia home, Montpelier. After Madison, the scale and frequency of entertaining gradually increased administration by administration, and required additional household staff. By 1845, President James K. Polk determined to completely reorganize the household under a manager. To economize, Sarah Polk replaced salaried white servants and free blacks with enslaved people. Hoping to avoid embarrassing scenes, President James Buchanan, seeing sectional conflicts over slavery in the 1850s boil over into White House events, specified that domestic employees were to be British, and removed all African American staff from the White House. Buchanan, who had been a diplomat in England, knew that people trained to domestic service in Great Britain would be discreet, securing his privacy and peace of mind. The 1860 census listed ten servants living in the Buchanan White House. Except for the Belgian butler, Pierre Vermereu, all of the staff

were born in England, Ireland, and Wales. President Abraham Lincoln inherited these employees. Some left to go home; some joined the Union Army; others remained. Little documentation has been found of the Lincoln domestic staff, but Laurance Mangan, the brother of the White House coachman who on occasion substituted for him, found the president "Quiet and gentle in every respect; he was always thoughtful of those who served him."

Managers of the House

The White House is a large and complex place, so domestic operations have required a general manager. These managers held a powerful and delicate position that called for the ability to communicate with the presidents and politicians, as well as with the servants they supervised. In the 1850s, these managers began to be called "stewards." Later, they became known as "chief ushers." The title was borrowed from great houses abroad where an individual had the job of "ushering" people in to meet the head of the house.

It was common for early presidents to bring house managers to Washington. Jefferson's French steward Etienne Lemaire had duties that a chief usher today would not have to consider. For example, Lemaire saw that the animals bought at market were driven to the White House to be slaughtered in pens and then the meat smoked or salted so it would not spoil. Cheese had to be inspected for mold, spices had to be kept dry, and wine that arrived in bulk had to be bottled and racked.

In 1866, Congress created the federal post of Steward of the White House and appropriated funds for it. William Slade, Lincoln's African American messenger and valet, became the first man to hold the official post and also worked under President Andrew Johnson. Slade and those who followed him were required to post a bond, as Congress created the position to safeguard the silver, plates, and furnishings in the house. Slade was responsible not only for the

Eugene Allen (above) cleans silverware in the pantry. Opposite: Chefs Kevin Saiyasak and Jeremy Kapper harvest winter greens from the Kitchen Garden, March 13, 2012.

president's home and its servants, but also for the president's personal funds as they related to the chief executive's household. Presidents then and now must purchase their own food and supplies for personal use when not hosting a public reception or State Dinner. Slade's wise judgment is reflected in one of his extra responsibilities, the president's wardrobe. Johnson had been a tailor prior to public life and had an eye for fashion, style, and quality. He trusted Slade to dress him properly. Slade was still working at the White House when he died in March 1868 at age 53.

President Ulysses S. Grant, an ex-army general, replaced Johnson's last steward, James L. Thomas, with a quartermaster who the president knew would understand his preference for economy and plain food. The quartermaster would soon in turn be replaced by a Sicilian immigrant restaurateur, Valentino Melah. Melah, who was celebrated as "the silver-voiced Italian" by a newspaper correspondent, notably improved the food and ably managed elaborate State Dinners.

As the administration of the household became more unwieldy, President Benjamin Harrison appointed Edson S. Dinsmore to the post of "chief doorkeeper" in 1889, to manage the house and the growing domestic workforce. Executive management responsibilities eventually were ceded formally to the chief usher in 1903, with a staff reorganization during

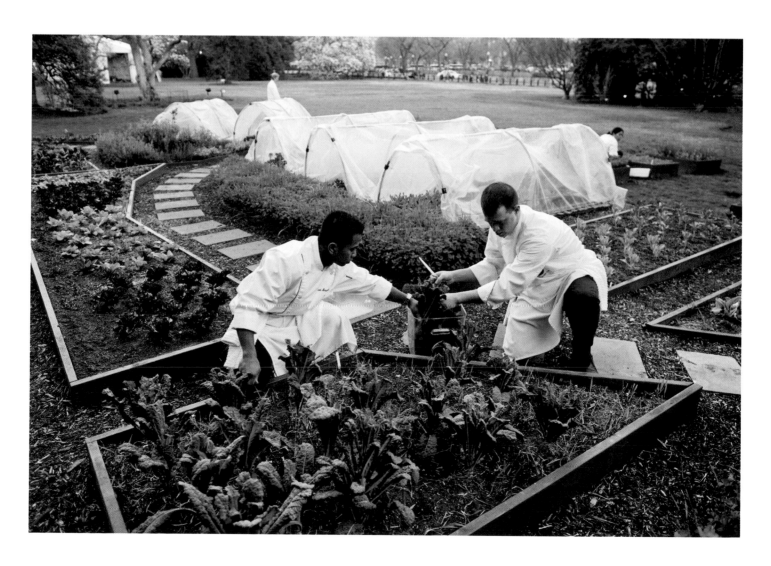

the Theodore Roosevelt administration. White House electrician Irwin "Ike" Hoover, who maintained the house's first electric lighting system installed in 1891, became an assistant usher in 1904, under Thomas Stone. Hoover rose to the position of chief usher in 1913, and served in that job until his death in 1933. Chief ushers who approached his longevity were Rex Scouten and Gary Walters. Both came to the White House as members of the Secret Service protective force, then joined the residence staff as assistant ushers, to later be appointed chief usher. Scouten was chief usher from 1969 to 1986, and Walters retired in 2007 after 21 years as the manager of the president's home. In recent years, Rear Admiral Stephen W. Rochon and the current chief usher, Angella Reid, have managed the household.

The Backstairs Hierarchy

By the first decade of the 19th century, a hierarchy of top-ranking men—the chief usher, the butler, the head of the stables, and several others—dined together in a White House pantry. The servants' dining room, which was located on the ground floor, served maids and footmen. Other employees sat at another table in the large

kitchen. The structure of the White House staff remains essentially the same today, with the chief usher at the top, a bonded federal employee who functions as the manager of the house.

An inventory for the year 1826, during the John Quincy Adams administration, suggests the typical furniture used by servants at that time. The cook slept on a cot and had a pine wardrobe and pine table. Other servants' rooms had similar cots and mattresses, blankets, and sheets. Those with the most responsibilities naturally had the best rooms. Until the 1930s, about one-third of the servants lived in the building in the third- and ground-floor rooms. Their permanent homes were elsewhere, so this temporary housing was plain.

The ground floor also contains the kitchen—with a large fireplace at each end, storage bins, and hanging utensils in earliest times. The modern kitchen is not so large, but is fully equipped with useful kitchen technology and gadgets.

In past years, rodents were drawn to the downstairs kitchen and storage bins, and to the living quarters at times. Newcomers to the kitchen were shocked to see rats and mice scampering over the worktables and across the floor to hiding places in the walls. President

Chief ushers Rex Scouten, Gary Walters, and Stephen W. Rochon.

Chief Ushers

The White House is managed by the chief usher, a title that is a holdover from the days when the chief duty was "ushering" people in to meet the president and first lady. The chief usher serves as the general manager of the building, including construction, maintenance, remodeling, food, as well as the administrative, fiscal, and personnel functions. "During all my years of managing the White House . . . my loyalty was not to any one president but rather to the presidency and to the institution that is the White House," wrote chief usher J. B. West (1957–1969). Three chief ushers—Rex Scouten (1969–1986), Gary Walters (1986–2007), and Rear Admiral Stephen W. Rochon (2007–2011)—represent 40 years of service in the White House.

Andrew Johnson's daughter, Martha Patterson, who planned a remodeling of the White House in 1866, tried in vain to get rid of the vermin with poison, traps, and cats, but failed. Two decades later, First Lady Caroline Harrison, accompanied by the Metropolitan Police with guns, set out to ambush the rats in the cellar, and she did well.

Today, none of the domestic staff live in the White House, although some might bunk on cots overnight when official events run late. They are all federal employees who retain their jobs only at the president's pleasure. The turnover is amazingly low.

A Day in the White House

The morning of Friday, April 3, 1807, dawned chilly, and residence staff in the White House of the third president, Thomas Jefferson, wanted the building to be warm. Steward Etienne Lemaire was up early to instruct the footmen to start fires in the several hearths. After that, the same footmen worked at dusting, tidying up the house, and polishing the silver. At least one would

Jean Pierre Sioussat, known as "French John" when Thomas Jefferson appointed him doorkeeper to the White House, was born in Paris in 1781. He was one of several Frenchmen hired by Jefferson, who had lived in Paris as an ambassador. Sioussat advised Dolley Madison on the evacuation of the White House during the War of 1812.

change into uniform and greet visitors at the door. While other servants fed the chickens in the yard, made the beds, readied the table linens, and cleaned the privies, Lemaire and chef Honoré Julien prepared the menu for the four o'clock evening meal: a quarter of bear, a French-style partridge and sausage specialty, a custard dessert, and European wines served with fruits, nuts, and olives. At dinner in the small dining room (today's Green Room), footmen uniformed in blue waited on the president's table, discreetly withdrawing after delivering each course. Lemaire poured after-dinner coffee and tea in the oval drawing room. Communication through the house was by a crank-powered bell system. At times, servants scurried to answer. Today, a convenient house phone system links the 132 rooms of the house.

By 1902, there was no need to start fires to warm the president's home because central heating had long been installed. Dusting and tidying were controlled in part by a central vacuum system. Details of the house management fell under the housekeeper, who answered to the first lady and chief usher. We know a lot about the first housekeeper, Elizabeth Jaffray, a Canadian that President William H. Taft hired in 1909. Every weekday at 8:30 a.m., she emerged from her apartment in the White House, then consulted with First Lady Helen Taft about the day's meals, personnel, and general management issues. At nine, the cook brought menus to Jaffray's office for review. By ten o'clock, the housekeeper was on her way to the city's

market stalls to make bulk purchases of fruits, vegetables, meats, seafood, game, and butter. She tried to be back in time to oversee the daily delivery of flowers from the White House gardens and conservatories, or to inspect broken china and glassware or worn table linen. Under her direction, the head cook and two or three assistants prepared almost all the food, not only for the president's table but also for receptions, State Dinners, and the servants. Kitchen staff washed dishes and flatware by hand, with the aid, after 1920, of a silver-cleaning machine.

Jaffray would be astonished to see today's household staff and modern air conditioners, heaters, refrigerators, ice machines, and great stoves. The stables and the chickens in the yard are gone. She would also be amazed by the tightened security at the White House. Perhaps the most significant change for the White House during the past several decades has been addressing security concerns. This has made the house an increasingly isolated environment, which the president leaves

less frequently. Presidential security is nothing new, but no longer allows for much freedom for the head of state. James Monroe, the fifth president, used to take daily walks between four and six o'clock in the evening, and John Quincy Adams, who followed him in office, swam nude in nearby Tiber Creek, which fed into the Potomac. First Lady Grace Coolidge strolled a few blocks away, accompanied by one guard, to Belle Pretty's beauty salon, after which she walked along inspecting Pennsylvania Avenue's dress shops. The public was granted access to the grounds during prescribed hours beginning in the early 1840s.

7,000 Visitors a Week

Now the president leaves the grounds only with a full security escort. The Secret Service finds it safest to guard the president in the fully secured White House rather than elsewhere. Activities he used to take outside are now held inside. The world comes to him unless absolute necessity takes him away

WHITE HOUSE MEMORIES ★

WASH DAY AT THE WHITE HOUSE

"Every day is wash day at the White House," said Elizabeth Jaffray, former housekeeper. Jaffray, who arrived in 1909, had three maids assigned to do laundry before the days of electrical appliances. The immense amount of daily washing was done manually, and then pressed with flatirons. Before running water was installed in 1833, workers hauled water nearly a half mile for washing, and Abigail Adams hung the laundry to dry in the unfinished East Room. Laundry was hung along the corridor of the ground floor in the 19th century, as propriety would not allow it to be hung outside. By the early 20th century, clotheslines were tucked out of view south of the executive offices. Electric washing machines and dryers became popular in the 1940s, and today modern washers, dryers, and irons make laundry much less labor intensive.

A laundry room in the West Terrace about 1917.

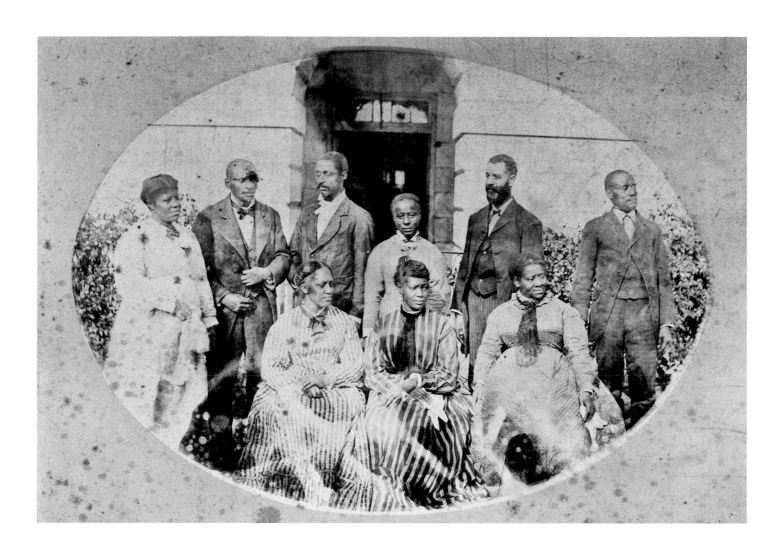

The earliest known photograph of the African American White House residence staff was taken in 1877, during the Rutherford B. Hayes administration. At the time, the domestic staff was predominantly black; this photo does not include the entire staff. Additional staff—both African American and white—included ushers, valets, gardeners, coachmen, stable hands, and messengers.

for a speech or other official business. In commenting on entertaining, former chief usher Gary Walters said that "we transferred from a house where we only occasionally did parties to a major catering facility. Now we are doing three or four events a day sometimes."

Visitors have been welcomed to the White House since the administration of Thomas Jefferson, and now the building hosts approximately 7,000 unofficial visitors each week, mostly on self-guided tours. From Tuesday through Saturday, the White House staff must prepare the public rooms starting at 6 a.m. As Gary Walters explained, they "have to roll up the carpets, put down the mats on the floor, put out the ropes and stanchions, and get ready for tours each day." Visitors follow a path through the rooms of state, but are not allowed into the first family's living quarters or the Oval Office in the West Wing where the president conducts the business of state. ★

Mirror on America: The Changing Workforce

WHITE HOUSE RESIDENCE STAFF HAVE ALWAYS REFLECTED the population of the nation. Native-born and immigrant men and women, enslaved and free, have all helped maintain the president's home. Many southern presidents brought enslaved servants to Washington. Immigrants from Ireland, Germany, Belgium, and elsewhere came into domestic service at the White House. Domestic service was a leading occupation in the days that preceded laborsaving electricity and machines, especially for women. African Americans have long been a major presence on the White House staff.

By 1800, one-quarter of the capital city's population was black. A sizeable number of these people were free, but with the end of the African slave trade in 1808 and the decline of the Tidewater tobacco plantations, free African Americans greatly outnumbered the city's slave population by 1830. Slave sales were still common, and Washington became a center for the domestic slave trade. Coffles—lines of enslaved men and women driven in chained groups—were seen on Washington's principal thoroughfares, and slave pens used by traders were located on the Mall in the shadow of the Capitol Building. In April 1848, one of the largest recorded attempts at escape by enslaved blacks took place when 76 of the District of Columbia's slaves tried to sail down the Potomac River and then north up the Chesapeake Bay on the schooner *Pearl* in hope of reaching New Jersey. Paul Jennings, who had been President James Madison's personal servant in the White House, was one of those who helped plan the flight, which ended after only a few days when the escapees were found stranded on a sandbar at Cornfield Harbor at the southern tip of Maryland. Largely because of the *Pearl* incident and a subsequent pro-slavery riot in Washington, D.C., the slave trade in the capital was outlawed by the Compromise of 1850.

On the eve of the Civil War, the 1860 census counted 11,131 free blacks and 3,185 enslaved people in Washington, D.C. For blacks in the city, formal education was easier to acquire (black-established schools dated to 1807), property ownership was possible, and some government jobs (usually messengers and doorkeepers) were open. However, before 1862, late-night curfews required blacks to be jailed unless they carried a certificate of freedom, and blacks were not permitted to get licenses to run restaurants or to operate any business certified by the District of Columbia government except driving hired carriages. Article I, section 8, of the Constitution gave Congress authority to "exercise exclusive legislation" over the District of Columbia. The District of Columbia Emancipation Act was signed by President Lincoln on April 16, 1862, nine months prior to the Emancipation Proclamation. The act freed the 2,989 enslaved persons remaining in Washington. April 16 is now a legal holiday in the District of Columbia.

Between 1890 and 1940, several waves of African American migrations from the South brought rural blacks to Washington, and some of the new residents found jobs in the White House. Domestic staff, while carrying out their daily responsibilities, interacted with

Butler James Ramsey (opposite) with a tray and glasses. Ramsey worked at the White House more than 25 years before retiring in 2010. In the early 20th century, residents summoned butlers or maids by an appropriate button on an electric call box (above).

the first family as well as with presidential friends, relatives, and associates. They served queens and prime ministers, actors, journalists, and playwrights. The household staff not only became familiar with these individuals as human beings but also, while caring for the house and its occupants, they saw history in the making.

Enslaved Servants at the White House

Documentary evidence is difficult to interpret on enslaved people working in the White House. It is likely that some were hired from their owners, a common practice in Washington, D.C., before emancipation. Many of the White House employees who were black were free. What is assured is that slavery played its part in the early White House. The first president, George Washington, had some 30 enslaved servants along with freemen and immigrants at the president's residence in Philadelphia. In doing so, he set a precedent for the southern presidents who followed him. Seven of them—Jefferson, Madison, Monroe, Jackson, Tyler, Polk, and Taylor—brought enslaved people from their southern plantations to augment paid domestics. New Englander John Adams, the second president, did not

believe that a "free" nation should allow slavery. Andrew Jackson was a slaveholder who brought a large household of enslaved domestics with him from the Hermitage, his Tennessee plantation, to the President's House. Many of them lived in the servants' quarters on the ground floor, but Jackson, a widower and in chronically poor health, had a male servant sleep in his room to attend him. In his zeal to economize, Taylor brought 15 enslaved house servants, including children and his body servant who had accompanied him during the Mexican War, from Louisiana to join a small professional residence staff of largely European immigrants. By his term, in 1849–50, northerners in Washington were not comfortable with the presence of enslaved servants in public view at White House events. Taylor's enslaved servants generally remained in the family quarters, where northern congressmen and increasingly vocal abolitionists did not see them. General Ulysses S. Grant was the last president who actually owned an enslaved person—and that was before he was president.

Jefferson, impressed by what he experienced during his years as a minister to France between 1784 and 1789, employed trained Frenchmen to manage his

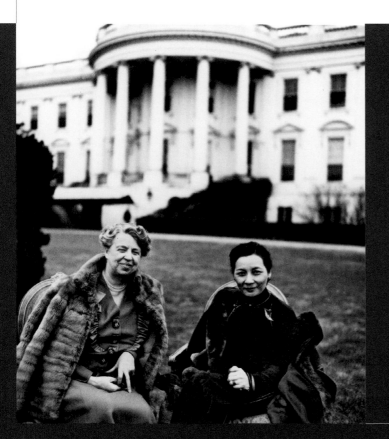

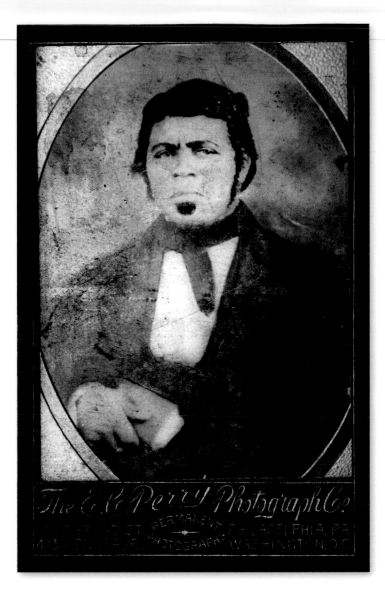

While I was a servant to Mr. Webster, he often sent me to her [Dolley Madison] with a market-basket full of provisions, and . . . occasionally [I] gave her small sums from my own pocket.

PAUL JENNINGS describes helping an elderly Dolley Madison, *A Colored Man's Reminiscences of James Madison*, 1865

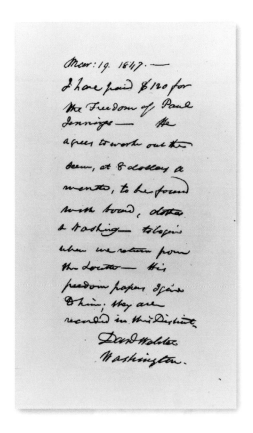

Paul Jennings (above), who bought his freedom through Daniel Webster, was an enslaved man owned by the Madisons at the White House. As a free man, he supported the attempt by 76 slaves to escape on the *Pearl*. Jennings's work agreement (right).

domestic staff, which consisted of enslaved house workers from his home, Monticello. During his administration, Etienne Lemaire was his "steward," Honoré Julien was chef, and Jean Pierre Sioussat was the "doorkeeper," or concierge (the title that later became "usher"). The rest of the staff were enslaved men and women from Monticello; some brought their children.

John Quincy Adams brought to the White House the Belgian Antoine Michel Giusta, a deserter from Napoleon's army who he had encountered in Brussels in 1814, to continue as his valet. Grant briefly employed Sicilian Valentino Melah as White House chef and steward. General Zachary Taylor, the 12th president, hired a 30-year-old immigrant from Germany, Ignatius Ruppert, and Ruppert hired three housemaids, two from Ireland and one from Sweden. Among those working as laborers and gardeners on the White House grounds in August 1888, during the term of Grover Cleveland, were employees born in France, Germany, Ireland, Scotland, and Switzerland, as well as Maryland, Pennsylvania, Virginia, and Washington, D.C.

RESIDENCE STAFF PORTRAITS

These portraits of domestic staff members taken during the George W. Bush administration (2001–2009) depict just a sampling of the many responsibilities in the modern White House. Nancy Clarke (opposite) was a floral designer; Cletus Clark (above left) was painter foreman; housekeeper Anita Castelo (middle) is shown in the laundry; Richard Carter (above right) was White House engineer; Irvin Williams (below) was superintendent of the grounds.

RESIDENCE STAFF MEMOIRS

The published memoirs of White House staff of the 19th and 20th centuries offer capsules of the daily tasks, errands, schedules, and chores that have kept the White House running. One of the best known memoirs was Lillian Rogers Parks's *My Thirty Years Backstairs at the White House* (1961), which became the 1979 television miniseries, *Backstairs at the White House*. The miniseries captured a sweep of history largely from the perspective of Maggie Rogers and Lillian Parks Rogers, but it also used chief usher Ike Hoover's *Forty-Two Years in the White House* (1934).

This followed a rich tradition of White House residence staff memoirs dating to the mid-19th century, including *A Colored Man's Reminiscences of James Madison* (1865), the recollections of Madison's enslaved manservant by Paul Jennings; Mary Todd Lincoln's seamstress Elizabeth Keckley's *Behind the Scenes* (1868); doorkeeper Thomas Pendel's *Thirty-Six Years in the White House* (1902); and disbursing agent Colonel William H. Crook's *Memories of the White House* (1911).

In the latter half of the 20th century, Alonzo Fields's *My 21 Years in the White House* (1960), chief usher J. B. West's *Upstairs at the White House* (1974), and doorman and butler Preston Bruce's *From the Door of the White House* (1980) add to the narrative. The memoirs document the authors' dedication and powerful belief in belonging to the nation—citizens serving and sustaining an American institution.

Lillian Rogers Parks's memoir, *My Thirty Years Backstairs at the White House* (1961).

President Taft, who had served as governor-general of the Philippines for three years, brought Filipinos to add to the largely African American staff when he became president in 1909, including his valet, Monico Lopez Lara, who shaved the president daily.

Racial segregation first appeared at the White House in 1909. Elizabeth Jaffray, Taft's autocratic housekeeper, ended any social mingling of black and white workers, including the tradition of the staff eating together, to serve the rules of segregation being imposed on government workers in general. All of the servants objected, but Jaffray threatened expulsion for any who disagreed. Segregation continued at the White House for decades. Alonzo Fields, a black man who joined the staff in 1931 and rose in the ranks to maître d' of the White House, found the policy distasteful: "We all worked together, but we couldn't eat together." This policy lasted until the mid-1940s, in the latter days of the administration of Franklin D. Roosevelt, but Jim Crow persisted backstairs at the White House until after the Civil Rights Act of 1964.

Loyalty and Longevity

Over the 20th century and into the 21st, hundreds of people have worked behind the scenes at 1600 Pennsylvania Avenue, serving elaborate State Dinners, tending the grounds, and welcoming visitors to a mansion that has swelled to 132 rooms. Many have spent decades at the White House. For instance, Lillian Rogers Parks was a seamstress and maid from 1929 until 1961. She first came to the White House as a young girl helping her mother, a maid during the Taft administration. She and other longtime workers such as Alonzo Fields (butler, chief butler, maître d', 1931–1953), Preston Bruce (doorman, 1953–1976), John Ficklin (butler and maître d', 1939–1983), and Eugene Allen (chief butler, maître d', 1952–1987) helped define the culture of White House workers.

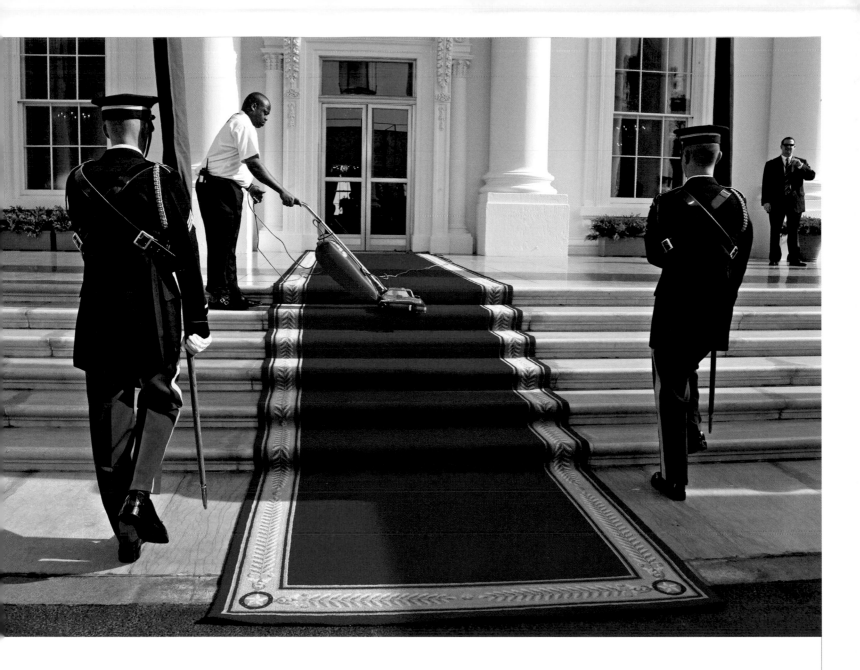

Presidential security precludes a precise description of exactly how many people perform which jobs today. From 1909 to 1927, records show that the kitchen staff included five cooks and detailed the house's organization in that period. According to Elizabeth Jaffray, "The first cook does practically all the cooking for the 'upstairs,' that is, for the president's own table . . . The second cook prepares the vegetables and does the ordinary baking and cooking for the servants." She observed that low pay in the White House was offset by the great honor of serving the first family.

Eleanor Roosevelt, first lady in the Depression years, was charged with reducing White House expenses by 25 percent. She did it by firing the white residence staff members, as she felt they would be more likely to find other employment. Roosevelt tried to strike a balance between her political views and the requirements of the White House budget. She insisted that domestic employees work six days a week and a half day on Sunday, as her domestic staff in New York had done. Pay was low, so Alonzo Fields, who was chief butler at the time, recalled years later that he started a rumor that the Roosevelts' residence staff were organizing a union. Eleanor Roosevelt did sign an agreement that employees would get compensatory time off if they worked more than 40 hours a week. Residence staff today receive wages comparable to those working in similar jobs in other government agencies. ★

Kinship and Community

A SPIRIT OF KINSHIP EXISTS AMONG THOSE WHO WORK in the White House. Daily employment at such a high-profile location requires skill and flexibility, and carries great prestige outside the White House. "To serve tea at the White House to a queen is something most people . . . don't know how exactly it is done," said Eugene Allen, former chief butler and later maître d' for eight presidents. "You have to learn these things. It's something you don't learn in a hotel."

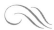

Over the years, hundreds of people have worked behind the scenes at the White House preparing family meals, serving elaborate State Dinners, tending the grounds, and welcoming visitors. Today, a household staff of approximately 95 full-time domestic and maintenance employees—including butlers, maids, engineers, housemen, chefs, electricians, florists, ushers, doormen, carpenters, and plumbers—work together to operate, maintain, and preserve the residence. James Ketchum, a White House curator during the Kennedy administration, observed, "It's just like a small town [but] all under one roof."

Many of these workers have spent decades at the White House. Few outsiders understand the importance of this continuity or the nature of the work, which takes specialized training and experience. Although some staff had been trained in renowned hotels or residences, working at the president's home is different. World leaders and famous people come to visit, and the domestic staff over the years have had to learn unique procedures and traditions.

For example, long-time doorman Preston Bruce often observed that his job title was misleading. During the 19th century, doormen, or doorkeepers, were posted at the entrances to the White House. Bruce noted that he did not simply open the door to visitors. Rather, he oversaw the intricate protocol of greeting, escorting, and seating guests at official White House functions. Another example is an employee who works in the kitchen storage area and takes care of clearing and washing the dishes from the president's table, called a pantryman. Eugene Allen began work as a pantryman in 1952, and advanced to the role of maître d' (short for maître d'hôtel—literally, "master of the hall"), in charge of staffing and managing formal events.

White House staff adapt to each new first family, to balance serving the nation and serving the home's residents to the highest possible standards. The White House workplace is distinctive as both a symbol of the presidency and the residence of an American family. In 19th-century published memoirs or 21st-century oral history interviews, residence staff consistently remark that they represented the nation in their service at the White House. During their careers, they considered themselves citizens serving at a national institution. This strong sense of citizenship, dedication, and status as members of the working community at the White House created a powerful belief in belonging to a residence and a nation—citizens serving and sustaining an American institution.

Employees with different responsibilities, delicate or otherwise, collaborate regularly to prepare for special events or accomplish daily tasks. "We helped each other out and I feel we made very few mistakes," said Henry Haller, White House chef from 1966 to 1987. Perhaps there were very few mistakes, but at least some goofs were inevitable. One time, Haller left

Lillian Rogers Parks holds a picture of her mother, Maggie Rogers, a White House maid who began working at the White House during the Taft administration (1909–1913). Lillian Rogers Parks later became a seamstress and a maid in the president's home from 1929 until 1961, and wrote a book about her experiences.

strings on beans that were served to Lyndon Johnson. He was called out of the kitchen by the president, who had the strings in his hand and told his chef in no uncertain terms to remove the strings from the string beans in the future. Haller went back into the kitchen to the smiles of the other employees. "Join the corps," one of them said. "We have all been bawled out by this president at one time or another." Johnson's tongue-lashing was memorable, but Haller said, "He was the same to me as always the next day."

Traditions

In 1977, a task force chaired by President Jimmy Carter's cousin, White House assistant Hugh Carter, Jr., was appointed to study and propose ideas for reorganization and efficiency throughout the federal government, including the White House. Both the new first family and the task force believed the presidential mansion should be run like a business. And indeed, then and now, if people tried to find inefficiencies in the

president's home, they would find many. There seem to be no official business procedures, only traditions. And yet that does not translate to an idly run household. No one at the White House can count on working nine to five. Employees at all levels are likely to be called from their homes around Washington at any hour of the night to perform services at the White House that might not be part of what some might consider their job descriptions. When the task force completed its work, it discovered that the spirit of the staff was the key to success, and that spirit was high.

That shared spirit, marked by decorum and courtesy, has long been as strong a tradition as any in the White House. Already in the 1830s, a British traveler in the new nation and former member of Parliament, James Silk Buckingham, found the servants "polite and agreeable." He remarked upon how he did not hear an angry word between the servants and the drivers of the carriages, which makes one think that kind of discussion happened in London a great

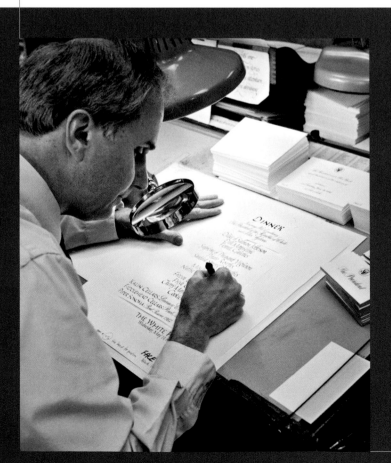

CALLIGRAPHY: HAND-LETTERED ELEGANCE

Almost everything is self-contained at the White House, and that extends to the preparation of invitations, menus, place cards, programs, and other formal social documents that are carefully designed and written by the White House calligrapher's office. The tools of a White House calligrapher include 28 pen holders, eight brushes, and so many nibs (special points for the ends of the pens) that one cannot even begin to count them all. The brushes are used for large lettering; changing the nibs allows for a range of lettering styles. Calligraphers often begin a project by making numerous pencil lines on the paper to center the text from top to bottom. They use tracing paper to practice, but then a steady hand must flow gracefully across the page to produce an impeccable work of calligraphic art. It's painstaking work.

Calligrapher John Scarfone prepares the menu for a 1992 State Dinner; a detail of a Christmas menu (opposite).

deal. Of the White House itself, Buckingham said, "The whole air of the mansion and its accompaniments is that of unostentatious comfort . . . and therefore well adapted to the simplicity and economy which is characteristic of the republican institutions of the country."

Tradition preserves this courtesy through time. During World War II, Alonzo Fields as butler faithfully delivered Winston Churchill sherry early in the day, champagne later, and then 90-year-old French brandy in the prime minister's late-night working hours during his wartime stays at the president's home. "His was a healthy appetite," Fields recalled in his memoir. "On his breakfast tray I was instructed to have something hot, something cold, two kinds of fresh fruit, a tumbler of orange juice and a pot of frightfully weak tea. For 'something hot' he had eggs, bacon or ham, and toast. For 'something cold' he had two kinds of cold meats with English mustard and two kinds of fruit plus a tumbler of sherry. This was breakfast."

Housekeeper Christine Limerick, who worked at the White House from 1979 through 1987, and again from 1991 through 2007, moved on tiptoes as she turned off the lights when the first family was retiring for the night. Though no one ordered her to do it, she knew that they lived constantly surrounded by crowds and did not need further interference by house staff.

White House maid Lillian Rogers Parks described the work of the domestic staff as "backstairs," which refers to residential staff working out of public sight as opposed to the much more visible political and policy staff offices in the East and West Wings. The backstairs staff knew where the food was stored and prepared, did the laundry, tracked where the cleaning supplies were kept, dusted and cleaned, and shut off the lights. They were linked to the rest of the mansion by a winding service stairway seldom seen by anyone other than themselves and the first family.

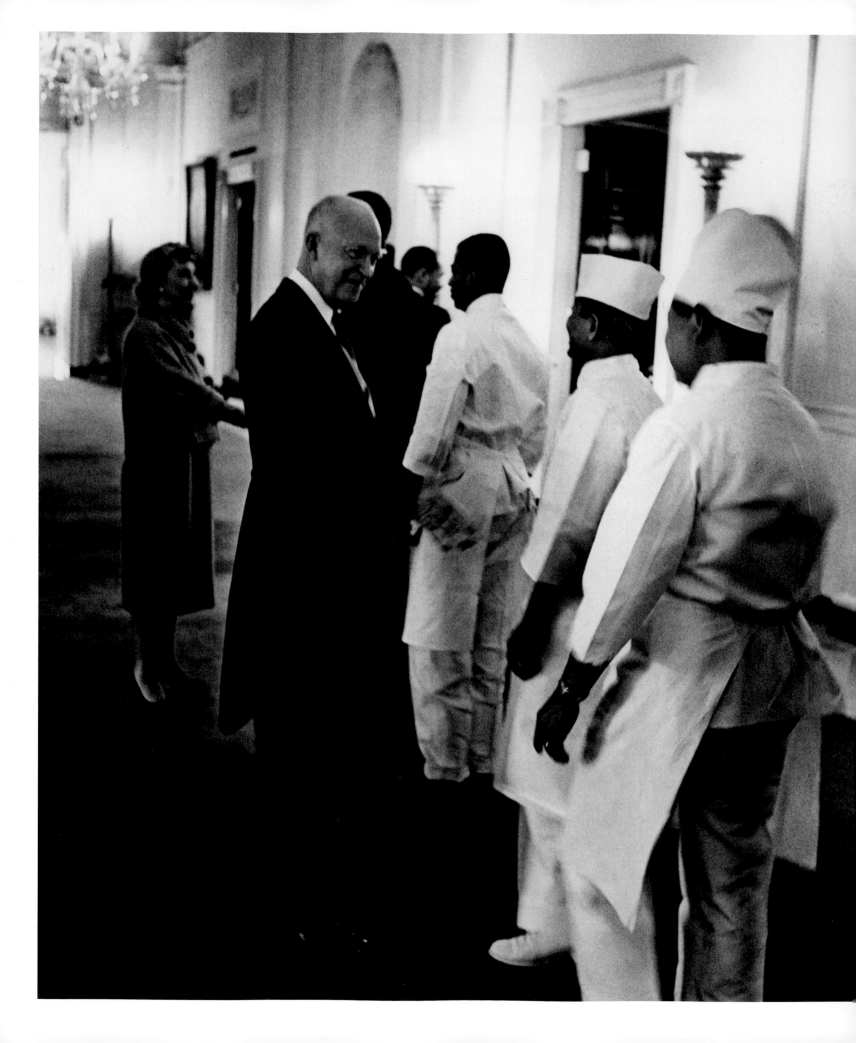

In carrying out their daily responsibilities, White House domestic staff interact regularly with the first family but also friends, relatives, associates of the first family, and even the pets. Accordingly, they regularly have had to adjust to the customs and habits of the incoming president and first family, each member of which has its own way of doing things. For example, Theodore Roosevelt's family members were much different from the Tafts who followed them. The Roosevelt children were young and numerous and allowed to be boisterous; they were sometimes joined by their father in their romps. The Taft children were older, often away, and the White House relatively quiet. Even Taft heard the echoes of the rollicking Roosevelts, who dominated the White House to an amazing extent. Taft said to a friend, "When they say 'Mr. President' I always look around and expect to see Roosevelt." Even time-honored White House public festivities such as the Pageant of Peace and the Easter Egg Roll have been tailored over time to the first family's preferences.

The transition to a new administration requires all White House staff to help the new residents understand how the household has previously functioned, while also adapting to the incoming family's style and traditions. Longtime butler, chief butler, and maître d' Alonzo Fields explained his role and pride in his country and its leaders, "As I look back over twenty-one years in the White House, I am very happy that I was able to serve at so important a place in so critical a period in our history. Just think what a time it was and what a privilege it was for me to watch some of the most important men and events at such an intimate range." In this spirit, the White House domestic staff remains apolitical, as they are working as public servants representing the institution of the presidency.

Passing the Torch

When a White House domestic employee has been trusted for decades, that makes it easy to hire another family member, or someone a longtime employee knows and recommends. The continuity of these family lines through the generations speaks to the level of confidence that first families place in the integrity of the household staff. "There were whole families working there sometimes, sisters and brothers, fathers and sons," wrote Lillian Rogers Parks in her 1961 memoir, *My Thirty Years Backstairs at the White House.* Nine members of the Ficklin family, including butlers John and Samuel Ficklin, worked at the White House through the years. A 1979 television miniseries dramatizing Parks's memoir, and the 1934 memories of Ike Hoover *(Forty-Two Years in the White House)* tell of the close bonds that formed among the White House staff.

The president and his family have responded to the household staff's dedication. In 1806, when Jefferson was in the White House, he provided for the nursing care of the sickly child of one of his Monticello servants at his own expense. (Sadly, the child died before its second birthday.) Belgian-born Joseph Boulanger, steward for President Andrew Jackson, did not live at the White House, and when he was gone, Jackson entrusted the keys to the house to Irish-born doorman Jemmy O'Neil. Doorman Preston Bruce was asked by First Lady Jacqueline Kennedy to walk with French president Charles de Gaulle, Emperor Haile Selassie of Ethiopia, and other world leaders in a procession from the White House to President John F. Kennedy's funeral Mass at St. Matthew's Cathedral.

A White House staff reunion in June 1983 was the scene of a joyous gathering of former domestic staff. Heinz and Shirley Bender recalled their romance, an attraction that began while he was pastry chef and she was a housekeeper for the first family, that led to marriage. Luci Johnson Nugent, daughter of President Lyndon Johnson, arrived at one reunion with her three-year-old daughter, hoping to see "a lot of old friends." ★

Learning the Ropes: Training, Tasks, and Teamwork

EXPERIENCED EMPLOYEES PASS ON THEIR KNOWLEDGE to newcomers, and all need patience and teamwork to master the learning curve. "I thought I knew how to serve," said Eugene Allen, a former maître d'. "But the White House is different. Other places you can make mistakes and you don't feel bad, but you don't feel like making mistakes for the president and first lady."

Previous formal training can serve individuals well in the White House, but each employee also quickly has to learn the ways of the Executive Mansion: what to do and when to do it, who is in charge, how to offset a crisis, and how to adjust to the first family's tastes and preferences. The staff, as chief usher J. B. West noted, "are selfless people . . . ushers, housekeepers, butlers, maids, chefs, cooks, doormen, florists, gardeners, electricians, plumbers, storekeepers, engineers—each of whom, has a passion for anonymity."

New employees must learn White House protocol no matter the formality they may have experienced elsewhere. "The first time I was introduced to President Truman," remembered former butler Norwood Williams, "I said 'well, it's a real honor to meet you Mr. Truman, and Alonzo (Fields, the maître d') about had spasms. You just don't address the president of the United States as 'Mr. Truman.'"

New workers are typically assigned mentors. At a State Dinner, Samuel Ficklin was told by Alonzo Fields that he had to measure how close the silver pieces were to each other with his thumb. "Alonzo was a stickler for excellence," added Norwood Williams.

Sometimes, the duties of the domestic staff have extended well beyond what one might imagine. Security, for example, is a responsibility that falls upon everyone. In October 1881, doorman Thomas F. Pendel and chief usher Eldon Dinsmore apprehended a visitor who turned out to be armed with a Smith & Wesson revolver and had a letter of introduction from "Almighty God, Communicated by the Holy Spirit," stating that "Dr. John Noetling is lawfully elected President of the United States and occupies the White House every day." They disarmed the potential assassin and prevented an attempt on President Chester A. Arthur's life.

Jackson's Inauguration

Inaugurations are always a festive yet harried time for the domestic staff. The house is in a sort of limbo between the time the outgoing president departs and the new president arrives. Usually this lasts for several

Flower arrangements have long added beauty to the White House rooms; floral designer Rusty Young completes an arrangement in the Green Room in 1966 (above). A staff member rolls up the carpeting (opposite) to prepare for tours of the Blue Room in 2001.

hours. Staffers stand at the windows, the chief usher at the front door to welcome the new president and his family. Chaos famously reigned after Andrew Jackson was inaugurated in 1829, and the domestic staff was overwhelmed by the unprecedented wave of visitors who swept over the White House and its grounds to celebrate the triumph of the "frontier" candidate and hero of the common man. The work of entertaining the unexpected guests was left to a holdover from the John Quincy Adams administration, Belgian steward Antoine Michel Guista. Supporters stood on the silk-covered furniture with their boots to get a look at the president. At last, fearing the new president might be crushed, Jackson's friends hustled him out a window and onto a coach, which sped him back to his rooms at John Gadsby's National Hotel on Pennsylvania Avenue. Guista emptied the house by having the servants place washtubs full of spiked lemonade and orange punch out on the lawn. "What a scene did we witness!" sniffed Margaret Bayard Smith, a redoubtable observer of the Washington social tableau. "*The Majesty of the People* had disappeared, and a rabble, a mob, of boys, negroes, women, children, scrambling fighting, romping. What a pity, what a pity!"

The Wilson Years

A shift toward more permanent government employees at the house began under Woodrow Wilson. Wartime security restrictions in 1917 would end the free access to the White House for a small army of independent electricians, plumbers, painters, floor polishers, chimney sweeps, and tradesmen.

Other changes were common to the start of any administrations. The staff worried on the day of Wilson's inauguration, because a new president usually replaced some of the employees in a transition. This president was a Democrat replacing a long line of Republicans. One staffer who was not worried was Elizabeth Jaffray, who had met with Ellen Wilson just after the election and knew she would be retained.

An addition to the Wilson White House was Isabella Hagner, who had been the first social secretary, establishing the position under Theodore Roosevelt's wife, Edith Roosevelt. She returned at

the request of Ellen Wilson, who admitted that she "knew nothing of Washington," having been there only once, and who wanted to perform properly and to carry on the tradition surrounding the presidency.

President Wilson announced after the election that he would not have an inaugural ball as it was too expensive and unnecessary for the solemn occasion. A surprised staff took some time to adjust to the Wilsons,

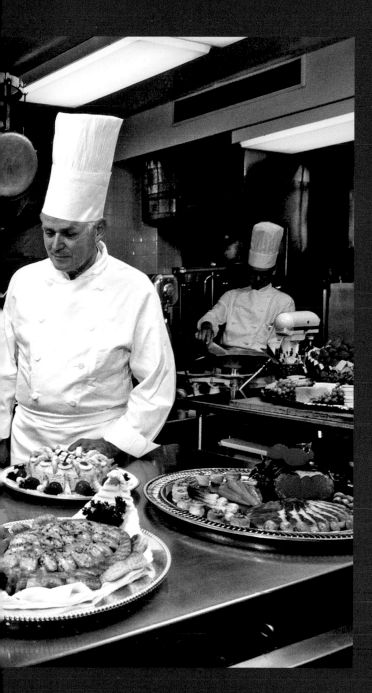

First Lady Nancy Reagan tastes dishes and desserts of pastry chef Roland Mesnier (left) and executive chef Henry Haller in 1982. Mesnier constructed spun-sugar elephants and swans for his dessert, following the first lady's suggestions. Cristeta Comerford (top right) works with staff in the White House to plate a course for a meal in 2011.

Chefs at the White House

Cristeta Comerford, a Philippine native trained in French classical techniques and specializing in ethnic and American cuisine, became the first woman appointed executive chef in 2005. The executive chef heads the White House kitchens and manages four sous chefs, as well as coordinating with the executive pastry chef. She reports to the chief usher but also works daily with the first lady and the social secretary. The position and title of executive chef in the modern era began with Jacqueline Kennedy hiring French chef René Verdon in 1961. Many cooks have worked at the Executive Mansion. Many have been African American. George Washington's chef at Mount Vernon and in Philadelphia was an enslaved man named Hercules. Dolly Johnson cooked for Benjamin and Caroline Harrison, Mary Campbell for Franklin and Eleanor Roosevelt, and Zephyr Wright for Lyndon and Lady Bird Johnson. Thomas Jefferson entertained in style, and his French chef Honoré Julien prepared sumptuous meals. Many presidents preferred the plainer fare to which they were accustomed. Ulysses S. Grant, an army man of simple tastes, wooed Sicilian Valentino Melah, a New Jersey restaurateur, to the White House for several years to direct preparation of official dinners, but preferred wholesome country fare, crispy meat, and fresh vegetables.

with their shelves of books and their insistence on privacy. Unpacking the new president's suitcase, presidential valet Arthur Brooks was shocked to find that Wilson owned too few suits, and they were not very good ones at that. The president turned his wardrobe over to Brooks, who found fabrics that were properly presidential and brought in tailors to do fittings. Woodrow Wilson became a style setter.

But the Wilsons were understanding, and Ellen Wilson came to be beloved by the domestic staff for her kindness and easy manner. Her death from Bright's disease in August 1914 put the whole White House in a state of mourning. President Wilson gave up most entertaining at the White House.

President Wilson in a short time provided yet another surprise for the White House staff. After a whirlwind courtship, in December 1915, a Washington widow named Edith Bolling Galt became the second Mrs. Wilson. The new first lady, however, did not inspire the same affection the staff had felt for Ellen Wilson. Some of the staff privately referred to Edith Wilson as "Pocahontas" because she had Native American ancestors of the Powhatan tribe. Some called her "Bo-Peep" under their breath for her home-front support of bringing sheep to the White House lawn during World War I to reduce manpower cutting the lawns and to promote the Red Cross through the auction of the herd's wool. Edith Wilson was to accompany the president through the First World War and the events surrounding the Treaty of Versailles, and she was at his side protectively when he suffered a paralyzing stroke while campaigning for the League of Nations, which he hoped would bring peace to the future world. ★

First Families and White House Residence Staff

A CLOSE RELATIONSHIP OFTEN ARISES BETWEEN FAMILIES who occupy the White House and the domestic staff that works there. Presidents and ushers have become friends, staff have cared for children living in the White House, and offspring of both the leader of the world and the people who serve him have played together. Staff memoirs are rich in detail about the family atmosphere of the White House and how that atmosphere has changed with each administration. Letters, photographs, and notes of encouragement and appreciation testify to the friendly relations between domestic staff and the families that lived at 1600 Pennsylvania Avenue.

One of the most searing events of the 20th century in the White House was the assassination of President John F. Kennedy. Staff had said goodbye to the president and first lady, and the next day heard the news of the shooting in Dallas. "A brave young man I had learned to love," recalled doorman Preston Bruce years later, adding, "I struggled to keep my composure." Eugene Allen said, "When Mrs. Kennedy came home, still wearing that suit with the blood on it, I knew I should say something. But a look between us was sufficient." Still, the White House had to continue to function. As employees had done for generations, the residence staff welcomed members of the Lyndon Johnson family and made them feel at home.

Joyful Times

In contrast, White House domestic staff memories can also be joyous. Valet James Amos served as umpire for the baseball games of Theodore Roosevelt's children. Mamie Eisenhower remembered the birthdays of the staff, who had been sick, and who had surgery. Usher Nelson Pierce taught Caroline Kennedy how to turn somersaults; he also read stories to her brother, John F. Kennedy, Jr. Lynda and Luci Johnson baked cookies in the White House kitchen. Many presidents and first ladies have held holiday parties for staff families.

Among those who were especially close to the first families was Ike Hoover, who worked at the mansion

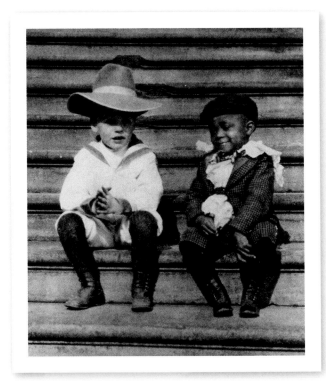

Winnie Monroe (opposite), cook and nurse, posed in 1877 with Scott, eight, and Fanny, ten, youngest children of President Rutherford B. Hayes. Quentin Roosevelt (left, above), son of President Theodore Roosevelt, played at the White House with Roswell Pinckney, son of steward Henry Pinckney. Quentin Roosevelt died in aerial combat during World War I. Roswell Pinckney worked for the State Department from 1917 until his retirement in 1960.

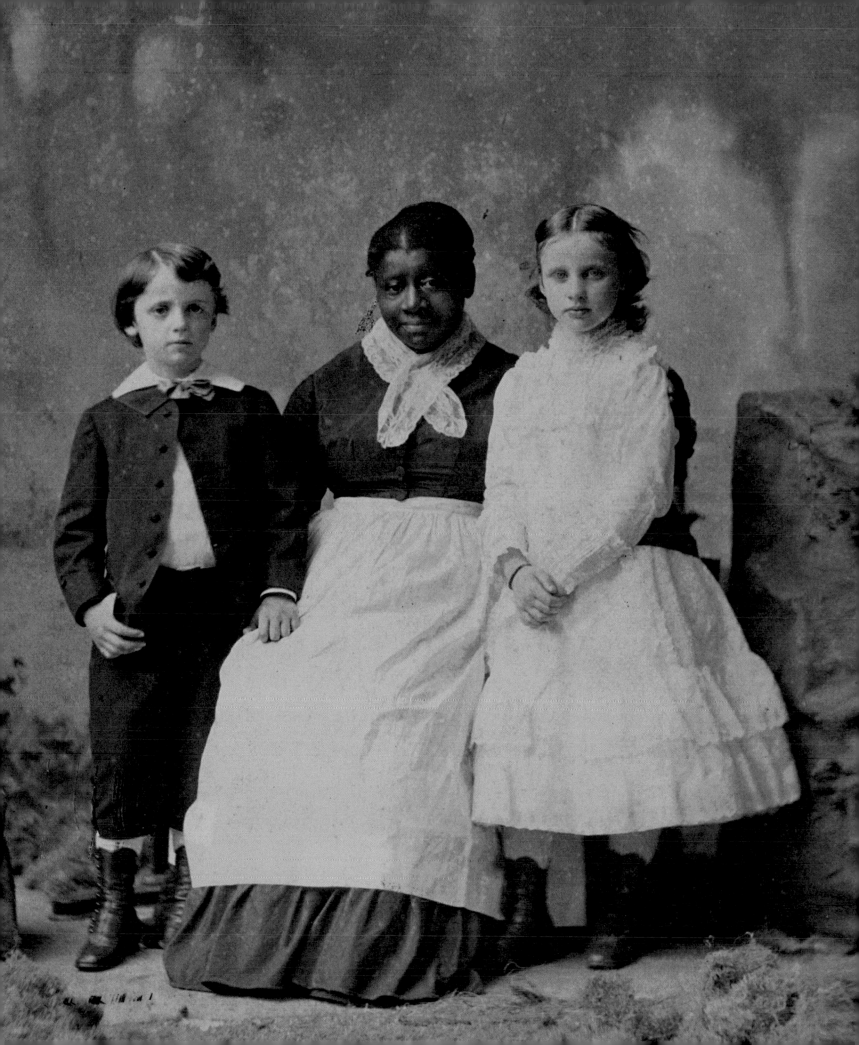

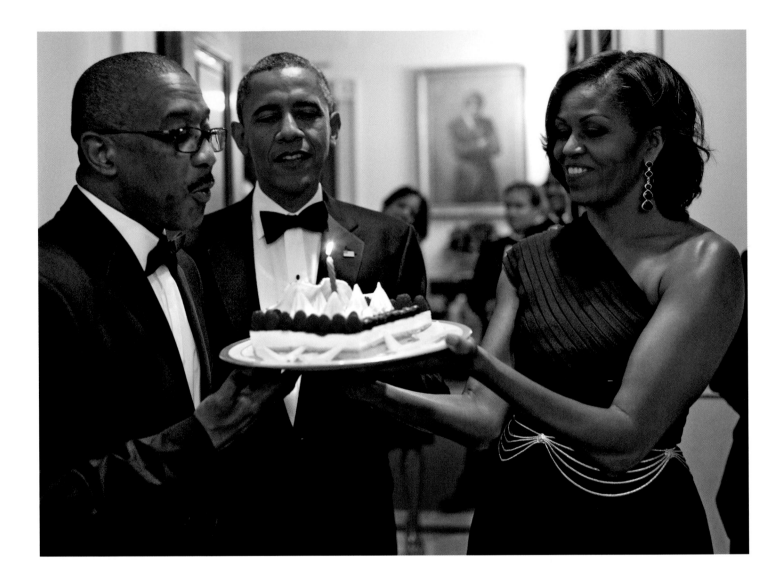

for 42 years and greeted ten presidents, rising from electrician to serve as chief usher from 1913 until his death in 1933. Howard "Reds" Arrington was a plumber who kept the 17 bathrooms, the pool, and the fountains running for seven presidents. Arrington delights in telling how he successfully installed powerful water jets in the shower to please President Lyndon Johnson. Chef Henry Haller baked a six-tier cake for the 1971 wedding of Tricia Nixon in the White House. Staff gave a party for First Lady Patricia Nixon's 60th birthday in 1972, making a sign that said, "You are not yet 39!" When President Jimmy Carter and his wife, Rosalynn, celebrated their 31st anniversary in 1977, White House staff surprised them with a gift of a silver tray.

Memoirs testify to the closeness between the first family and residence staff. In her 1868 book, *Behind the Scenes, Or, Thirty Years a Slave and Four Years in the White House,* seamstress Elizabeth Keckley, a former slave, described her role as confidante to Mary Todd Lincoln during her years in the White House. Harry Truman encouraged maître d' Alonzo Fields to record his memories in a book. Jacqueline Kennedy was dismayed by Lillian Rogers Parks's *My Thirty Years Backstairs at the White House,* and ordered her personal secretary, Mary Gallagher, to circulate a confidentiality agreement for all the domestic staff to sign. Mary Gallagher's own memoir, *My Life with Jacqueline Kennedy,* was published in 1969. The agreement was not legally binding but reflects the concern presidents and first ladies have of intrusive reports.

Relations between the first families and staff were not always smooth. First Lady Julia Grant got off on

President Barack Obama and First Lady Michelle Obama present a birthday cake to assistant usher Reggie Dickson outside the chief usher's office of the White House. The informal occasion on June 13, 2012, followed a Presidential Medal of Freedom ceremony and a dinner honoring President Shimon Peres of Israel.

I believed that in a small way I was a part of history. I felt that I was playing some role for the man who holds the greatest job in the world. I constantly kept this thought before myself during the whole time I worked in the White House until it became almost a sense of dedication.

ALONZO FIELDS, chief butler and maître d', 1931–1953

WHITE HOUSE LIVES ★

ALONZO FIELDS

No one set the tone for a White House worker better than Alonzo Fields, who served under both Republican and Democratic presidents: Hoover, Roosevelt, Truman, and Eisenhower. Fields expressed pride in his patriotic service to the four presidents and the nation and explained that he was honored to have been a part of history. He lived by his saying, "Hear nothing, know nothing, see nothing, and keep everything to yourself!" Fields served as butler, chief butler, and maitre d' at the White House and was known for his ability to adapt to successive first families. Despite the personal enmity that existed between Hoover and Roosevelt, he made a smooth transition after the election of 1931. When Mrs. Roosevelt's housekeeper from Hyde Park, Henrietta Nesbitt, proposed filling the plates for a state banquet in the kitchen, a horrified Fields shrewdly maneuvered the decision to Mrs. Roosevelt, who reversed it. After the flutter and pressure of the Roosevelt administration, the White House quieted down considerably under the practical Trumans. Fields remembered of Mrs. Truman, "The First Lady would not stand for fakers, shirkers or flatterers, and the only way you could gain her approval would be by doing your job to the best of your ability. This done, you would not want a more understanding person to work for."

Alonzo Fields, on the dust jacket of his White House memoir.

My 21 years in the
WHITE HOUSE
By ALONZO FIELDS
The Chief Butler and Maître d'Hôtel
for Hoover, Roosevelt, Truman and Eisenhower
tells what he heard and saw

the wrong foot with the staff when she expelled the ushers from the room off the Entrance Hall where they congregated, smoked, and ate their lunches. They chafed when she turned it into a waiting room for guests, and were further irritated when she put them in black suits and white gloves, requiring they stand at attention in the Entrance Hall.

At times, some members of the domestic staff became especially close to a president's family, as in the case of Winnie Monroe, who came to the White House in 1877 with the family of Rutherford B. Hayes. Monroe had been a nurse to the Hayes children for years, as well as the family cook. Her daughter Mary was First Lady Lucy Hayes's personal maid. The Hayes children adored their nurse, who called herself "the first colored lady of the land." President Hayes added $20 from his own pocket on top of the $30 paid to Monroe monthly by the government.

Servants also loved Hayes's successor, James Garfield, a jolly man who was kind to them. They prayed for Garfield when he was shot by an assassin at the Washington train station, and to help him recuperate, his cook, a Roman Catholic, secretly sprinkled holy water in his milk. They mourned when he died of his wounds more than two months later. Frances Cleveland, the youngest first lady in the history of the presidency at 21 years old, brightened the White House with her wit. When Jerry Smith, who had joined the staff as a stable boy in the Grant administration, tearfully prepared to say goodbye to her as Grover Cleveland's first term ended in 1889, Frances Cleveland told him that she wanted him to take care of the furniture and the ornaments so they would be ready when she and President Cleveland returned. A startled Smith asked how long that would be, and Frances Cleveland replied, smiling, "in four years." And she was right. The Cleveland family returned in 1893 for a second term after the administration of Benjamin Harrison.

Grover and Frances Cleveland returned to the White House with one daughter, Ruth. A second girl, Esther, was born in the White House in 1893. (A third daughter, Marion, was born in Buzzard's Bay, Massachusetts, while Cleveland was still in office.) "The Cleveland children were . . . much beloved by everyone around the place," Ike Hoover wrote about the demure and pretty girls. "We often wished that more of them had been born in the White House."

The staff got their wish for more children two administrations later when the uninhibited offspring of Theodore Roosevelt occupied the mansion and the domestic staff sometimes had to deal with rambunctious high spirits. There were four boys between the ages of 3 and 14—Theodore, Jr., Kermit, Archibald, and Quentin—plus Ethel, 10, and their willful half sister, Alice, age 17, who once jumped fully clothed into a ship's pool while on a cruise. "A nervous person had no business around the White House in those days," observed Ike Hoover. "Nothing was too sacred to be used for their amusement and no place too good for a playroom." President Roosevelt joined them in games, including tag, wrestling, and baseball, and famously said, "I don't think that any family has ever enjoyed the White House more than we have."

The story of the working White House is embodied in the dedication and skills of the residence staff and their relations with the first family. For more than two centuries, these workers have left a lasting impression on the White House, not only as a home but also as a symbol of the American presidency. ★

Preston Bruce, who served five presidents as White House doorman from 1953 to 1977, holds the gloves worn by Robert Kennedy at the funeral of President John F. Kennedy, later presented to Bruce.

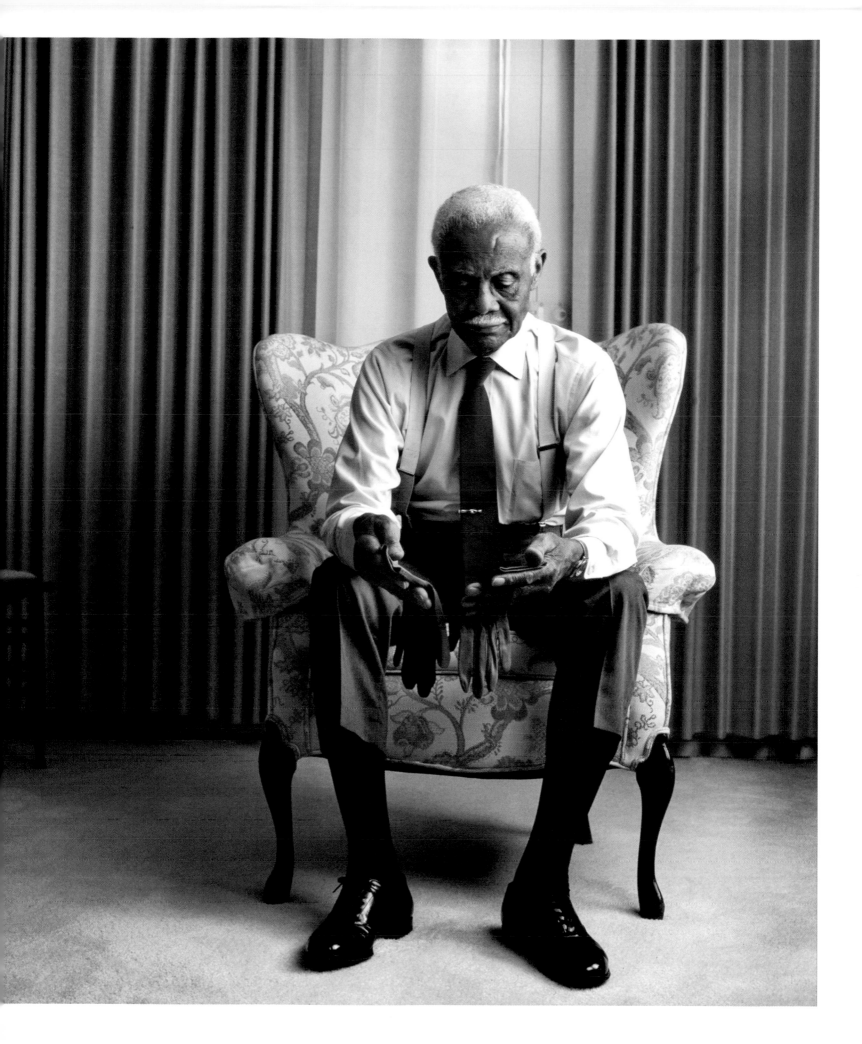

At HOME in the WHITE HOUSE

MAKING *the* WHITE HOUSE *a* HOME ★
SIX MEMORABLE WEDDINGS ★ RECREATION
at the WHITE HOUSE ★ ANIMALS *and* PETS ★

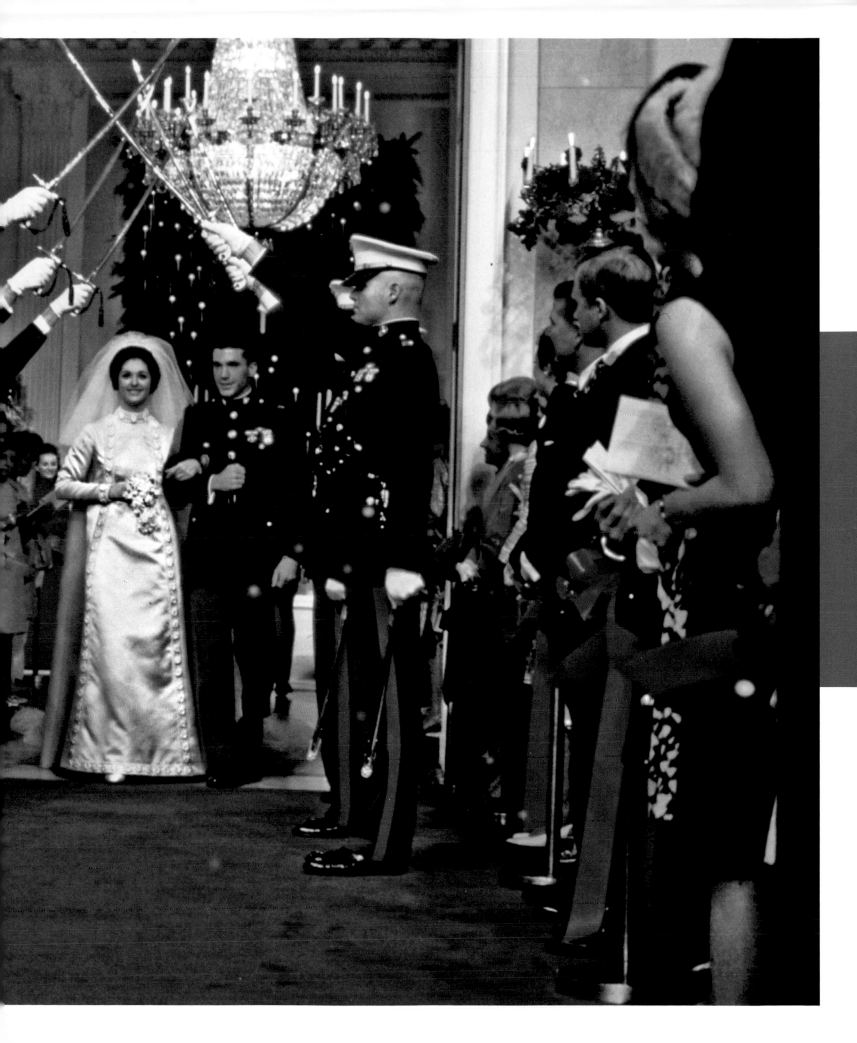

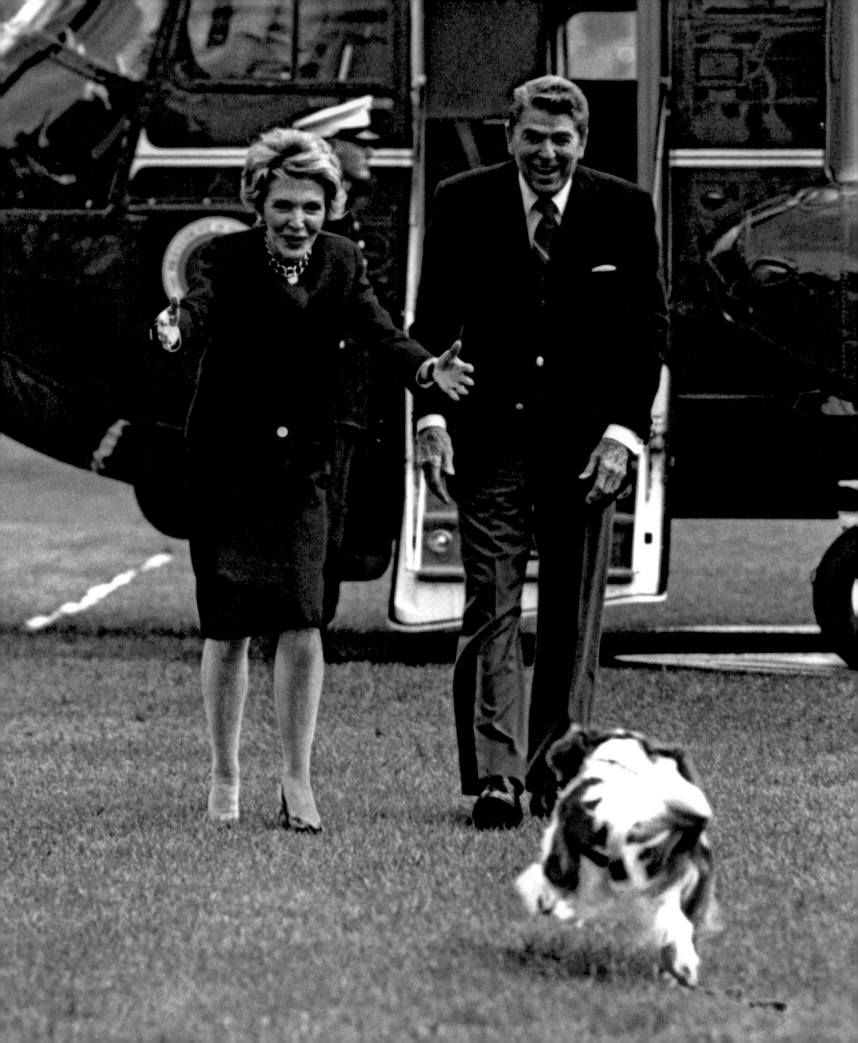

F ORTY-TWO FAMILIES HAVE MADE THE WHITE HOUSE their home since 1800, and all tried to make the house fit their hectic and harried lives. Some presidents arrived as bachelors or widowers, whereas others brought large extended families with them to the executive residence. Each president and his family shaped the house to accommodate their way of living and to fit their needs.

The White House adapts to the first families and evolves. At its core, it is a national symbol, workplace, and home representing the values, tastes, and accomplishments of American society.

Preceding pages: Lynda Johnson Robb and Marine Captain Charles Robb leave the East Room under the crossed swords of an honor guard after their White House wedding. Opposite: Rex, the Reagans' King Charles spaniel (named for chief usher Rex Scouten), bounds across the South Lawn to welcome the president and first lady to the White House as they exit the presidential helicopter.

A view of the White House as home provides rare glimpses into the differences between the public and private lives of presidents and their families. The public has always been fascinated to learn about presidential household amenities, security, weddings, recreational pursuits, presidential children and grandchildren at play, and the first family's pets and animals.

All the occupants of the White House have had something in common: They believed in the United States and hoped their time in office would make the country better. That, and the history associated with the house, kept it from being moved. Several major proposals in the 19th century were made to build a new White House elsewhere. In 1881, Chester A. Arthur tried, but failed, to build a new executive residence and to convert the existing mansion into an office building.

Theodore Roosevelt, although he realized the house was aging and in disrepair, said: "Mrs. Roosevelt and I are firmly of the opinion that the President should live nowhere else than in the historic White House."

Making the White House a Home

MOVING INTO ANY NEW RESIDENCE CAN BE EXCITING and challenging. But what if you are moving to a house that is almost as old as your country, has a world of history behind it, customs of its own, and more staff than you could ever imagine? The residence staff are dedicated to letting the chief executive concentrate on the responsibilities of office. The house and its routines have evolved to allow the president and his family to carry on with their busy daily lives.

Thomas Jefferson, a private man and widower, made work central to the executive residence, placing his personal office in the largest of the building's finished rooms, the State Dining Room. Millard Fillmore, the 13th president, did little to the executive residence but approved the plans of his wife, Abigail, to create a White House Library in the second-floor oval room and obtained a $2,000 congressional appropriation. Caroline Harrison, wife of Benjamin Harrison, found the White House cramped and without privacy. She tried to restrict tours and to convert the State Rooms to family use. She wished to enlarge the White House into a quadrangle with the addition of an open court and a glass conservatory on the South Front, plus flanking buildings to accommodate an art gallery and business office. Congress refused to fund the project. Theodore and Edith Roosevelt had six active

children, and the eight rooms of the family quarters overflowed with them. With family quarters and offices jammed together on its second floor, the White House was clearly too small for the Roosevelt family. Finally, Congress agreed to a White House renovation in 1902, and Edith Roosevelt solved the problem of the crowded family quarters with architect Charles McKim's plan to convert the entire second floor into private living space.

Congress appropriates funds every four years for the care, repair, refurnishing, and maintenance of the White House and its grounds. Each incoming president finds furnishings that need replacement due to everyday wear and tear. The $14,000 appropriated to John and Abigail Adams in 1800 remained steady until it was raised to $20,000 in 1833 for Andrew Jackson's second term; the allowance was raised to $50,000 in 1925. Congress appropriated $100,000 for the second term of George W. Bush.

The first lady usually supervises the refurbishments, but always approves them. Today, changes to the public spaces on the ground and State Floors are made in consultation with the Committee for the Preservation of the White House. The White House curator, the director of the National Gallery of Art, and other arts agency heads belong to this committee, established in 1964.

The White House remains recognizable through the years on moving day (above), but the equipment has evolved. In 1800, President John Adams (opposite) welcomes wife Abigail to the President's House after a long journey in a horse-drawn coach.

Every evening, while I took a bath, one of the maids would come by and remove my clothes for laundering or dry cleaning . . . Five minutes after Ronnie came home and hung up his suit, it would disappear from the closet to be pressed, cleaned or brushed. No wonder Ron used to call the White House an eight-star hotel.

NANCY REAGAN, *My Turn*, 1989

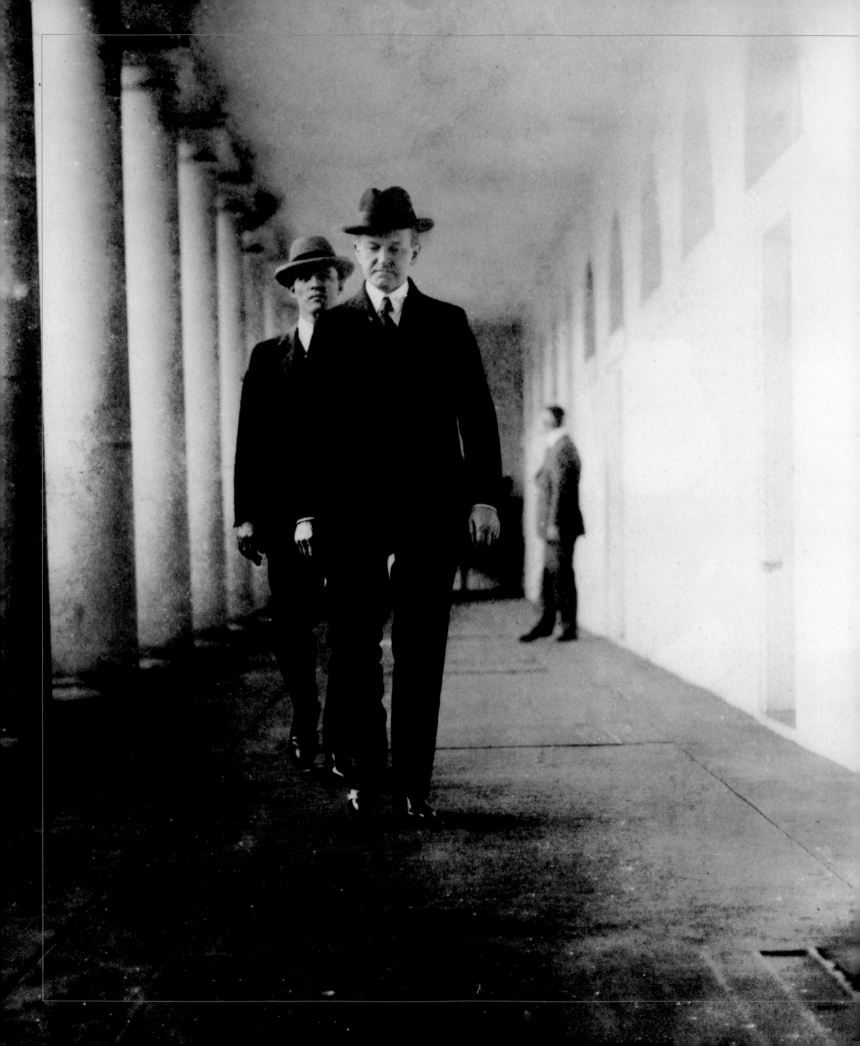

Hard Use Over Centuries

The house is more than 200 years old and through the years has had hard use. Untold numbers of visitors have entered the house for tours and events since 1800, including Andrew Jackson's rowdy supporters at his first inaugural. They caused great damage to the house when people broke glassware and china at a reception and stood on furniture in muddy boots to get a look at Jackson. Congress appropriated only the standard $14,000 for repairs, replacements, and redecoration after the inauguration. Jackson also acquired additional funds to finish and furnish the East Room with blue upholstered furniture and mahogany tables. Jackson left the presidency in 1837, having spent $45,000 for new furnishings, an enormous sum at the time.

More than a half century later, the house again was in poor repair, and Chester A. Arthur attempted to build a new mansion, but was rebuffed by Congress. He would not occupy the White House until it was redecorated to suit his tastes. The rooms were cleared, and

President Calvin Coolidge, followed by a Secret Service guard in 1925, walks along the West Colonnade, an open columned walkway that connects the West Wing executive offices to the White House.

24 wagonloads of furniture and 30 barrels of old china were sold at a public auction. Arthur commissioned Associated Artists, of which Louis Comfort Tiffany was a partner, to lavishly redecorate the mansion in the style of the fashionable Aesthetic movement, with stained glass, lighting fixtures, mantels, overmantel mirrors, and decorative painting using gold and silver leaf. The crowning achievement was the famous Tiffany screen of colored glass, one of the most legendary objects of the White House, installed in the Entrance Hall in 1882. Times and taste shifted and the screen was removed in 1902, in a neoclassical makeover for Theodore Roosevelt, emphasizing an American taste that accompanied the rise of the nation as a world power and the emergence of the president as an international figure.

The mansion's interior was reinvented again when President Harry S. Truman had the building gutted between 1949 and 1952, addressing fire hazards and serious structural deficiencies by replacing old timber framing with steel. In the words of one inspector, the house was "standing up purely from habit." The Truman renovation was the most extensive construction project since the house was first built. The plans retained the original walls, the third floor, and the

WHITE HOUSE LORE ★
WHITE HOUSE GHOSTS

Americans love ghost stories, and the White House has long been considered a prime spot for the paranormal. Tales of the ghosts of Abigail Adams hanging her laundry in the East Room and Dolley Madison overlooking the Rose Garden add to White House legend and lore. William Henry Harrison, the first president to die in the White House, is said to haunt the halls he once walked. Abraham Lincoln's ghost is the most famous of all. There are also lesser known stories of spirits such as the unidentified 15-year-old boy called the Thing, which frightened the domestic staff in

1911. President William Howard Taft's aide, Major Archibald Butt, wrote his sister Clara: "It seems that the White House is haunted . . . The ghost, it seems, is a young boy . . . They say the first knowledge one has of the presence of the Thing is a slight pressure on the shoulder, as if someone were leaning over your shoulder to see what you might be doing." When Butt repeated gossip about the Thing to the president, Taft flew into a "towering rage." Taft ordered Butt to tell the White House housekeeper that the first member of the staff to repeat stories about the Thing would be fired.

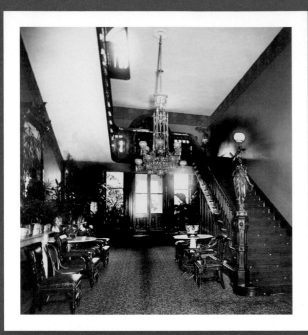

ELECTRICITY COMES TO THE WHITE HOUSE

Electric lighting was installed in the White House in 1891. Few people at the time had enough faith in electric lighting to use it exclusively instead of gas lighting—its commercialization was barely a decade old. The electrical work at the White House was planned as part of a project for wiring the State, War, and Navy Building next door, today's Eisenhower Executive Office Building. The Edison company installed a generator for both buildings, with wires strung across the lawn and introduced into the White House under the conservatory. Wires were buried in the plaster, with round switches installed in each room for turning the current on and off. President Benjamin Harrison and his wife, Caroline, refused to operate them for fear of a shock. One of the electricians was Irwin "Ike" Hoover, who finished the wiring and stayed on to maintain the system. Hoover stayed at the White House for 42 years, many of them as chief usher.

The gaslit private stair hall to the family quarters, 1889.

roof, while removing and reinstalling the interiors within a skeleton of steel structural beams on a new concrete foundation. Two levels of subbasements and service areas under the North Portico were constructed, and the Grand Staircase was substantially changed. Updated conveniences were added, including central air-conditioning. When the mansion was finished, it was truly "built for ages to come" as Abigail Adams had written in 1800.

Kitchen Modernization

Perhaps no room in any house over time receives updates more often than the kitchen. The White House kitchen, along with other service areas in the Executive Mansion, is not well known to the public. The main kitchen was first located on the ground floor at the center of the building under the Entrance Hall, with two great fireplaces at each end. Cooking in the late 18th century, when the White House was designed, was by "open hearth." Food would be heated in pots hung on a number of cranes that swung over the open fire, controlled at a proper distance from the fire by a series of S-hooks. The food could be cooked on stoves with three legs at least five inches above a bed of coals scraped out of the fireplace onto the hearth. Another method of cooking was roasting, one of the most successful of open-hearth processes, in which food was placed on spits above the flames. Cooks of the day knew how to control temperatures and moved the logs around or insulated hot coals with ash.

Kitchen staff, working directly below the Entrance Hall, cooked busily all day to provide food for servants, staff, and any guests who might be visiting. Jefferson added the first iron range fitted to the existing firebox for his chef to prepare his meals. The windows of the kitchen were visible from the bridge that led to the North Door until the North Portico was built over the windows. It became a darker and less advantageous space. At some point in the mid-19th century, two adjoining rooms, a small and a large kitchen, were located in the northwest corner of the ground floor, where they remain today. The small kitchen was used for everyday meals for the first

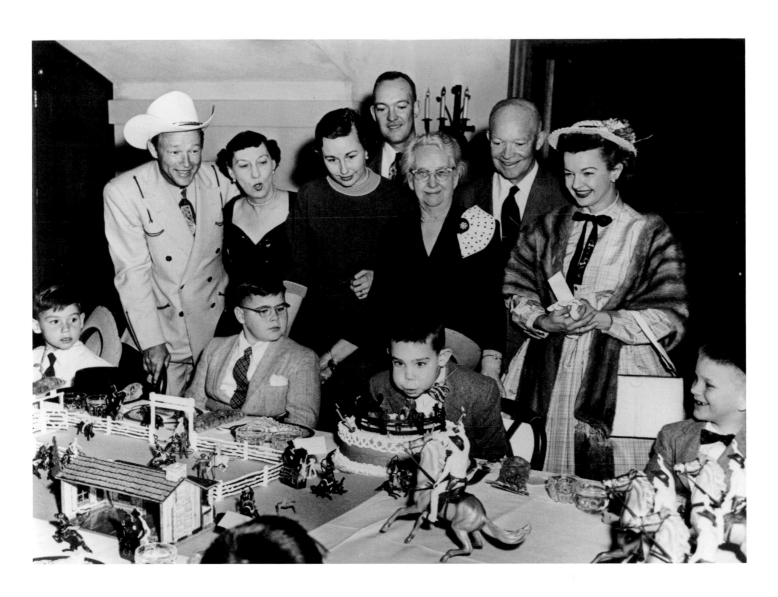

David Eisenhower, grandson of President and Mrs. Dwight D. Eisenhower, blows out candles on his cake at a cowboy-themed birthday party in 1956. Next to First Lady Mamie Eisenhower, wearing his trademark cowboy hat, stands film star Roy Rogers, who attended the party with his wife, Dale Evans (far right), in the Ground Floor Corridor of the White House. Jeff and Annette Carter (left), son and daughter-in-law of President Jimmy Carter, relax on the Truman Balcony in 1977.

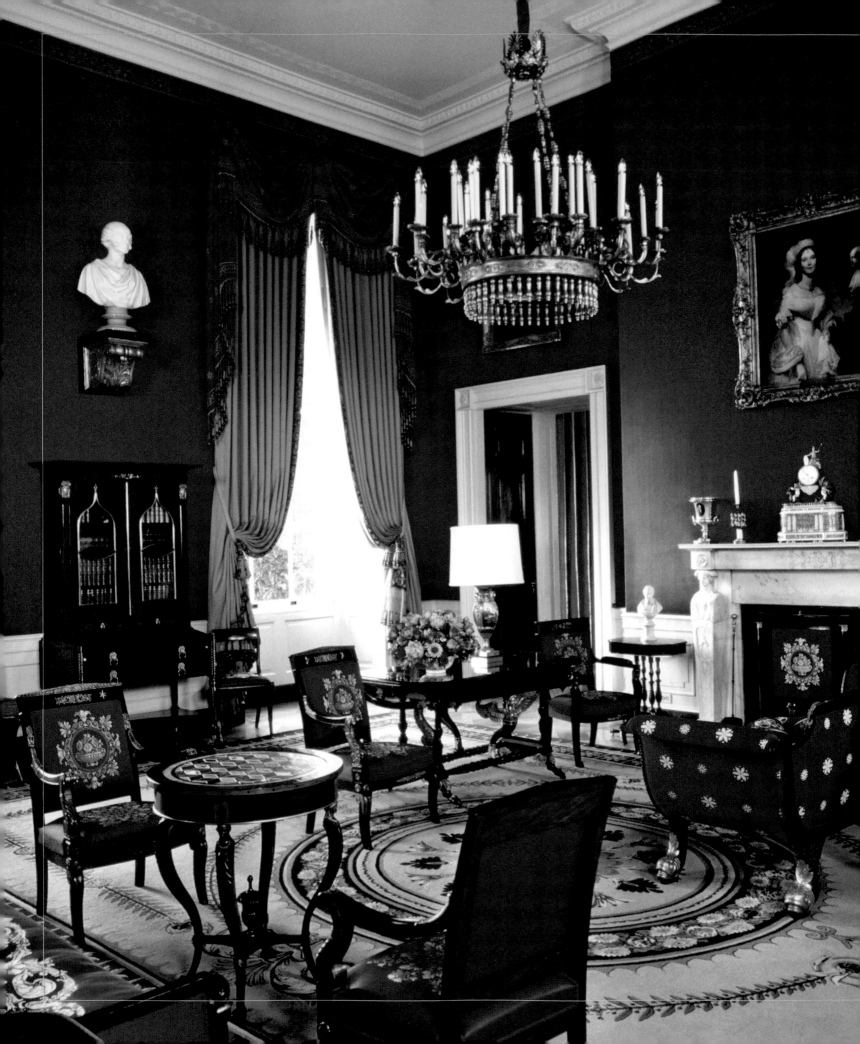

family and staff. The larger kitchen, today's main kitchen, was an area for preparation of food for major occasions.

At the beginning of the 20th century, Theodore Roosevelt upgraded the kitchens with modern equipment and electrical lighting and improved the small kitchen's access, adding an electric dumb-waiter and better circulation to the ground-floor corridor and food storage areas. He also converted the old central kitchen space into a furnace room that remained until the Truman renovation 50 years later completely modernized the heating and cooling systems. Stainless steel equipment and walls first appeared in a new kitchen built in 1935, nicknamed the "New Deal Kitchen" by the staff. It was equipped with the latest electric dishwashers, choppers, and a mixer. Staff unfamiliar with the newfangled contrivances continued to wash dishes and chop food by hand until the electric company sent a workman to show them how things operated. Today, the kitchen staff labor in this relatively small space and use all the latest conveniences to prepare food for hundreds of guests at large receptions.

Public and Private Spaces

It seems inconceivable today that the White House and its grounds were once open to the public at prescribed hours without security checks. The presidents could walk the streets of Washington without guards, in plain view of the public, before the Secret Service officially began protecting the president in 1902.

During the Madison administration, the Red Room was Dolley Madison's famous sunflower yellow salon. It was known as the "Washington Parlor" when the Gilbert Stuart portrait of George Washington, now in the East Room, was displayed there. Yellow dominated the room's decor until 1845, when President and Mrs. Polk decorated with a dark crimson French antique suite and dark ruby carpet. Fabric samples (above) for the 1961 Red Room restoration.

Today no one enters the presidential grounds without clearance. First families naturally chafe under the isolation imposed by this security, but as Theodore Roosevelt noted, the Secret Service is a "necessary thorn in the flesh." William Howard Taft and Helen Taft once famously slipped the Secret Service detail on Christmas Eve in 1911 to call on friends. When their absence was discovered, there was panic as Chief John Wilkie and his men scurried all over town to find the couple. Eventually, President Taft returned to the White House smiling broadly, with his wife holding his arm.

First families adapt to living in a residence that is a home, an office, and a museum with distinctive public and private spaces. When John Adams first occupied the President's House in 1800, the second floor was generally reserved for family use, and today it is the only truly private area in the house. During the 19th century the presidents used the east end of the second floor for offices and the Lincoln Bedroom actually was Abraham Lincoln's office and Cabinet Room. The rooms on the first floor are the most public, but even these spaces have a dual role. Throughout the 19th century the Red Room was often used as a music chamber and contained instruments, such as a pianoforte and guitar ordered by Dolley Madison. It was also a popular spot for Sunday evening family gatherings, and President and Mrs. Lincoln frequently used the space for informal entertaining.

Other public rooms on the State Floor include the Green Room, Blue Room, State Dining Room, and East Room. The Green Room since the time of John Quincy Adams has served as a parlor for teas and receptions and, occasionally, for small formal dinners. The Blue Room, one of the most elegant spaces of James Hoban's plans for the White House, has been used for receptions. The State Dining Room, which seats as many as 140 guests, was originally much smaller and served at various times as a drawing room, office, and Cabinet Room. ★

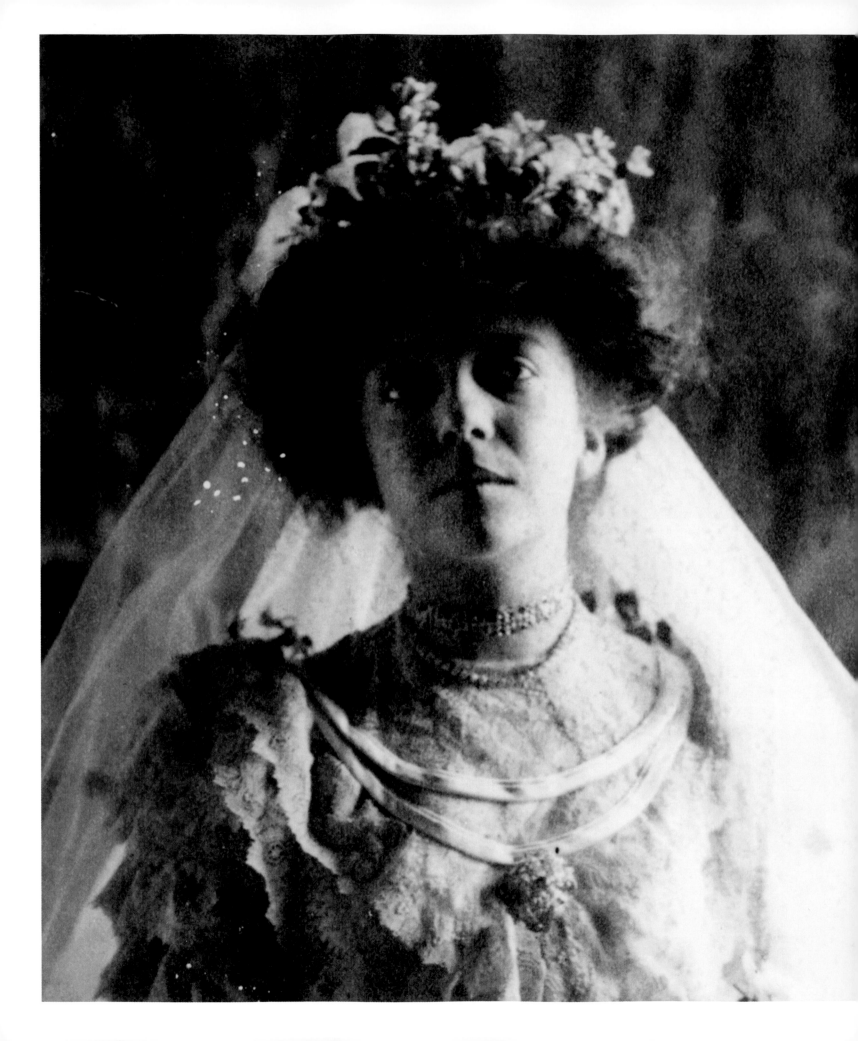

Six Memorable Weddings

THE FIRST WEDDING IN THE PRESIDENT'S HOME was not of a daughter, but of the sister of First Lady Dolley Madison, Lucy Payne Washington, to Supreme Court Justice Thomas Todd in 1812. Nine children of presidents were married at the White House. John Adams II, son of John Quincy Adams, was the only son of a sitting president married in the White House. When he married his cousin Mary Catherine Hellen in 1828, she was familiar with the mansion because she had lived with the Adams family after her parents had died.

Two of Woodrow Wilson's daughters were wed at the White House just six months apart in 1914: Jessie Wilson married Francis Bowes Sayre and Nell Wilson married William Gibbs McAdoo. The first was a large and glittering event, while the second was small and intimate. Both were family weddings, not state occasions.

Seventeen White House weddings have been documented. All were historic, but six stand out as especially memorable for the public interest they attracted.

Maria Hester Monroe

The first presidential daughter to marry in the President's House was Maria Hester Monroe, who wed Samuel Laurence Gouverneur, her first cousin and the president's secretary, in 1820. The wedding came after the War of 1812 and the reopening of the Executive Mansion following its reconstruction after the 1814 fire. Maria, not yet 17, married with only her attendants, the relations, and a few old friends present. Just 42 guests attended the romantic candlelit ceremony, which was probably held in the Oval Room upstairs. Foreign diplomats felt snubbed, and

Washington society dames were vocal in their annoyance.

Nellie Grant

The first truly grand wedding was that of Nellie Grant and Englishman Algernon Sartoris. Nellie was the only daughter of President Ulysses S. Grant and his wife, Julia, who indulged her. Nellie, who turned 16 in the White House, liked to have a good time and dressed well, which set Washington tongues wagging. Her street clothes and riding habits were fashionable, and her hats had feathers and bows. When she went on a trip to Europe at the age of 18, she came back in love with an Englishman she had met. The Grants announced their young daughter's engagement with reluctant approval.

The date, May 21, 1874, was announced with engraved cards that were distributed to 250 guests. Three Washington caterers—one of whom put on parties only for the richest Washingtonians—prepared a wedding feast. Much money was spent on Nellie's trousseau, which included morning dresses, afternoon dresses, "gaslight" dresses, and opera dresses—each with an accompanying shawl and fan. The wedding setting was the East Room, redecorated specially for the event, which featured three massive gasoliers with 38 burners, each made largely of cut glass with thousands of prisms so well polished they made rainbows in the gaslight. Reporters were assured that the trousseau would have been manufactured in Paris had

Pretty and willful Alice Roosevelt (opposite) in her 1906 wedding portrait (enlarged detail). A 1920 bas-relief of Maria Hester Monroe (above), the first president's daughter married in the White House.

there been time for the fittings. As it was, the dresses were bought in New York. The wedding took place in late morning in the East Room, where tubs of palms and fruit trees were lined up in front of the windows to resemble a tropical garden. Banks of flowers were everywhere. The eight bridesmaids formed a semicircle before the raised dais that was covered with Turkish rugs. Nellie came into the East Room on the arm of her father, her dress of point lace purchased in Brussels and formed into a great wavy overskirt of horizontal lines that covered a white satin gown and ended in a six-foot train.

After the ceremony and while a receiving line formed before the dais, the Marine Band played classical music. Gifts were in the Oval Room upstairs, and included earrings, flounces of rare lace, fans of silk and satin, gold knives, tea and coffee services, and numerous other items. At 11:30 a.m., the doors to the State Dining Room opened and a fairyland was revealed, with gaslights blazing above and candles twinkling below. The wedding cake was a towering white pyramid in the center of the main table, with white blossoms at the top and cascading down one side. The feast included soft-shelled crab on toast, followed by lamb, beef, wild duck, and chicken. After the ceremony, thousands outside the gate in the President's Park cheered the couple, who rode in a carriage to the train that would take them to New York, where they caught a ship to England. The president shed tears at the wedding, perhaps because the groom was described as a "cad and a bounder," perhaps because his only daughter was to make her home in England. Thirty years later, the event was still recalled as "one of the most brilliant weddings ever given in the United States." The couple separated after a decade but never divorced. Sartoris died an alcoholic in 1890.

Frances Folsom

In 1886, the only president to marry in the White House, Grover Cleveland, 49, wed Frances Folsom, who was 21. Historian Martha J. Lamb wrote a year after the wedding, "It is doubtful whether an earthquake in New York City or a war with Europe could have created so perfect a sensation or half as much genuine excitement . . . this romantic episode adds fresh interest to the White House." Cleveland's courtship of his former law partner's daughter, the darkeyed and agreeable Frances, took place in secret. Frances's father, Oscar Folsom, was killed in a carriage accident when Frances was 11. For a while, it was thought that Cleveland would marry Oscar Folsom's widow, Emma. "I don't see why the papers keep marrying me to old ladies," Cleveland complained in jest to a friend. "I wonder why they don't say I am engaged to marry her daughter?"

The president was worried about the marriage because of the difference in their ages and because he had never been married before. "I want my marriage to be a quiet one," he said to his sister Mary Hoyt. The only place they could be married seemed to be the White House, because then the "dirty gang," which was how Cleveland referred to the press, could be avoided. The president loved flowers, so tulips, white narcissi, and orchids were placed around the Blue Room, bringing their perfume to the air. There were roses, ferns, lilies, and pansies, too. Scarlet begonias were arrayed in the fireplace. The couple was married about 7 p.m. Frances had no attendants and wore an elegant gown of heavily corded satin draped in pearl-white silk, with a 15-foot train. The couple then went into the East Room where they greeted guests for a half hour, then into the State Dining Room for a dinner. With mounted policemen all around, they traveled by train to the Deer Park

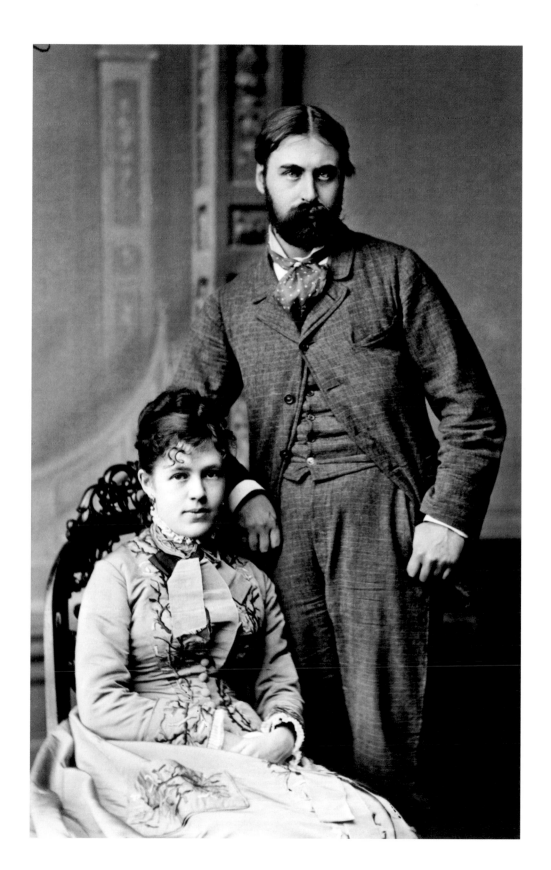

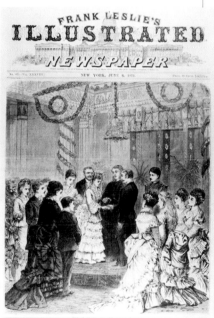

The 1874 marriage of Nellie Grant to Algernon Sartoris was a lavish affair. The engagement portrait, wedding reception menu, and illustrated cover of *Frank Leslie's Illustrated Newspaper* documented the wedding.

Hotel in western Maryland, where they honeymooned. Their solitude was ruined by reporters who watched them through binoculars and came out of the woods with questions when they went for walks. Frances Cleveland brightened the White House when they returned, but the prying press always bothered the president.

Alice Roosevelt

Entertaining at the White House of Theodore Roosevelt reached its zenith on February 17, 1906, upon the marriage of Roosevelt's daughter Alice to Congressman Nicholas Longworth of Ohio. "Princess Alice" was 22 at the time, the most celebrated young woman of the era for her impudence and penchant for breaking the rules of polite society. On a cruise to Japan in 1905, she jumped, fully clothed, into a swimming pool. Roosevelt once said, "I can do one of two things. I can be President of the United States, or I can control Alice. I cannot possibly do both." Alice—only daughter of Roosevelt and his late first wife, Alice Hathaway Lee—and her stepmother, Edith, were usually entertained once or twice daily at luncheons, teas, and dances when they were in Washington. One thousand guests attended the wedding.

Guests had three entrances—the North Door for family and friends, the south for foreign diplomats, and the east entrance for everyone else. All one thousand people crammed uncomfortably into the East Room, where the wedding took place. The widow Nellie Grant Sartoris, who married at the White House three decades earlier, now 50 years old, attended. The Marine Band struck up the "Wedding March" and Alice and Theodore Roosevelt marched in, the wedding party behind them. Alice wore a luxurious dress of white satin trimmed in lace handed down by her mother and worn by her grandmother in Georgia before the Civil War.

Immediately after the ceremony, Alice embraced her stepmother. When everyone had gone through the receiving line, the bride and groom went into the State Dining Room to cut the wedding cake. Newspapers reported that Alice seized a saber from a military aide and held it aloft before cutting the cake with it, but she corrected the reports years later. "That makes me

GROVER CLEVELAND,
PRESIDENT OF THE UNITED STATES.

FRANCES C. FOLSOM.

President Grover Cleveland created a sensation with his May–December romance and engagement to Frances Folsom. The announcement of their impending marriage in 1886, accompanied by the couple's portraits (above), was featured throughout the nation in newspapers such as *Frank Leslie's Illustrated Newspaper*. Frances, the daughter of Cleveland's late law partner, was 27 years younger than her husband. She brought youth and exuberance to the White House. A souvenir postcard (left) depicted guests assembling at the East Gate entrance before the grand wedding of Alice Roosevelt and Nicholas Longworth in 1906.

sound like a rude hoyden," she said. "He was standing beside me and politely offered it, so I used it to cut the cake."

Lynda Johnson

Alice Roosevelt Longworth would appear again at a wedding in the White House at the age of 83, when she was invited to the union between Lynda Johnson and Marine Captain Charles Robb. The weddings of the two daughters of President Lyndon Johnson and his wife Lady Bird riveted attention on the Johnson family. The White House reception for Luci after her August 1966 wedding to Patrick Nugent at the Shrine of the Immaculate Conception in Washington, D.C., was said to be brilliant, but the wedding of her older sister Lynda to Robb 16 months later in December 1967 was called "storybook." Lynda had met Robb while he was a military aide to the White House as a captain in the Marine Corps. (Robb would go on to become governor of Virginia, and then a U.S. senator.) The setting was again the elegant East Room, decorated for the Christmas holidays. The press reported on fashions of the guests, as they had in the days when journals dispatched "lady correspondents." The most striking fashion statement was by actress Carol Channing, who came to the wedding in "short, bloomer-type harem pants of yellow chiffon." Lynda Johnson's wedding dress was quickly copied and available at Gimbels department store within a few days for $150, and the long veil an additional $135.

Tricia Nixon

The first and thus far only wedding at the White House held outdoors in the Rose Garden was when Tricia Nixon married law student Edward Cox on June 12, 1971. The immense public interest led the White House to agree to a live television broadcast. Decorations were elaborate, with white tree roses, Madonna lilies, pink geraniums, and white petunias everywhere, recalling the White House weddings of the 19th century. The official wedding announcement promised the White House would be a "bower of flowers." About 400 guests were seated in the garden, which resembled an old-fashioned valentine. Standing before the altar was a wrought-iron pavilion laced with white blossoms. On a perfect summer day,

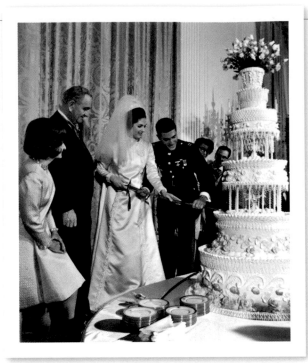

Lynda Bird Johnson cuts her wedding cake with a sword (above), 1967. Tricia Nixon (opposite) and Edward Cox dance, 1971.

President Richard Nixon walked his eldest daughter down the wedding aisle. Tricia wore a lacy Juliet cap, cascading veil, and white organdy and lace gown by Priscilla Kidder of Boston. After the ceremony, the family returned to the Blue Room for photographs and to receive guests. Then the bridal couple had their first dance in the East Room, where 20 cabaret tables were set up.

Bill Harris and his orchestra provided the dance music, including "Love Walked In," "People Will Say We're in Love," the theme from "Dr. Zhivago" and "A Time for Us." Even President Nixon danced at the wedding with Tricia, his wife, Pat, and Lynda Johnson Robb. It was the first time he had danced at the White House and told reporters, "My parents were Quakers and didn't believe in this sort of thing."

After the dancing came the cake cutting. The wedding cake was placed in the Entrance Hall in front of a gilded mirror. Chef Henry Haller produced a 350-pound lemon-flavored cake that was five feet in diameter at the bottom and rose to a height of six feet, ten inches. Pulled-sugar roses and cherry blossoms and a spun-sugar lovebird with the initials P.N. and E.C. decorated the cake. The bride threw the bouquet from the Grand Staircase. She left the reception in her wedding dress and departed with her new husband in a limousine out of the North Gate. The wedding marked the social high point of the Nixon administration. ★

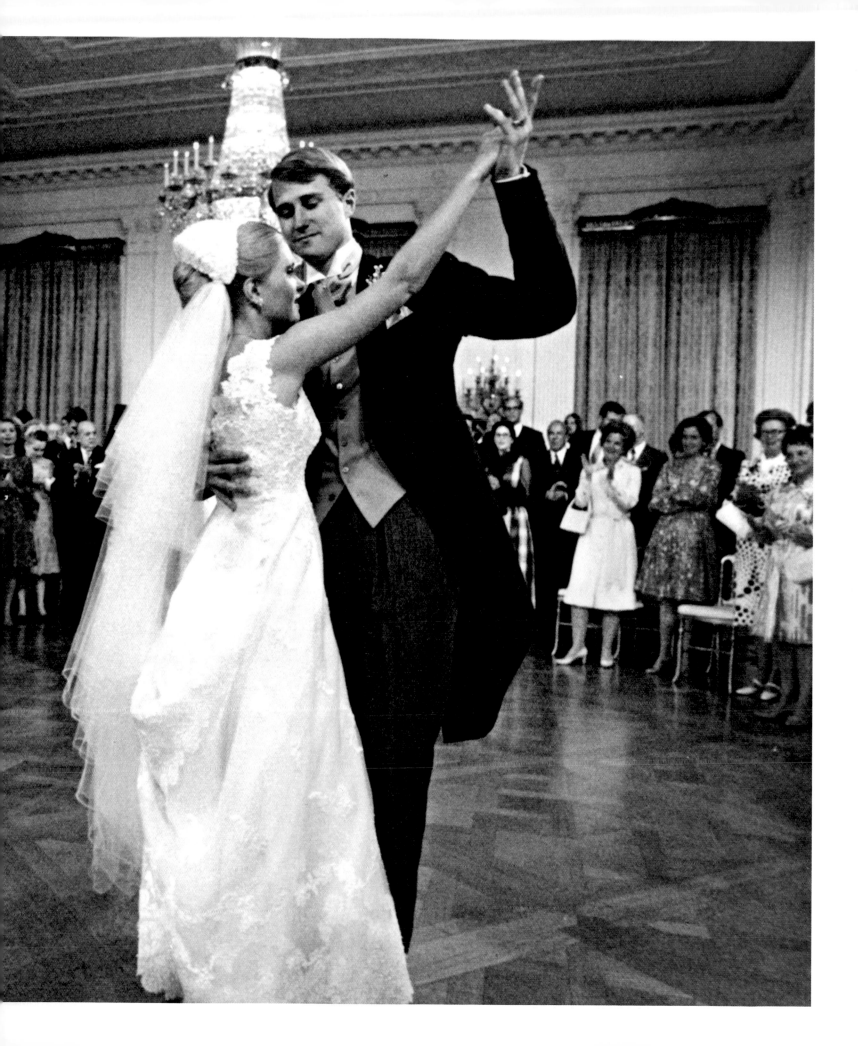

Recreation at the White House

THE PRESIDENT DOES HAVE OPPORTUNITIES to take a break at home away from the stress of the job. There are plenty of ways to relax and have fun, and thus there have been numerous changes to the White House to let presidents relax. Indoor and outdoor swimming pools, tennis courts, bowling alleys, croquet courts, putting greens, and other facilities have been added. All have allowed people with heavy responsibilities to forget their business occasionally and just enjoy a favorite pastime. Presidents have also engaged in recreational pursuits away from home— even the White House grounds do not have sufficient space for a full golf course.

The early presidents exercised as part of their daily routines. Walks and horseback riding were popular pastimes for John Adams and Thomas Jefferson. There was no garden at the White House during Adams's brief stay at the President's House, but if there had been one, then gardening would have been an outlet for him. His son, John Quincy Adams, liked to garden too, and long before swimming pools were common, he liked to swim in the Potomac River. Many presidents preferred walking, a practice that has continued in modern times. Ulysses S. Grant wanted to project the image of a man unconcerned about world affairs, so he officially worked only an average of five hours a day in his office and spent his recreation time playing billiards or driving fast-stepping horses through the streets of Washington. Rutherford B. Hayes marked out a croquet court near the South Portico where clerks as well as family "used to spend an hour now and then . . . over hard-fought games with mallet and ball."

Riding

Horseback riding has been a favorite pastime of numerous presidents. Andrew Jackson made a splendid, straight figure on a horse when he felt well enough to ride. Abraham Lincoln rode horses to and from the Anderson Cottage at the Soldiers' Home in Washington where he stayed during the summers. He also acquired ponies for his sons Willie and Tad to ride on the grounds of the White House. Franklin Pierce liked to get away every day and ride his prized black gelding, Union. Grover and Frances Cleveland kept five matched brown horses in the White House stable for their carriages. Their favorite carriage was the open landau that was taken out for drives in the Rock Creek Valley and the surrounding hills of Washington. Andrew Johnson, James A. Garfield, and William McKinley also famously enjoyed such relaxing excursions with their wives and families. Ulysses S. Grant and Rutherford B. Hayes were the most avid enthusiasts of driving as a sport.

Automobiles were introduced when Theodore Roosevelt was president, but he seldom rode in them, preferring carriages. Horses had been part of his recovery from a sickly youth and he rode daily as president. The athletic Roosevelt built the first tennis court on the White House grounds in 1902, and the press called the associates who joined him there for hard, tough games his "tennis cabinet." Eighty years later, President Ronald Reagan matched Roosevelt's passion for riding, but the capital had grown by then and Reagan preferred to ride Western style on his ranch in California.

President Richard Nixon rolls the ball toward the pins in the Old Executive Office Building bowling alley (opposite). The Nixons had a one-lane alley built at the White House in an underground workspace in 1969. A bowling pin (above) from the White House.

William Howard Taft, Woodrow Wilson, and Warren G. Harding were avid golfers. Harding practiced his golf shots on the lawn and trained his Airedale, Laddie Boy, to retrieve a ball. Another golf enthusiast was Dwight Eisenhower, who had a putting green installed on the South Lawn, with a small sand trap to one side. The U.S. Golf Association even installed a practice putting green just outside the Oval Office. (In 1961, Kennedy aide Richard Goodwin noticed that Eisenhower's golf shoes had left cleat marks on a wooden mat in the Oval Office.) Eisenhower improved his game while relaxing on the South Lawn and taking his mind off presidential problems.

Horseshoes and Hooverball

Pitching horseshoes, a game brought to the United States by English settlers, has been the favorite sport of several presidents. Early chief executives probably played at pitching an open horseshoe (or a ring when the game was called quoits) toward a stake 40 feet away. Harry Truman was shown several times on the White House lawn with horseshoes in his hands, as was President George H. W. Bush, who put a horseshoe pit next to the swimming pool on the White House grounds. His keen interest in pitching horseshoes

helped spur the popularity of the sport and rang up sales of equipment. Bush took up horseshoe pitching in 1984 while vice president, when members of his Secret Service detail began playing at his vacation home in Kennebunkport, Maine, and he joined in the fun. Bush, an active man, also had a basketball half-court built.

Herbert Hoover enjoyed vigorously tossing and catching an eight-pound medicine ball over a nine-foot net every morning from 7 to 7:30 (except Sundays) on a 30-by-60-feet court on the South Lawn. The medicine ball's weight made the game physically demanding and excellent for strength training. A collection of aides and cabinet members, who came to be known as the "medicine ball cabinet," would join him in the game of "Hooverball," scored like tennis. The president dressed in a flannel shirt, rubber shoes, old pants, and a worn leather jacket or sweater. Afterward, the group would partake of grapefruit, toast, orange juice, and coffee served under the Jackson Magnolia to the west of the South Portico.

Swimming Indoors and Outside

When he became president in March 1933, Franklin D. Roosevelt had already been disabled by polio, and was accustomed to swimming as part of his therapy in the

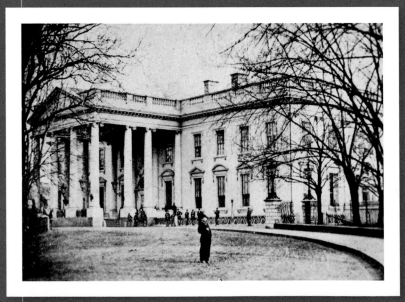

TAD LINCOLN AND COLONEL CROOK

Thomas "Tad" Lincoln, the youngest son of Abraham and Mary Lincoln, was a mischievous boy. Colonel William H. Crook, a Lincoln bodyguard, recalled in his memoir, "Tad Lincoln was never cruel to any living creature," and recounted the boy's successful plea with his father on behalf of a woman with starving children to free her husband from prison. Crook fondly wrote, "I see him most plainly . . . seated in a little wagon, driving a pair of goats around the White House grounds." Tad died in 1871, probably of pneumonia, at age 18. Crook became a mainstay of the presidential staff and worked for five administrations.

Tad Lincoln on the North Drive of the White House, 1865.

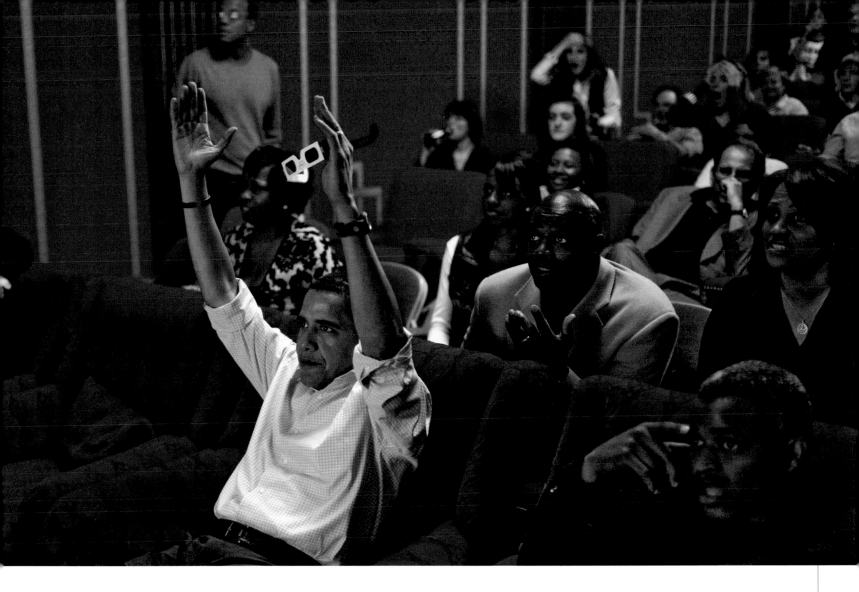

pools at Hyde Park and in Warm Springs, Georgia. On March 14, 1933, the *New York Daily News* announced a campaign to raise money to build a pool at the White House. Other New York newspapers joined in the effort. Contributions came from several states, but the pool was largely a gift from New York, celebrating its fourth native son to be president. The pool was completed in June 1933, and the president said to the workmen from his wheelchair, "I want you men to know that this pool will be a big help to me, as it will be about the only air I can get. It will be one of the greatest pleasures for me during my stay in the White House."

President John F. Kennedy used the pool twice a day to help relieve his back problems, which stemmed from a wartime incident while he was commanding a U.S. Navy patrol torpedo (PT) boat. His father, Joseph P. Kennedy, redecorated the pool space, with a mural depicting a Caribbean scene on three walls and a

mirror on the fourth. The area assumed a clublike atmosphere. Richard Nixon, making space for the new pressroom, covered over the pool in late 1969 and January 1970.

There have been few presidents as athletic as Gerald R. Ford. A prominent athlete, especially in football in high school and at the University of Michigan, Ford kept himself in shape throughout his adult life with strenuous exercise. He longed to swim when he became president, but the pool was beneath the pressroom by this time. There was talk of uncovering it, but Ford wanted a larger outdoor swimming pool. In

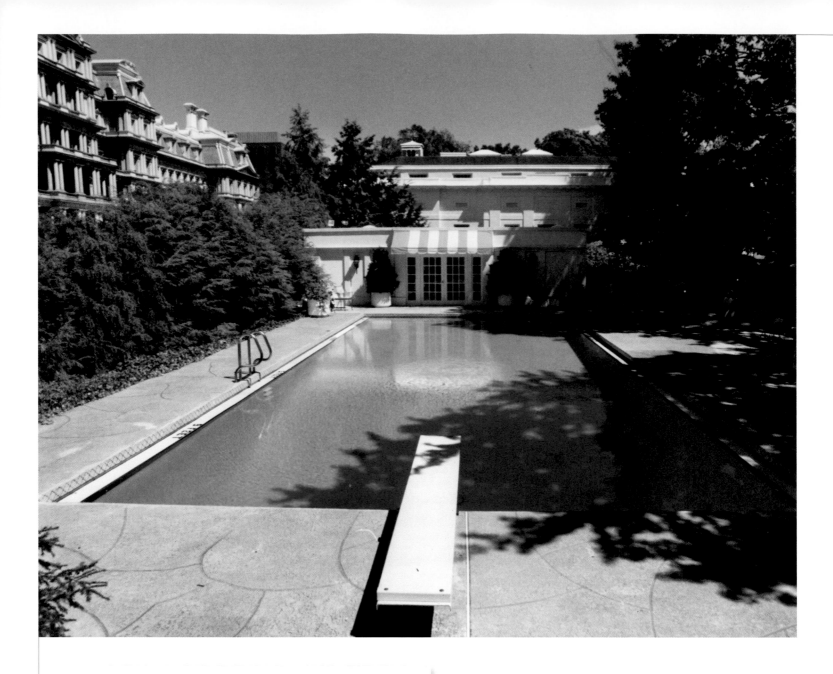

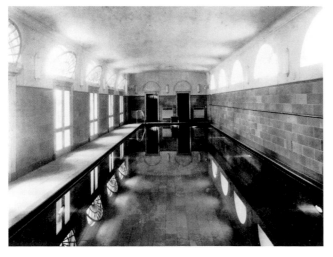

Swimming for exercise and physical therapy has been an important part of White House recreation in the 20th century. A heated indoor swimming pool (left) was built in 1933 for Franklin D. Roosevelt's therapy as he was disabled by polio. During Richard Nixon's first term, this space was converted into the White House pressroom, but the pool still remains below the floor. Gerald Ford, one of the most athletic presidents, built an outdoor pool (above) in 1975.

Steve Ford leaps the net in victory after playing a tennis match with his father, President Gerald Ford. Theodore Roosevelt built the first court behind the 1902 executive offices for his "tennis cabinet." Over the years, the court was moved ever farther from the house to its present location on the southwest grounds.

mid-May 1975, work was begun to dig a pool on the South Lawn, which was completed in midsummer. Ford invited the press to see him dive gracefully into the water and swim several laps. The staff could use the pool by appointment, but it was an exercise facility for the president and his family, not a place for recreation. The practice dramatized the idea of physical fitness for the public as it had never been emphasized before. The first family still uses the pool today.

Bowling and Other Pastimes

Bowling lanes were first built in the basement of the West Wing in 1947, and then were moved to the Old Executive Office Building in 1955. In 1969, President Nixon had a one-lane alley built in an underground workspace below the North Drive that the first family and residence staff still use today. The Nixon family all enjoyed bowling, including First Lady Pat Nixon and daughters, Julie and Tricia. The bowling lane has since been a popular place for parties for presidential children; both Amy Carter and Chelsea Clinton have entertained friends there. One of the first things the Obamas did as a family at the White House was to check out the bowling lane. President Nixon enjoyed golf and played on several occasions, and when a pool table was sent as a gift, he set up a room for it on the third floor.

Jimmy Carter was an outdoorsman, who enjoyed fly-fishing, playing tennis, cycling, skiing, and woodworking. George H. W. Bush was well known for his speed golf, as he liked to drive a cart at break-neck pace around the course at Cape Arundel Golf Club in Kennebunkport. His son, George W. Bush, also enjoyed golf, but his real passion was cycling. Bill Clinton jogged and had a quarter-mile jogging track added to the White House grounds that was used briefly and has since been removed. Eisenhower's putting green, long since removed, was restored by Clinton to the South Lawn. A basketball player on his high school team, Barack Obama continues to enter scrimmages while president. At the White House, he shoots baskets on the half-court that George H. W. Bush had built. President Obama also plays golf.

All presidents have enjoyed the 40-seat movie theater installed in the East Wing in 1942. The space doubles as a cloakroom and has tiered seats with a front row of four large armchairs, originally installed by Dwight Eisenhower. The decor, red floral curtains with well-upholstered white seats, was made over in red in 2004. Margaret Truman watched her favorite movie, *The Scarlet Pimpernel*, 16 times. Eisenhower loved Westerns. Nixon enjoyed inspirational films like *Patton*. Reagan enjoyed "oldies" as he called them from the early days of film. Clinton said he considered the theater to be the best perk in the White House and praised *Fight Club* and *American Beauty*. ★

Animals and Pets

A MENAGERIE OF ANIMALS HAS ACCOMPANIED PRESIDENTS onto White House grounds. There have been outdoor working animals, indoor cats and dogs, and even snakes. Brought mostly for the many children who have occupied the President's House, they have also provided amusement and diversion to the most important leaders in the world. They have also stirred affection among the public, not least in the many children who write notes to White House pets.

The first animals at the White House were working horses or milk cows, needed for transportation and food. Throughout the 19th century, presidents kept one to six milk cows, and stable space was provided for them. Many presidents, including Jackson and Grant, were consummate horsemen. Jackson had racing thoroughbreds and built a new stable on the grounds for them. Grant had fine saddle horses, trotters, and carriage horses as well, and relaxed by either riding or driving them himself around town. People on the sidewalk stopped to look as the president and national hero went by, leaning back with a whip in his teeth, driving a team of high-stepping bays.

Animals as Companions

From the earliest days of the White House, there were indoor animals, too. Thomas Jefferson bought his first mockingbird 30 years before entering the White House and had four mockingbirds with him in the executive residence; he taught his favorite, Dick, to peck food from his lips and to hop up the stairs after him. An alligator was rumored to stay in the East Room of the President's House when the Marquis de Lafayette visited John Quincy Adams in 1825, but it is unclear whether *Alligator mississippiensis* actually accompanied the French hero of the Revolution. There were plenty of dogs and cats, and also a raccoon, bears, and several goats. In the late 19th century, it was believed all children should have pets to nurture individual responsibility.

President Franklin Roosevelt enjoying a drive in Hyde Park with Fala, his loyal Scottish terrier, about 1943. Roosevelt's paralysis required that he drive a car with customized hand controls.

The Hayes family pets, known as "Lucy's ark," included a goat; four canaries; two German shepherds; an English mastiff; four kittens, two hunting dog pups, and a mockingbird.

KATIE SCHANK, *White House Pets*, 2007

TOP DOGS

Since the early 20th century, presidential companions have humanized a president's political image. Theodore Roosevelt preferred "Heinz pickle" dogs, such as Skip, a mongrel terrier, brought home from a Colorado bear hunt. Laddie Boy, Warren G. Harding's Airedale, had his own seat for cabinet meetings. Belgian police dog King Tut not only fixed Hoover's image problem in the 1928 presidential campaign, but also became a White House patrol dog. Franklin D. Roosevelt's Scottie was so recognizable that Fala's appearance revealed the president was nearby and became a security concern. As a goodwill gesture, Soviet leader Nikita Khrushchev gave Caroline Kennedy Pushinka, the daughter of Strelka, one of the first Russian dogs in space. Him and Her gained fame from Lyndon B. Johnson's "great ear lift," when the president playfully hoisted the beagles by their ears in front of news cameras. Since the 1960s, White House dogs from Nixon to Obama, including King Timahoe, Liberty, Grits, Rex, Millie, Buddy, Barney, Miss Beazley, and Bo have become media stars.

Clockwise, from top left: Bo, top dog of the Obama administration, poses for the camera; Lyndon Johnson howls with his mixed-breed dog Yuki in 1968; the Bushes' spaniel, Spot, holds the distinction of being the only second generation presidential pet; Laddie Boy, Warren Harding's Airedale, awaits his master's return in 1923.

Animals have also been ambassadors, and the White House has received several as gifts. In 1959, the French Community of African Republics gave President Eisenhower a baby forest elephant, Dzimbo, as a symbol of friendship. The White House has no facility for elephants, so Dzimbo was sent to the National Zoo in Washington, D.C. In 1961, Soviet leader Nikita Khrushchev gave Caroline Kennedy, the daughter of President John F. Kennedy, a dog named Pushinka, whose mother was one of two dogs who had orbited the Earth in a Soviet spacecraft and returned alive.

The first presidential couple to bring a child of their own under age ten into the Executive Mansion was Abraham and Mary Lincoln, parents of Thomas, or "Tad," who was seven, as well as William, ten. Lincoln encouraged his two youngest boys to collect and raise pets, including dogs, ponies, and goats. A tragic fire in the White House stable in 1864 destroyed the Lincoln family horses. Sergeant Smith Stimmel, a guard on duty that night, later wrote: "Mr. Lincoln asked hastily if the horses had been taken out, and when told they had not, he rushed through the crowd and began to break open one of the large doors with his own hands; but the building was full of fire, and none of the horses could be saved."

The tale of Tad Lincoln's turkey Jack has often been cited as the inspiration for the modern tradition of the president pardoning a turkey at Thanksgiving. Tad had made a pet of Jack, a bird sent to the White House for the dinner table, and when Jack was about to be killed by the cook for Christmas dinner in 1863, Tad pleaded for his life and his father gave the bird a presidential pardon. Lincoln once bought a pair of goats, Nanny and Nanko, for five dollars each for Tad. Lincoln became quite fond of Nanny and Nanko, who would come to the president's voice when he called them, and he and Tad would play with them on the White House lawn. Tad taught them to pull goat carts and kitchen chairs; Lincoln roared with laughter when told that his son had hooked the goats up to a chair, using it like a sled, and driven them through the East Room, to the consternation of a visiting group of ladies from Boston.

Photographers mostly ignored pets in the era of slow exposures, because animals would not sit still for pictures.

However, a goat figured in the most famous posed photograph of a presidential grandchild of the 19th century when "His Whiskers" became the pet of Benjamin "Baby McKee," President Benjamin Harrison's grandson, who lived in the White House with his family during the Harrison administration. By the 1890s, photography had advanced to the easy-to-use box camera with rolled film, and picture takers had a heyday as youngsters played. Reporters got good copy from an incident when the goat ran off with Baby McKee, and the short portly Harrison, dressed in a top hat and frock coat, ran after them down Pennsylvania Avenue.

Menageries

The president whose family was the biggest news and had the most interesting pets was Theodore Roosevelt. Even the eldest, Alice, had snakes and would often take a green one called Emily Spinach in her purse to parties. Quentin, the oldest boy, also kept snakes and once brought four newly purchased ones in a box to the office where the president and several party leaders were holding a meeting. In the process of hugging his father, Quentin dropped the box on the table and the snakes escaped, resulting in the distinguished guests rushing for the door. The president and his son rounded up the snakes, and Quentin returned them to the pet shop. Roosevelt was presented a pet badger when he was on a whistle-stop in the West and he took it home with him. The Roosevelts also had more ordinary pets, including ponies, a blue macaw, and five guinea pigs that each had names. One of them named Father O'Grady had babies, and the children barged into another meeting when the president was talking with an important guest and cried, "Oh, oh, Father O'Grady has had some children!"

President William Howard Taft not only was the first president to have cars instead of carriages, but also was the last one to keep a cow on White House grounds. Before dairy companies made deliveries of fresh milk, cows were kept in stables, but in Taft's case, Pauline shared space with Taft's four cars.

The Coolidges were second only to the Roosevelts in their variety of pets. They always had dogs, but at various times, their menagerie also included birds, a goose, a donkey, lion cubs, a pygmy hippo, a wallaby, a bobcat,

White House Menagerie

Animals, whether pampered household pets, working livestock, birds, squirrels, or strays, have long been a major part of life at the White House. Photographers took great interest in the six children of Theodore Roosevelt and their pets, including this blue macaw held by Theodore Jr. (opposite) in the White House greenhouse in 1902. Grace Coolidge (above) holds her raccoon, Rebecca, which she took on walks with a leash. William Howard Taft's cow, Pauline Wayne, shown in 1910, was the last White House bovine. A 1924 image (right) shows the famous one-legged rooster, stuffed for posterity, that belonged to Theodore Roosevelt's children. A flock of ducks had the run of the South Lawn in 1962.

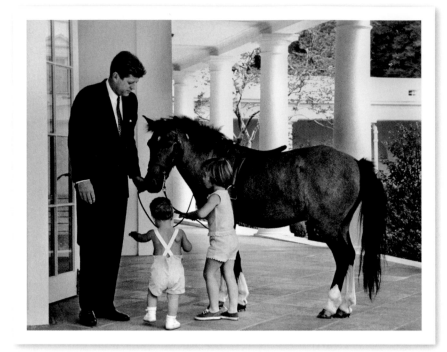

President John Kennedy takes a break outside the Oval Office when he greets his son and daughter, John and Caroline Kennedy, and pony Macaroni. Mrs. Kennedy was an ardent horsewoman, and Caroline rode from an early age. Opposite: Wearing a cap from the presidential campaign, Bill Clinton poses with Socks the cat in 1993, soon after Clinton's inauguration.

a bear, and a raccoon that became a household pet that Grace Coolidge used to walk on a leash.

Pets in Public

Politicians began to notice how photographs taken with their pets humanized their public image. Warren G. Harding's Airedale, Laddie Boy, became much photographed when the couple brought no children to the White House and the dog became, in the eyes of the press, the third member of their family. Reporters fawned over Laddie Boy, and he was "interviewed" by the *Washington Star* for his opinions on Prohibition and cabinet members; he even advocated for an eight-hour day for guard dogs. President Harding himself did Laddie Boy's ghostwriting. A stuffed toy was made of Laddie Boy, and a pet food company named a dog food after him.

Herbert Hoover was perceived as a cold politician until his portrait with his German shepherd, King Tut, warmed up public opinion. Hoover was photographed with the dog during the 1928 presidential campaign, and thousands of the images were sent to potential voters. Hoover also befriended an opossum that wandered onto White House grounds. Billy was tamed, and his picture made it into the newspapers. In 1929, a Hyattsville, Maryland, high school baseball team that

had recently lost a pet opossum mascot was losing game after game and asked to borrow Billy for good luck. Hoover agreed, and the school won championships in several sports that year.

Perhaps no dog has been better known and more a part of politics than Fala, Franklin Roosevelt's black Scottish terrier. Fala was given to the president as a puppy in 1940, and became extremely close to his master. Roosevelt took him to press conferences, fishing trips, and international meetings and sometimes spoke about him in his famous fireside chats. A picture taken of the Allied participants in a conference on board a ship off Newfoundland in 1941 includes Fala. In the campaign of 1944, Roosevelt's opponents charged that Fala had been left behind in a trip to the Aleutian Islands, and that the heavy cruiser U.S.S. *Baltimore* had been sent to pick him up, costing taxpayers millions of dollars. The charge was false and Roosevelt mentioned it in a September 1944 speech, claiming that his opponents "have not been content with attacks on me, or my wife, or on my sons. No, not content with that, they now include my little dog, Fala."

The most famous pet during John F. Kennedy's administration was Macaroni, Caroline's pony, a gift from then vice president Lyndon Johnson. However, the Kennedys' Russian dog, Pushinka, created a stir

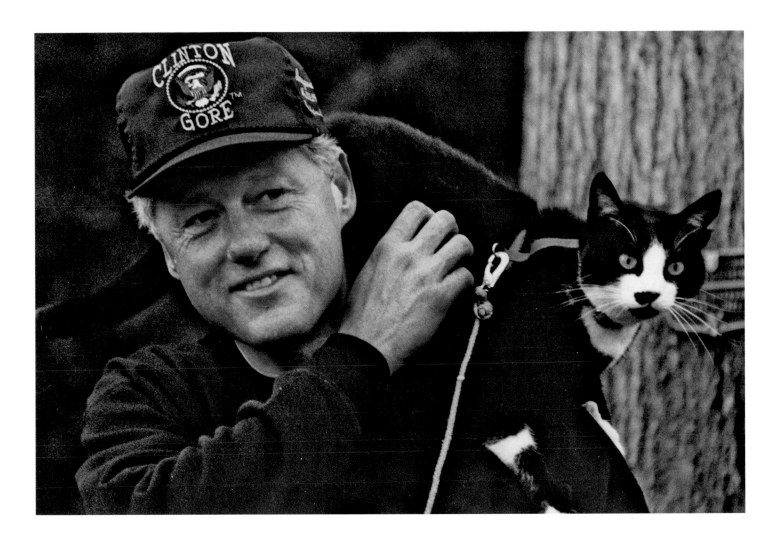

as some raised the possibility that she might be bugged. She won over everybody after delivering "pupniks" fathered by Charlie, the Kennedys' Welsh terrier.

As president, Johnson loved his dogs, but he did not win any friends with animal lovers when, in 1964, he lifted his beagles, Him and Her, by the ears and the dogs yelped. Richard Nixon's famous cocker spaniel Checkers died five years before Nixon entered the White House, but as president, Nixon owned three less well-known dogs—an Irish setter (King Timahoe), a poodle (Vicky), and a terrier (Pasha)—that had their own Christmas tree, their own stockings, and a dog-size Santa Claus.

George H. W. Bush's springer spaniel, Millie, wrote her own book (with help from Barbara Bush) and had a litter of puppies that were much

photographed. His son George W. Bush's dog, Barney, bit a reporter, following in the paw prints of Franklin Roosevelt's dog Meggie, who nipped an Associated Press reporter, Bess Furman, on the nose. Barney became a celebrity in the Bush White House for his popular "Barneycam" tours. Few cats have been more celebrated in the White House than Socks, Bill Clinton's pet. Socks got piles of letters from children and became a favorite of photographers who posed him in anthropomorphic situations, such as answering questions at a lectern.

Barack Obama, in a speech accepting victory in the 2008 election, promised his two daughters, Sasha and Malia, the puppy they had always wanted. Senator Ted Kennedy supplied the Obamas with a Portuguese water dog puppy, and Bo has become the pet of the Obama administration. ★

ENTERTAINING, CELEBRATING, and the HOLIDAYS

HOLIDAYS at the WHITE HOUSE ★ STATE DINNERS ★
TEAS, RECEPTIONS, and GARDEN PARTIES ★
CELEBRITY GUESTS ★ MUSIC and ENTERTAINMENT

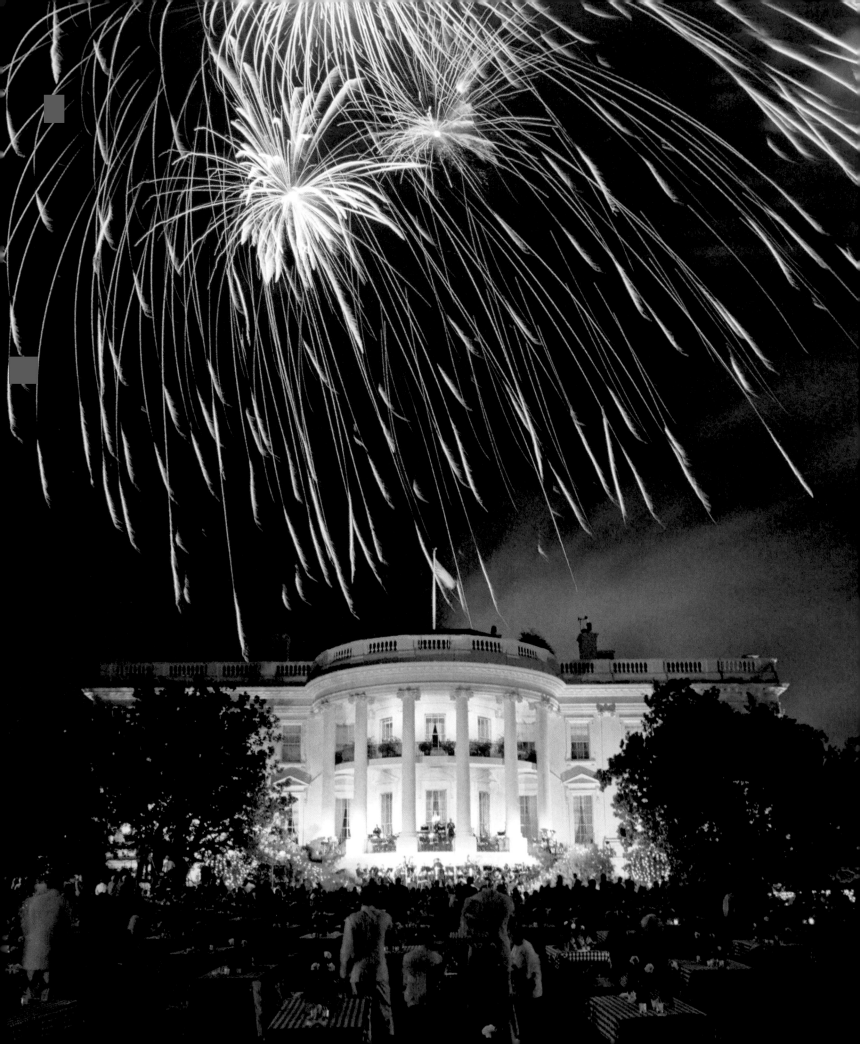

T HE WHITE HOUSE IS NOT ALL ABOUT THE SERIOUS BUSINESS OF government; it is also about the community that is enriched by traditional celebrations and entertainment. Presidents and first ladies have employed the Executive Mansion's spacious, elegant State Rooms for large receptions for members of Congress, governors, justices of the Supreme Court, foreign dignitaries, and royalty. White House entertainment includes a wide range of events from gala diplomatic receptions to children's holiday parties, though the official social season usually follows an annual schedule. Less formal affairs include intimate lunches or dinners with family and friends, parties, and holiday celebrations. The White House and its grounds have been the stage for open houses, levees, diplomatic receptions, garden parties, teas, and memorable performances from acclaimed musical and dramatic artists. It has celebrated both famous people and ordinary people who have accomplished extraordinary things.

Preceding pages: Diana, Princess of Wales, dances with actor John Travolta in the Entrance Hall at the White House in 1985. The dance took place during the royal visit, and photographs were published throughout the world. Opposite: Fireworks explode over the White House at the White House congressional barbecue in 1987. "I hope they wet down the roof," joked President Ronald Reagan.

The White House always has been a social center. The first receptions were formal levees, with respectful bows to the leader of the young nation, following the customs set by diplomats. Eventually an American style of entertaining evolved, allowing informal mingling of the president and his guests. Handshaking conveyed equality. Early occupants opened the White House to large receptions for all citizens, and today the residence is called the "people's house." In the late 20th century, security concerns gradually limited access only to those with invitations. But the White House remains more accessible than other houses of state. Hundreds of thousands of people still come to the White House and its grounds every year.

Holidays at the White House

THE WHITE HOUSE IS THE SITE OF A HOST OF EVENTS, including special seasonal holiday celebrations throughout the calendar. George Washington, the first president, invented traditions as he went along, including how the new country should celebrate on special days. Washington, if not staying at his Mount Vernon home, usually attended church services and entertained invited guests at the President's House in New York or Philadelphia on the Fourth of July. Independence Day was observed with patriotic displays, as it is still.

On January 1, 1801, John and Abigail Adams held the White House's first New Year's Day public reception, beginning a tradition that would last for more than 130 years. The custom continued until Herbert Hoover ended the practice after more than 6,000 people arrived at the 1932 reception and he and First Lady Lou Hoover greeted visitors until their hands were swollen and painful.

Each year, the White House observes the Christmas holiday and decorates the public rooms with glittering ornaments and trees, hosting thousands of visitors who enjoy tours of the decorations. In 2001, George W. Bush and Laura Bush began a tradition of celebrating the Jewish festival of Hanukkah with a White House party. The White House also stages an annual Easter Egg Roll, which draws thousands of children dressed up in their best, and Fourth of July celebrations that allow guests to watch Washington's spectacular fireworks from a prime location.

Christmas Trees

The White House observance of Christmas before the 20th century was not an official event. The first White House Christmas tree, decorated with candles and toys, was placed in the upstairs Oval Room for Benjamin Harrison and his family in 1889. Three years after electricity was introduced in the White House in 1891, the first electric lights on a family tree delighted the young daughters of Grover Cleveland.

Theodore and Edith Roosevelt held a "carnival" for 500 children during the 1903 Christmas season, including dinner, dancing, musical entertainment, souvenirs, and a special treat of ice cream in the shape of Santa Claus. President Roosevelt, an avowed conservationist, did not approve of cutting trees for Christmas decorations. However, his son Archie defied the ban and smuggled in a small tree that was decorated and hidden in a closet in the upstairs sewing room.

In 1909, William Howard Taft's children helped decorate the first tree on the State Floor in the Blue Room. Calvin Coolidge in 1923 was the first chief executive to preside over a public celebration of the Christmas holidays with the lighting of the National Christmas Tree, which he placed on the Ellipse. During World War II, the tree lighting ceremony was moved within the White House grounds for security reasons. Today, the Christmas Pageant of Peace, a major event held annually on the Ellipse since 1954, celebrates holiday worship of all faiths.

First Lady Lou Hoover established the custom of decorating an official tree in the White House in 1929.

A decorated tree, one of dozens in the president's home, brightens the Cross Hall in 1995 (opposite). The first family Christmas tree appeared in the mansion in 1889. A Christmas ornament (above) honors Chester A. Arthur, president from 1881 to 1885.

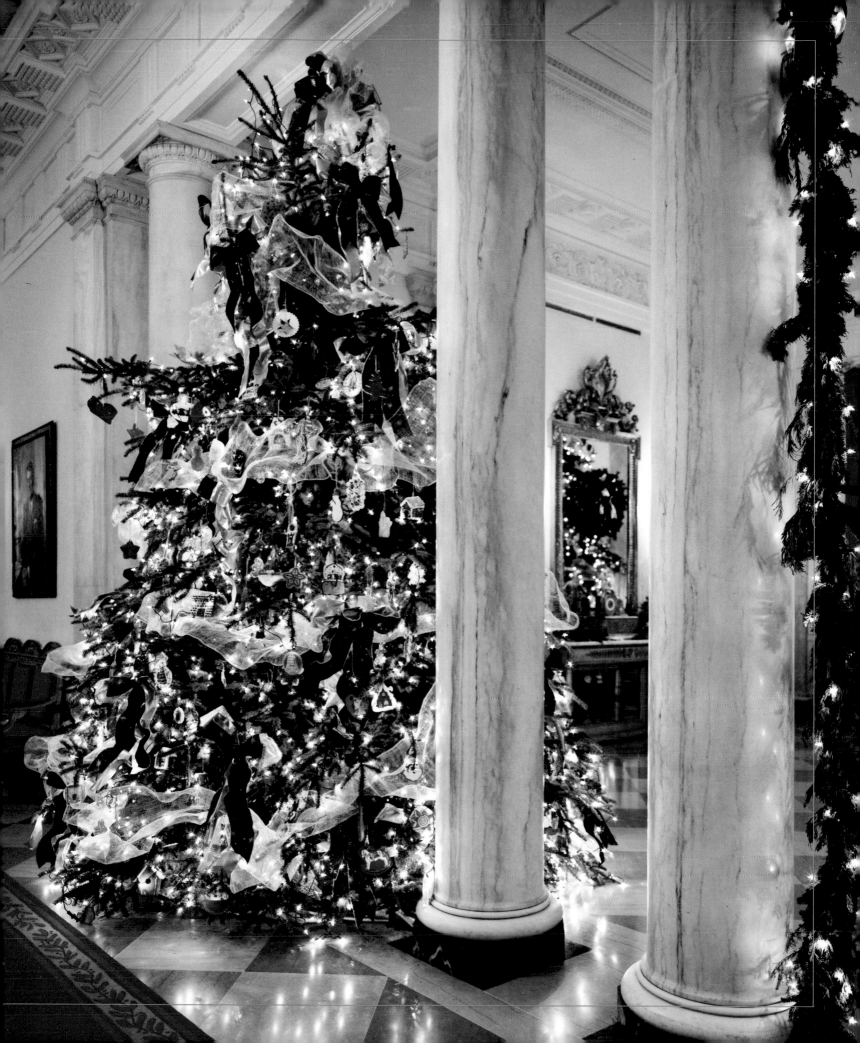

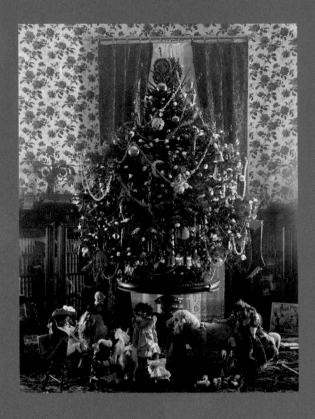

CHRISTMAS TREES AND CARDS

On the morning of December 25, 1889, President Benjamin Harrison gathered his family around the first indoor White House Christmas tree. It stood in the upstairs Oval Room, branches adorned with lit candles. In 1894, three years after electricity was introduced in the White House, lightbulbs were strung on a tree in the family's Oval Room (left). Theodore Roosevelt, an ardent conservationist, did not approve of cutting trees for Christmas, but in 1902, his son Archie defied the ban and smuggled a small tree into an upstairs sewing room. First Lady Grace Coolidge had trees in the 1920s, but it was First Lady Lou Hoover who started the decoration of the first "official" tree in 1929. Since that time, the honor of trimming the principal White House Christmas tree has belonged to the first lady. Official White House Christmas cards are usually traced back to Calvin Coolidge's holiday message sent out in 1927.

A sleigh ride across a snow-covered South Lawn on John F. Kennedy's 1962 presidential Christmas card (below left); Barney and Miss Beazley play in the snow on George W. Bush's 2005 Christmas card (below right).

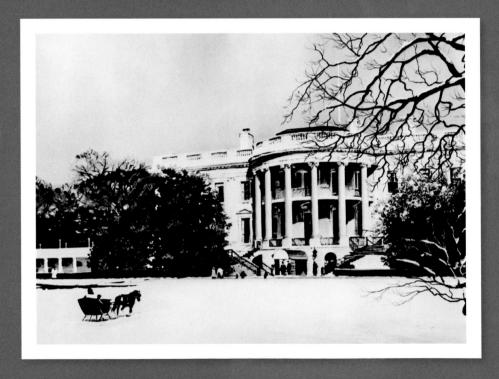

The Easter Egg Roll has been held on the White House lawn almost every year since 1878, and before that, on the Capitol grounds. Children race with long-handled spoons during the event on the South Lawn of the White House in 1981 (top). Commemorative eggs became part of the tradition that year. At the 1922 Egg Roll (inset), two children share a soda.

Since then, the honor of trimming the tree on the State Floor has belonged to the first lady. In 1961, Jacqueline Kennedy began the tradition of selecting a theme for the official White House tree. That year, the tree was adorned with ornamental toys, birds, angels, and characters from the *Nutcracker (Suite)* ballet. For the "American Flowers Tree" in 1969, Pat Nixon arranged for disabled workers in Florida to make velvet and satin balls featuring each state's official flower. Over her eight White House holiday seasons, Hillary Clinton showcased the talents of American artists. Laura Bush varied the decorations, including the themes of "All Creatures Great and Small" in 2002, highlighting her love of animals, and a patriotic "A Red, White, and Blue Christmas" in 2008. Michelle Obama announced the theme of "Shine, Give, Share" in 2011, and "Joy to All" in 2012.

Walking inside a bubble, a performer in a butterfly costume entertains children from Washington, D.C., Maryland, and Virginia at a 2009 Halloween party.

Easter Egg Roll

The Easter Egg Roll was originally held annually on the grounds of the Capitol, but in 1876, Congress—annoyed by the damage to the lawn—prohibited using the grounds as a playground. Heavy rain in 1877 left the edict unchallenged. When families were denied access to the Capitol grounds in 1878, Rutherford and Lucy Hayes invited the children to roll their eggs on the White House's South Lawn, and a tradition was born. World War I and food rationing stopped the event from 1917 to 1920. In 1942, egg rollers were sent back to the Capitol grounds. World War II stopped the festivities

from 1943 to 1945. Food conservation efforts caused Harry Truman to reluctantly cancel the affair. Then, from 1948 through 1952, Truman's renovation of the White House made the South Lawn a construction zone. Dwight D. Eisenhower revived the tradition after its 12-year hiatus. In 1981, Ronald and Nancy Reagan introduced souvenir eggs that celebrities signed and participants took home. Barack and Michelle Obama extended the celebration to 35,000 people in 2013, and added sports and fitness activities and cooking demonstrations.

Fourth of July

John Adams's successor, Thomas Jefferson, immediately stamped his ideas of republican simplicity on events at the President's House. Jefferson established the tradition of a White House Fourth of July celebration open to all. On that day, the North Grounds of the President's Park—the

"common"—came alive at daybreak with the raising of tents and booths, soon followed by crowds of people. What we know as Lafayette Park became a fairground. Food, drink, and goods of all types were sold. There were horse races, cockfights, and parades of the Washington militia and other military companies. Jefferson watched from the steps of the White House and invited everyone in to partake of his hospitality. Celebrants remembered that the Marine Band played in the Entrance Hall, performing "The President's March" and other "patriotic airs."

As the country and capital grew, both the New Year's Day and Fourth of July open houses drew ever larger crowds and eventually became impossible to sustain. Today, these outdoor public celebrations have shifted to the National Mall and the grounds of the Capitol and Washington Monument.

Thanksgiving

Thanksgiving at the White House is a quiet holiday for the president's family, featuring a meal that traditionally included turkey, Chesapeake Bay oysters, rockfish from the Potomac, terrapin from the Eastern shore, cranberries from Cape Cod, and mince and pumpkin pies.

During Taft's term, the president's Aunt Delia Torrey of Millbury, Massachusetts, sent "Nephew Will" a package of homemade apple pies, jellies, and jams for Thanksgiving and Christmas dinners. For years a prize turkey, delivered by Horace Vose, the poultry king of Rhode Island, graced the presidential table.

Recently, White House mythmakers have claimed that Harry Truman began a lighthearted holiday tradition when he gave a turkey, presented to him by the Poultry and Egg National Board, a reprieve in the White House Rose Garden in 1949. However, the Truman Library and Museum has found no evidence to support the notion. Reports of turkeys as gifts to American presidents can be traced to the 1870s, when Vose began sending his well-fed birds to the White House. Poultry gifts frequently involved patriotism, partisanship, and glee. In 1921, a Harding Girls' Club in Chicago outfitted and airmailed a turkey costumed as a flying ace, complete with goggles. After many years of turkey gifts and presentations to the White House, the formalities of pardoning a turkey gelled by 1989, when George H. W. Bush quipped, "This guy [has] been granted a presidential pardon as of right now." ★

HORACE VOSE, THE "POULTRY KING"

Horace Vose, called the "Poultry King" in the press, began supplying turkeys to the White House for Thanksgiving and Christmas in 1873. Vose, of Westerly, Rhode Island, provided the birds and shipped them to the president, starting a tradition that lasted four decades. A major supplier to the New York market, Vose became a national figure in the late 19th and early 20th centuries. The birds for the White House never weighed less than 30 pounds and sometimes reached 50. Vose prepared and dressed them before shipping them. Occasionally, Vose had competition. In 1913, the clerk of the House of Representatives, South Tremble, sent a turkey to President Woodrow Wilson that was fed a special diet that included red peppers and was therefore, he said, more flavorful. There is no record of which bird actually graced Wilson's table.

Horace Vose packs a prize bird for shipment to Theodore Roosevelt in 1904.

State Dinners

A STATE DINNER HONORING a visiting head of government or reigning monarch is one of the grandest of White House affairs. It is part of an official state visit and provides the president and first lady the opportunity to honor the visiting head of state and his or her spouse. It is a courtesy —an expression of goodwill—a way of extending hospitality. It brings to mind the tradition of breaking bread to seal a friendship. It is also an event that showcases global influence.

In the early 19th century, dinners honoring the president's cabinet, Congress, or other dignitaries were called State Dinners even though they lacked official foreign representation. At that time, those who dined at State Dinners were officials, diplomats, a small circle of local citizens, and perhaps the families of some senators and representatives. In those days, the city was a collection of isolated villages widely separated and at times almost inaccessible. Under such conditions, large receptions and dinners were rare.

Times changed and so did the nation's capital. Later in the 19th century, a series of State Dinners were held every winter social season to honor Congress, the Supreme Court, and members of the diplomatic community. In recent times, the term "State Dinner" has come to mean more specifically a dinner hosted by the president with a foreign head of state as the guest of honor. The event is orchestrated and paid for by the Department of State. The first ruling monarch to attend a State Dinner at the White House was King David Kalakaua of the Sandwich Islands (Hawaii), hosted by Ulysses and Julia Grant on December 22, 1874.

In 2011, President Barack Obama and First Lady Michelle Obama welcome President Hu Jintao of China at the North Portico, where heads of state are formally greeted.

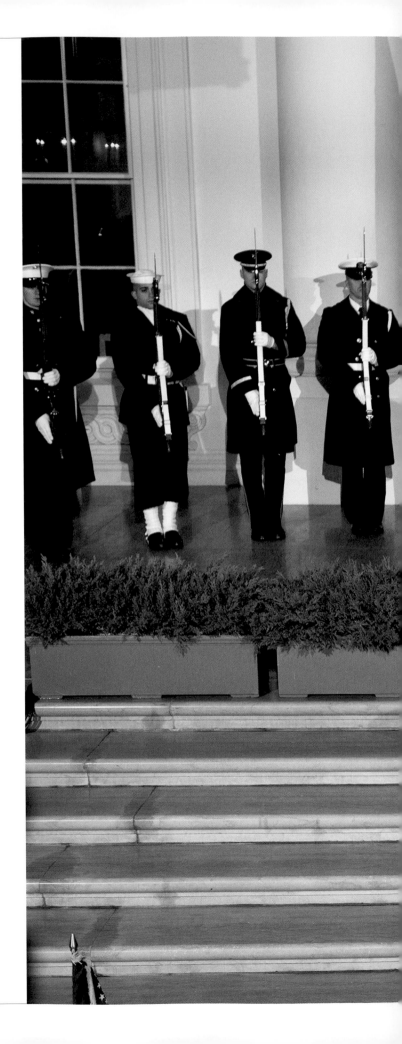

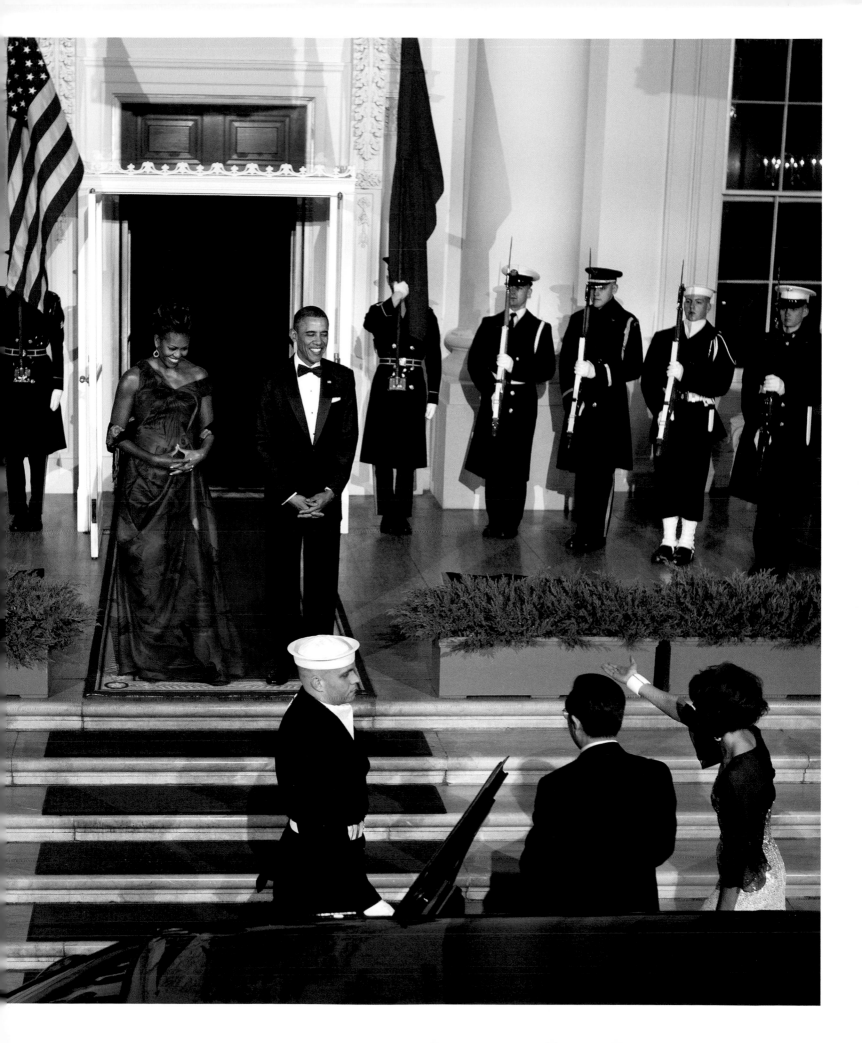

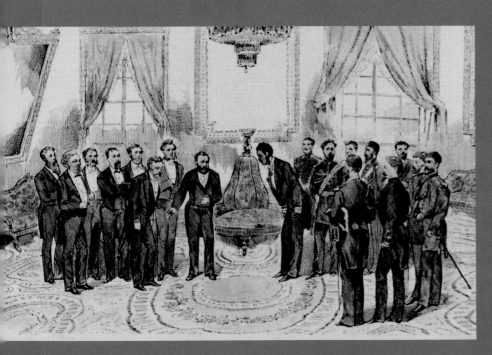

King David Kalakaua, Sandwich Islands (Hawaii), meets President Ulysses S. Grant.

THE FIRST DINNER FOR A HEAD OF STATE

The first White House State Dinner—hosted by the president for a foreign head of state as the guest of honor—was held by Ulysses S. Grant for King David Kalakaua of the Sandwich Islands (Hawaii) on December 22, 1874. The *Washington Evening Star* called dinner "brilliant beyond all precedent." The Monroe plateau, a horizontal mirror running the length of the State Dining Room's table, was adorned with flower-filled gilt bouquets. The 36 guests were served more than 20 courses of French cuisine, washed down with champagne, claret, sherry, and water. King Kalakaua ate no food until it was inspected by a royal cupbearer, who stood behind the king's chair.

President Franklin D. Roosevelt (opposite) holds a copy of the United Nations Declaration signed by Bolivian president Enrique Penaranda, to his right, at a State Dinner in 1943. The china made by the Lenox Company in 1952 (right) was first used by President Harry S. Truman at a dinner for Queen Juliana and Prince Bernhard of the Netherlands.

The restoration of the White House in 1902 created a then up-to-date elegance appropriate to the nation's official entertaining. Moving the president's office to the newly constructed West Wing and remodeling the mansion's State Rooms in neoclassical style gave Theodore Roosevelt a perfect setting that reflected the growing power and influence of the United States.

Elaborate entertaining has been very rare in wartime. Even the traditional New Year's reception was called off by President Wilson in 1918. During World War II, there were no State Dinners, although small simple entertainments substituted, as when Marshal Ferdinand Foch visited Wilson, and Churchill visited Franklin D. Roosevelt. These were working visits with little room for showy entertainment. President Truman revived the State Dinners, but he held these affairs at Washington hotels because the White House was under reconstruction.

Setting the Tone

Presidents and first ladies tend to introduce the style of their administration by the character of their first entertainment.

The first lady and her staff attend to the elaborate planning behind the elegance and ceremony of the State Dinner, creating invitations and guest lists, deciding upon menus, flowers, table settings, seating arrangements, and the entertainment that will conclude the evening. The first lady works closely with her social secretary and the executive residence staff. One major player outside the White House is the Department of State's Office of the Chief of Protocol.

The White House goes to extraordinary lengths to make the visiting head of state feel at home, researching his or her likes and dislikes, discovering themes that reflect the heritage of the country, and serving food and arranging decor that not only hints of that cultural pride, but also does not challenge the traditions of the guest of honor. Established February 4, 1928, the head of the protocol office carries the title "Chief of Protocol of the White House." Since 1961, the chief of protocol has had the rank of an ambassador, requiring the president's nominee to be confirmed by the Senate.

Behind the festive gloss of the social scene, the important business of government unfolds: Information is gathered, opinions are exchanged, powerful connections are made, and appearances are upheld. The State Dining Room seats 140 people and must accommodate the official party and an equal number of administration people, leaving space for 40 additional couples. That's not many when you consider people who must be invited, as well as people who would stimulate interesting conversation and make the evening enjoyable one-on-one.

Elegant Dining

During the Kennedy administration, the U- or T-shaped table traditionally used in the State Dining Room or East Room was replaced by round tables that seated 10 or 12. Originally introduced by Theodore Roosevelt, this arrangement of separate tables freed up seating so each of the tables could feature a high-ranking guest as a host, with the president and first lady also seated at separate tables, drawing them closer to the guests. Such an arrangement allows conversation with dinner mates all around the table, not just to each person's right or left.

Although engaging conversation is important, it wouldn't be a State Dinner without food. Kennedy's French chef, René Verdon, provided the inspiration for haute cuisine that affected American notions about the sophistication of food. In the past, State Dinners were often catered, but since the Kennedy administration, full-time executive chefs have been employed to manage the White House table. Walter Scheib, executive chef

Violinists from the United States Marine Band disperse throughout the State Dining Room and perform for the seated guests around the candlelit tables. The Marine Band made its White House debut at John and Abigail Adams's first New Year's Day reception in 1801. Known as "The President's Own" after the title bestowed on them by Thomas Jefferson in 1803, members of the Marine Band are called upon by the White House to perform at welcoming ceremonies, State Dinners, receptions, and other official functions.

> *Music will always be a vital part of the American adventure of discovery, and the White House will remain a prime mover in the voyage.*
>
> ELISE K. KIRK, *Music at the White House*, 1986

from 1994 to 2005, recalled his experience of State Dinners: "You know, while it's called a State Dinner, I think it really is more like a Broadway play in terms of all the different components that come into it to make it work. There are literally thousands of people involved and the chefs are one component of that."

The Carters retained the Kennedy seating arrangements of the round tables, but kept themselves and other couples together at a table.

The logistical details have become ever more intricate, but receptions and dinners have been and remain at the heart of White House entertaining since John and Abigail Adams occupied the house in 1800. Fittingly, on November 9, 2000, Bill and Hillary Clinton hosted a historic dinner in celebration of 200 years of presidential occupancy of the White House, when they gathered the nine living presidents and first ladies, the most ever assembled in one place. They seated the dinner in the East Room, watched over by the Stuart portrait of George Washington, the first president.

Today, dinners may be held inside or outside. Barack and Michelle Obama dined under a tent on the South Lawn on the evening of November 24, 2009, with Prime Minister Manmohan Singh of India and his wife, Gursharan Kaur. The evening was a brilliant success both socially and, as it turned out, diplomatically. The Obamas' style favors a relaxed atmosphere at outdoor State Dinners, which can be a magical night under the stars. They also held a beautiful event of this character for German chancellor Angela Merkel in the Rose Garden in June 2011. ★

Teas, Receptions, and Garden Parties

HOSPITALITY MAKES HISTORY AT THE WHITE HOUSE. Every president knows the importance of making a good impression while entertaining, and the leader of the United States and the first lady are seen the most favorably close-up, when conducting social calls, teas, and receptions. Such affairs are less formal than State Dinners, and on occasion welcome large crowds of people. Over the years, these smaller, less momentous events have provided an opportunity for people from all walks of life to come in close contact with the president at the White House.

In earlier eras, afternoon teas were weekly events at the White House during the social season, December to May. They provided large crowds with the social distinction of a White House invitation. A visitor to Washington could leave a calling card at the door and expect to receive an invitation to a White House tea. Edith Roosevelt perfected the political art of the tea by inviting 300 to 600 people by handsome, engraved invitation to each event. The teas lasted from two until four with coffee, tea, punch, and cakes splendidly presented on the long State Dining Room table. No alcohol was served. The ladies were allowed to walk through the State Rooms and enjoy the music. Social secretary Isabella Hagner scrutinized the lists. Female guests were expected to wear hats, while male guests wore business attire.

In 1929, the first lady's teas, usually covered in the society news, made front-page headlines by breaking a long White House tradition of racial segregation. Lou Hoover invited the wives of U.S. congressmen to the White House, as was customary. The guests included Jessie DePriest, the wife of Illinois congressman Oscar DePriest, the first African American man elected to Congress in the 20th century. No black person had been entertained at the White House since Booker T. Washington's dinner with Theodore Roosevelt in 1901. It was a courtesy that ignited a firestorm of newspaper protest. As the women assembled for tea in the Red Room, Ike Hoover, White House chief usher (unrelated to the president), noted that "Mrs. DePriest conducted herself with perfect propriety. She really seemed the most composed one in the group." Public reaction was far less complimentary. Southern newspaper editors accused the first lady of "defiling" the White House. Lou Hoover's secretary, Ruth Fesler, later recalled that the first lady "stood her ground; she had done the right thing and she knew it."

Although Eleanor Roosevelt held to long-established customs of proper invitations, cards, and seating charts, she greatly expanded the size of teas and garden parties. They were less social affairs and more public occasions as thousands of people were entertained each week. She held two tea parties almost every afternoon, with 500 and sometimes as many as a 1,000 people attending each one. The first lady moved through the crowd and had the remarkable ability to make the guests feel they had spoken intimately with her.

A page from the 1806 dinner guest lists of Thomas Jefferson in his own hand (opposite) shows the president's attention to planning. This tea set (above) was a gift to Franklin D. Roosevelt from Crown Prince Olav and Princess Märtha of Norway in 1939.

Receptions

Receptions involve the president as well as the first lady. The Wednesday drawing rooms begun at the White House in 1809 are still legendary. The Madisons created a stage for presidential entertaining on a grand scale that was both formal and informal. Their guests moved freely about in a stunning suite of three rooms that had been redecorated by Dolley Madison and the architect Benjamin Henry Latrobe. Key to the success of these events was Dolley Madison herself. Kindhearted and open, she made everyone feel welcome and ready to have a good time. Beneath the surface, no event could have been more political. Opposing factions were brought together in civility, if not friendship, and the Madisons acted as a team to advance the administration's goals.

The Polks established a more orderly, simple form of state ceremony at receptions and dinner parties. At larger events, moving people from the reception room to a dinner table or refreshments could create confusion. So Sarah Polk devised a "figure" or march to organize the movement of the guests. She is also usually credited with introducing "Hail to the Chief," an old Scottish martial anthem she had learned as a schoolgirl, as the music the Marine Band would play to announce the arrival of the president. James K. Polk was modest and unassuming and not a physically impressive man, so with this fanfare it no longer mattered if the president were short and stout or tall and splendid.

Establishing Social Procedures

Theodore Roosevelt's receptions reflected an entirely new tone. He is famous for his exuberance, entertaining the Rough Riders from the Spanish-American War in a reunion at the White House and holding an exhibition of Japanese jujitsu in the East Room. However, Roosevelt also established the social protocol and procedures for White House receptions that have become customary. After the 1902 renovation of the house,

the White House had two major entrances. For the first time, special or diplomatic guests entered from beneath the South Portico, passing through the renovated basement Oval Room and up an elevator eight at a time to the State Floor. Other guests entered from the new east entrance through the terrace and up the stairs to the State Floor. Another change was the appearance of military aides in dress uniform to assist and escort guests.

Roosevelt also introduced a substantial procession of the president and his official party from the private quarters down a main staircase and into the Blue Room to receive guests. There had always been a strained effort to make great events seem homey, and critics found the new pageantry "imperial" or "kingly." Nonetheless, at this point, elegance had become important and receptions were seen for what they really were, ceremonial performances serving to bring the guests into personal contact with the head of state.

Ceremonial forms in the White House have changed little since 1902. Some presidents—including all of the more recent ones—have rejected Theodore Roosevelt's grand march down the main staircase in favor of the elevator, and Franklin D. Roosevelt had to use the elevator, so the march has not been used for many years. However, the military aides still receive minute directions for preparations and timing of the event.

Garden Parties

An important addition to the social season and the first lady's entertaining options was the White House garden party. First Lady Julia Grant began the tradition in the 1870s. Edith Roosevelt expanded the guest list to more than 600. After passing through the receiving line, guests would gather on the broad South Lawn. Refreshments

A line of 3,303 people waited to shake hands with Calvin Coolidge at a New Year's reception in 1927. The presidential tradition of greeting the public on New Year's Day ended in 1932.

were served from two open-sided canvas tents under the trees, and the Marine Band played popular music.

Garden parties were one of Helen Taft's favorite ways to entertain, reminding her of the cherished years she spent in the Philippines when her husband served as civil governor. The Tafts held the grandest of all garden parties, inviting as many as 8,000 guests to an evening celebration of their silver wedding anniversary in 1911 on the South Grounds. The Wilson, Harding, Coolidge, and Hoover administrations all held annual spring garden parties; one was always scheduled for veterans. Eleanor Roosevelt continued that tradition and also used the outdoor events to greet and honor civic groups and organizations at the White House. The Roosevelts' housekeeper, Elizabeth Nesbitt, recalled that more than 3,000 sandwiches were made for such occasions. In recent times, George W. Bush and Laura Bush have added festive Cinco de Mayo parties in the Rose Garden. Michelle Obama put a new twist on the tradition: She held a harvest garden party in 2009, with students from Washington's Bancroft and Kimball Elementary Schools who had helped plant the White House vegetable garden. ★

Celebrity Guests

THE WHITE HOUSE HAS NO TROUBLE ATTRACTING celebrities of all types to events. Performers with a variety of talents—musicians, singers, dancers, actors, comedians, and writers— all have appeared at the chief executive's home, as guests and as entertainers. It's an honor for many of the most notable artists to appear in the ultimate celebrity's house before an exclusive audience with a built-in appreciation of their craft.

The most famous American author of the early 19th century was Washington Irving, who visited two presidents, James Madison and Millard Fillmore. Irving seemed startled at his reception in Dolley Madison's drawing room, where he was graciously received. Some 40 years later, Irving met with President Millard Fillmore, and was again surprised at the informality of the reception: "I met with many interesting people there . . . but I had to shake hands with every man, woman, and child."

Also visiting the White House in the early 19th century was American novelist James Fenimore Cooper, who was the guest of James and Elizabeth Monroe on several occasions. The first visit was short, he related, but polite. "Colonel Monroe received us politely, but with an American gravity," wrote Cooper, author of *The Last of the Mohicans*, and that, "He offered his hand to me." Cooper attended a dinner where he found the furnishings "neat, sufficiently rich, without being at all magnificent, and, on the whole, very much like a similar apartment in the house of a man of rank and fortune in Europe."

Singer Beyoncé performs at a State Dinner for President Felipe Calderon of Mexico in 2010.

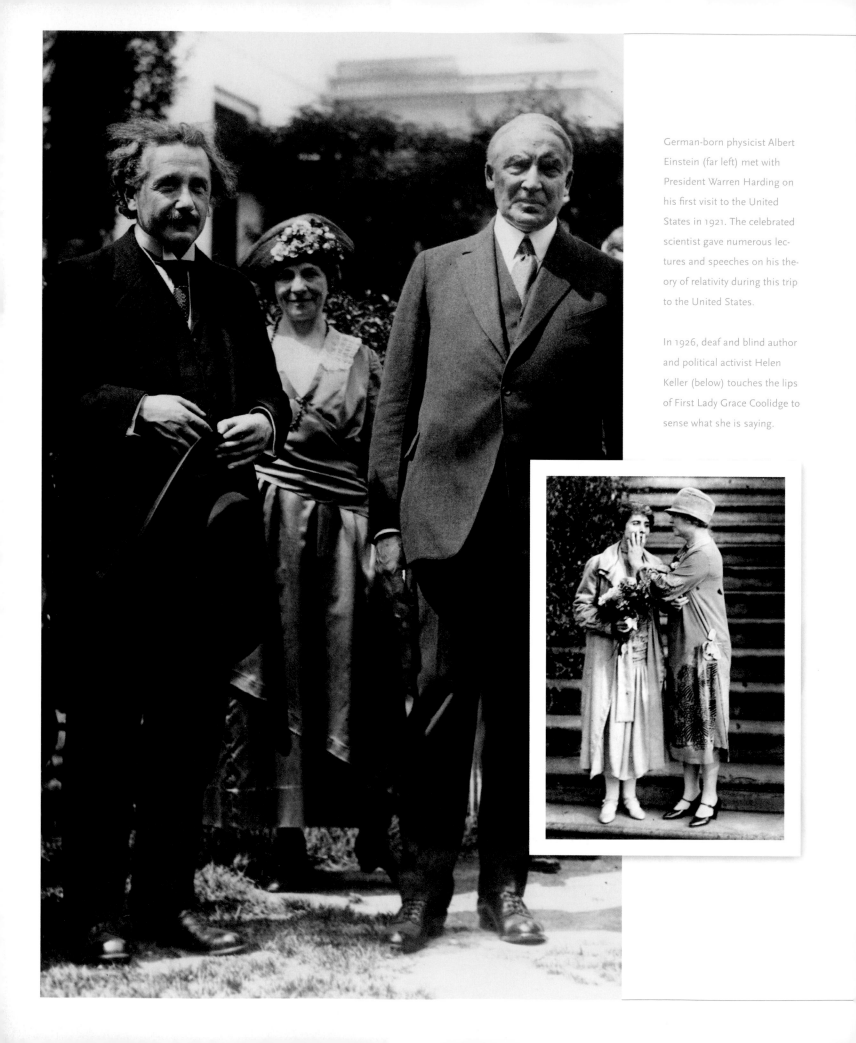

German-born physicist Albert Einstein (far left) met with President Warren Harding on his first visit to the United States in 1921. The celebrated scientist gave numerous lectures and speeches on his theory of relativity during this trip to the United States.

In 1926, deaf and blind author and political activist Helen Keller (below) touches the lips of First Lady Grace Coolidge to sense what she is saying.

President Andrew Jackson had received Fanny Kemble, a notable British actress on tour in the United States, at the White House in 1833. She would marry and later divorce Pierce Butler, a Georgia planter, and recorded her experiences in an influential antislavery tract, *Journal of a Residence on a Georgian Plantation in 1838–1839*, published during the Civil War. In 1842, Charles Dickens, already one of Britain's most celebrated authors, toured the United States. In Washington, he met with President John Tyler and attended an evening reception at the White House.

During the Fillmore administration, the famous diva Jenny Lind, known as the Swedish Nightingale, visited the White House in 1850. The Fillmore family attended both of her concerts at the National Hall to benefit the Washington Monument fund.

Photo Opportunities

With the growth of illustrated newspapers, magazines, and mass media in the 20th century, performers have become more visible and socially influential. Cameras greatly increased the exposure and power of celebrity. First Ladies Florence Harding, Grace Coolidge, and Lou Hoover all wielded cameras, snapping pictures of guests and events. Presidents in an age of mass media saw that it was important that they be photographed with people in the news and use new forms of communication technology, including radio and newsreels, to get their message out to the American people. Posed portraits, such as the one of Herbert Hoover presenting the National Geographic Society Special Gold Medal to Amelia Earhart in June 1932 to commemorate her nonstop solo flight across the Atlantic Ocean, may now seem quaint to the modern eye, although visits from celebrities to the White House still produce plenty of photos.

Black Entertainers and Advisers

African Americans were welcomed as entertainers before the Civil War, but invitations as guests were slow to appear from the President's House. Young coloratura soprano Marie Selika in 1878 became the first African American to present a White House musicale. Abraham Lincoln met abolitionist Sojourner Truth at the White House, a visit made famous in an 1893 artist's depiction

Movie stars, entertainers, and other celebrities are welcomed to the White House for the glamour and glitz they bring to a state occasion. Often the A-list celebrities are invited at the behest of a visiting foreign head of state. Celebrities can help raise money for campaigns, and others drop by for behind-the-scenes tours or to promote a cause.

Barack and Michelle Obama, like Ronald and Nancy Reagan and many other presidents and first ladies before them, have used the White House as a platform to promote cultural events and charitable causes. A Hollywood cavalcade of stars—James Cagney, Kathryn Grayson, Betty Hutton, Lucille Ball, Greer Garson, Jose Iturbi, Fred Astaire, Harpo Marx, Mickey Rooney, and Paul Henreid—put the spotlight on a savings bond drive in 1943. Judy Garland, Danny Kaye, and Carol Burnett visited in 1962, and were photographed with John F. Kennedy to promote fund-raising for the Joseph P. Kennedy, Jr., Foundation, which aimed to raise awareness of severe learning disabilities. Singer Bono of U2 has promoted global development and the fight against AIDS in Africa. Leonardo DiCaprio discussed the environment with Obama.

Not all visits have focused on serious topics. Warren G. Harding hosted movie stars Dorothy and Lillian Gish and director D. W. Griffith at the White House, as well as circus giant George Auger, who held two "midgets" named Harry and Gracie Doll. Vaudeville singer Al Jolson and a chorus of Broadway theatrical stars came to a campaign rally for Calvin Coolidge on the South Lawn in 1924. Franklin D. Roosevelt entertained Jean Harlow and Robert Taylor at a luncheon in 1934, and enthusiastically collected Mae West's scripts.

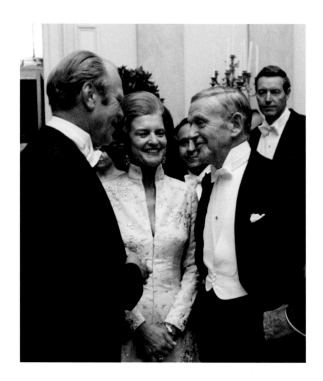

of them together examining a Bible. Frederick Douglass, the most famous African American of his time and the father of the civil rights movement, advised Lincoln on issues surrounding emancipation. Theodore Roosevelt invited black educator Booker T. Washington to dinner in the first year of his presidency. One of the most memorable performances in White House history was Marian Anderson's rendition of Schubert's "Ave Maria" as the culmination of a gala "Evening of American Music" presented for King George VI and Queen Elizabeth by Franklin and Eleanor Roosevelt in 1939. Martin Luther King, Jr., regularly advised the Kennedy and Johnson administrations and was in the East Room to witness the signing of the Civil Rights Act of 1964, a law that was a major victory in the struggle for racial equality.

Nobel Laureates

John F. Kennedy and Jacqueline Kennedy celebrated at the White House on April 29, 1962, by hosting a dinner for all the living Nobel laureates of the Western Hemisphere at one of the largest formal gatherings ever held at the White House. Included were poets Robert Frost and John Dos Passos; writers James Baldwin, William Styron, and Pearl S. Buck; scientist J. Robert Oppenheimer; and doctor Linus Pauling. The widows of Ernest Hemingway and George C. Marshall represented their husbands as guests of honor. Actor Fredric March read excerpts from the works of Sinclair Lewis, Hemingway, and Marshall.

The president welcomed his guests: "I think this is the most extraordinary collection of talent, of human knowledge, that has ever been gathered together at the White House, with the possible exception of when Thomas Jefferson dined alone."

Arts and Jazz

In 1965, Lyndon and Lady Bird Johnson held the first White House Festival of the Arts, which exhibited contemporary American work in sculpture in the East Garden. Programs of poetry, prose, jazz, drama, ballet, and symphony were presented during the day, and that evening, a concert was held in a half-shell bandstand, followed by a buffet supper on the South Lawn. The guest list was a roster of who's who in the world of literature and the arts. The first lady greatly enjoyed sitting between actor Gene Kelly and photographer Edward Steichen.

Richard Nixon had a 70th birthday party for Duke Ellington, with performances by Dizzy Gillespie, Dave Brubeck, Mahalia Jackson, Benny Goodman, and Richard Rogers. Concerts also took place outdoors; in June 1978, an all-star jazz festival was held on the South Lawn featuring legends including Eubie Blake, George Benson, Chick Corea, Herbie Hancock, Pearl Bailey, Stan Getz, Clark Perry, Mary Lou Williams, and others.

At an April 1975 State Dinner for the Zambian president Kenneth Kaunda, President Gerald Ford, who had once heard that Kaunda played guitar, asked whether he would perform. Kaunda complied, his wife sang, and 22 members of his entourage joined the couple on stage and sang a song that Kaunda had composed. No one could ever remember when a head of state had performed at the White House before.

Ronald Reagan brought many popular performers to the White House, including friends Sammy Davis, Jr., Dean Martin, and Frank Sinatra. Sinatra provided the entertainment for the 1982 State Dinner for President Alessandro Pertini of Italy. One particularly great evening of the Reagan presidency was the 1987 State Dinner for the Gorbachevs that featured a performance of a Rachmaninoff piece and "Moscow Nights" by renowned pianist Van Cliburn. ★

Music and Entertainment

THE WHITE HOUSE HAS BECOME one of the most significant stages for the performing arts in the nation. Performances by American and international artists at the White House have often reflected the musical tastes of first families. "The White House has been a showcase for the performing arts and has vividly mirrored American life from its earliest days," according to Elise K. Kirk, author of *Musical Highlights from the White House.*

Music including folk, country, gospel, and classical has been heard in the East Room or on the South Lawn. The Hutchinson Family Singers, one of the most popular singing groups of the 19th century, delivered political, comic, dramatic, and sentimental songs for seven presidents. The Fisk Jubilee Singers sang spirituals for Chester Arthur in 1882.

By inviting the media to White House cultural events, John F. Kennedy and Jacqueline Kennedy placed a spotlight on the White House. Grace Bumbry, the African American Wagnerian singer, made her American debut in 1962 in the East Room. Actor Basil Rathbone recited the "St. Crispin's Day Speech" from Shakespeare's *Henry V* during an evening of Elizabethan drama and music in May 1963.

The poised and cultured Edith Roosevelt secured the tradition of musicales after State Dinners, with eight musical programs held every year during her husband Theodore's administration. She moved a gold Steinway grand piano—the company's 100,000th—into the East Room in January 1903. The case was decorated with the coats of arms of the original 13 states. Beneath the lid was a painting of the young republic of America receiving the nine muses. Concert pianists

Cellist Pablo Casals, 85 years old in 1961, bows after a solo concert for John F. Kennedy, Jacqueline Kennedy, and guests in the East Room.

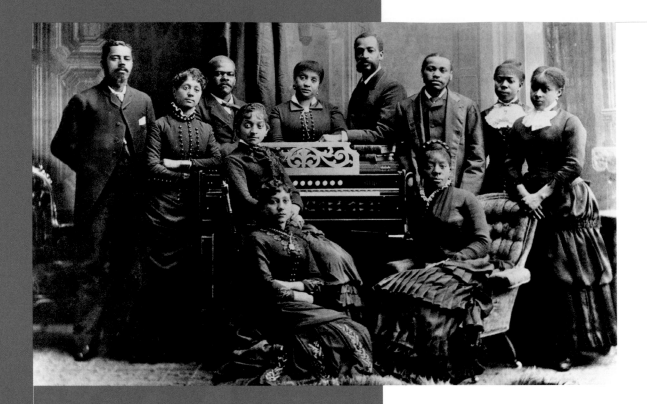

BLACK HEADLINERS IN THE 19TH CENTURY

Black entertainers have been headliners at the White House since the mid-19th century. In 1860, pianist Thomas Greene Bethune, called "Blind Tom," was the first black artist to perform at the White House. He is said to have played with the virtuosity of Mozart. One of the outstanding entertainers of the Hayes administration was the brilliant coloratura soprano Marie Selika, who in 1878 appears to have been the earliest African American artist to have presented a White House musical program, including Verdi's "Ernani, involami," Harrison Millard's "Ave Maria," and Richard Mulder's "Staccato Polka." The Fisk Jubilee Singers introduced the spiritual as an American art form and visited the White House as part of an 1882 tour to raise funds for Fisk University. Their performance of "Safe in the Arms of Jesus" moved President Chester A. Arthur to tears.

The Fisk Jubilee Singers appeared at the White House in 1882.

Josef Hofmann and Ignacy Paderewski performed in the Roosevelt White House along with Spanish cellist Pablo Casals. Remarkably, Casals returned more than a half century later to play for John F. Kennedy and Jacqueline Kennedy.

Presidents and First Ladies Who Played

Presidents have enjoyed music and have sometimes played instruments. Thomas Jefferson considered music "the favorite passion of my soul" and often played the violin, as did John Tyler. Louisa Adams, wife of John Quincy Adams, plucked the harp. Helen Taft was a fine amateur pianist who practiced almost every day on her Baldwin piano in the Blue Room, also called "Mrs. Taft's Music Room." Taft himself preferred opera on the Victrola.

Florence Harding studied classical piano in her late teens and for a time gave piano lessons in her hometown. Legendary singer, comedian, and Broadway actor Al Jolson helped Calvin Coolidge launch his 1924 election campaign at a White House pancake breakfast. Sergei Rachmaninoff played in the White House on three separate occasions for the Coolidges. During the long administration of Franklin D. Roosevelt, more than 300 concerts were performed, including women's musical organizations, black performers (notably Todd Duncan and Marian Anderson), ballet and modern dance (Martha Graham), and children's opera (*Hansel and Gretel*).

Sometimes the presidents provided the entertainment. Harry Truman played Paderewski's Minuet in G on the piano for President Kennedy and guests in November 1961. In 1978, Jimmy Carter joined trumpeter Dizzy Gillespie and drummer Max Roach to sing an impromptu rendition of Gillespie's bebop melody "Salt Peanuts" at a White House Jazz Festival. Bill Clinton played saxophone, and Barack Obama sang at a gathering of his supporters, demonstrating a smooth baritone.

In Performance

The most important Executive Mansion musical event in the modern era was the initiation of the PBS television series "In Performance at the White House," begun by Jimmy and Rosalynn Carter. In 1978, five one-hour concerts were broadcast nationally and to Europe from the East Room, demonstrating the talents of

Jamming with fellow musicians, President Bill Clinton plays saxophone at the 40th anniversary of the Newport Jazz Festival in 1993.

Vladimir Horowitz, Leontyne Price, Mikhail Baryshnikov with Patricia McBride, Mstislav Rostropovich, and Andres Segovia.

During Ronald Reagan's two administrations, "In Performance at the White House" broadened to include not only classical styles as seen under the Carters, but also Broadway, country, jazz, and gospel. Artists such as Pinchas Zukerman (1982), Frank Sinatra (1982), Jessye Norman (1986), Lionel Hampton (1987), and others continued the long tradition of brief after-dinner concerts held in the East Room.

Speaking on the program on August 10, 1988, Nancy Reagan said, "Ever since this wonderful house was built, it has been filled with music. Thomas Jefferson played his violin and Harry Truman played his piano in this [East] room . . . The Marine Band has serenaded countless foreign dignitaries at State Dinners and some of the world's most dazzling performers have appeared beneath these chandeliers." The long-running series continues to air from the White House. ★

DIPLOMACY, CEREMONY, and PERFORMANCE

VISITING DIGNITARIES ★

The STATE VISIT ★

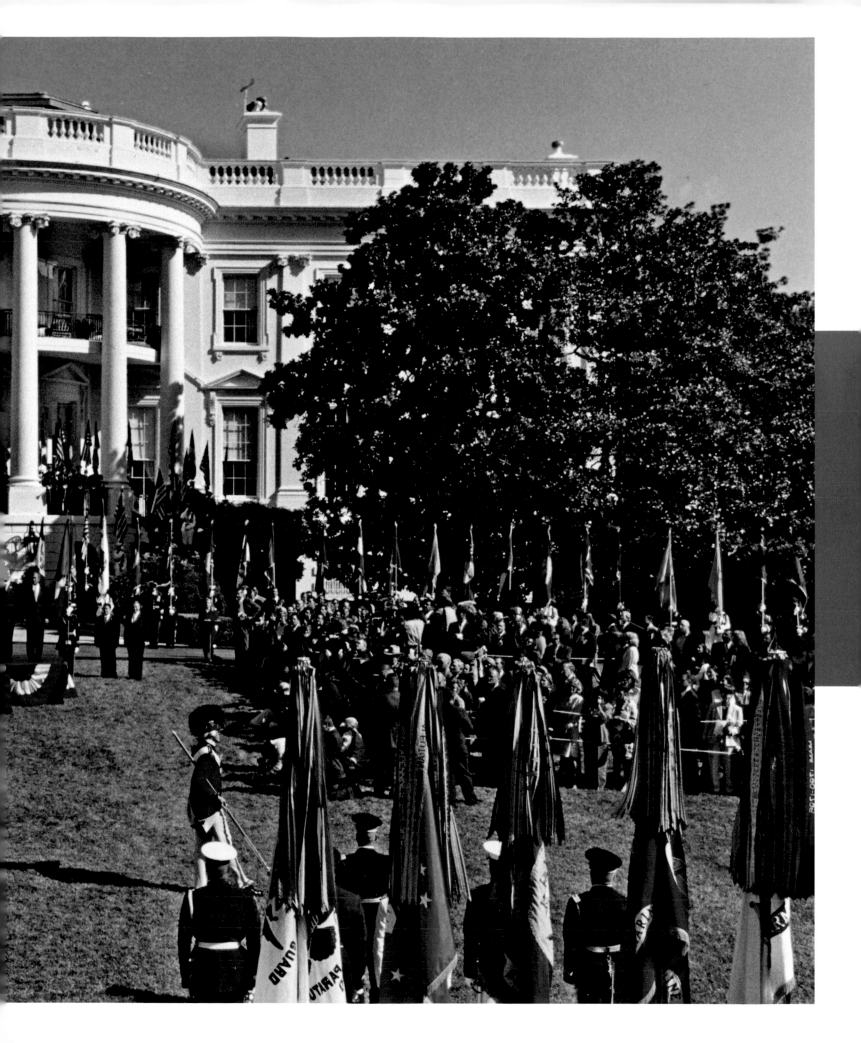

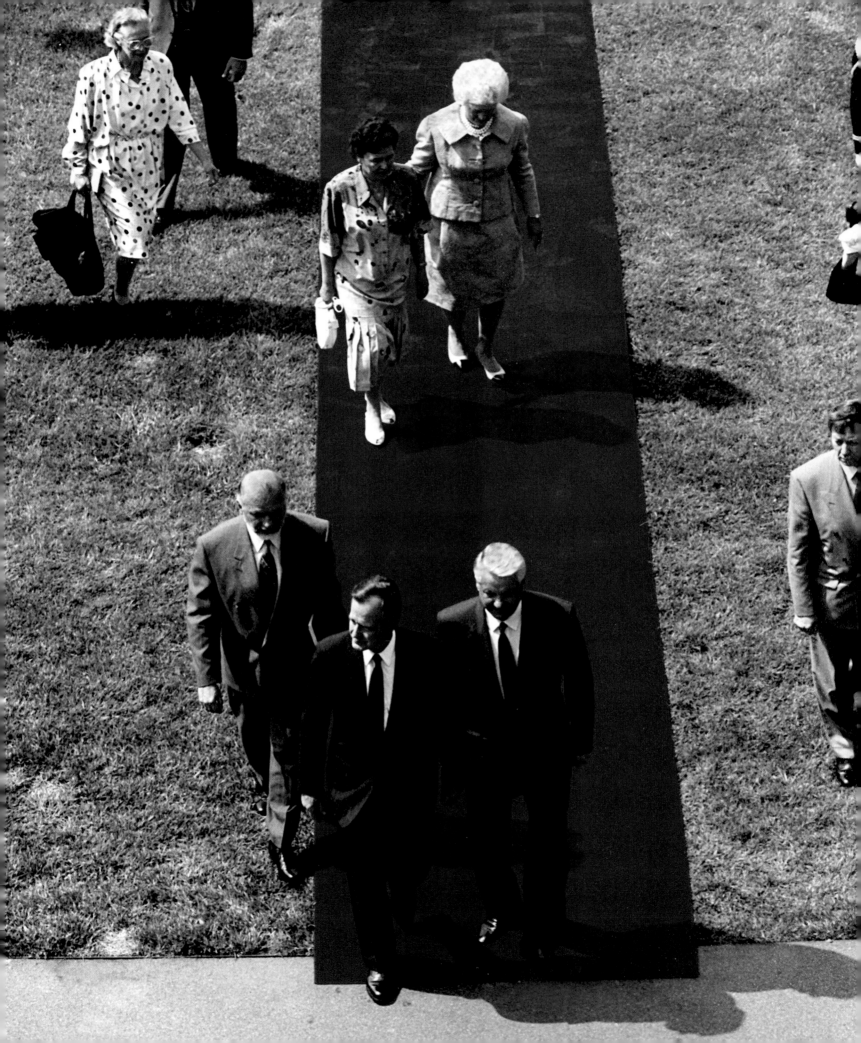

THE WHITE HOUSE HAS BEEN THE STAGE for presidents to support American diplomacy. Ceremony and musical performances filled with touches of pageantry and glamour are key ingredients to honoring dignitaries and building international relations. Foreign policy issues are strong undercurrents at all State Dinners and receptions.

Important visitors are regularly welcomed to the White House. A special Japanese delegation arrived in Washington in May 1860, in response to Commodore Matthew C. Perry's expedition to Japan and opening of trade with that nation. This was during a tense time of sectional crisis in the United States, with the nation headed toward civil war. Japan had been in isolation for centuries, and the samurai emissaries in native costume were a curiosity to Americans. President James Buchanan and U.S. diplomats received the visitors as honored guests, while the public greeted them as celebrities, exotic figures from a fairy tale. Buchanan received the Japanese delegation in the East Room. The two countries exchanged pledges of friendship. The room was so densely crowded with guests wanting to see the Japanese that ladies stood on chairs to get a better view.

Preceding pages: The Old Guard Fife and Drum Corps marches at a state arrival ceremony on the South Lawn in 2001, before President George W. Bush and President Vicente Fox of Mexico standing on the dais. Opposite: President George H. W. Bush walks with Russian president Boris Yeltsin to the White House, and First Lady Barbara Bush accompanies Naina Yeltsin during a visit in June 1992.

In the same year, Buchanan invited the Prince of Wales to the United States, not 50 years after the British had burned the White House. The cordial visit brought a period of warm diplomatic relations between Britain and the United States, which was to be temporarily chilled by Britain's accommodations of the Confederacy. With time, though, the British became one of the closest U.S. allies, and that relationship has been marked by many a visit to the White House by British government leaders and members of the royal family.

Visiting Dignitaries

AS THE HOME OF AMERICA'S CHIEF EXECUTIVE, who is also its leading diplomatic figure, the White House has long opened its doors to prominent people from foreign nations. The list of authors and diplomats, monarchs and musicians, and prime ministers and poets that have come to the White House is long and noteworthy. Countless guests have been received at the President's House to strengthen friendly ties between nations, to open dialogue, to promote cultural understanding, and to influence public opinion.

While lecturing in Washington in 1853, William Makepeace Thackeray worked with the British minister to the United States, John Crampton, to secure passage of an international copyright bill in Congress. Like many other British authors of the time, Thackeray resented that his writings were routinely pirated in cheap editions in the United States, providing him little if any compensation. Thackeray dined with President Millard Fillmore and President-elect Franklin Pierce and almost certainly brought up the issue with them. Unfortunately for Thackeray, the legislation failed to pass, and the United States would remain without a copyright law protecting foreign authors until 1891.

One of the most popular American authors of the early 19th century was Washington Irving, who visited several presidents over the decades. With James Fenimore Cooper, Irving was the first American writer to be acclaimed in Europe, where he lived from 1815 until 1832. He was also a diplomat, serving as secretary to U.S. minister to Great Britain Louis McLane in the 1830s, and as minister to Spain for four years beginning in 1842. His extensive visits to the Continent honed his social and conversational skills and made him a coveted guest.

Washington Irving (opposite), American author and U.S. minister to Spain, visited the White House several times. British writer William Makepeace Thackeray (above) was a guest of Millard Fillmore in 1853.

Charles Dickens visited the White House during a tour of the United States in 1842. He took a dim view of the office seekers milling around the president's offices and commented on the uncouth American habit of spitting tobacco juice. As for the White House social gathering, Dickens was struck by the variety of visitors and their respect for Washington Irving, who also attended the event: "I sincerely believe that in all the madness of American politics, few men would have been so earnestly, devotedly and affectionately caressed, as this most charming writer; and I have seldom respected a public assembly more, than I did this eager throng." For President John Tyler, he also had kind words; he found "his manner remarkably unaffected, gentlemanly and agreeable. I thought that in his whole carriage and demeanor he became his station singularly well."

American Diplomatic Style

The foreign diplomatic corps, used to the formality of European capitals, was not always impressed by the unpretentious clothing and simple manners some Americans adopted. Thomas Jefferson, who outwardly opposed the rigid rules of protocol common to the European courts, especially annoyed the diplomatic corps.

Although some of these diplomats may have seen his actions as personal snubs, Jefferson meant instead to illustrate that America was an unceremonious republic. What's known as the "Merry Affair" began when Great Britain's diplomatic representative,

Anthony Merry, went to the White House on November 29, 1803, to present his credentials to Jefferson. As was customary in other world capitals, he wore full, formal diplomatic uniform. Jefferson deliberately received him while wearing worn clothes and slippers. The startled British minister had recovered enough from the affront to attend a White House dinner a few days later, on December 2, only to be insulted once more. Jefferson escorted Dolley Madison—rather than Merry's wife, Elizabeth, as diplomatic etiquette demanded—to the dinner table. When Secretary of State James Madison then took Elizabeth Merry's arm and ushered her to the table, Merry was left fuming without an escort and was forced to search alone for a chair. Merry then noticed that the French chargé d'affaires and his wife had also been invited to the dinner—even though Britain and France were at war. Jefferson had little use for the delicacies of diplomatic conduct.

American author James Fenimore Cooper attempted to explain the difference to a French friend: "I have known a cartman leave his horse in the street and go into a reception room to shake hands with the President." Cooper explained that the laborer probably felt uncomfortable in his dirty clothes. The president wanted citizens to be welcome at the White House and to know that they would not be turned away as they would at a king or emperor's court.

Welcoming the World

Diplomats are schooled in adapting to new surroundings and situations. They adjusted to American customs, but considered Washington a backwater town well into the 19th century, especially during its hot, humid summers. Depending on the president and first lady, and their personal style, the White House was more or less accessible to diplomats and the public.

President James Monroe welcomed the Marquis de Lafayette to the White House as part of his famous 16-month tour between 1824 and 1825. He was given a hero's welcome in America, with numerous celebrations, parades, and dinners in cities and towns across the nation in recognition of his service in the

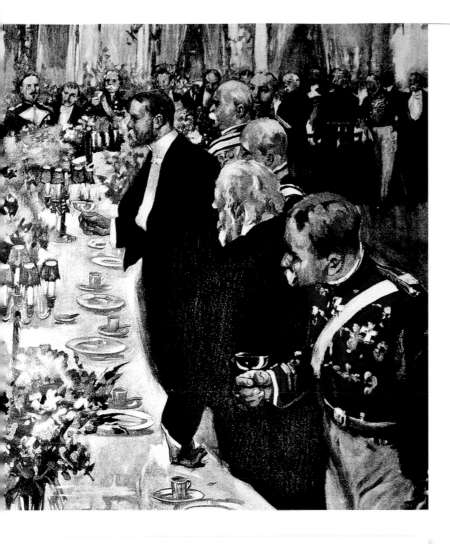

Theodore Roosevelt offers a toast to Prince Henry of Prussia, the brother of German king Wilhelm II, at an East Room dinner in 1902 (left). *Harper's Weekly* captured the elaborate lighting, floral decorations, and the pomp and circumstance of the event. In 1939, Franklin and Eleanor Roosevelt welcomed King George VI and Queen Elizabeth to the Executive Mansion. The first lady and the queen (below) rode to the White House from Union Station. Eleanor Roosevelt observed that the queen "had the most gracious manner and bowed right and left with interest." The program (opposite) with the seating plan and menu for a dinner given by Rutherford and Lucy Hayes to honor the Grand Duke Alexis of Russia and foreign diplomats in 1877.

American Revolution. Lafayette visited former president Thomas Jefferson at Monticello and was formally received at the White House by Monroe and his cabinet in December 1824, before he began the southern part of his trip. President Adams also entertained General Lafayette on his journey north before the general's return to France. A correspondent for the New York newspaper *Statesman* noted on September 9, 1825: "The most ample hospitality and attention have been sedulously attended to him in the President's mansion . . . On Friday evening the house of the President was thrown open to all citizens who wished to visit the General, of which a large number of ladies and gentlemen availed themselves."

Between 1828 and 1829, crowding at White House events was alleviated with the completion of the East Room during Andrew Jackson's first term. Congress had provided $10,000 for the decor, which included three handsome candle chandeliers, fine lemon-colored wallpaper, great pier mirrors to reflect the light, and mantels of black marble surmounted with mirrors. Jackson's levees were large, and guests at these events did not require an invitation. The rooms could be so crowded that some people who attended the event never saw the president or were able to get a glass of punch. Colorful frontier characters, such as Davy Crockett or Sam Houston, would show up and shake hands with surprised visitors. Most famously, Jackson opened the White House to the public in 1837

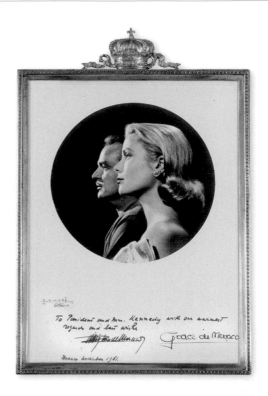

to partake of a bite of a 1,400-pound wheel of cheese. It was gone in two hours, but the odor and stain on the wooden floors lingered for several years.

As president, Martin Van Buren struck a contrast to Jackson and closed receptions to the general public with the exception of New Year's Day. Under Van Buren, the White House took on his refined manners; he entertained lavishly at small and exclusive dinners. He discarded or auctioned off worn furniture and spent $25,000 to replace it, for which his political opponents accused him of aspirations to kingliness. His costly decorations and exclusive entertaining as Americans began to feel the pinch of an economic depression became a major campaign issue.

Van Buren's successor, William Henry Harrison, won the election as a man of the people whose campaign emblem had been a log cabin. He died of pneumonia after only a month in office. Harrison's vice president, courtly John Tyler, was from an aristocratic Virginia family and entertained in a hospitable style. The Tylers staged a memorable dinner and ball for the Prince de Joinville, the son of Louis-Philippe of France,

Dwight and Mamie Eisenhower with King Frederick and Queen Ingrid of Denmark (left) before a State Dinner in 1960. An official portrait of Prince Rainier and Princess Grace of Monaco (above) was given to John F. Kennedy.

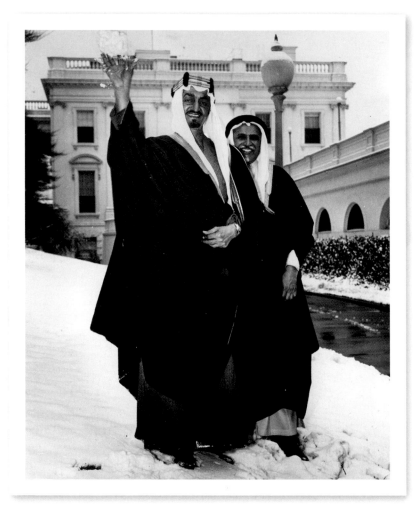

Prince Faisal of Saudi Arabia waves while standing in the snow after a meeting with President Dwight Eisenhower in March 1953. Opposite: President Bill Clinton welcomes Prime Minister Yitzhak Rabin of Israel and King Hussein of Jordan to the White House Rose Garden in 1994 for the signing of a peace treaty between Israel and Jordan.

when he visited the United States in 1841. It was attended by Daniel Webster, then the secretary of state, his wife, the other members of the cabinet, the diplomatic corps in full court dress, and army officers in full dress uniform. The president's pretty teenage daughter Elizabeth and the tall prince led a *quadrille d'honneur* in the East Room, adding merriment to a formal evening.

President James Buchanan brought to the White House his experience as minister to Russia and Great Britain, where he followed the most formal European forms of court etiquette. Buchanan was a bachelor president, but to satisfy protocol he turned to his niece, Harriet Lane, to serve as hostess at the White House.

Abraham Lincoln cared little for Washington's established forms of entertaining. His wife, however, had social ambitions in Washington and dressed in fashionable gowns with elaborate flower headdresses.

One visitor groused that she had "her bosom on exhibition, and a flower pot on her head, while there was a train of silk or satin dragging on the floor behind her." Even the president smiled at her extravagances. Elizabeth Keckley, her seamstress, recalled as Mary Lincoln prepared to descend the staircase from the family quarters for a formal dinner in a dress that had a low neckline and a long train, that Lincoln commented, "Whew, our cat has a long tail tonight! Mother, it is my opinion that if some of that tail were nearer the head it would be in better style." Yet Lincoln was a stickler for correctness in protocol and listened to his secretary of state more than to his wife.

A Prince Visits Lincoln

An August 1861 visit to the Lincoln White House by Prince Napoleon Joseph Charles Paul Bonaparte of France, cousin of Emperor Napoleon III, reflects how not since Jackson's day had social etiquette become so

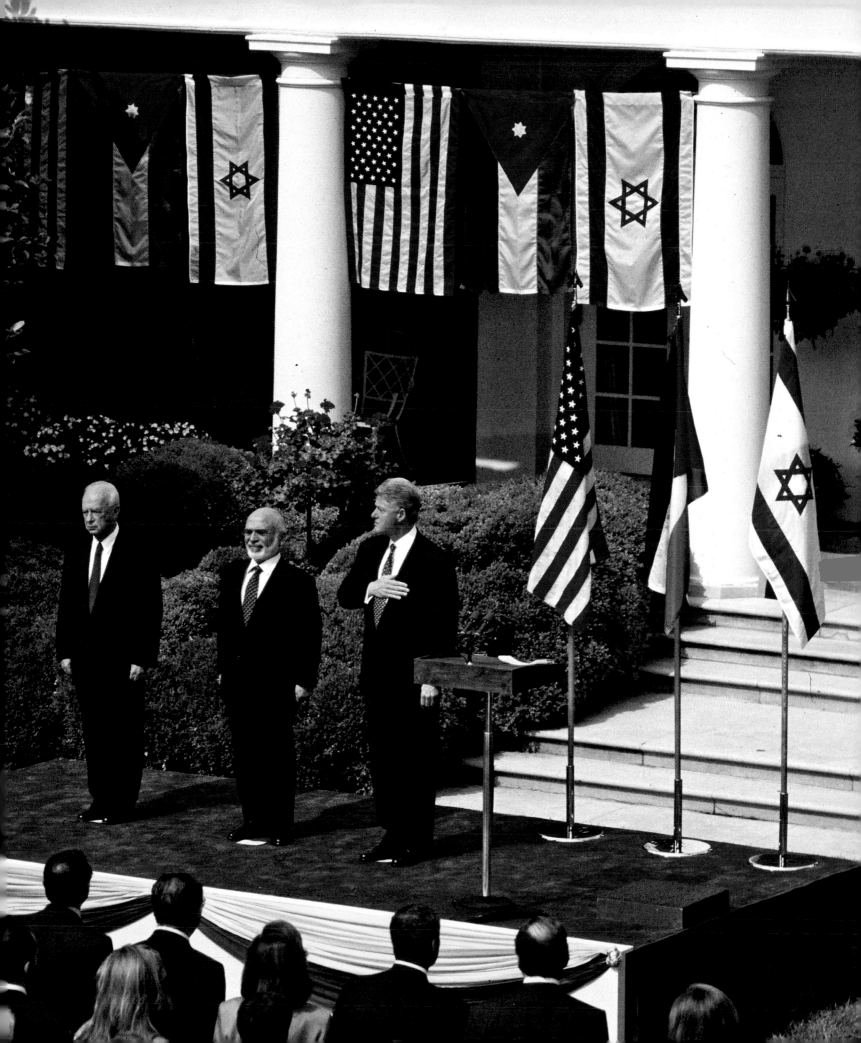

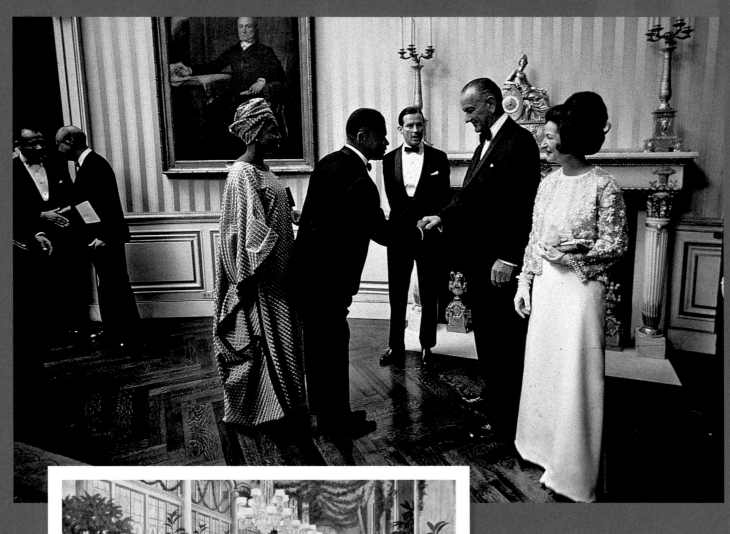

Lyndon and Lady Bird Johnson greet diplomats in the Blue Room in 1966 (above). Large State Dinners today are held in outdoor tents, but they were set up in the Cross Hall in the past, as in this 1900 print (left). Opposite: President's place card for a State Dinner.

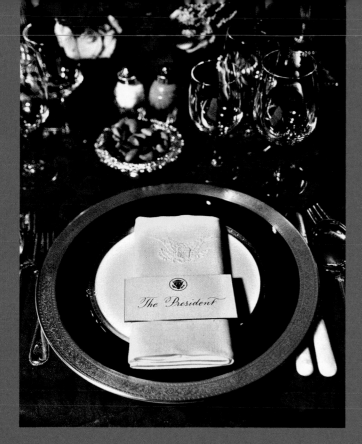

DIPLOMATIC DINNERS

It has been customary at the White House from earliest times to hold a dinner for the diplomatic community once every winter. These diplomats come to the White House dinner bedecked in full court dress. In 1911, William Howard Taft and Helen Taft entertained "the representatives of all the powers with which the United States has diplomatic relations." The Marine Band provided music throughout the evening, and after dinner the guests were entertained in the East Room with a musical program, as has been the practice for more than a hundred years.

By the 1920s, the diplomatic corps had grown so large that only heads of mission, ambassadors, ministers, and their wives received an invitation to dinner. By 1946, the official guest lists had doubled and the diplomatic dinner had to be divided into a pair of dinners. In 1965, Lyndon and Lady Bird Johnson made a concerted effort "to get to know" foreign diplomats socially through dinners and receptions and on a private basis. At that time, there were 115 embassies in Washington, and the Office of the Chief of Protocol at the State Department recorded that the president had met with each chief of mission at least two or three times. Then and now, the nation's diplomatic and political interests continue to be served right along with the presidential meals.

relaxed, and proved a fiasco. The prince and his retinue were left waiting at the front door because no butler, doorman, or valet was available to receive them; a clerk finally let them in, where they cooled their heels for 15 minutes before President Lincoln appeared. Conversation lagged badly as an awkward Lincoln tried to make small talk. At a State Dinner the next day, Mary Lincoln tried mightily to impress the prince, who wrote privately afterward of her inferior judgment in clothing and the dreadful quality of the food. When the large bill for the dinner arrived some weeks later, Mary Lincoln charged it to White House groundskeeper John Watt's expense account, sarcastically called "the manure fund."

After the period of mourning following Lincoln's assassination, the new president, Andrew Johnson, held the usual frequent dinner parties and receptions. The Johnson State Dinners were devised along traditional White House lines developed over more than 60 years. Johnson held the dinners on Tuesday evenings, usually followed by an hour of conversation in the Blue Room. These events honored Congress, the Supreme Court, military officers, and members of the diplomatic community. Large levees or receptions were held twice a month. In 1866, Johnson hosted a dinner for Queen Emma of the Sandwich Islands, now Hawaii. Queen Emma, the widow of the late king Kamehameha IV, allowed Johnson to open the reception after the dinner so that all who wished might come and greet her. During his impeachment trial in 1868, Johnson held a diplomatic reception at the White House and appeared relaxed standing next to his smiling daughter and hostess, Martha Patterson.

A Welcome for a King

Ulysses S. Grant and his wife, Julia, had a flair for entertaining and ushered in a new era of elegance. Fair and 40 and an army wife who had to adapt to frequent moves, Julia Grant greatly enjoyed her eight years at the White House. She once said her days there were "like a bright and beautiful dream . . . Life at the White House was a garden spot of orchids, it was a constant feast of cleverness and wit, a co-mingling of men who were the brainiest their states and countries could send to represent them and women unrivaled anywhere for beauty,

talent, and tact." The Grants gave a dinner every Wednesday at the White House, inviting 36 guests, the maximum the State Dining Room could accommodate at that time. Julia Grant hired a Sicilian steward, Valentino Melah, who created lavish 29-course banquets. Grant entertained important dignitaries, including Prince Arthur, the third son of Queen Victoria, as well as the first ruling monarch to visit the White House, King David Kalakaua of the Sandwich Islands, now Hawaii.

There was a remarkable change in the atmosphere of entertaining at the White House when Rutherford B. Hayes succeeded Grant. Hospitality immediately became warm and dry. Hayes banned the use of alcohol and ended the long-held custom of serving wine at a White House dinner. When Grand Duke Alexis, son of the Russian czar, was the honored dinner guest of Hayes in 1877, an exception was made for that evening. A colorful figure, Grand Duke Alexis traveled to the West and took part in a buffalo hunt with William F. Cody, known as Buffalo Bill. Chester A. Arthur entertained elegantly and often, but pared back the dinner courses to 14, with eight varieties of wine, and increased capacity by placing long tables in the East Room.

How a visit by a foreign dignitary can be both glamorous and substantive was demonstrated when Princess Eulalia of Spain came to the United States to attend the World's Fair in Chicago in 1893. Princess Eulalia's was really the first state visit with all the trimmings. Visits of state were still rare in the 19th century, and the visit of the king's daughter was a diplomatic gesture to soothe the rising tensions between the nations created by Spain's activities in Cuba. On May 26, Princess Eulalia, accompanied by her husband, Prince Antonio, and 19 Spanish nobles, attended an elegant dinner that Grover and Frances Cleveland gave to mark her visit. The evening dinner was a protocol-filled affair planned to the minute, but a mix-up in instructions occurred:

Princess Eulalia was supposed to meet the Clevelands upstairs and descend the Grand Staircase with them, but she went directly to the East Room, where she looked for the president. The Clevelands hurried downstairs when they realized the mistake and the evening proceeded smoothly. The guests sat around an I-shaped table decorated with roses of red and yellow, the national colors of Spain.

In the 1902 restoration of the White House, Theodore Roosevelt significantly expanded the size of the State Dining Room, taking the space formerly used for a private staircase on the west side of the house. This allowed a State Dinner to accommodate more than 100 guests. Roosevelt's neoclassical remodeling of the White House made it an elegant place to conduct diplomacy.

The social revolution that the Roosevelts started at the White House continued during the administration of William Howard Taft. His State Dinners were large, elaborate, and beautifully served. The biggest social event of the administration was the Taft silver wedding anniversary in June 1911, which transformed the gardens and lawn of the White House into a fairyland of Chinese lanterns, electric lights, and floral displays for 8,000 guests. Official social entertaining slowed to a leisurely pace with the scholarly Woodrow Wilson and came to halt during World War I.

Between the Wars

After the war, Calvin and Grace Coolidge entertained the Prince of Wales at a luncheon. He would become King Edward VIII, and then, after abdicating the British throne in 1936, the Duke of Windsor. Queen Marie of Romania was the guest of honor for a Coolidge State Dinner in 1926. Chief usher Ike Hoover recalled that "Silent Cal" maintained his stoic reputation despite the queen's best effort: "The dinner proper was not different from hundreds of others. Of course all eyes were on

President Ronald Reagan meets with British prime minister Margaret Thatcher on the terrace outside the Oval Office in July 1987.

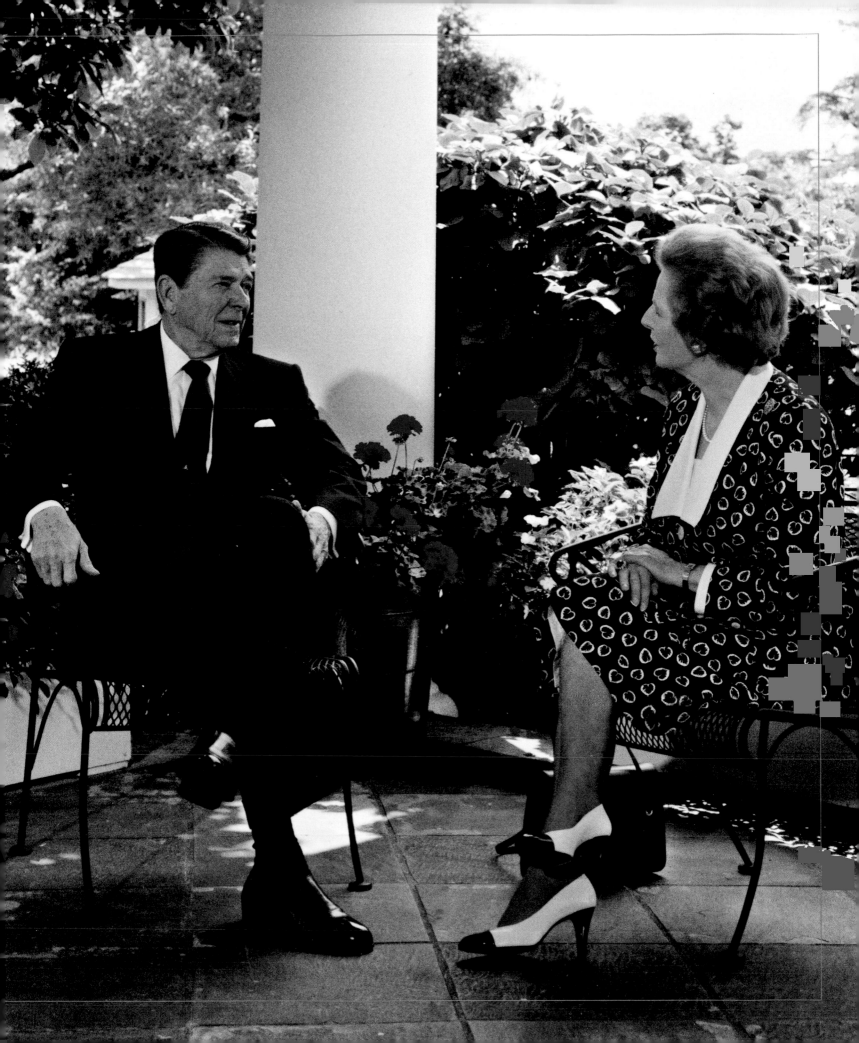

the queen, especially during her efforts to engage the president in conversation. In this she was not any more successful than others who had tried it before."

Herbert and Lou Hoover, wealthy and cosmopolitan, held a memorable state dinner for British prime minister Ramsay MacDonald in 1929 and another outstanding dinner in 1931 for the king and queen of Siam, now Thailand. The State Department suggested that the dinner called for bowing to the reigning monarch, but Hoover vetoed the idea.

Toward the beginning of the 12 years that Franklin D. Roosevelt was in office, the Roosevelts held an "open house" for friends and acquaintances. Large-scale entertaining became the order of the day, in a way that would be possible only for a wealthy president, as only State Dinners and formal receptions are paid for with

government funds. Even during the Depression, the Roosevelts also hosted State Dinners and official receptions with additional dinners for chiefs of state who visited Washington. After the State Dinners, there was music in the East Room with additional guests, sometimes as many as 200, invited to the musical program that started at 10 p.m. The most spectacular Roosevelt State Dinner honored King George VI and Queen Elizabeth, the first British monarchs to visit the White House. The royal couple arrived by train at Union Station on June 8, 1939, after weeks of transatlantic communications that preceded the visit. The State Dinner was given for the couple that evening. A crowd estimated at up to 700,000 cheered them on their way to the White House. Two years later, both nations were allied in war against Germany, Italy, and Japan.

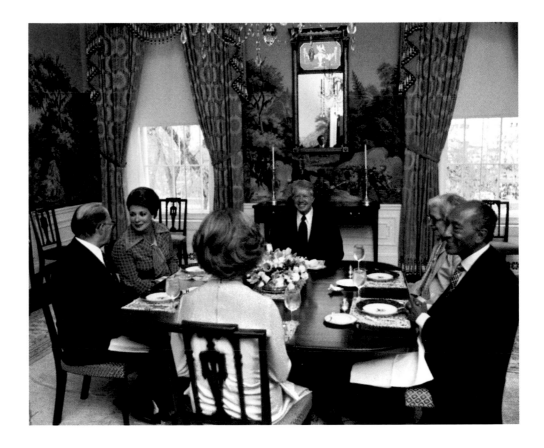

Jimmy and Rosalynn Carter host a luncheon for Egyptian president Anwar Sadat and Israeli prime minister Menachem Begin and their wives (right) before the signing of the historic Arab-Israeli peace accords on the White House South Lawn, March 29, 1979. Opposite: Trumpets, honor guards, and friendly crowds herald the arrival of Georges Pompidou, president of France, in February 1970.

President Roosevelt toasted the young monarch and cited the friendship of the Americans and the British as an example to the world of the "methods of peace, divorced from aggression." After dinner, the group was joined by 200 more people in the East Room for entertainment from opera singers, square dancers, and folksingers. The highlights of the evening were Kate Smith singing her radio theme song, "When the Moon Comes Over the Mountain," and a sublime "Ave Maria" sung by Marian Anderson. During World War II, large-scale entertaining ceased, and the social seasons were canceled. The Roosevelts did continue simpler dinners, luncheons, and teas. Prime Minister Winston Churchill was a frequent guest along with many royals, including King George of Greece, King Peter II of Yugoslavia, Queen Wilhelmina of the Netherlands, Crown Princess Martha of Norway, and others. The food was notoriously bad, thanks to Eleanor Roosevelt's kitchen economies. But then, people do not attend such dinners for the food.

The White House was a beehive of activity during Churchill's visits there. He and British cabinet members and advisers met often with President Roosevelt and his civilian and military aides. High-level British and U.S. military staffs also held meetings with Churchill and Roosevelt to hammer out a preliminary joint strategy for defeating the Axis powers. Churchill, though a congenial guest, did as he pleased. The first lady assigned the Lincoln Bedroom for Churchill's use, but he disliked its bed and instead chose the Rose Room, where Queen Elizabeth had lodged in June 1939, and sent his secretary Sir John Martin to occupy Lincoln's bed.

President Harry S. Truman reopened the White House for dinner diplomacy after World War II and actually held two diplomatic dinners in 1946, as the list of diplomats in Washington had grown too large for one event. However, the glamour of white-tie dinners gave way to serving à la buffet, and then the White House was closed during the Truman renovation, from 1949 to 1952. The Trumans moved into the much smaller Blair House across Pennsylvania Avenue. Formal dinners during that period were held at hotels. ★

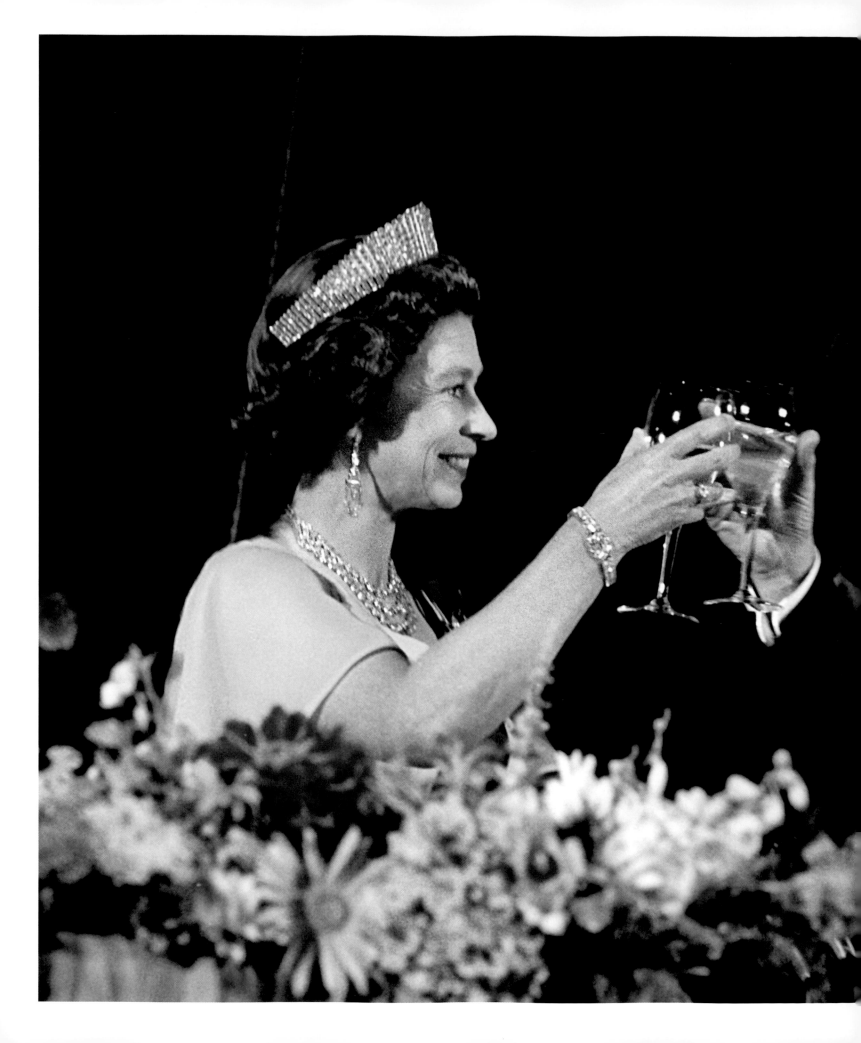

The State Visit

BEFORE WORLD WAR II, the important White House social events were annual dinners for the cabinet, the Supreme Court, the Senate and House, and the diplomatic corps. But jet travel made the world a smaller place where it no longer took weeks to travel across the Atlantic or Pacific. Visits between the president and other heads of state became more frequent, and so Dwight D. Eisenhower entertained more heads of state in the White House than any other president before him.

American diplomacy was tested when Soviet leaders came to visit the United States during the Cold War. Nikita Khrushchev, the Soviet premier, landed in Washington on September 15, 1959. At a formal White House dinner in his honor, Khrushchev arrived in a black business suit. President Eisenhower had on a white tie and tuxedo and Mamie Eisenhower wore a gold gown. Nina Khrushchev wore a plain blue-teal gown. The tables were turned, suit-wise, on the president, 156 years after Jefferson accepted the British minister's credentials in his everyday clothes. The message was plain, as Jefferson's had been: The communist leader wanted to make a statement.

Jacqueline Kennedy focused her energy on showcasing the cultural significance of the White House. The Kennedy restoration of the State Rooms created new life for the White House as home, office, and a museum of the presidency. The Kennedys held 15 State Dinners during the two years and ten months of the Kennedy presidency. One of the most notable was held for French minister of culture André Malraux. The guest list was a roll of great poets, musicians, artists,

President Gerald Ford shares a toast with Queen Elizabeth II during a State Dinner in honor of the British monarch on July 7, 1976.

GIFTS TO THE WHITE HOUSE

Most gifts to presidents become part of the collection of the Presidential Libraries. Opposite: Portrait of Amy Carter by Magdalene Schummer, 1979. Clockwise from right: Puppet forming his fingers in the familiar "V" sign was given to Richard M. Nixon by Larry N. Frost of Colorado; Texan Anthony S. Rome, Jr., sent this flag that he had flown throughout the 444-day Iranian hostage crisis to Jimmy Carter to express his support; in 1957 King Saud of Saudi Arabia gave Dwight Eisenhower this watch, painted with a portrait of himself; cowboy boots made in about 1953 were presented to Eisenhower by Zeferino and Eli Rios of Texas; Yugoslavian ambassador Sava N. Kosanovic presented *Sluzhebnik,* a rare 1519 book of the Serbian Orthodox Liturgy, to Harry S. Truman.

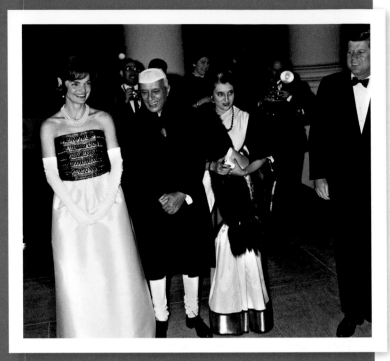

KENNEDY ENTERTAINING STYLE

John F. Kennedy and Jacqueline Kennedy insisted on excellence in whatever went on at the White House. *It had to be the best.* During their three years in the White House, the Kennedys wrote an entirely new chapter in the history of the White House as a center of the cultural and social life of the nation. It was their belief that the White House itself, with its imposing history, should be an inspiration to all Americans and a part of diplomacy. That led them to blend history and culture into the entertainment of foreign heads of state. That is why a spectacular outdoor event was held at George Washington's Mount Vernon estate for President Ayub Khan of Pakistan in 1961. President Kennedy also believed that intellectual and cultural honors were just as important to democracy as those bestowed on soldiers and statesmen, which is why he invited all the Western Hemisphere's living Nobel Prize winners to dinner in 1962.

John and Jacqueline Kennedy greet Jawaharlal Nehru, first prime minister of an independent India, and his daughter, Indira Gandhi, 1962.

actors, and authors including Robert Lowell, Leonard Bernstein, Mark Rothko, Saul Bellow, George Balanchine, Tennessee Williams, Julie Harris, and Arthur Miller.

The Texas-born Lyndon and Lady Bird Johnson were gregarious and brought a warm and informal atmosphere to the White House. So close behind the sophisticated Kennedys, they had a hard act to follow. The Johnsons proved to be innovators and gave the first State Dinner in the Rose Garden, held on a summer evening in June 1964 for Ludwig Erhard, chancellor of the Federal Republic of Germany.

Richard and Pat Nixon held numerous dinners to honor special guests from the Duke and Duchess of Windsor to Duke Ellington. The entertainment at the Duke Ellington dinner was a remarkable group of jazz legends including Dave Brubeck, Gerry Mulligan, and Earl "Fatha" Hines. The entertainment turned into a jam session that lasted until 2 a.m. Nixon played the piano and led a chorus of "Happy Birthday" for Duke Ellington, to the delight of the guests.

Bicentennial Entertaining

Gerald and Betty Ford were busy and amiable hosts during their two and a half years, including 11 State Dinners in 1976. "During the bicentennial summer, we had so many requests for State Dinners—everybody wanted to come over and wish us happy birthday—that Mrs. Ford made the decision that we would erect a very beautiful small tent in the Rose Garden," said the Fords' social secretary, Maria Downs. The Fords used that tent for an exquisite State Dinner held to honor Queen Elizabeth II on July 7, 1976. Queen Elizabeth and Prince Philip had made a special trip to commemorate America's bicentennial.

Jimmy and Rosalynn Carter opened their state entertaining at the White House by inviting

Guests socialize inside the South Lawn tent for the State Dinner in honor of Prime Minister Manmohan Singh of India and his wife, Gursharan Kaur, 2009.

Mexican president José López Portillo to Washington for their first State Dinner, in February 1977. President Carter was intent on improving relations with Latin America, and regarded Mexico, with its common border and extensive trade with the United States, as vital to diplomatic relations in the region. Rosalynn Carter had discovered that the Mexican first lady played the piano and was a great admirer of Rudolf Serkin. That evening, Serkin gave a memorable Beethoven program at the White House. Rosalynn Carter's consideration for her state guests inspired table decorations reflecting King Hussein of Jordan's love of sea sports, and crape myrtles as floral displays for Hannelore Schmidt, the wife of German chancellor Helmut Schmidt, who greatly enjoyed these colorful and long-lasting flowers.

Ronald and Nancy Reagan's first State Dinner on February 26, 1981, was for British prime minister Margaret Thatcher. Nancy Reagan was a stickler for details, and not even the smallest mistakes, such as in the spacing of silver and place settings, were tolerated. U.S.–Soviet tensions started to ease when Mikhail Gorbachev came to power in 1985. The gregarious Soviet leader was largely hailed in the West for his policy of glasnost (openness) that reduced Cold War tensions. Gorbachev visited the White House in December 1987. In addition to signing the Intermediate-Range Nuclear Forces Treaty, he attended a State Dinner where he socialized with American celebrity guests including the Reverend Billy Graham and baseball great Joe DiMaggio, made toasts with California sparkling wine, and joined pianist Van Cliburn in singing the elegiac ballad "Moscow Nights."

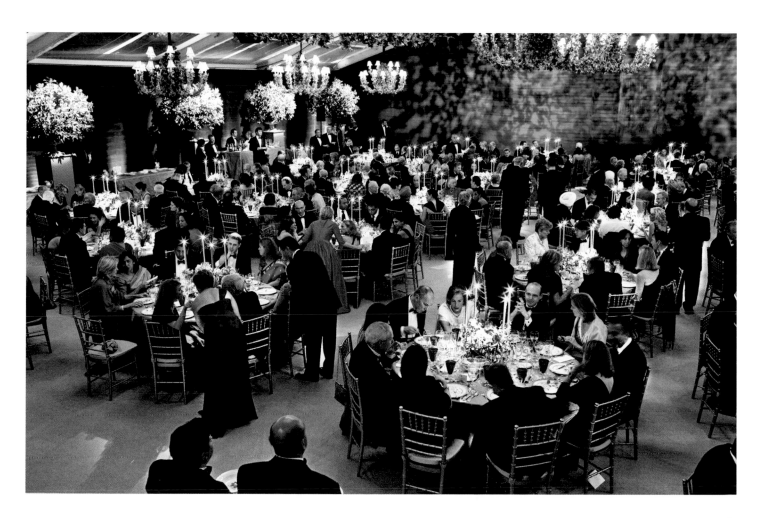

The earliest known photograph of the Marine Band (right) was taken in 1864 at the Marine Barracks in Washington, the band's home since 1801. Today's Marine Band musicians include graduates of the nation's most prestigious music schools. Once selected and enlisted, they are assigned exclusively to the band. Opposite: A cover from an 1892 concert tour program shows the band's most famous director, John Philip Sousa. In approving Sousa's request for a concert tour the previous year, President Benjamin Harrison said, "I believe the country would rather hear you than see me."

Dinner Diplomacy

George H. W. Bush entered the White House after a distinguished diplomatic career as ambassador to the United Nations and special envoy to China. He well understood dinner diplomacy. The Bushes' first three State Dinners, for Prime Minister Yitzhak Shamir of Israel, President Hosni Mubarak of Egypt, and King Hussein of Jordan, signaled the president's advocacy of Middle East peace negotiations. A grand dinner was held during Queen Elizabeth II's state visit in 1991, but her majesty's attendance at Baltimore's Memorial Stadium with the president for a baseball game was the headlined event.

Bill and Hillary Clinton's first State Dinner was held in June 1994, in honor of Emperor Akihito and Empress Michiko of Japan. The Clinton administration had 30 state dinners in eight years; the guest list was usually spiced with Hollywood celebrities and media stars. The first lady would describe the Clinton style of entertaining in *An Invitation to the White House: At Home With History,* along with the record of her efforts to preserve the mansion.

George W. and Laura Bush received more than 100 heads of state, including Pope Benedict XVI in 2008, the first official papal visit since the establishment of full diplomatic relations between the United States and the Holy See in 1984. However, most of the visits were unpublicized and intimate, held at Camp David or the Bush ranch in Crawford, Texas. The highlight of the Bushes' formal entertaining took place in May 2007, a white-tie dinner for perennial favorites Queen Elizabeth II and Prince Philip. The British royals' state visit celebrated the 450th anniversary of Jamestown, the first permanent English settlement in North America.

The Marine Band

The history of the Marine Band is as storied as the White House itself. On July 11, 1798, President John Adams approved legislation that officially brought the band into being, making it the nation's oldest professional musical organization. The fledgling band consisted of a drum major, fife major, and 32 drums and fifes; some of the musicians were from a military band in Italy. When the nation's capital relocated from

Philadelphia to the new federal city of Washington in 1800, the Marine Band came with the chief executive and made its White House debut at John and Abigail Adams's first New Year's Day reception in 1801.

Music has been an essential part of life in the White House from the earliest days of the nation, not only as a "companion" to divert, delight, and "sweeten many hours," as Thomas Jefferson professed, but also as an element of the pageantry accompanying international diplomacy. Through the years the United States Marine Band, known as The President's Own, has musically represented the nation and the nation's presidents before worldwide audiences. The White House calls upon the Marine Band to perform at welcoming ceremonies, State Dinners, receptions, and many other official functions. The band traditionally plays "Hail to the Chief," with its preceding fanfare "Ruffles and Flourishes," to announce the arrival of the president at state functions. Derived from an old Scottish air, the song was used in a dramatic setting of an epic poem in 1812. The band honors the president with "Hail to the Chief" hundreds of times a year at ceremonial and diplomatic events.

Since its founding more than two centuries ago, the Marine Band has had 27 directors who serve as

Young John Kennedy, Jr., (above) joins members of the Marine Band in playing piano at his birthday party. The band plays in a parade performance (right) on the South Lawn of the White House in 1963.

music adviser to the White House. The Sousa baton, a symbol of the dedication, leadership, and vision of director John Philip Sousa (1880–1892), is passed to an incoming director. The Marine Band has provided a continual opportunity for presidents to enjoy music. Thomas Jefferson, an avid violinist, called music his "favorite passion." James Madison invited

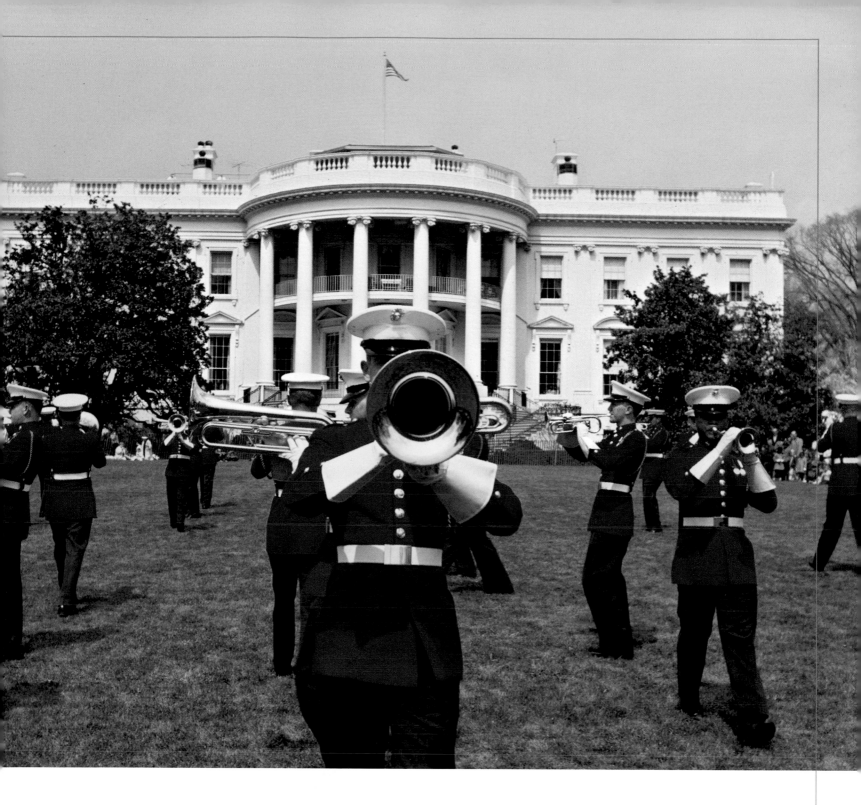

the band to perform at the first inaugural ball. Abraham Lincoln found the band's concerts a lift from the gloom of the Civil War.

Many of the world's finest performing artists have shared the White House stage with the Marine Band. Through the years the band has introduced America to Italian opera and the works of Wagner and Brahms as well as chamber music, and performed theatrical scores, folk music, and jazz. For more than a century, Marine Band public concerts on the White House grounds were a fixture of cultural life in Washington. An 1891 account of the popular summer and fall concerts noted: "Administrations come and go, but the band plays on forever." ★

INNOVATIONS
and TECHNOLOGY

CHANGING WITH the TIMES ★
PRESIDENTIAL TRAVEL and VEHICLES ★
COMMUNICATIONS ★ *TELEVISION and the*
INFORMATION AGE ★

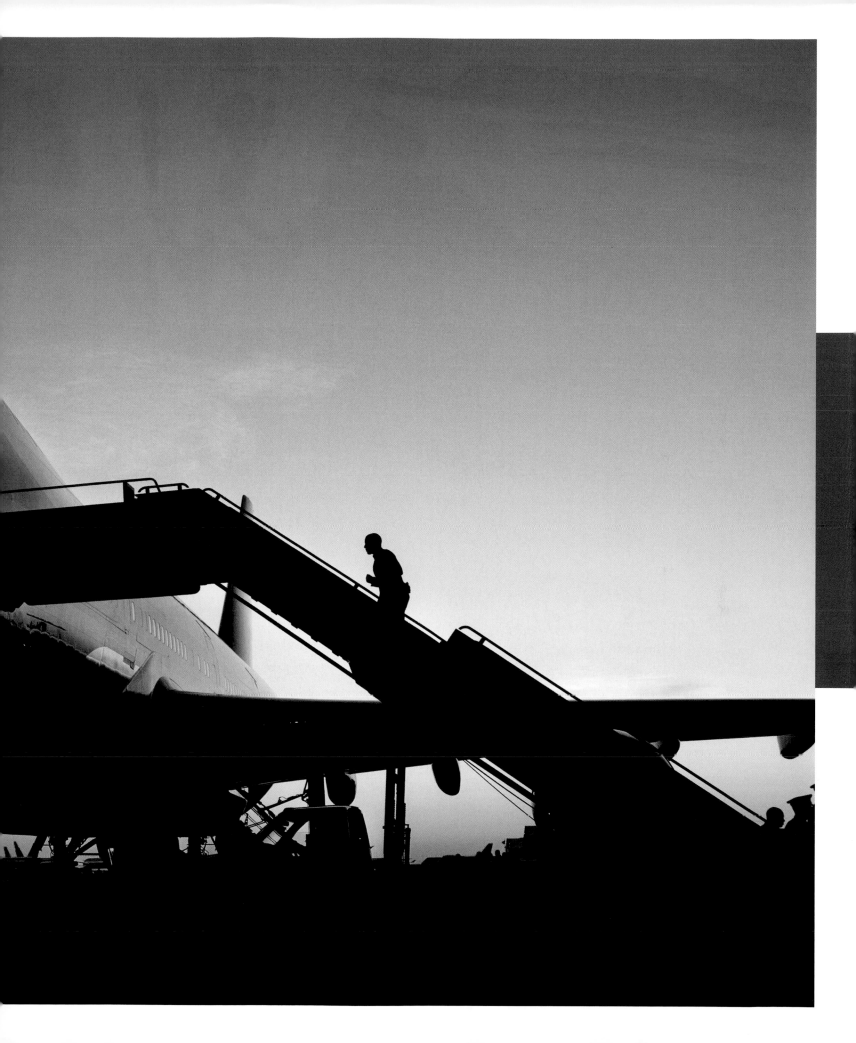

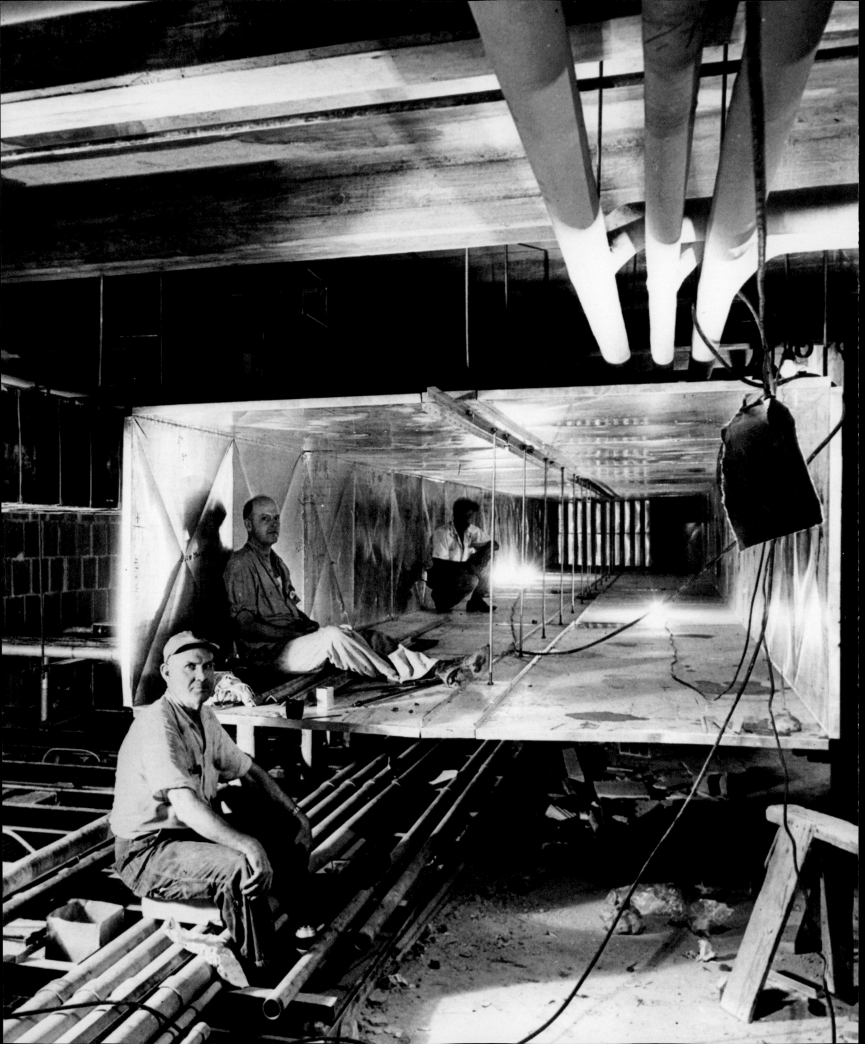

T HE WHITE HOUSE MAY EMBODY HISTORY, but that doesn't mean it does not embrace change. The mansion is constantly evolving to meet the needs of its principal occupants. Through the years, technologies and conveniences have been added for comfort and efficiency. Thomas Jefferson, the second president to reside there, added features that made the house more livable, including replacing outdoor privies with indoor water closets and adding hob grates to replace wood heat from the fireplaces with coal.

At times, innovations were greeted skeptically. First Lady Sarah Polk insisted on using candles in one room—the Blue Room—when gaslights were installed in 1848. Electric lighting came in 1891, but President Benjamin Harrison and his family refused to use the switches, fearing shocks. In 1935, the White House kitchens were equipped with new electric stainless steel appliances that initially baffled the kitchen staff, who needed operating instructions from the electric company.

The President's House is a heavily used structure that has repeatedly been redecorated and renovated. There have been constant upgrades, but not until the Theodore Roosevelt restoration in 1902 was there a comprehensive infrastructure overhaul. The house that George Washington built had been given new life, but less than a half century after Roosevelt, the old wooden structural system was considered an unsound firetrap. Harry Truman moved out in 1948, and gutted the building to create a safe and modern house. Historian William Seale best described the changing White House over 200 years as being "pulled apart, rearranged, gutted by fire and renovation, reassembled; yet it is always the same. Its idea has become its essence."

Preceding pages: President Barack Obama ascends the stairs at Andrews Air Force Base in 2012, to enter *Air Force One*, one of the most recognizable symbols of the presidency. Opposite: Photographer Abbie Rowe shot this portrait of the workmen in 1951 to emphasize the massive scale of the heating and ventilation ducts installed in the new White House basement during the Truman renovation.

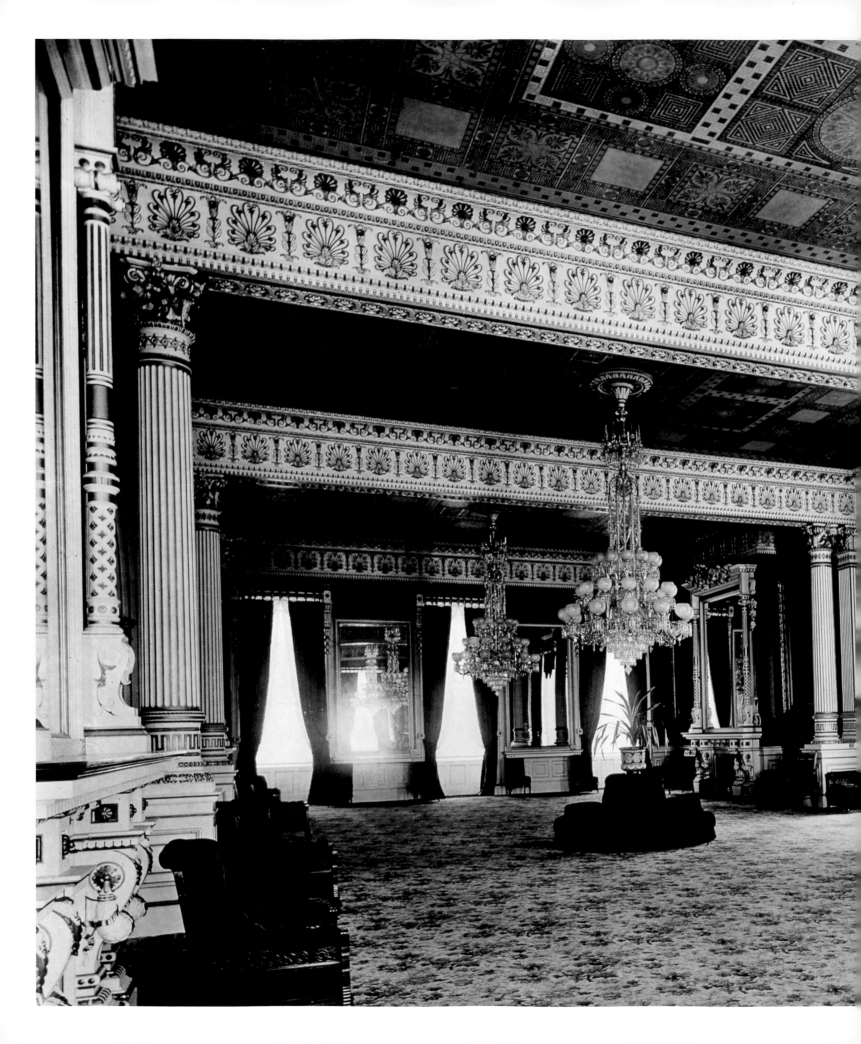

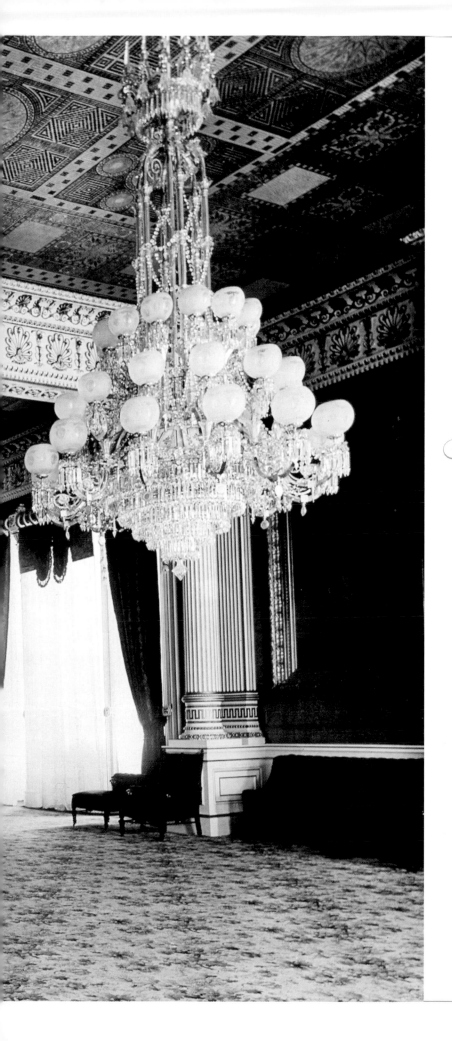

Changing With the Times

WHEN THE WHITE HOUSE was built around 1800, construction involved stone laid upon stone, brick upon brick, timber pinned to timber with pegs. This system was rebuilt after the 1814 fire with more wooden construction than before and then again in 1950, when the framework and interiors inside the historic stone shell were replaced with structural steel and concrete.

The White House was one of the finest residences in the nation. Still, the large and numerous rooms were hard to heat, depending on fireplaces through the cold and damp winters of the Federal City. "Shiver, shiver," Abigail Adams wrote. Her rheumatism came back in the chill of the northwest winds that rattled the tall, wide windows.

Thomas Jefferson introduced hob grates, adapting wood-burning fireplaces to coal. A coal fire burned hotter and longer than wood, but how well it heated large rooms was questionable and so it was probably not a major improvement. In 1810, architect Benjamin H. Latrobe installed a gravity-based "Pettibone" furnace, which used a cluster of "kettles" or air chambers. Warm air rose up through a funnel insert in the chimney and was drafted off through a system of clay pipes used as ducts. Lost in the fire of 1814, the Pettibone furnace was not replaced. James Monroe, John Quincy Adams, and Andrew Jackson warmed themselves with wood and coal fires. Martin Van Buren, accustomed to the latest luxuries of city

The East Room in 1898 (left) had gaslight chandeliers and ceilings decorated by Louis Comfort Tiffany. Electric sconces introduced in 1891 (inset) are in storage.

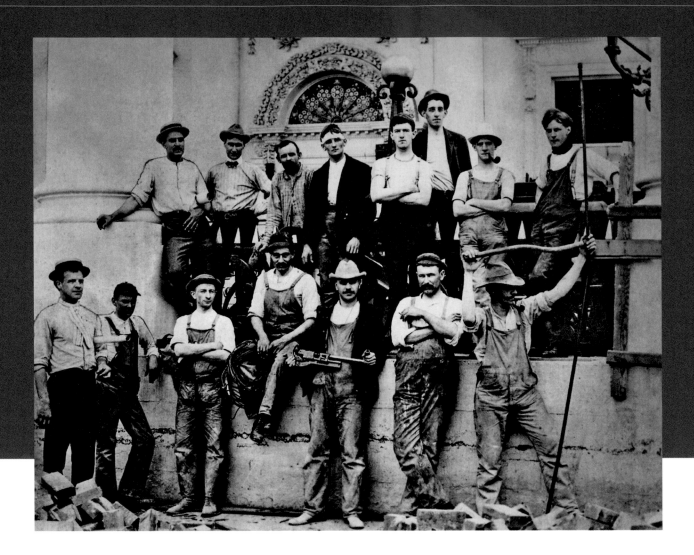

Electricians and their crews pose at the White House in 1898.
Electricity was installed in 1891 as backup lighting for gas, fed by
power generated in the old State, War, and Navy Building.

life, ordered a central heating system in 1837, which
was installed in the spring of 1840.

Five years later, James K. Polk ordered a furnace and
duct system to increase heating capacity. Plaster-lined
air ducts were threaded in the walls of the State Rooms,
bedrooms, and offices. These ducts terminated in regis-
ters of nickel plate, brass, or iron, depending on the
importance of the room.

The White House of Franklin Pierce came to repre-
sent the best domestic technology of its time. The heat-
ing system was modified in 1853, with the addition
of a hot-water furnace. Pierce also made significant
improvements to the plumbing, including the installa-
tion of a bathroom on the second floor with the first

permanent bathing facilities. The new bathroom
was luxurious in having both hot and cold water
piped in. Before 1853, bathing on the second floor
required portable bathtubs, and kettles of hot water
had to be hauled up from the existing bathing room
in the East Terrace.

Keeping Cool

During the hot summer months, first families in the
19th century often left the city for the seashore or escaped
to the higher and cooler elevation of the hills around
Washington. The Lincolns enjoyed spending summers
at the cottage at the Soldiers' Home, and the Clevelands
had "Red Top," their house in the city's northwest sub-
urbs. An experimental form of air-conditioning was
attempted at the White House in 1881, when an electric
blower was installed in the sickroom of mortally
wounded James A. Garfield, who was shot on July 2.
The device forced air through a box with screens that

Kitchen Space

Most visitors today are surprised to find how small the White House kitchen is, but space is so limited at the Executive Mansion that the kitchen, which is a commercial-type facility, is continually upgraded in the interest of maximum use of its square footage. The main kitchen was rebuilt and outfitted with gleaming stainless steel appliances in 1933, reconstructed again during the Truman renovation, and then improved with modern appliances, better layout, and increased ventilation in 1971. Since then, appliances have been replaced as needed, but few other alterations have been made.

The southwest corner of the White House kitchen, as recorded by the Historic American Buildings Survey in 1992.

were kept wet with ice water. William Howard Taft also attempted to install a type of air-conditioning in the expanded West Wing in 1909. The experimental system consisted of electric fans that blew over great bins of ice in the attic, cooling the air, which was forced through the air ducts of the heating system. This never worked well enough and was soon abandoned. Taft also built a sleeping porch, a screened-in room on the roof of the White House for a cool place to sleep amid breezes on summer evenings. Reconstruction of the West Wing in 1930 after extensive damage by a Christmas Eve fire in 1929 included a central air-conditioning system installed by the Carrier Engineering Company. When Franklin D. Roosevelt and his family experienced their first warm season at the White House in 1933, air-conditioning units were added to the private quarters. All of the mechanical systems were replaced in the Truman renovation, including central air-conditioning.

From Candles to Electricity

The White House was designed to be lit in the simple way known to the world in 1800. Natural light streamed in through windows that stretched 14 feet high and 5 feet across. During the day, tables and chairs were pulled close to the windows so people could read or sew. At night, the building was lit by lamps and candles. Lard oil made from animal and vegetable fats, purchased in large quantities, fueled the lamps and was foul smelling but cheap. Candles came in many types; when the common ones burned down to stubs, they were melted to make new ones. The tall, graceful tapers associated with the age of candlelight were reserved for formal occasions. All of the State Rooms had overhead light from chandeliers that burned candles as table lamps would be precarious in crowded reception rooms. Large oil lanterns burned in the hallways.

The Argand lamp, an innovative oil lamp that burned brighter than candles, made its debut in the Adams White House and was used by both Jefferson and Madison for hall lanterns. Candles were still used for overhead light until Andrew Jackson installed small glass lard-oil lamps in the East Room chandeliers. Gas lighting made its appearance in 1848, during the administration of James Polk, who had gas lines

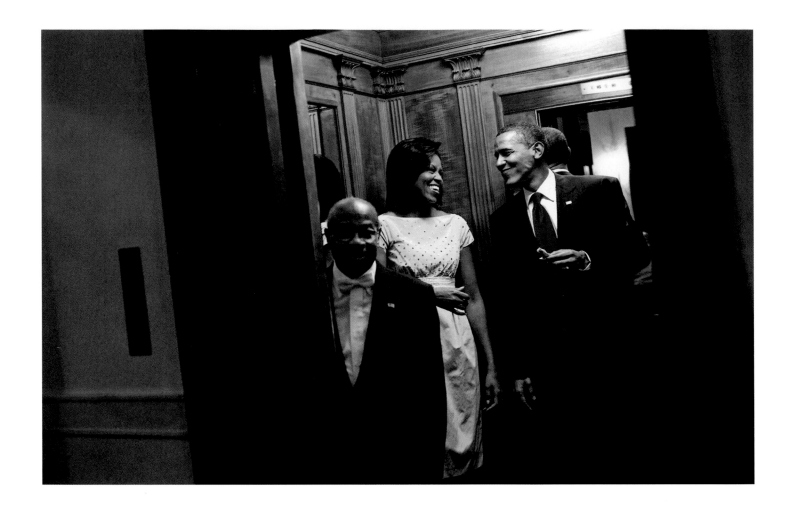

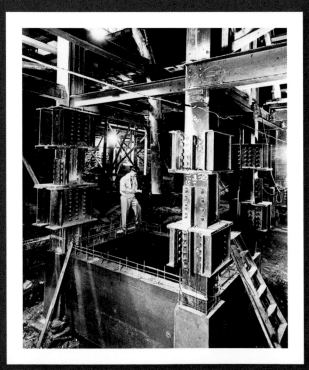

Main Elevator

James Garfield planned the first elevator in the White House in 1881, for his 80-year-old mother. Construction was postponed when the president was mortally wounded by an assassin. Chester A. Arthur, who succeeded Garfield, had the hydraulic elevator built in a space that had been the old back staff staircase that Lincoln made famous. That device was replaced by an electric elevator in 1898. A more efficient electric model was installed in 1902; the cab was made of wood from the Old North Church in Boston. Franklin D. Roosevelt replaced the manual elevator with a modern push-button version. The existing main elevator was installed during the Truman administration.

An engineer inspects construction of an elevator shaft in 1950.

piped to the chandeliers on the State Floor. First Lady Sarah Polk was not enthusiastic about this and insisted that the Blue Room chandelier still hold candles, which she thought gave a softer light. She was vindicated on the night when the new gaslights debuted and the rooms were plunged into darkness when the gas supply ran out. Gaslight soon became dependable, and by the Civil War, was the primary artificial light source for the White House.

Electricity came to the White House in 1891, during the Benjamin Harrison administration. The electrical work at the White House was planned as part of a well-funded project for wiring the State, War, and Navy Building (today's Eisenhower Executive Office Building) next door. The Edison company installed a generator for both buildings that was put in the State, War, and Navy Building's basement, with the wires strung across the lawn and introduced into the White House under the conservatory. The relatively new method of illumination was initially intended to be only a supplement to gaslight, but one after another, rooms were lit by electricity. Wires were buried in the plaster, with round switches installed in each room for turning the current on and off. By the time Theodore Roosevelt took office, the use of electric light was common in American houses. The entire wiring system was replaced during the major restoration of the White House in 1902. Only the service areas of the house retained their gaslight fixtures, and these were used only in case of a power failure.

The White House has had its share of electrical upgrades since 1902. The wiring was completely replaced during the Truman renovation. There have been continuous updates to the White House electrical system and, on occasion, experiments. In 1979, Jimmy Carter installed solar panels on the roof of the West Wing over the Cabinet Room to heat the water supply for the White House staff mess. The panels were removed in 1986 during roof repairs.

Indoor Plumbing

Although servants in early presidential households hauled water in buckets from a spring five blocks away, indoor plumbing got an early start in the Executive Mansion. Thomas Jefferson had the outdoor privy demolished and two indoor water closets installed on the second floor in 1803. Rainwater was collected in reservoir tanks in the attic; at the turn of a crank, water rushed down the pipes to flush the toilets. Servants used privies, one for men and one for women, opened off the covered passages that ran between the house and the wings. In 1833, cold running water was piped into the White House. Within the next year, a "bathing room" was established in the East Terrace. Servants bathed in tin tubs in the terrace bathroom, hauling water buckets from one of the pumps. In 1853, a permanent bathtub, with hot and cold running water, replaced the portable painted tin tubs in the president's quarters.

In 1881, engineer George E. Waring inspected the White House plumbing system and found that many pipes had disintegrated. The drainage from seven toilets and three bathtubs, water from the kitchen and pantries, and about a dozen extra lavatories in the bedchambers had saturated the soil beneath the basement and fouled a nearby crude septic field. The plumbers went to work in 1882, removing old pipes from within the walls and replacing them. New septic fields were created. Bath and toilet rooms were remodeled with new tile, wallpaper, and fixtures. In the family quarters, there were two large bathrooms, one on the northwest and another on the north side opening into the service hall. The president's office had a lavatory and washroom in the corner of the telegraph room, and another had been built off the attic stair landing for the use of the private secretary. In 1902, one of the major improvements was that most of the 12 bedrooms had private bathrooms, complete with white ceramic tile and nickel-plated fixtures. The Truman renovation that was completed in 1952 updated the baths in the family quarters. Eleanor Roosevelt likened the appearance of the post-renovation bathrooms to a modern Statler Hilton hotel. Today, the White House has 35 bathrooms. ★

Presidential Travel and Vehicles

HOW THE PRESIDENT TRAVELS has evolved with technology, and that has required significant changes to the White House grounds over time. The White House stables, always a hub of activity, progressed from a simple Georgian brick building in 1800 to a High Victorian mansard-roofed structure commissioned by Ulysses S. Grant in 1871. This last stable, expanded in 1891, was extensive enough to include stalls for 25 horses, a carriage house, tack and harness rooms, and a living area for coachmen and stable hands.

The primacy of the horse at the White House ended in 1909, when William Howard Taft converted the stable into a garage for his giant steam cars. Two years later, the stable was demolished and horses remained available to the White House primarily for leisure or to lend stately dignity to ceremonies. During World War I, however, Woodrow Wilson rode in an open landau during "gasless days."

Before the 20th century, the president's vehicles were not armor-plated or specially built. Presidential carriages were similar to those of citizens of wealth. George Washington had the most elaborate turnout of the presidents for state occasions, sporting a cream-colored carriage drawn by six matched horses "all brilliantly caparisoned." Coachmen and footmen wore livery trimmed with white and brilliant red-orange that Washington had selected long before for his racing silks. Franklin Pierce preferred an informal coach and often rode through Washington in an

The South Portico of the White House is reflected on the hood of the presidential limousine in a photograph taken in 2009.

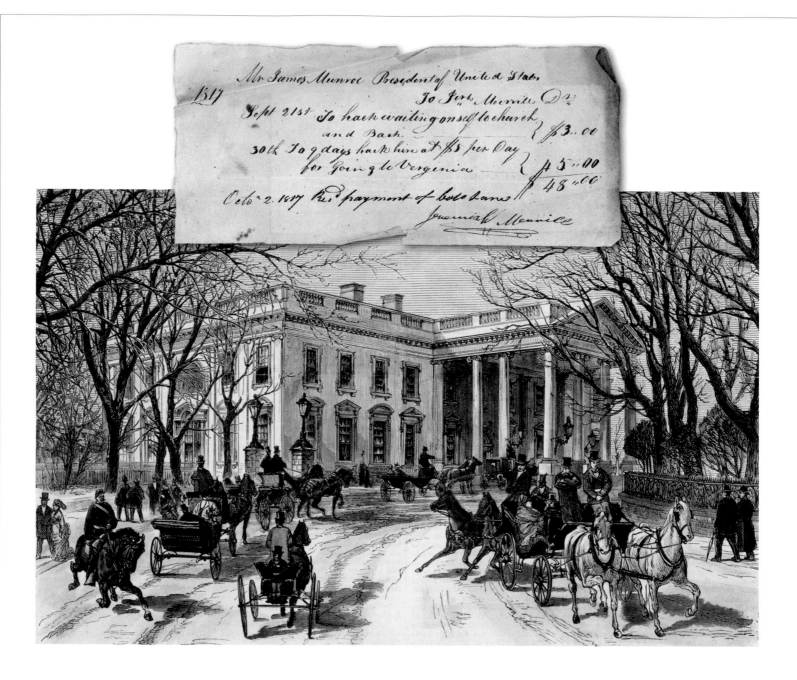

"unpretentious one-horse shay." Chester A. Arthur was far more conspicuous in his stylish dark green landau drawn by two perfectly matched mahogany-colored bays. The harness was mounted with silver, and dark green kersey dress blankets were ornamented with the president's monogram. No matter what the purpose, the president's style always was on display in carriages, equipage, and livery.

Presidential Automobiles

William McKinley was the first president to ride in a Stanley Steamer automobile, driven by its inventor, F. O. Stanley, in Washington, D.C., in 1899. Theodore Roosevelt was the first to do so in public, in Hartford, Connecticut, in 1902, and the first to have his photograph taken in a car. However, his love of fine horses was legendary and played a part in shaping his vigorous personal image and his advocacy of the "strenuous life." When offered an automobile, the president said, "The Roosevelts are horse people."

His successor, William Howard Taft, while serving as secretary of war became smitten with the White steamer, the department's car of choice. A pre-gasoline steam-powered touring car, it was manufactured by the White Sewing Machine Company of Cleveland, Ohio, in Taft's home state. Taft believed in the future of the

automobile and wanted a White when he entered the White House. After some wrangling with opponents in Congress over the costs and dangers of motorcars, he obtained a $12,000 budget through an emergency deficiency bill. His staff negotiated a favorable price with the White Company for the steamer at $3,000, and two Pierce-Arrow limousines, a "Suburban," and a landaulet, at $4,900. Taft added the Great Seal of the United States to all of his cars, providing the fledgling automobile manufacturers prestigious publicity.

In 1921, Warren Harding was the first president to ride to his inauguration in a car, a Packard Twin-Six. By 1938, Franklin D. Roosevelt had two Cadillac convertibles, dubbed "Queen Mary" and "Queen Elizabeth" after the great ocean liners. Automobile companies leased or sold cars to the government for presidential transportation. In 1939, specially built vehicles began to be commissioned with advanced communications equipment, special conveniences, and armor plating. Called "The Sunshine Special," the Lincoln V-12 convertible became the first in a long line of enormous cars built specially for presidential use. The most recent presidential car is a Chevrolet Kodiak-based Cadillac-badged limousine, called Cadillac One or Limo One, popularly known as "the Beast."

Riding the Rails

On June 6, 1833, Andrew Jackson boarded a Baltimore & Ohio Railroad train in Ellicott's Mills, Maryland, for a journey to Baltimore, becoming the first president to ride a train. Subsequent chief executives often rode the rails, to head to vacation spots, to

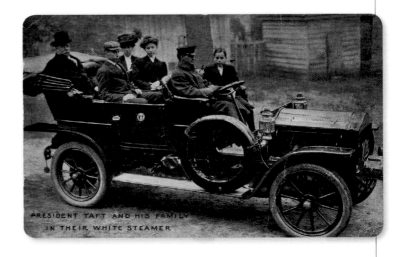

PRESIDENT TAFT AND HIS FAMILY IN THEIR WHITE STEAMER

Marine One approaches the White House with a helicopter escort (left). The Jefferson Memorial can be seen in the distance. The South Portico viewed from the cockpit as *Marine One* nears the landing on the South Lawn (below). Dwight Eisenhower was the first president to use helicopters for transport in 1957; helicopters are also used today to convey senior cabinet staff and dignitaries to the White House.

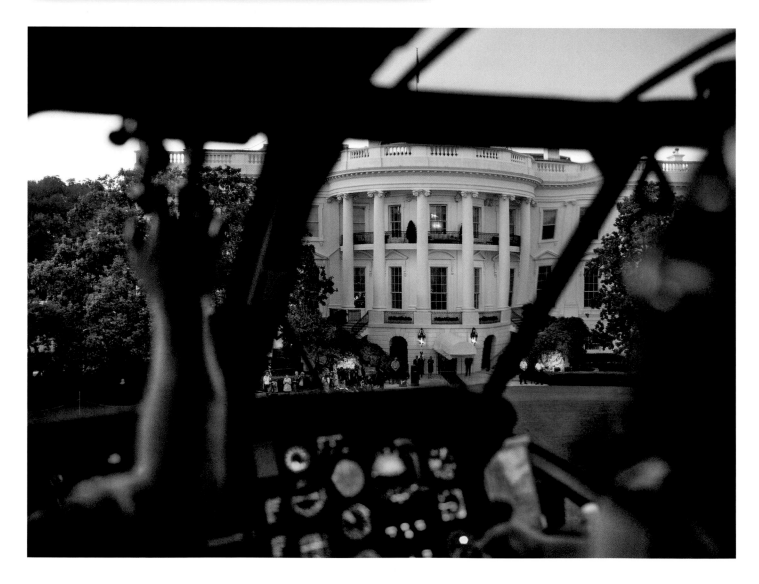

arrive at special events, or simply as a means of meeting and greeting citizens of a vast nation. Inspired by the outreach Lincoln's funeral train achieved, Andrew Johnson in 1866 took an 18-day railroad trip called "a swing around the circle" that followed the same path to take his political battle with the Radicals in Congress to the people. His Chicago-bound train went to Baltimore and then Philadelphia, following the course of Lincoln's funeral cortege 16 months earlier. Johnson's effort failed as he projected an image less as a friend of the people than as an angry man.

Charisma was everything to William Jennings Bryan. To make as many public appearances as possible in his campaign against William McKinley in 1896, he touched millions of people in crisscrossing the nation by rail, and was the first to employ "whistle-stops." Even though Bryan lost to McKinley, he demonstrated the advantage of traveling long distances quickly, and reaching multitudes of voters left its message. A whistle-stop train tour from town to town was a strategy instrumental in electing Harry Truman 50 years later. In more recent times, Jimmy Carter, George H. W. Bush, and Bill Clinton all have staged nostalgic whistle-stops during their campaigns so they could meet voters and gain free publicity.

Trains became the principal means of long-distance travel for presidents, and reporters began traveling with them. At first, the reporters simply bought tickets and traveled on the same train, but later railroads added an extra "press" car. Eventually, a special presidential train wound its way along the nation's extensive railways. The president usually traveled in a special Pullman observation car—the *Mayflower* for Wilson, the *Superb* for Harding, the *Marco Polo* for Hoover, and the *Ferdinand Magellan* for Franklin Roosevelt. When Harding traveled west on the *Superb* in 1923, his car was equipped with a public address system for whistle-stop speeches.

Air Force One

Airplanes eventually replaced trains for long-distance travel. Franklin Roosevelt usually traveled by train in the 1930s and '40s, although his wife, Eleanor, began traveling by airplane. Nonetheless, Franklin Roosevelt was the first president to fly on a plane while he was in office, traveling in January 1943 to the Casablanca Conference during World War II in a Pan American Airways Boeing 314 long-range flying boat. In February 1945, he used a converted C-54 Skymaster to travel from Malta to the Crimea for the Yalta Conference. Harry Truman, who succeeded Roosevelt, used Roosevelt's airplane and later a DC-6 named *The Independence*. Dwight Eisenhower's official airplanes were originally a series of Lockheed Constellations, then a Boeing 707 intercontinental jet. John Kennedy enlisted celebrated industrial designer Raymond Loewy to remodel the exterior of the presidential jet, creating its insignia in blue, chrome, and white and dispensing with military markings, replacing them with the words "United States of America" and the presidential seal. Today, any airplane that is carrying the president is designated as *Air Force One*.

Since the Eisenhower administration, helicopters have been used for middle-distance travel. Eisenhower needed a quick way to reach the presidential retreat at Camp David and his home in Gettysburg, Pennsylvania, because an airplane could land neither at the White House nor his summer retreat. A Bell UH-13J Sioux was commissioned, and on July 12, 1957, Eisenhower became the first chief executive to take a helicopter ride. Ample space had been found for the helicopter to land on the South Lawn, and a precedent was established. As a security measure, several other helicopters identical to the one carrying the president take off and shift in formation. ★

Communications

IT HAS LONG BEEN AGREED THAT IN A DEMOCRACY, a well-informed citizenry is best equipped to govern itself. In the United States, where voters determine who will serve them in government, it is important that citizens know what the president is thinking, what his plans are, and how he hopes to tackle the challenges that face the nation. Throughout history, presidents have employed technology to reach ever greater numbers of Americans and used new inventions to communicate as swiftly and fully as possible to people spread across a vast area. In their own times, those have included the telegraph, telephone, and radio.

When President George Washington took office in 1789, he decided that he would visit all 13 states in the nation—from New Hampshire to Georgia. His tours came at different times, traveling on horseback and in a horse-drawn carriage, one tour to the north and another through the southern states. His journey to the south took more than two months, and Washington traveled almost 2,000 miles. Washington believed that this was the best way to communicate directly with the nation and to get to know the American people, the cities and towns where they lived, the geography and economy, and the road system on which they traveled—which turned out to often be sandy, muddy, or rutted.

James Monroe, president more than 20 years after Washington, still found that the best public outreach to the country was touring, just as Washington did, by horse and carriage. Coach tours yielded largely to train travel by 1840.

Telegraph and Telephone

During the Civil War, Abraham Lincoln used the telegraph to keep in touch with his battlefield generals and took daily walks to the telegraph office at the War Department. In 1866, Andrew Johnson installed the first telegraph in the White House, in a southeast corner room next to his office.

In 1877, Rutherford B. Hayes spoke on the telephone to the instrument's inventor, Alexander Graham Bell. Two years later, Hayes installed a telephone in the White House. The telephone number was "1." At that point, there were still very few people to call, as not even the members of the Hayes cabinet had phones, except Treasury secretary John Sherman. Communicating by telephone was faster than telegraph, but its use at first varied according to the president's attitude. Calvin Coolidge famously refused to use the telephone for presidential business.

During the Spanish-American War of 1898, the White House for the first time became a wartime communications center. Newspapers followed every move of President William McKinley and the busy activity at the White House. When the ship U.S.S. *Maine* exploded in Havana Harbor on the evening of February 15, McKinley received a telephone call at three in the morning. Immediately, the president established a special telegraph office control center on the second floor of the White House called the "war room." The office allowed McKinley to contact the army and navy. Pins stuck into maps recorded the movements of troops and supplies. The war, which lasted three months, was a major victory for the United States, and French ambassador Jules Cambon commented that "much of the rapid success of the United States" was due to the communication equipment available to the president.

On January 25, 1915, President Woodrow Wilson joined the first transcontinental telephone call from

President William Howard Taft with a telephone, circa 1909. Taft's interest in technology included a Victrola in the Blue Room, on which he played for his guests the thick Edison disks that recorded tenor Enrico Caruso or soprano Dame Nellie Melba.

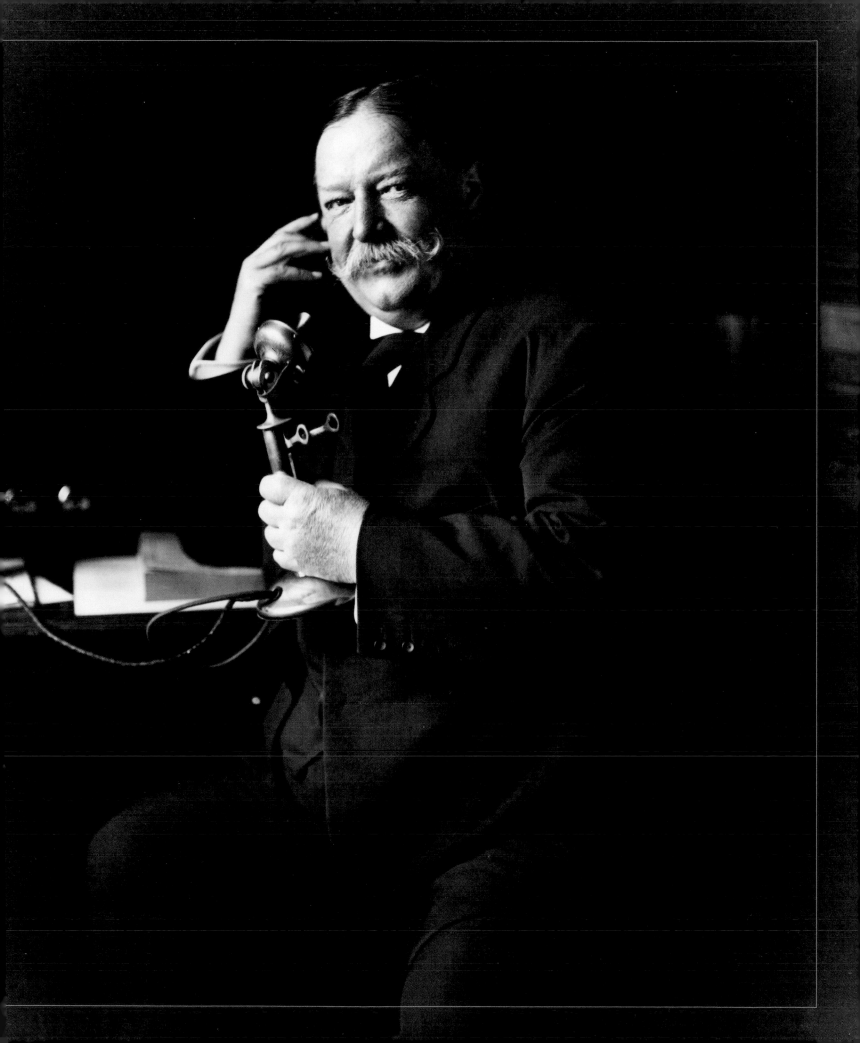

New York to San Francisco via a loop connection that included the White House as well as Jekyll Island, Georgia, where the president of AT&T was recuperating from an injury. During World War II, direct telephone communication between the White House and Prime Minister Winston Churchill's underground cabinet war room bunker in Whitehall was established, and was kept protected by an early secure speech system.

Although John F. Kennedy and Soviet leader Nikita Khrushchev resolved the Cuban missile crisis peacefully in 1962, the dangerous close call of a possible nuclear exchange caused both leaders to wish to avoid an accident or miscalculation in the future. On August 30, 1963, Kennedy became the first president to establish a direct

communications link to the Kremlin. A far cry from today's fiber-optic communications, the system worked with the president calling his message to the Pentagon, where it was encrypted and sent via a Teletype machine to be transmitted securely to the Kremlin. The red phone hotline often depicted in movies and television shows never existed. During the six-day Arab-Israeli war in 1967, President Johnson was the first to use the hotline to prevent a misunderstanding between the Soviet Union's Black Sea Fleet and the U.S. Navy's Sixth Fleet on patrol in the Mediterranean Sea.

Today, landline and wireless phones are ubiquitous and number in the billions around the world. Telephones on the presidential desk have been a necessity since Herbert Hoover's time. Now, even the president carries a cell phone with him. Barack Obama is well known to be a fan of a smartphone for email as well as voice communication.

Rutherford B. Hayes must have been amenable to technological innovations for he not only installed the

The telegraph, telephone, and cipher room in the West Wing, circa 1903. Edward Smithers (center) was the chief of communications for more than 25 years; he joined William McKinley's staff in 1898.

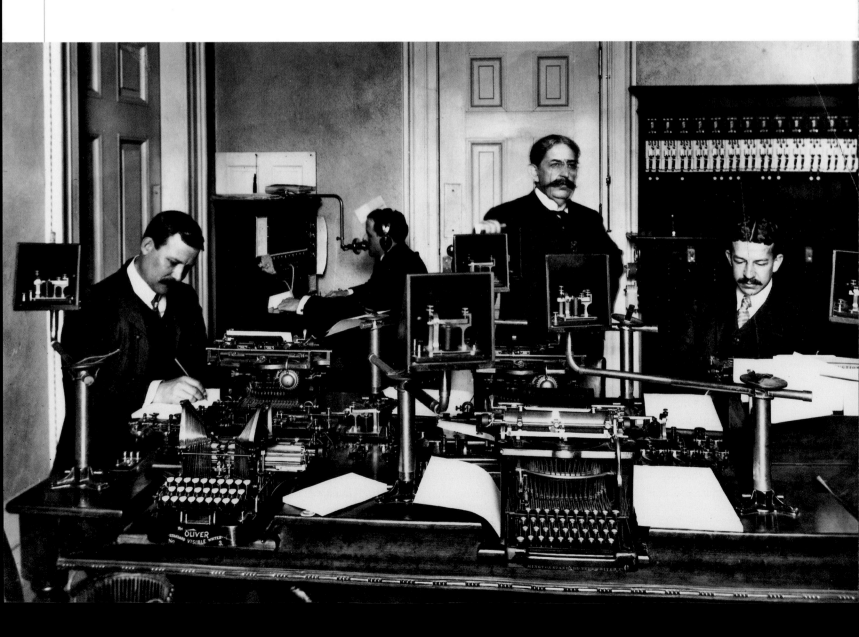

FAMOUS OVAL OFFICE SPEECHES

Televised speeches from the Oval Office have the power of immediacy and the weight of originating in the symbolic center of presidential authority. In 1957, Dwight D. Eisenhower sent army troops to Little Rock to protect African American students from angry crowds as they desegregated Central High School, entering classes the morning after his speech affirming the order of a federal court. Lyndon Johnson, during the height of the Vietnam War in 1968, announced that he would not seek another term. Gerald Ford announced the 1974 pardon of Richard Nixon. Ronald Reagan gave a memorable speech after the *Challenger* explosion in 1986. George H. W. Bush's declaration of the Gulf War and George W. Bush's address to the nation after the terrorist attacks on September 11, 2001, came in an era of cable television, the Internet, and the 24-hour news cycle, intensifying attention on these moments.

President Harry Truman delivers his eight-point "Fair Deal" domestic plan in a speech from the Oval Office in 1949.

first telephone, but also bought the first typewriter for the White House in 1880. Hayes also invited inventor Thomas A. Edison to the White House to demonstrate his new invention, the phonograph, which amazingly could record and play sounds.

Mass Communication

Although President Harding was the first president to make a radio broadcast, Calvin Coolidge mastered the medium and is considered "Our First Radio President"; the White House had entered the age of mass communication. Coolidge made his first coast-to-coast presidential radio broadcast on December 6, 1923. It was his annual message to the 68th Congress and his opportunity to introduce himself and his programs to the American people. It is estimated that Coolidge broadcast his inaugural address to *23 million* radio listeners on March 4, 1925—one-fifth of all the nation's men, women, and children. Radio brought profound changes to American society, opening a new medium for information and entertainment.

Probably the most successful communicator on the radio was Franklin D. Roosevelt, who defeated Hoover in the 1932 election. From the Diplomatic Reception Room, on the ground floor of the White House, Roosevelt delivered his "fireside chats" directly to Americans about the problems they were facing during the Great Depression and World War II. Families and friends would sit in their living rooms, by their fireplaces, and listen to the president. On Sunday night, March 12, 1933, 60 million Americans, almost half the population, heard Roosevelt present his first fireside chat. He discussed the bank crisis in order to forestall a run on the banks: "Let us unite in banishing fear. We have provided the machinery to restore our financial system, and it is up to you to support and make it work."

Radio speeches lost their luster in the age of television, but have been revisited by recent presidents. Ronald Reagan, who warmly remembered Roosevelt's fireside chats, revived the tradition in April 1982, when he gave the first of what would be 331 weekly radio addresses. His four successors have continued the practice. Today, the address is delivered on the radio each Saturday and made available by video on the White House website and via YouTube. ★

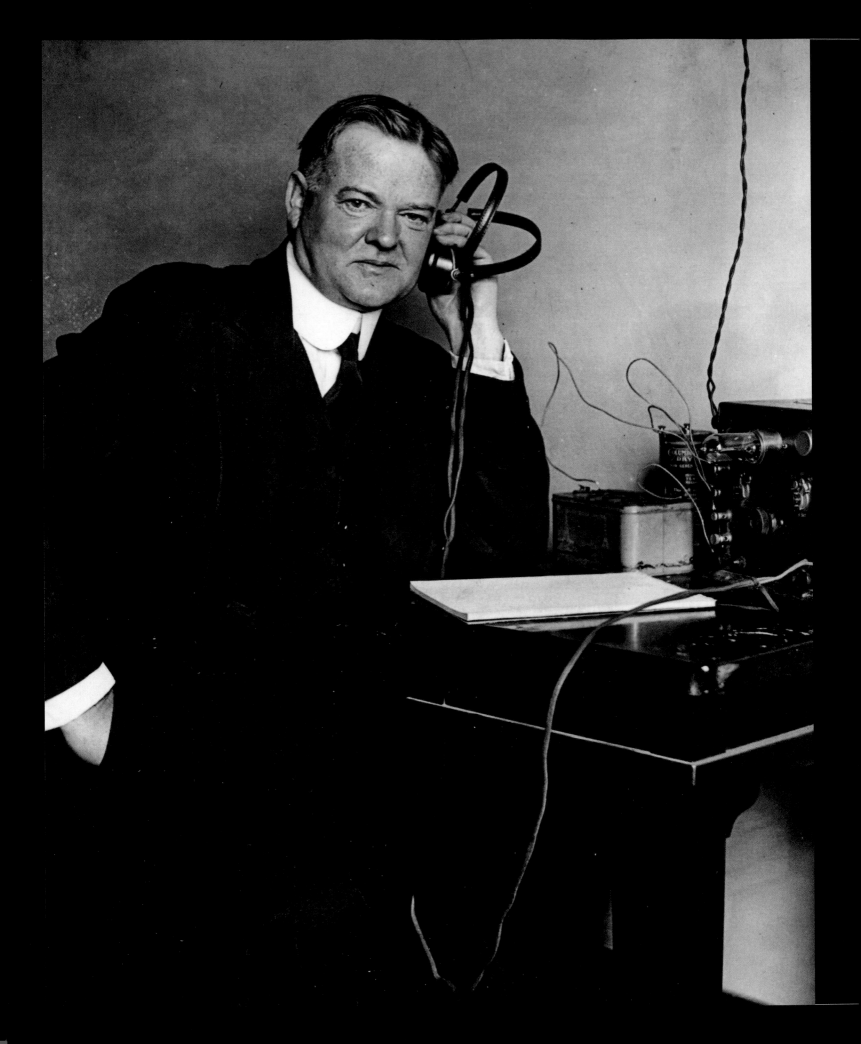

The President requests the several heads of Departments to take the most prudent and œconomical arrangements for the removal of the public offices, & clerks and Papers, according to their own best Judgments as soon as may be convenient, in such manner that the public offices may be opened in the City of Washington for the dispatch of Business by the fifteenth of June.

John Adams

Philadelphia
May 15. 1800.

COMMUNICATION DEVICES

Presidential communications tools evolved with technology. In 1925, Herbert Hoover, while secretary of commerce, listens to a wireless radio (opposite). Warren Harding made the first radio broadcast in 1922, but Calvin Coolidge was the first president to use radio regularly to address the nation. John Adams's order to department heads to

Television and the Information Age

TECHNOLOGY HAS PROVIDED PRESIDENTS with ever changing methods to communicate their messages. Horseback messengers were overtaken by the telegraph, and the telephone made one-to-one communication more immediate. Radio transformed presidential communication, allowing chief executives to reach millions of people at a time, and television increased the importance of stage presence. Now computers, the Internet, and the 24-hour news cycle continue to alter communication.

On April 30, 1939, at the opening of the New York World's Fair, Franklin D. Roosevelt became the first president to deliver a speech on television, speaking to a few hundred people who owned television receivers within a 50-mile radius. Harry S. Truman was the first president to appear on television from the White House. On October 5, 1947, he spoke about the world food crisis and was seen in New York and Philadelphia. Just two years later, about 10 million viewers saw Truman's inauguration, and more than 100 million heard it on the radio.

Televised Press Conferences

"Well, I see we are trying a new experiment this morning," Dwight D. Eisenhower observed at the beginning of his January 19, 1955, press conference—the first time that radio, television, and newspaper camera equipment was present to record a president facing the press. Active in Republican politics, actor Robert Montgomery pioneered the role of a political "image consultant" in

President Nixon's first press conference, televised from the East Room on January 27, 1969.

1954, coaching Eisenhower on his television appearances and how to look his best on camera. Concerned that the president might make an unintentional gaffe or misstatement, the White House press secretary, James Hagerty, drew the line at live coverage and reserved the right to review all footage before it was released.

On January 25, 1961, John F. Kennedy held the first live presidential press conference in U.S. history, broadcast at 6 p.m. on a Wednesday. About 65 million people tuned in to watch. Throughout his presidency, Kennedy not only held live news conferences and delivered live addresses on national television, but also was the first chief executive interviewed by television journalists. Kennedy took the medium of television and made it his own, much as Franklin Roosevelt had done with radio

30 years before. In the period before live television, press conferences favored the presidents. Usually, the sessions from Woodrow Wilson to Harry Truman were off the record, and the president—if he believed he had said something unwise—could revise the statement.

Soon after he arrived in the White House in 1969, Richard M. Nixon established an Office of Communications to coordinate the ways his administration could present information, ideas, and arguments to the public. He appointed Herbert G. Klein, a San Diego newspaper reporter who had worked for him on and off for 20 years, as the first White House communications

First to have a televised press conference in 1955, Eisenhower changed the president's ability to communicate with the nation.

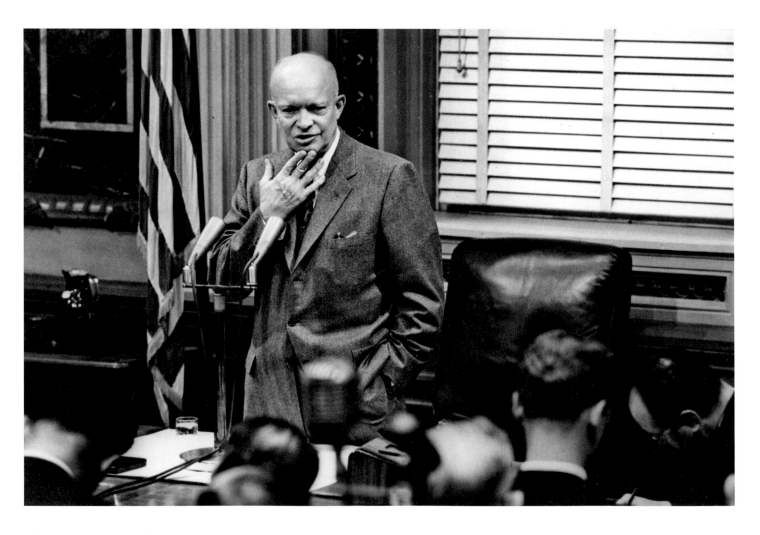

Hello, Neil and Buzz, I'm talking to you from the White House, and this certainly has to be the most historic telephone call ever made.

RICHARD NIXON, speaking by radiotelephone, 1969

WHITE HOUSE MEMORIES ★

LIVE FROM THE MOON

On July 20, 1969, President Richard Nixon held a brief radiotelephone conversation from the White House with astronaut Neil Armstrong on the surface of the moon. An estimated 600 million people saw Nixon's image and that of the astronauts in split screen on television. Armstrong and Buzz Aldrin took photographs, set up scientific instruments, and raised a metal American flag before receiving the congratulatory call. Nixon spoke for about a minute, and then Armstrong responded for about 30 seconds. Nixon told them he thought it was the most historic phone call ever made from the White House. The call defined long distance—some 239,228 miles. The mission was considered a triumph of American technology in the space race.

Split-screen image of President Nixon talking to Apollo 11 astronauts Neil Armstrong and Buzz Aldrin after the moon landing in 1969.

director. Effective presidential communications requires the president to have an organization in the West Wing that can craft his messages for the public and find effective ways to reach them.

For Presidents Nixon and Reagan, the nighttime East Room news conferences live on the three national broadcast networks (ABC, NBC, and CBS) provided a largely unfiltered way to communicate to a large audience. Today, television is still key to reaching the American people, but now there are numerous local and national cable news outlets.

No matter the platform, presidents continue to need news organizations. Towson University political science professor Martha Joynt Kumar, who has studied the president and the press for more than 35 years, observed:

"News organizations represent the vehicle for the President to reach the public on a daily basis with news of himself and his administration. For the press, the President is just as important as news organizations are for him. He is central to the concept of news their readers or viewers have. It is the need that each side has for the other that makes the Presidential–press relationship an important feature of the modern Presidency."

In 1996, President Bill Clinton's press secretary, Mike McCurry, opened the daily press briefing to live television coverage. That has increased the flow of information directly to the public; it has also made for some heated public exchanges as press secretaries bob and weave, fend off or respond to questions from the media.

Computers and New Media

Another medium would become very important to life in the President's House. In 1969, when Richard Nixon took office, Henry Kissinger, his national security adviser, was alarmed at the amount of information that was pouring in to be processed and analyzed at the height of the Cold War. Kissinger directed the National Security Council to begin automating its information systems, and the first computer was installed at the White House, thrusting the West Wing into the information age.

Jimmy Carter's administration was the first to begin automating the West Wing with office computers as part of a program to improve efficiency at the White House. One by one, the offices were reorganized on the basis of the latest in technology. Within two years, the administration had been computerized in the areas of project management, presidential personnel, job applications, scheduling, correspondence tracking, and electronic mailing. In November 1977, Carl Calo was appointed the first White House director of information systems. By the end of Carter's term, the White House had its first laser printer, a water-cooled IBM model. Under Carter's successor, Ronald Reagan, staff in the 1980s expanded the uses of computerized office technology, adopting word-processing software with the widespread introduction of personal computers. Email was introduced in 1992, with George H. W. Bush the first president to use this technology.

In 1992, the Clinton campaign used the Internet to distribute information, and carried this technique into the White House after Clinton was elected. The first White House website made its debut on October 21, 1994, and several updated versions of the site followed, establishing the online presence of the "Gateway to Government." At that time, only 10 percent of the people had access to the Internet, but the number of visitors to the White House website more than tripled each year of the Clinton administration.

The Obama campaigns of 2008 and 2012 made highly successful use of the Internet, and as president, Obama maintained a heavy presence on the Web.

Participating in a live Twitter session while in the White House, President Barack Obama (back to camera) responds to questions in 2012. Press Secretary Jay Carney (second from left) and support staff used laptops and mobile devices to assist in handling questions. The Carter administration introduced office computers to the White House in 1978. Initial uses included tracking correspondence, developing a press release system, and compiling issues and concerns of Congress.

The White House has also used social media platforms. In May 2009, the White House officially launched pages on Facebook, MySpace, and Twitter; it also has accounts on Flickr, iTunes, Tumblr, Vimeo, and YouTube. On July 6, 2011, President Obama held the first "Twitter Town hall," answering questions in the East Room from Twitter users while the conversations were displayed on large screens. In January 2013, the White House launched a Twitter account for the first lady: @FLOTUS, short for

First Lady of the United States. This handle joined @Whitehouse and @WHLive.

The Internet is just the latest means by which presidents and their administrations have used technology to ease communications. They have not led in the adoption of technology, but neither have they lagged, when they saw how it could be of benefit. It is fair to say that as technology evolves in ways we have not yet seen, presidential communications will evolve, too. ★

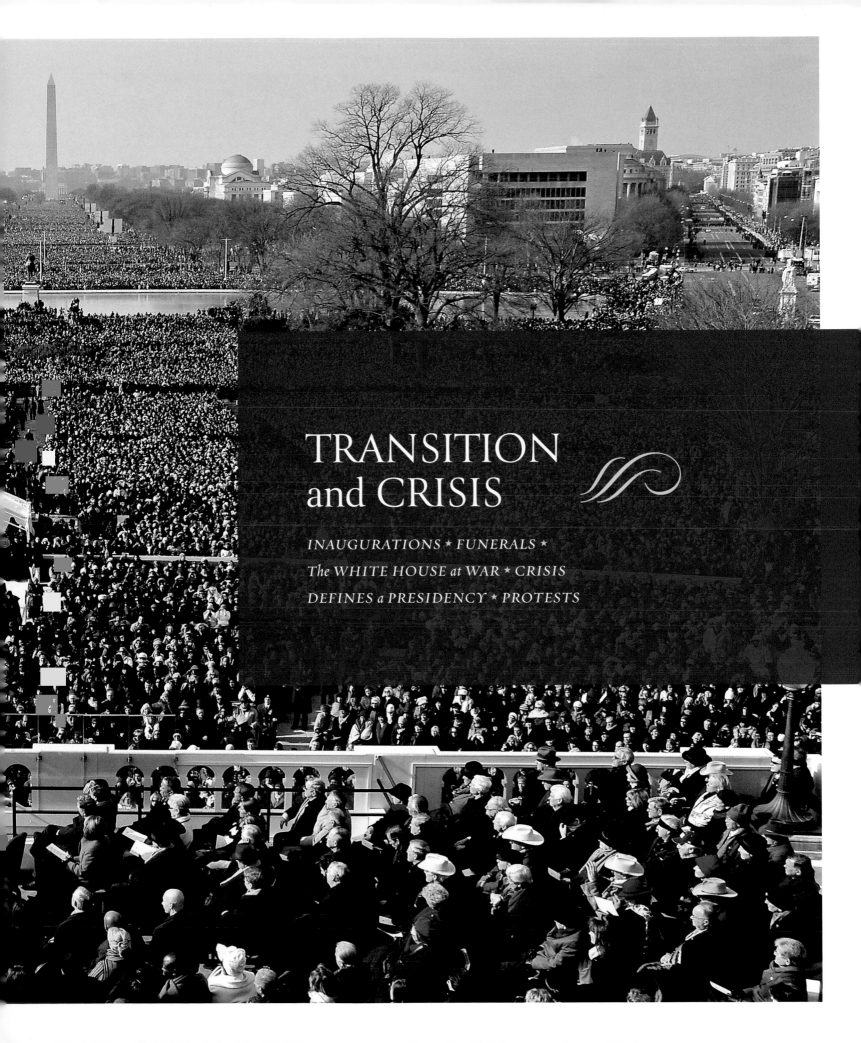

TRANSITION and CRISIS

INAUGURATIONS ★ FUNERALS ★
The WHITE HOUSE at WAR ★ CRISIS
DEFINES a PRESIDENCY ★ PROTESTS

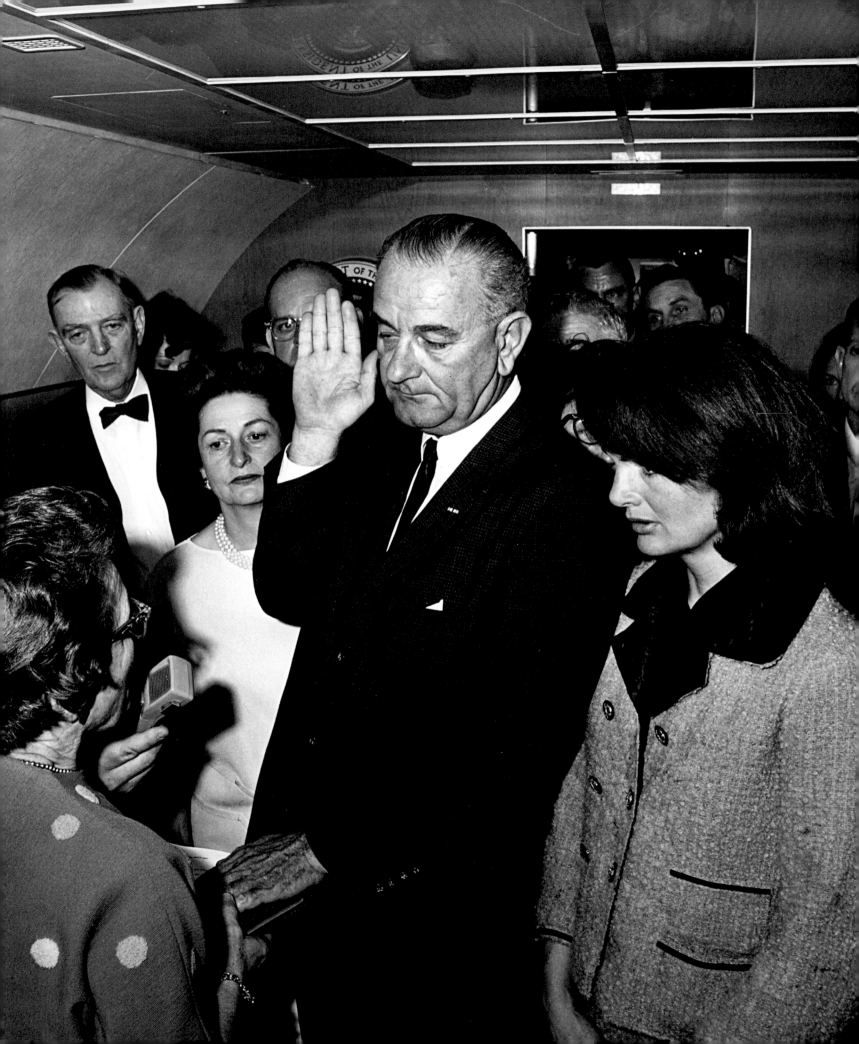

A PRESIDENTIAL TRANSITION, THE BRIEF TIME BETWEEN
the election and the inauguration, is a remarkable process. The new president has just
two months to plan a new administration and then move into the White House on
Inauguration Day. After being sworn in, the president can relax and enjoy the occasion,
at least until the pressures of the new job begin.

Some transitions, however, have taken place under tragic circumstances. Four presidents have been slain in office: Abraham Lincoln, James Garfield, William McKinley, and John F. Kennedy. Broadcast journalist Walter Cronkite delivered the dreadful news of Kennedy's assassination on November 22, 1963: "From Dallas, a flash, apparently official, President Kennedy died at 1:00 p.m. central standard time, 2:00 eastern standard time, some 38 minutes ago."

Although he would later be criticized for it, Lyndon Johnson immediately boarded the presidential plane, *Air Force One,* to return to Washington. He arranged to have the swearing-in ceremony on board, before the plane took off. If there was a conspiracy and he needed to act, he wanted the clear authority to do so. To seal the legitimacy of the transfer of power, Johnson asked Jacqueline Kennedy, the slain president's widow, to stand beside him as he was sworn in. At 2:30 p.m., less than an hour and a half after Kennedy's death, Johnson took the oath of office.

Throughout history, the American people have looked to the White House for leadership in times of transition and crisis. Inaugurations can represent renewal and hope. Presidential funerals serve to mark the loss of a leader and can define the end of an era.

Preceding pages: An immense crowd witnesses Barack Obama delivering his 2009 inaugural address. Opposite: Cecil Stoughton's iconic image of Lyndon B. Johnson taking the oath of office aboard *Air Force One* after John F. Kennedy was assassinated on November 22, 1963. U.S. District Court Judge Sarah T. Hughes administered the oath as Lady Bird Johnson (left) and Jacqueline Kennedy looked on.

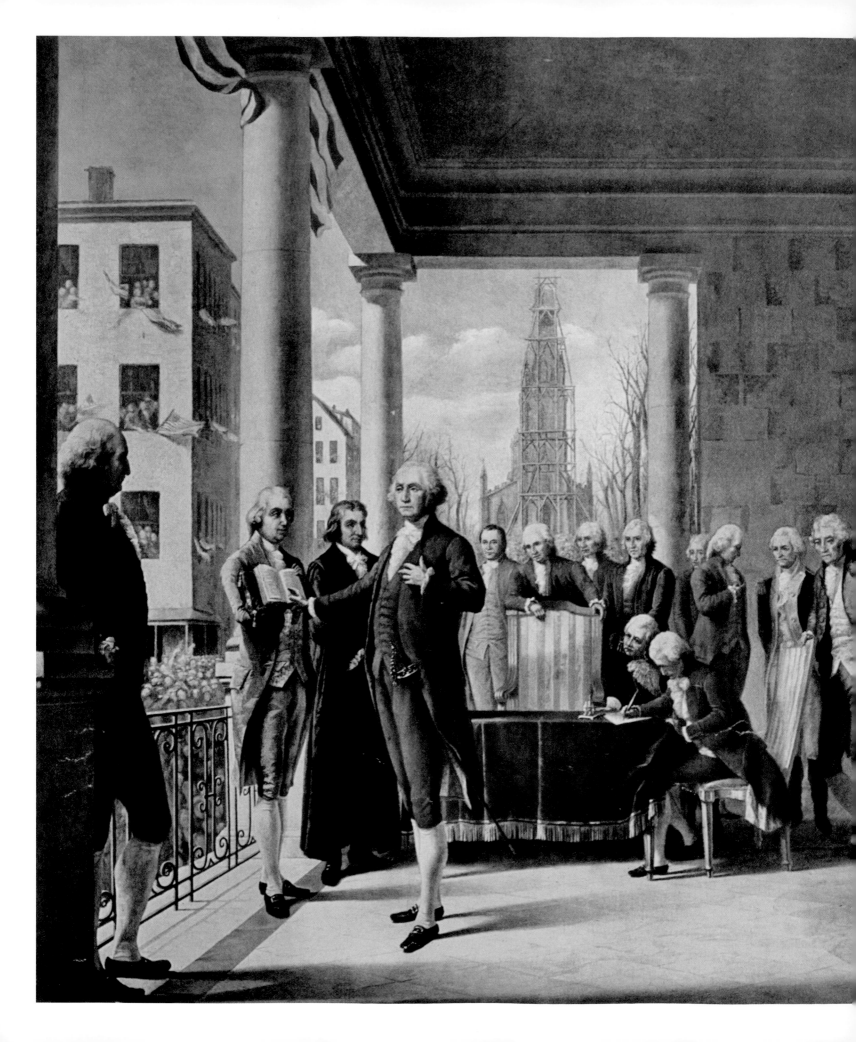

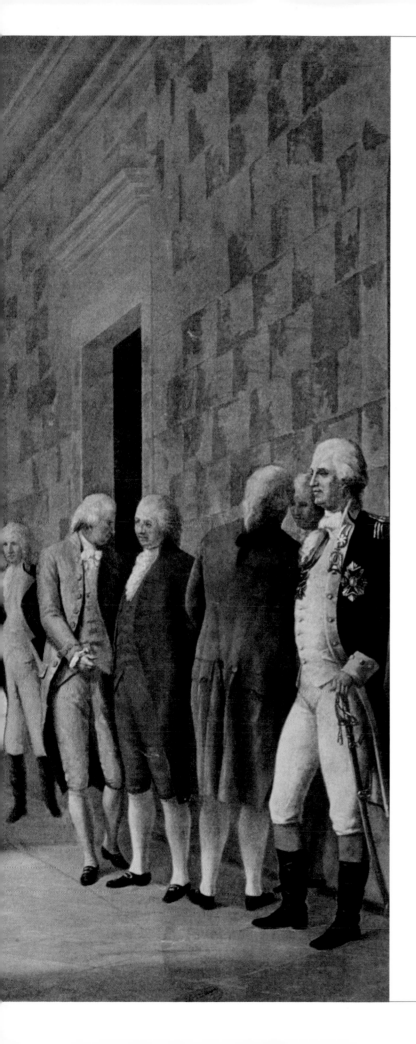

Inaugurations

IN APRIL 1789, GEORGE WASHINGTON took the oath of office in New York City; a crowd in the streets shouted "repeated huzzas and exclamations." Washington and the members of Congress retired to the Senate Chamber, where he delivered the first inaugural address to a joint session of Congress. Washington humbly noted the power of the nation's call for him to serve as president and the shared responsibility of the president and Congress to preserve "the sacred fire of liberty."

Thomas Jefferson, the third president, was the first to be inaugurated in Washington, taking the oath in the Senate Chamber on March 4, 1801. Dispensing with a carriage, Jefferson walked to the Capitol from his boardinghouse accompanied by some District of Columbia marshals, military officers, a company of riflemen from nearby Alexandria, Virginia, and some members of Congress. The Marine Band performed at the ceremony, setting a precedent that continues to this day. Jefferson provided the *National Intelligencer* with an advance copy of his inaugural address, so it was printed and available to the public immediately following the ceremony.

First Parade and Ball in Washington, D.C.

James Madison's first inauguration, in 1809, marked the origin of two traditions: the inaugural parade and the inaugural ball. After taking the oath of office, Madison reviewed nine militia companies in an organized parade. The next evening, the first inaugural ball was held at Long's Hotel. Four hundred guests attended.

George Washington takes the oath of office from Chancellor of New York Robert Livingston at Federal Hall, New York City, on April 30, 1789.

James Monroe in 1817 was the first president to take the oath of office and deliver the inaugural address outdoors, on a platform erected in front of the "Brick Capitol" (where the U.S. Supreme Court building now stands), built to serve as an interim meeting place for Congress following the destruction of the original Capitol by the British three years before. In 1837, Andrew Jackson and Martin Van Buren became the first president and president-elect to ride to the Capitol together for the inauguration. After the oath, Jackson mounted his horse and was accompanied along Pennsylvania Avenue to the White House by several thousand celebrants—the first inaugural parade to include the president. In 1841, a group of Washington, D.C., citizens formed the first official inaugural committee to organize the parade and inaugural ball. All inaugurations since have been followed by an inaugural parade that begins with the president leading a procession to the White House.

Inauguration Day originally was on March 4, before the 20th Amendment was enacted in 1933, placing it on January 20. If that date fell on a Sunday, inauguration would be observed on January 21. The last president to be inaugurated on March 4 was Franklin D. Roosevelt in 1933. From Andrew Jackson through Jimmy Carter,

the ceremony took place on the east portico of the Capitol. To begin his first term in 1981, Ronald Reagan took the oath of office on the west front to minimize the cost of construction and to improve visibility for a larger number of spectators. The ceremony has been held there ever since, weather permitting. For the start of Reagan's second term, January 20 fell on a Sunday, so he took the oath privately at the White House that day. His public inauguration was scheduled for the next day, but it was so bitterly cold—7°F at noon—that his swearing-in was held indoors, in the Capitol Rotunda.

The U.S. military participates in Inauguration Day ceremonies because the president is the commander in chief of the armed forces, and their presence reflects the strength of our democracy. It is customary for outgoing presidents to attend the inauguration of an incoming president, but there have been exceptions. John Adams did not attend Jefferson's inaugural because the situation was truly so new and he may simply have been uncertain as to what was proper. John Quincy Adams did not attend Andrew Jackson's inaugural, and Andrew Johnson did not attend Ulysses S. Grant's. Because of physical disability, Woodrow Wilson did not attend Warren G. Harding's swearing-in, but

The audience surrounds the east steps of the U.S. Capitol for the first inauguration of Abraham Lincoln in 1861.

Ladies fainted, men were seen with bloody noses and such a scene of confusion took place as is impossible to describe.

Margaret Bayard Smith to Mrs. Kirkpatrick, March 11, 1829

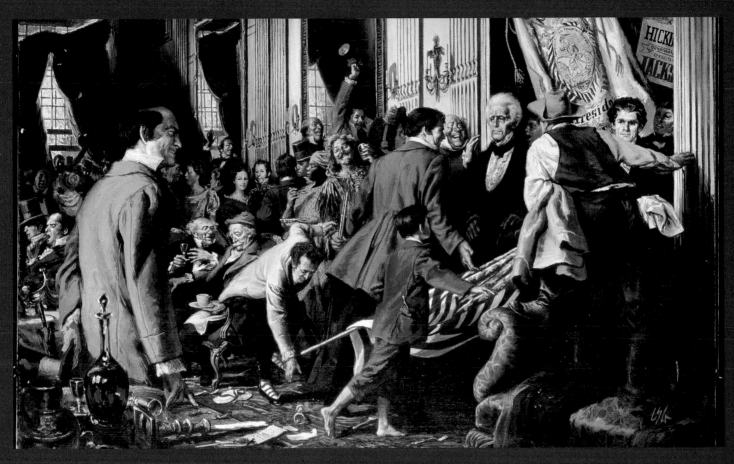

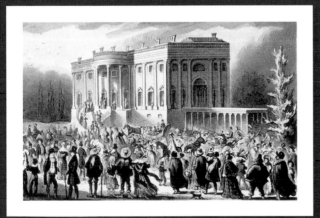

This imagined scene of Andrew Jackson's inaugural reception (top) depicts the rowdy event. An 1841 Robert Cruikshank print (above) is entitled "The President's Levee or All Creation Going to the White-house at Washington."

WHITE HOUSE LORE ★

THE WILD JACKSON RECEPTION

The wildest inaugural reception seems to have been that of Andrew Jackson in 1829. Senator Daniel Webster of Massachusetts remarked that folks came from 500 miles away and that they believed that the country had been "rescued from some dreadful danger." The President's House became chaotic as officials left and crowds of ordinary people rushed to shake Jackson's hand and to offer their best wishes. As they lunged for refreshments, they broke furniture, knocked over trays of food, and spilled drinks on the carpet. Jackson himself was carried by aides through a window and to a nearby hotel. To his opponents, the mayhem demonstrated the danger of an ungovernable rabble, a "mobocracy." His supporters viewed it as a celebration that got out of hand, with no real harm done.

President and Mrs. William H. Taft (left) ride in an open landau during a blizzard on Inauguration Day in 1909. Helen Taft was the first wife to ride to and from the Capitol in the presidential carriage for the inaugural. The pageantry of an inauguration is evident (opposite) as President George H. W. Bush is sworn in on January 20, 1989.

did ride to the Capitol with him. Richard Nixon left Washington before his resignation took effect and did not attend Gerald Ford's swearing-in.

The Oath of Office

Traditionally, the chief justice of the Supreme Court administers the oath of office, but there have been exceptions, including George Washington (1789 and 1793), John Tyler (1841), Millard Fillmore (1850), Chester A. Arthur (1881), Theodore Roosevelt (1901), Calvin Coolidge (1923), and Lyndon B. Johnson (1963).

The oath of office was at first given to the vice president separately from the president, but since 1937, oaths to the two have been administered at the same time and in the same place. Since George Washington, every president has said these words: "I, (name), do solemnly swear (or affirm) that I will faithfully execute the office of President of the United States, and will to the best of my ability, preserve, protect, and defend the Constitution of the United States." Only one president, Franklin Pierce, is known to have affirmed on a law book rather than swear upon a Bible.

After the oath of office, presidents give an inaugural address. George Washington's speech was the shortest, only 135 words, at his second inaugural. William Henry Harrison delivered the longest, at 8,495 words. Until William McKinley in 1898, speeches were given before

the oath of office was administered, but McKinley requested that his speech be given afterward so he could repeat the words of the oath. Since then, the speech has been given after the swearing-in process.

These speeches set the tone for a president's term, and have included some examples of powerful oratory. On January 20, 1961, John F. Kennedy declaimed, "Let the word go forth from this time and place, to friend and foe alike, that the torch has been passed to a new generation of Americans—born in this century, tempered by war, disciplined by a hard and bitter peace, proud of our ancient heritage." He called upon his fellow Americans, "Ask not what your country can do for you—ask what you can do for your country."

In recent times, the new president has given his speech from the west steps of the Capitol; it is broadcast on giant screens to the crowds listening live on the National Mall as well as to people watching on television from around the world.

Since 1953, a luncheon has followed the oath, held in Statuary Hall of the Capitol, with the president and vice president as honored guests. By tradition, the outgoing president and first lady do not attend, usually leaving town aboard *Air Force One* immediately after the swearing-in ceremony.

In 1977, Jimmy Carter and his wife Rosalynn Carter walked to the White House, but for security reasons, now

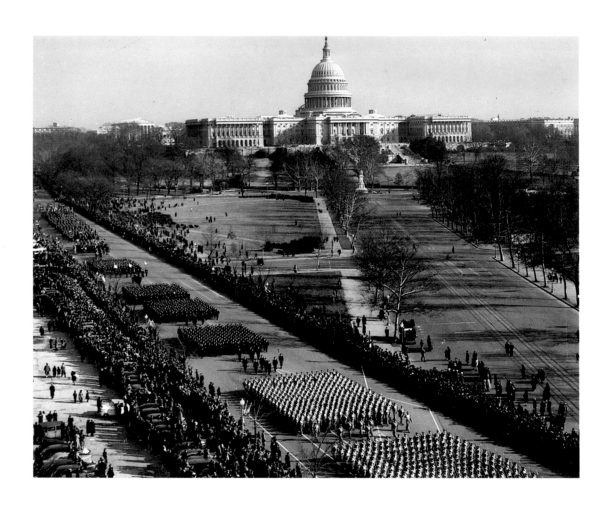

With the Capitol as a back-drop, mass formations of infantry sweep down Pennsylvania Avenue to pass the reviewing stand of Franklin D. Roosevelt in 1941. The inaugural parade began as an escort for the president's return to the White House and developed into a procession of ceremonial military regiments, citizens' groups, marching bands, and floats.

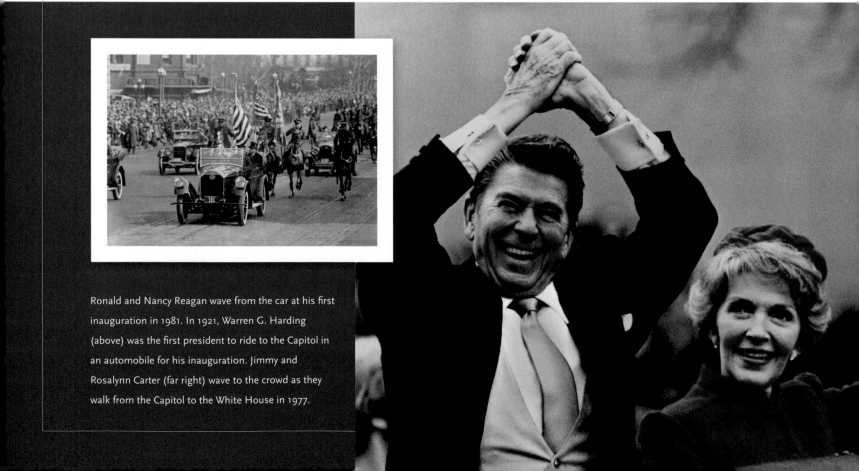

Ronald and Nancy Reagan wave from the car at his first inauguration in 1981. In 1921, Warren G. Harding (above) was the first president to ride to the Capitol in an automobile for his inauguration. Jimmy and Rosalynn Carter (far right) wave to the crowd as they walk from the Capitol to the White House in 1977.

presidents walk only partway. January in Washington can be frigidly cold and windy, but hundreds of thousands of people gather along 15 blocks of Pennsylvania Avenue, and in windows and on the balconies of office buildings that overlook the avenue, to see the bands, floats, honor guards, and, of course, the president.

Arriving at the White House

After the president and his party arrive at the White House, it has become traditional for them to observe the parade from an enclosed stand facing Pennsylvania Avenue and erected just for that purpose, then taken down. Before 1885, only troops were reviewed, but after that year, both military and civilian contingents took part. The 1953 parade celebrating Dwight Eisenhower's first term in office was the largest, longest, and most elaborate of all inaugural parades. The inaugural parade of 1865 was the first to include African Americans; the one in 1917 was the first to include women; and the one in 2009 was the first to include openly gay and lesbian participants.

The inaugural ball to celebrate the installation of the first president was held a week after George Washington was given the oath of office, but since then, the balls have been held closer to the actual inauguration. In 1833, two balls were held for Andrew Jackson's second installation, and a third was added for William Henry Harrison two administrations later. Jimmy Carter thought the balls had become too filled with frivolity and glamour and directed that they be made simpler. Bill Clinton holds the record at 14 official balls held in his honor at the outset of his second administration in 1997. George W. Bush reduced the number of balls to eight for his first inauguration and nine for his second. Barack Obama, stating that the economy was too stagnant to have so many balls, had only two for his second inauguration in 2013, the lowest number in 60 years.

Official balls are those arranged by the official inaugural committee. Washington in the days surrounding an inauguration is also the site of scores of unofficial balls, often fancy celebrations with a political flavor, even if the president does not attend. ★

PARADE HISTORY

Thomas Jefferson's 1801 inauguration, the first held in Washington, bore little resemblance to modern celebrations. Jefferson, after walking to the Capitol for his swearing-in, read his address and then returned to his boardinghouse. As time passed, escorts from the Capitol to the White House evolved into elaborate inaugural parades. Andrew Jackson's was the first. Grover Cleveland's 1885 parade lasted three hours. Eighty years later, Lyndon Johnson's parade included 52 bands. Early presidents rode horses from the Capitol to the White House after their inauguration, but it soon became tradition to ride in a carriage and, since 1921, in an automobile. In 1881, James A. Garfield was the first president to view the parade from a raised platform in front of the White House. Today, the reviewing stands are complete with protective glass, heaters, seats, and refreshments.

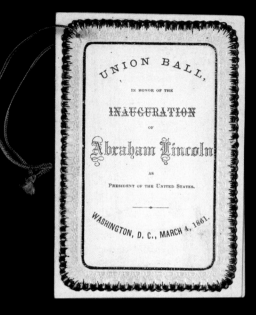

Inaugural Balls

Most inaugurations close with one or more gala balls held in hotels, temporary
buildings, or some of the larger government buildings in Washington. This page,
clockwise from above: In 2005, George W. and Laura Bush dance on the presiden-
tial seal at the Commander in Chief Inaugural Ball in Washington; a dance card
created for Abraham Lincoln's inaugural ball, 1861; couples dance at the 1889
inaugural ball held at the Pension Building, now the National Building Museum
and a popular venue for inaugural balls since Grover Cleveland's first in 1885; a 1981
ticket for the inaugural ball held at the Smithsonian Museum of Natural History.
Opposite, clockwise from top: Preparations for a 1981 inaugural ball inside the
Pension Building; the 1897 inaugural ball program cover showing the exterior of
the Pension Building; First Lady Caroline Harrison's 1889 inaugural gown was an
"all-American" creation, made in New York City by Ghormley, Robes et Manteaux.

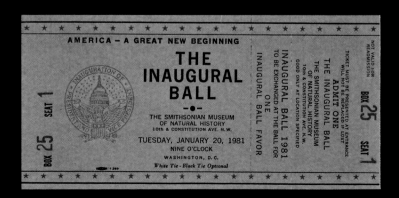

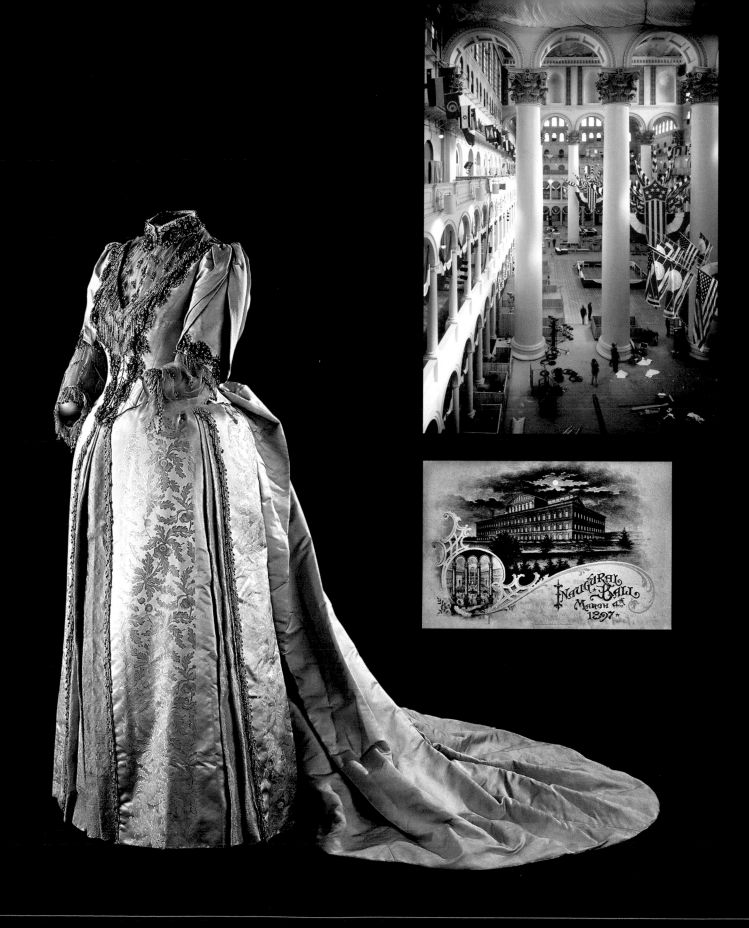

Inaugural Ball
March 4th 1897

Funerals

THE NATION IS DEEPLY SADDENED WHEN A PRESIDENT DIES in office, but unlike in some other countries, the death of a leader in the United States has not led to the overthrow of the federal government. Instead, power has passed seamlessly. Four U.S. presidents have been assassinated and four have died of natural causes—stroke, pneumonia, gastroenteritis, and heart attack. In all eight cases, the vice president assumed office and appropriate state funerals were held.

William Henry Harrison was the first president to die in office, after only 31 days as president in 1841. At 68, Harrison was the oldest man before Ronald Reagan to take the office of president. In late March, Harrison fell ill with a cold, believed to have been contracted during his inaugural ceremonies where he refused to wear a hat or overcoat, or perhaps when he went shopping in open-air markets. Harrison's cold worsened into pneumonia, and he told his nurse, "I am ill, very ill, much more so than they think me." The remedies applied to him—bleeding, cupping, laudanum, castor oil, and patent powders—only made the president feel worse. Just past midnight on April 4, Harrison died.

There had never before been a funeral for a sitting president, so members of Harrison's cabinet were unsure what to do. Clearly, the occasion called for some kind of ceremony. The marshal of the District of Columbia, Alexander Hunter, was placed in charge, and he patterned the procedures after royal funerals in Europe. Hunter ordered the White House and other public buildings to be swathed in bands and rings of black crepe. On April 7, after an Episcopalian service in the East Room, Harrison's remains were transferred to a carriage—known as a funeral car—built especially for his funeral procession. Harrison was temporarily interred in a receiving vault at the Congressional Cemetery until June 16, when his remains were moved to a permanent burial site in North Bend, Ohio. John

Tyler, Harrison's vice president, was sworn in on April 6 at the Indian Queen Hotel on Pennsylvania Avenue, by Chief Judge William Cranch of the U.S. Circuit Court of the District of Columbia.

Nine years passed before a second president died in office. On a hot Fourth of July, 1850, President Zachary Taylor spent hours bareheaded in the sun at dedication ceremonies for the Washington Monument, listening to an Independence Day oration by Senator Henry S. Foote of Mississippi. Back in the coolness of the White House, Taylor consumed cherries and other fruits, washed down with sizeable amounts of iced milk. By the evening, he was feeling very ill; when doctors were called, they diagnosed his severe stomach pain as "cholera morbus," a term used for acute gastroenteritis. Taylor's condition worsened as he suffered for the next five days. On the evening of July 9, he said with perfect clarity: "I am about to die. I expect the summons very soon. I have tried to discharge my duties faithfully; I regret nothing, but I am sorry I am about to leave my friends." He turned his head to look fondly at his wife, Margaret, and died at 10:30 p.m. The following day, William Cranch, who had sworn John Tyler into office

Warren G. Harding's mourning badge, 1923 (above).

Opposite: John Kennedy, Jr., salutes the flag-draped coffin of his father, President John F. Kennedy.

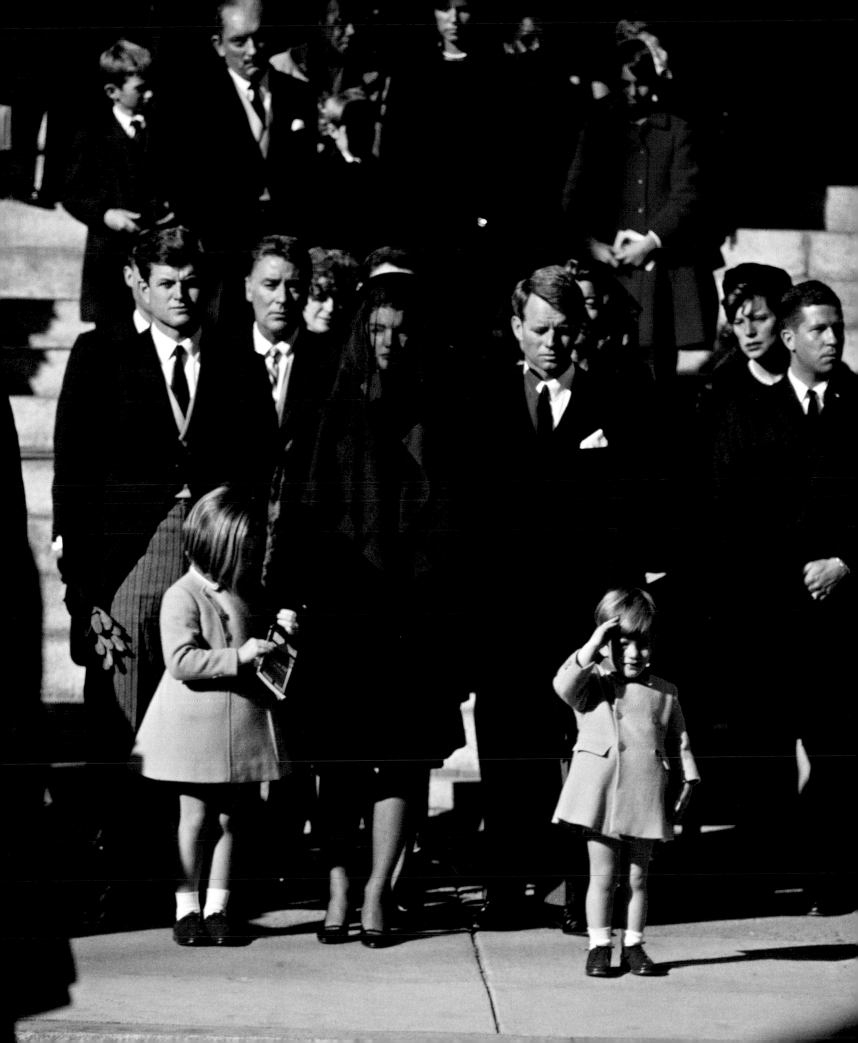

Onlookers on Pennsylvania Avenue (left) watch President Abraham Lincoln's body pass in a funeral procession headed to the Capitol, 1865. The death of a president while in office brings an end to an image of leadership—and to a greater or lesser degree, an end to an era in history. The White House was draped in black fabric in 1881 (below) to express a nation in mourning for James Garfield. Opposite: A funeral paper features a profile of Zachary Taylor's face, his birth and death dates, and an eagle atop an American flag.

in 1841, performed the same duty for Millard Fillmore in the House of Representatives chamber. On July 13, after a religious service in the East Room, more than 100,000 people watched Taylor's funeral procession and the late president's horse, Old Whitey, ambling riderless behind the coffin, Taylor's boots turned backward in the stirrups. Margaret Taylor, in her deep state of grief and shock, did not attend the funeral. Taylor was ultimately buried in a tomb in Louisville, Kentucky, where he had grown up.

Three Assassinations

Abraham Lincoln was the first president to be assassinated. He was shot by John Wilkes Booth at Ford's Theatre on April 14, 1865, in the waning days of the Civil War, during the play *Our American Cousin*. The president's bodyguard left the passageway unguarded and the president unprotected, when Booth entered the presidential box and shot him. Lincoln remained in a coma in the Petersen House across the street from the theater and died at 7:22 a.m. on April 15, 1865. Hours later, in a small parlor at the Kirkwood House hotel at the corner of 12th Street and Pennsylvania Avenue, Vice President Andrew Johnson took the oath of office, administered by Chief Justice Salmon P. Chase.

The late president lay in state in the East Room while thousands filed past, then was moved to the Capitol to lie in state there. An estimated 40,000 people filed past the casket during the next 14 hours. Black mourning material appeared on government buildings, places of business, hotels, and homes. After that, Lincoln's body went on a winding three-week train trip to Springfield, Illinois, stopping at towns along the way for people to pay homage to their dead president. Mary Lincoln stayed in the White House five weeks before she left, but she mourned her husband until her death 17 years later.

When James Garfield was shot twice while visiting the Baltimore & Potomac Railroad Station (where the National Gallery of Art's West Building stands today) on July 2, 1881, he lingered for more than two months before succumbing to blood poisoning on September 19. A disappointed office seeker, Charles Guiteau, fired point-blank from behind the president, causing Garfield to cry out, "My God, what was that!" Garfield's condition seemed to improve periodically. It was very hot in Washington during the summer, so on September 6, the president was taken to the beach in hopes that he might recover in the sea air and cooler weather. When he died two weeks later in a cottage at Elberon, New Jersey, Vice President Chester A. Arthur was sworn in as president at his New York City home by Judge John R. Brady of the New York Supreme Court. Garfield's body was brought back to Washington to be viewed over two days by thousands while Major Octavius L. Pruden, one of the assistant White House secretaries, supervised the packing of the Garfield family's possessions. Garfield was buried in Cleveland, Ohio, where the funeral was held.

William McKinley was shot by anarchist Leon Czolgosz on September 6, 1901, as the president was standing in a receiving line in the Temple of Music at the Pan-American Exposition at Buffalo, New York. Before he was shot, he had reached out to Czolgosz to shake his hand, but the assassin had a .32 Iver Johnson revolver hidden in his bandaged hand. McKinley had two wounds, one that grazed him and another that entered his abdomen. He stayed alive for eight days and seemed to be recovering, but died of gangrene on September 14. Vice President Theodore Roosevelt, who had been vacationing in the Adirondacks, arrived in Buffalo and took the oath of

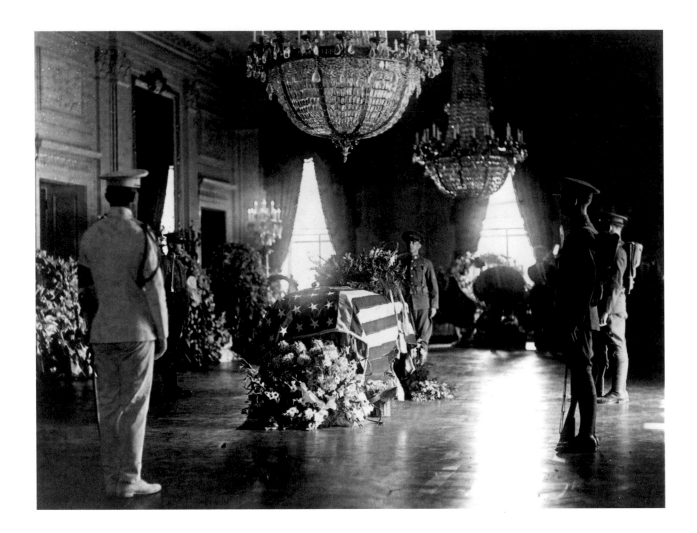

office from U.S. District Judge John R. Hazel of the Western District of New York. McKinley's body was brought back to Washington and taken to the East Room in the White House. The next day, it was taken to the Capitol where a state funeral was held, after which Ida McKinley and a great number of officials accompanied the body by train back to Canton, Ohio, for burial.

Natural Deaths

The stunning news of Warren Harding's death took the nation by surprise. While on a tour to gain support in the western states, he died at 7:32 p.m. on August 2, 1923, at the Palace Hotel in San Francisco where he had lain ill for several days. The diagnosis was apoplexy, but Florence Harding would not allow her husband's body to be subjected to an autopsy. Later speculation was that he died of a heart attack.

The body of President Warren G. Harding lies in state in the East Room in 1923, after Harding died suddenly of an assumed heart attack while on a West Coast trip. Opposite: A horse-drawn caisson carries the remains of President Franklin D. Roosevelt en route to the White House in 1945.

Similar to Lincoln, Garfield, and McKinley before him, Harding's remains traveled to Washington on a train with his coffin on a raised bier so people could see it on the way. The train arrived in Washington on August 7 at 10:30 p.m., and the body was taken to the White House, where it was placed in the East Room for viewing by family and close friends. At 10 a.m. the next day, it was mounted on a caisson and taken to the Capitol, where the funeral service was held before the Congress, the cabinet, and a few invited dignitaries. At the conclusion of the service, the silvery, flag-draped

coffin was put in the Capitol Rotunda for public viewing. Later that afternoon, the coffin was taken again to Union Station, where it was placed aboard a train to Marion, Ohio, where another funeral service was held and where Harding's body was placed in a vault on August 10. It remained there until 1927, when it was moved to the newly constructed Harding Memorial.

Franklin Roosevelt chafed at efforts to protect him during World War II, balking at the bombproof barriers, the blocking of traffic in front of the White House, and the sentries armed with machine guns who patrolled around the White House. Roosevelt felt the elaborate precautions might have a negative impression on the public, that he might be accused of cowardice. Because of his recalcitrance, most of the recommended precautions were not acted upon. Bulletproof glass was nevertheless installed halfway up the windows in the Oval Office, and a bomb barrier of

poured concrete was erected on the west wall of the Executive Office Building. Sentries patrolled the grounds, but as the war neared its end and it became clear that Germany would soon be defeated, Roosevelt ordered the soldiers removed and blackout curtains taken down.

When Roosevelt died of a cerebral hemorrhage on April 12, 1945, at the "Little White House" in Warm Springs, Georgia, it shocked the world that had known him as president for 12 years. Harry S. Truman, who had been vice president for only a few weeks, was hastily summoned from the Capitol and sworn in by Chief Justice Harlan F. Stone in the White House Cabinet Room at 7:09 p.m. At the announcement of Roosevelt's death, Eleanor Roosevelt flew on a military transport plane to Fort Benning, Georgia, to accompany Roosevelt's body back from Warm Springs to the capital on a train. On the way to the train, theatrical

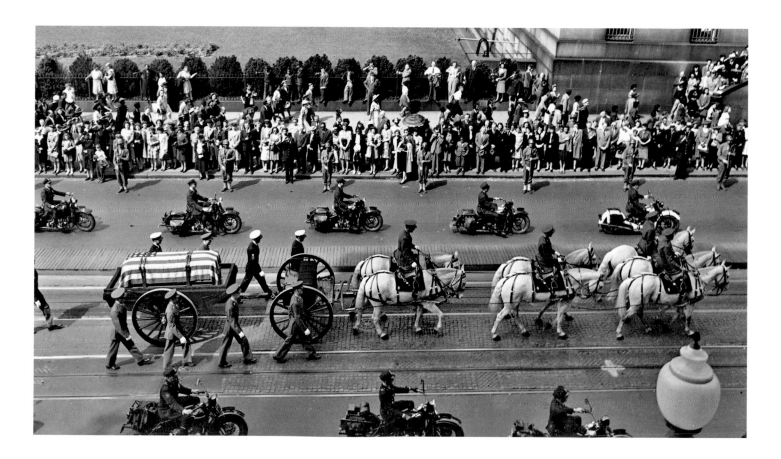

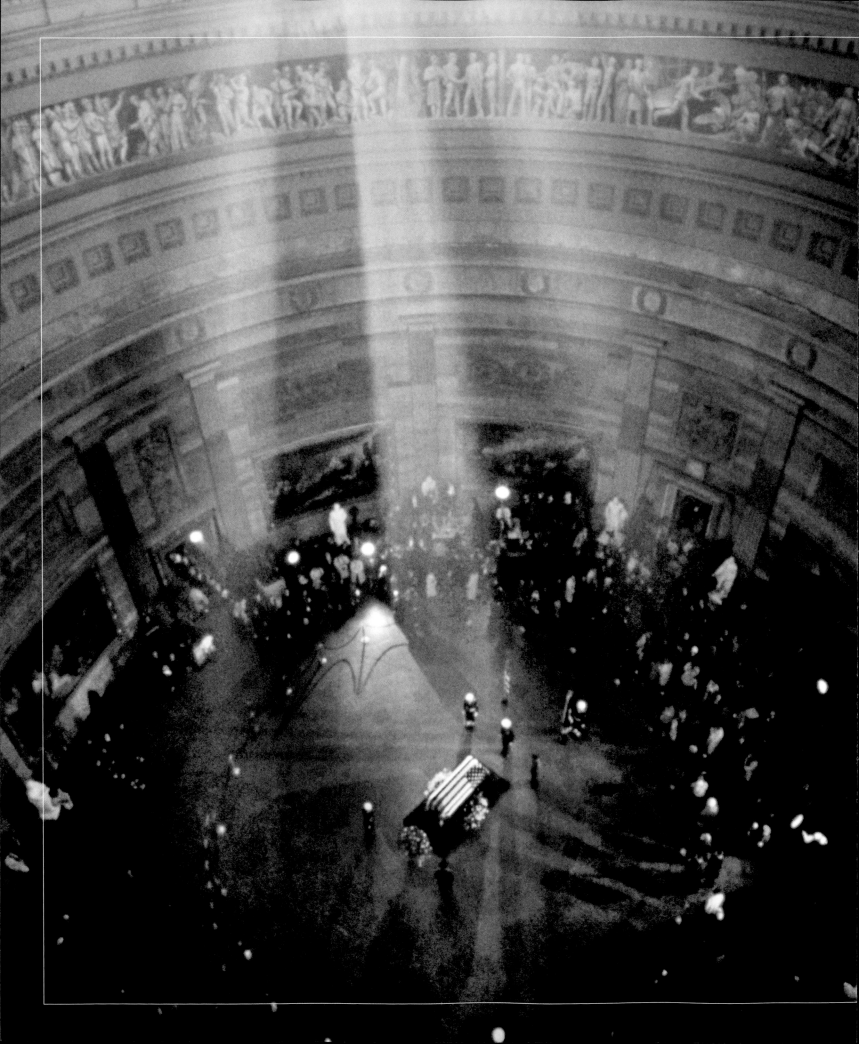

It was sad, very sad. When we came back from Arlington,

Robert [Kennedy] pulled off his gloves and said to me, "Keep these gloves

and remember always that I wore them to my brother's funeral."

PRESTON BRUCE, White House doorman, 1953–1977

Sunlight streams through the windows and columns of the Capitol Rotunda and onto the flag-draped coffin of President John F. Kennedy, November 24, 1963.

pianist and choral conductor Graham W. Jackson, Sr., who had played accordion for Roosevelt numerous times, played "Going Home" and "Nearer, My God, to Thee" with tears streaming down his face, an image that would be published across the nation.

The train moved slowly so that people gathered along the tracks at towns on the way could see the president's coffin in a lighted car. At Union Station in Washington, at least a half million people watched as the coffin was loaded into a hearse on April 14 and taken by slow procession to the White House. At Roosevelt's request, his remains did not lie in state at the Capitol, but were to remain in the East Room of the White House for about five hours. About 200 mourners were seated in the East Room, large numbers of others found space elsewhere on the State Floor, and thousands pressed against the iron fences outside. That afternoon, Roosevelt's body was taken again to Union Station, and then onward to Hyde Park for burial. His wish that his coffin sit before the fireplace where he had sat so many times in his home was not found until later and therefore was not followed. After a graveside service, Eleanor Roosevelt returned to Washington, packed her and the president's belongings into 20 army trucks, and departed the White House five days later.

The Kennedy Assassination

The assassination of vigorous 46-year-old President John F. Kennedy in Dallas, Texas, on November 22, 1963, stunned the world. In the United States, two

generations had grown up without the memory of the violent death of a president. Because no one had dreamed that Kennedy would require a state funeral, there had been no advance preparation. During the night of November 22 and early morning of November 23, ceremony and special events experts from the Military District of Washington planned the funeral in accordance with guidelines set down by the first lady. Jacqueline Kennedy, whose sense of history was as strong as her late husband's, wanted the funeral to follow the pattern of Abraham Lincoln's 1865 rites as closely as possible.

John F. Kennedy's remains were returned to the White House on November 23, and lay in repose in the East Room in the presence of a military honor guard and two priests. The White House domestic staff and an outside upholstery contractor had labored to make the room appear approximately as it had for Lincoln 98 years before—the windows were darkened by black curtains and the chandeliers were dimmed with bolts of black webbing. After a private religious service for members of the late president's family on November 24, the casket was taken by a horse-drawn caisson to the Capitol Rotunda, where it lay in state while more than 250,000 mourners filed by. The following day— Monday, November 25—President Kennedy's coffin was returned briefly to the White House and then taken to St. Matthew's Cathedral at Connecticut and Rhode Island Avenues for the funeral service. Afterward, the caisson and a lengthy line of limousines crossed the Arlington Memorial Bridge to Arlington National Cemetery, where Kennedy was buried on a peaceful incline and where an eternal flame now burns at his grave site overlooking Washington. ★

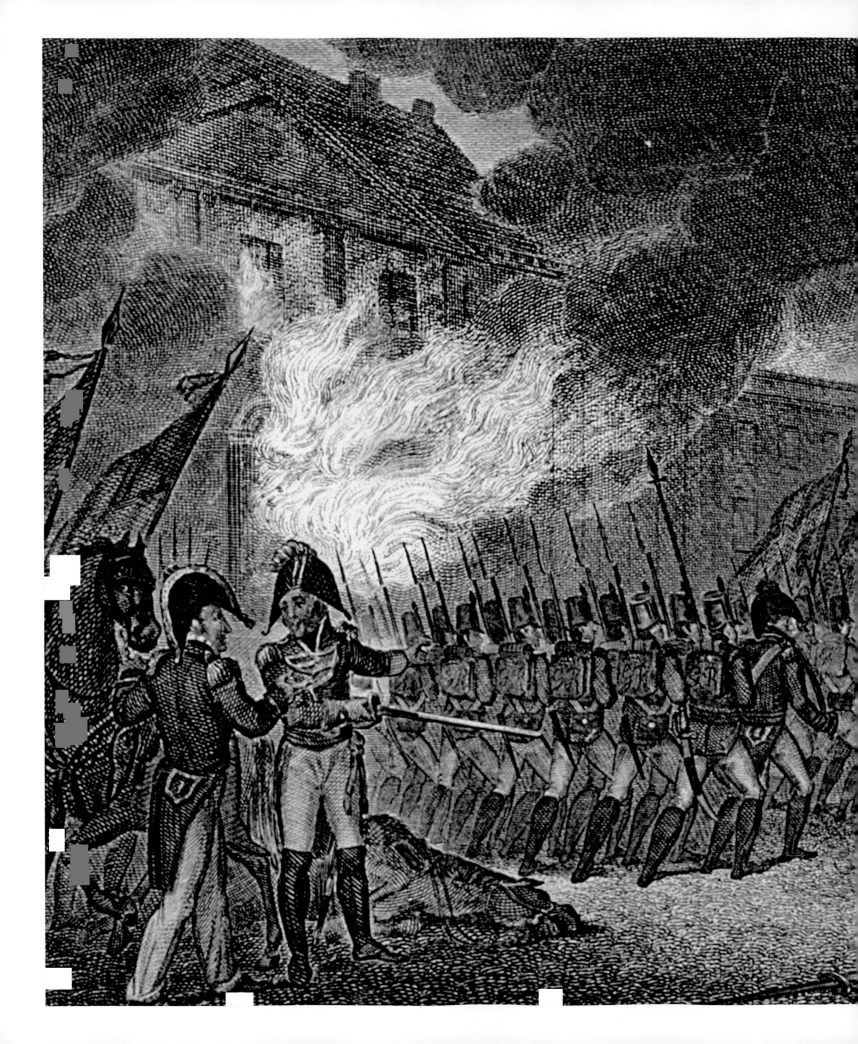

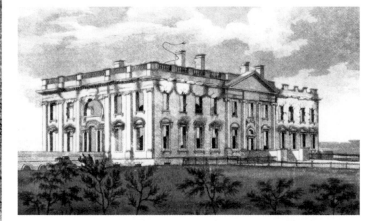

The White House at War

WAR HAS PHYSICALLY DAMAGED the White House only once, when the British burned the building to the ground in the War of 1812. But as the home and office of the president, the White House has served as the nerve center of the executive branch for U.S. wars over the centuries. From the White House, presidents have closely followed the conduct of military campaigns and remained in contact with military forces around the world.

On August 24, 1814, First Lady Dolley Madison, with the help of the White House domestic staff and a few local volunteers, gathered together important papers and Gilbert Stuart's celebrated 1797 "Lansdowne Portrait" of George Washington and sent them away for safekeeping. The British almost destroyed the White House, but it was rebuilt on the original site, using the walls that were still standing, a show of determination by a young America.

The Civil War made Abraham Lincoln's White House the center of attention for the divided country. From his first days as president, most of Lincoln's decisions related to bringing the southern states back into the Union. He seldom left the nation's capital during the war. Until Union troops captured Alexandria, Virginia, the enemy was just across the Potomac River. Southern troops again threatened Washington before being repulsed at Fort Stevens, less than five miles from the White House, in July 1864.

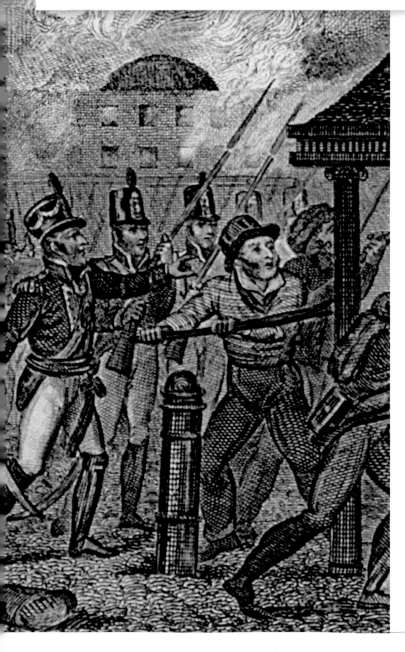

"Capture of the City of Washington," an 1815 engraving (left); the burned shell of the White House in an 1815 watercolor by George Munger (inset).

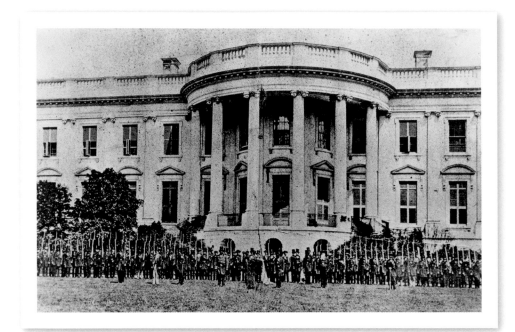

The Cassius M. Clay Battalion guards the White House, 1861 (left). William McKinley (below, standing at the head of the Treaty Table) witnesses the signing of the Peace Protocol between the United States and Spain in the Cabinet Room, 1898. Opposite: Franklin D. Roosevelt's handwritten edits on a draft of his message to Congress after the Japanese bombing of Pearl Harbor, December 7, 1941.

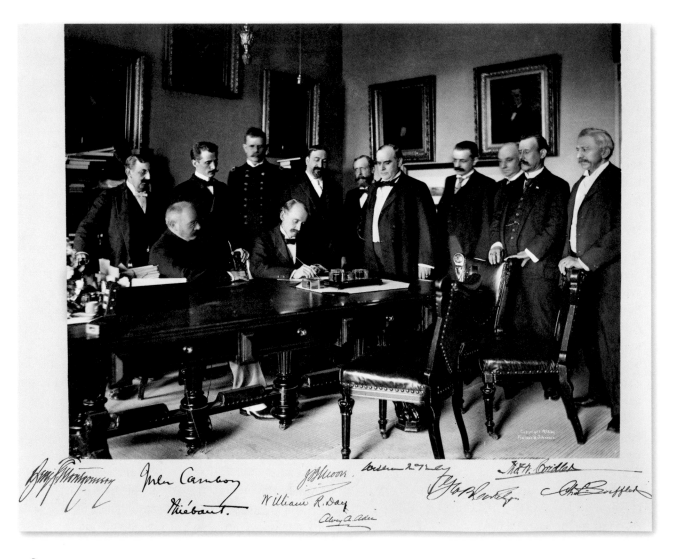

Communications Center

During the Spanish-American War of 1898, the White House for the first time became a communications center in wartime. When the ship U.S.S. *Maine* exploded in Havana Harbor on the evening of February 15, 1898, President William McKinley received a telephone call at three in the morning. Immediately, the president established a special communications, map, and tracking center in the southeast corner of the White House's second floor, called the war room.

U.S. Army Signal Corps Captain Benjamin F. Montgomery served as the war room's executive clerk and communications coordinator. The walls were covered with maps featuring strings marking cable and sailing routes, and flag pins denoting the location of U.S. and Spanish forces. Fifteen specially installed telephone wires and 25 telegraph wires kept McKinley, his cabinet, and his military advisers updated on the capture of Guam and on operations in Cuba, Puerto Rico, and the Philippines. The war, which lasted three months, was a major U.S. victory.

World Wars

During World War I, the sight of sheep grazing on the South Lawn of the White House was a highly visible symbol of home-front support for the troops. First Lady Edith Wilson organized war bond meetings, such as an April 1918 rally where Hollywood stars Charlie Chaplin, Mary Pickford, Marie Dressler, and Douglas Fairbanks began their nationwide tour for the Third Liberty Loan Campaign by autographing bond subscription books and selling bonds to crowds near the White House.

Crowds of angry Americans surrounded the White House on December 7, 1941, as news spread of the Japanese bombing of Pearl Harbor. The next day, Franklin D. Roosevelt described December 7 as "a date which will live in infamy." Congress declared war on Japan, and a few days later, the United States was also at war with Germany and Italy.

From a room in the White House basement called the Map Room, Roosevelt kept in touch with U.S. military forces and Allied leaders. The Secret Service ordered the White House windows blacked out so lights would not tip off would-be enemy bombers. For the same reason, Roosevelt was warned that it was too dangerous for him to light the 1941 Christmas tree—located in Lafayette Park across the street from the White House at that time. But the president did not want Americans to think their leader was a coward. A tree was placed on the South Lawn of the White House, where the Secret Service could keep watch on Roosevelt and his surprise guest, British prime minister Winston Churchill. The two world leaders gave the word, and the colored lights blazed.

During World War II, Americans were encouraged to plant "victory gardens." Diana Hopkins, the ten-year-old daughter of Harry L. Hopkins, President Roosevelt's personal representative, lived in the White House with her father and stepmother. With help from White House gardening staff, an overall-clad Diana

The Situation Room

William McKinley established a war room on the second floor of the White House in 1898; Franklin D. Roosevelt had a map room on the ground floor for intelligence and military strategy; and John F. Kennedy created a situation room in the West Wing basement as an area for real-time secure communications. In times of war, the modern situation room takes on great importance, just as the earlier war rooms did.

The "sit room" serves as a conference facility, a processing center for secure communications, a hub of intelligence gathering, and a center for emergency operations. Today, men and women from the Department of Homeland Security, the intelligence community, and the military monitor information and provide a one-stop conduit for detailed intelligence and crisis support.

The importance of the situation room is its proximity to the president. The president receives daily important intelligence briefings and advice from the director of National Intelligence and other key intelligence officials, but they cannot be at the White House 24 hours a day.

The space, or part of it, was once a light well and courtyard built as part of the 1934 West Wing expansion, but then covered for security reasons during World War II. Cramped and mostly devoid of natural light, the 5,000-square-foot complex on the ground floor of the West Wing includes a soundproof conference room flanked on three sides by two small offices, workstations, computers, and communications equipment.

The room is used in different ways by different presidents and, just as Kennedy did during the Cuban missile crisis, his successors have held important meetings and made calls to world leaders from the Oval Office or the Cabinet Room above it.

President George H. W. Bush (at the desk) and General Colin Powell receive status reports from the first Gulf War, 1991.

Hopkins converted a 20-square-foot flower bed into a vegetable plot. Diana also donated several rubber toys to the White House's rubber salvage campaign, joining the presidential Scottish terrier Fala, who donated two rubber bones.

People still debate President Harry S. Truman's decision to drop atomic bombs on Hiroshima and Nagasaki on August 6 and 9, 1945. Truman gave the order because he thought it would end the war quickly, and he would save thousands of lives that would be lost if U.S. troops invaded Japan. On the evening of August 14, reporters crowded into the Oval Office to hear Truman say he had received "a full acceptance of the Potsdam Declaration which specifies the unconditional surrender of Japan." World War II was over.

Korean War, Vietnam Conflict, War in the Gulf

On the evening of June 24, 1950, Truman was interrupted during a visit to relatives in Missouri by a telephone call from Secretary of State Dean Acheson. "Mr. President," Acheson said, "I have very serious news. The North Koreans have invaded South Korea." North Korea's government was communist, and supported by China and the Soviet Union.

Truman returned to Washington the next day and gathered military and political experts in his residence at Blair House. (At the time, the White House was being renovated.) They decided the attack was a test: The Soviet Union wanted to see how the United States would react. Truman decided that the United States would draw the line and fight to keep communism from spreading into South Korea. The war lasted three years, but there was no clear victory over communism.

One of the most important steps President Lyndon B. Johnson took to stop the Vietnam War came on March 31, 1968. From the Oval Office, he announced a partial bombing halt, named U.S. representatives for possible peace talks, and then shocked the nation by declaring that he would not run for president again.

The Vietnam War did not begin with Johnson and did not end with him, but he is known as the leader who increased the number of troops sent to Southeast Asia. By 1968, more than a half million troops were in Vietnam. Johnson's Oval Office speech told Americans that the process of winding down the unpopular war had begun.

Before daylight on August 2, 1990, Iraqi soldiers invaded Kuwait. Hundreds of Kuwaitis died, much of the wealth of the country was removed, and oil was dumped into the Arabian Gulf. All major powers condemned the occupation. The invasion most likely occurred because Iraq had huge debts from its war with Iran and wanted to profit from oil-rich Kuwait's income.

The White House of George H. W. Bush had direct communication with military commanders in Saudi Arabia. On January 16, 1991, the coalition forces launched air and ground attacks, and in Operation Desert Storm quickly defeated Saddam Hussein's Imperial Guard. In the 21st century, wars in Iraq and Afghanistan have been waged to seek out and eliminate al Qaeda and other militant organizations. ★

Crisis Defines a Presidency

WOODROW WILSON'S STROKE, JOHN F. KENNEDY AND THE BRINKMANSHIP of the Cuban Missile Crisis, Richard M. Nixon and the Watergate cover-up— these were defining events that will always be joined to the histories of their presidential administrations. Our leaders have struggled with serious illness, international tensions, political scandal, and national tragedy and have persevered. The nature of the presidency is such that huge, difficult, and often unpredicted situations will arise and demand a response from the president that affects the course of history.

President Ronald Reagan and First Lady Nancy Reagan honor the victims of the bombing of the U.S. Embassy in Beirut, Lebanon, at Andrews Air Force Base, Maryland, in 1983. A suicide bomber in a pickup truck loaded with explosives rammed into the embassy, killing 63 people, including 17 Americans.

On October 2, 1919, President Woodrow Wilson suffered a stroke, and for 16 months the President of the United States was not capable of fully carrying out his duties. Americans were unaware of Wilson's condition. Despite the urging of cabinet officials and some members of Congress, Vice President Thomas R. Marshall made no effort to exercise any sort of presidential authority. The 25th Amendment to the U.S. Constitution, which now makes provision for cases of presidential disability, would not be enacted until 1967, almost half a century in the future. Although Wilson was still able to communicate after the stroke, his poor health made him impatient. At the time, Congress was discussing whether the United States should enter an organization called the League of Nations. World War I had ended the year before, and Wilson hoped that the League would be able to keep the world's powers from going to war in the future. The president did not have the energy or the patience to turn the tide of strong isolationist sentiment in Congress, and the United States did not join the League.

Tension Over Cuba

One of the most frightening episodes in U.S. history occurred during a tense two weeks in October 1962. On October 14, a U.S. Air Force plane discovered that nuclear missile sites had been built in Cuba, a communist country, and President John F. Kennedy

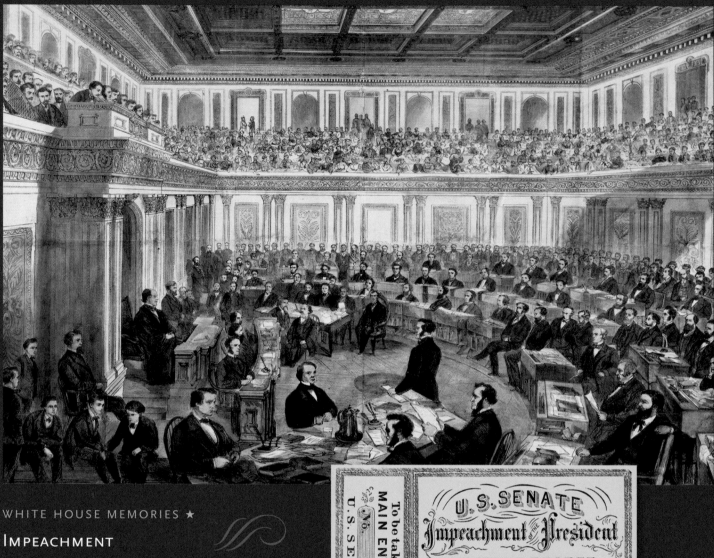

IMPEACHMENT

The U.S. Constitution gives Congress the power to remove presidents from office for "treason, bribery, or other high crimes and misdemeanors." This happens in two stages: The House of Representatives votes to impeach the president, and then the Senate holds a trial. Only two presidents have been impeached: Andrew Johnson and Bill Clinton.

Johnson and Radical Republicans disagreed about how to bring the South back into the Union after the Civil War. To stop Johnson from blocking their reconstruction plans, the Republicans passed a law that required the president to obtain Senate approval before firing certain officials. In defiance, Johnson dismissed his secretary of war, Edwin M. Stanton. The House voted to impeach the president. On May 26, 1868, the Senate fell one vote short of the necessary 36 to convict Johnson.

In the case of Clinton, one charge against him was that, while questioned under oath in 1998, he falsely denied an intimate sexual relationship. His belated apology and admission of the truth did not stop calls to remove him from office. The House impeached Clinton, but senators cast only 45 votes to convict—well short of the required two-thirds.

In 1868, the Senate voted 35 to 19 to remove President Andrew Johnson from office—one vote short of the two-thirds required.

President Woodrow Wilson waves from his carriage on Armistice Day in 1921. Wilson suffered a stroke on October 2, 1919, that left him paralyzed on his left side and blind in his left eye. Edith Bolling Wilson served as her husband's closest adviser and assistant during his long convalescence. Wilson did return to work and attended cabinet meetings to finish his term. The serious nature of his disability was not known to the public until after his death in 1924.

learned that the Soviet Union had placed nuclear missiles there. Because Cuba is just 90 miles from Florida, Americans feared that the missiles could easily and quickly strike the United States. Kennedy wanted to avoid the potential for nuclear war by making sure that the missiles in Cuba were disassembled and that no more missiles would be allowed in. On October 22, Kennedy announced a warning to Soviet leaders that the missile sites in Cuba should be dismantled. In a live television speech from the White House, Kennedy said that he was sending Navy ships to block the Soviet ships from landing in Cuba with more missiles. Soviet leader Nikita Khrushchev responded that he would not change his plans. For several days, a nervous world watched and waited. Would nuclear war begin? On October 26, a message was sent to the president: The Soviet ships would turn around and go home if the United States would agree not to attack Cuba. Kennedy agreed, and the crisis ended.

Watergate

Another White House crisis began with the arrest of five burglars, and ended with the only resignation of a U.S. president. In the early morning hours of June 17, 1972, five men were caught breaking into the headquarters of the Democratic National Committee in the Watergate complex in Washington. The burglars were hired by operatives who were working for the reelection of President Richard M. Nixon. It looked as if the burglars

were trying to steal information that would help Nixon defeat Democratic candidate George McGovern. There was no proof that Nixon had ordered the burglary, but it eventually was shown that he had used his power to tell the Federal Bureau of Investigation to stop investigating. In July 1973, White House aide Alexander Butterfield revealed to a congressional committee that Nixon had ordered Secret Service technicians to secretly install and maintain a sound-activated audio-taping system in the Oval Office and the Cabinet Room and to tap telephone lines in the Oval Office and Lincoln Sitting Room. In July 1974, the tapes were given to the House Judiciary Committee, which had subpoenaed them for its investigation into the possible impeachment of Nixon. Rather than face impeachment by the House and conviction in a Senate trial, Nixon resigned. He announced his decision to leave office in a televised address from the Oval Office on August 8, 1974. The next day, after a farewell to his staff in the East Room, he and his family left by helicopter from the South Lawn. Vice President Gerald Ford was sworn in as president by Chief Justice Warren E. Burger in a nationally televised ceremony in the East Room. Ford later pardoned Nixon.

Tragedies and Triumphs

Not since the British set Washington, D.C., aflame in August 1814 had the White House been a direct target of foreign aggression. That changed on

The last three days I was president . . . I spent all that time negotiating the release of the hostages . . . [their release] was one of the happiest moments of my life—every hostage came home safe and free.

FORMER PRESIDENT JIMMY CARTER, November 29, 2010

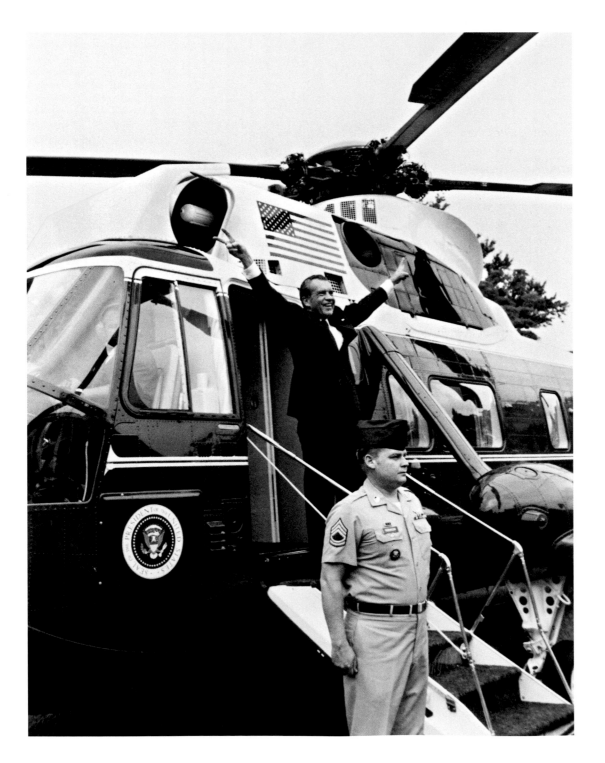

Richard Nixon smiles and gives his trademark two-handed V-sign before leaving the White House on *Marine One* in 1974, after resigning the presidency. Nixon resigned amid the scandal over a break-in at Democratic National Committee head-quarters in the Watergate complex in Washington nearly two years before in June 1972. Opposite: The White House became a crisis center in the last year of Jimmy Carter's presidency as he and aides meet to discuss the Americans taken hostage in the U.S. Embassy in Tehran, Iran, on November 4, 1979, and to negotiate their safe return, which took place on the day of Ronald Reagan's inauguration.

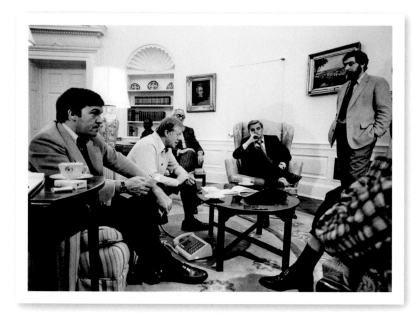

September 11, 2001. After the attacks on the World Trade Center and the Pentagon, officials realized there was another hijacked plane, and it was most likely headed for the Capitol or the White House. Inside the White House, the vice president and top aides were hustled into an underground emergency center, originally built in anticipation of a nuclear attack. For everyone else, there was only one order: evacuate.

As Secret Service agents and officers shouted, "Run! Run!" hundreds of tourists and White House staffers fled through the heavy iron gates into Lafayette Park and nearby streets. Many were barefoot, having kicked off their high heels or dress shoes, and many were sobbing. Terrified tourists had simply grabbed their children in their arms. President and Mrs. Bush returned home early that evening (the president began the day in Florida; Mrs. Bush was on Capitol Hill to appear before the Senate education committee).

Later, in the middle of the night, reports of a rogue plane sent agents racing into the Bushes' bedroom, yelling that the White House was under attack. The Bushes descended to the underground emergency shelter, but the plane turned out to be a fighter jet, "one of our own." On the ground, life at the White House was forever changed. Tours were canceled and security measures heightened: Windows were reinforced against car or truck bombs, and elite Secret Service teams patrolled the grounds. The White House still remains a target, profoundly altering the lives of every aide and staff member and, most of all, of each first family.

As incoming president in 2008, Barack Obama faced the economic crisis of the Great Recession, wars in Iraq and Afghanistan, and the continuing menace of terrorism as the United States pursued Osama bin Laden and the defeat of his al Qaeda militant Islamist group. Unprecedented federal spending helped rescue the economy and combat troops in Iraq were withdrawn and the force reduced in Afghanistan. In 2011, after nearly ten years of searching for bin Laden, the nation celebrated a small measure of justice for the man behind the 9/11 attacks on the United States. Two of the first people President Obama informed of the successful mission by military personnel on bin Laden's compound were President Bush and President Clinton. Soon afterward, in the East Room of the White House, President Obama addressed the nation, informing citizens of the death of Osama bin Laden. As he spoke and as the word spread, a large crowd spontaneously gathered outside the White House gates on Pennsylvania Avenue, waving flags and cheering.

A far more somber moment came in 2011 with the Tucson, Arizona, shooting that killed 6 and injured 13, including Representative Gabrielle Giffords. Again in 2012 and 2013, President Obama stepped to the podium to respond to the shocking mass shootings in Aurora, Colorado, and Newtown, Connecticut, and the tragic bombings in Boston, Massachusetts. At times like these, U.S. presidents must express confidence and resilience, leading the nation in overcoming tragedy, as Obama did in saying: "I'm supremely confident that Bostonians will pull together, take care of each other, and move forward as one proud city. And as they do, the American people will be with them every single step of the way." ★

Protests

LAFAYETTE PARK, NAMED IN 1824 AFTER REVOLUTIONARY WAR hero Marquis de Lafayette, is a seven-acre plot to the north of the White House. It has served many purposes. Early on, the park held a graveyard. The park has been the site of a racetrack, and was a military encampment during the War of 1812. In the 19th century, the area was a prime residential neighborhood. It is a reviewing area for inaugural parades. Like many spaces inside national parks, it is also a stage for freedom of expression protected by the First Amendment.

Lafayette Park is a place where many protests have taken place. Advocates understand the relevance of the location and use it to try to bring about change. Their campaigns sometimes affect the views of fellow citizens and, they hope, government decision makers.

On January 10, 1917, National Woman's Party members wearing ribbons with the suffragist colors of purple, white, and yellow started picketing the White House from 10 a.m. until dark, calling for enactment of a constitutional amendment guaranteeing the right of women to vote. Throughout 1917, the picketing continued by advocates to give all U.S. citizens the right to vote, regardless of gender. Supportive onlookers cheered; others, fearful of progress, hissed and accused the protestors of "bad manners and mad banners." Hundreds of brave women were arrested, charged with inciting unlawful assemblage and obstructing the sidewalk. In August, an unruly crowd, perturbed by a banner calling the president "Kaiser Wilson," heaved eggs and tomatoes at the Congressional Union for Woman Suffrage headquarters (Tayloe House on Madison Place), and a bullet was fired through a second-floor window. Justice prevailed and women finally won the right to vote in 1920, with the ratification of the 19th Amendment.

Demonstrations in Lafayette Park now take many forms, including marches, picketing, and nighttime vigils, and are regulated by the National Park Service, which administers the park.

Women stand on the Ellipse near the White House during the March on Washington for Jobs and Freedom, August 28, 1963.

Civil Rights and Antiwar Movements

When most people think of the civil rights movement and the nation's capital, they picture the mass of people stretched out from the Lincoln Memorial, listening intently to Martin Luther King, Jr., and his "I Have a Dream" speech in August 1963. Yet, Lafayette Park also played a pivotal role. Its symbolic location at the president's doorstep made it a frequent location for speaking out during the 1960s, notably during March 1965.

Early that month, civil rights activists attempted to march from Selma to Montgomery, Alabama, demanding voting rights for African Americans. After they were brutally attacked by state and local police on March 7, the day became known as "Bloody Sunday." Supporters flocked to Washington and gathered in Lafayette Square. They positioned themselves in front of the White House and demanded that President Lyndon B. Johnson send federal troops to protect the marchers in Alabama. The park played host to a number of sit-ins, vigils, marches, and prayer meetings that, along with the backlash against the violence during the march, prompted Johnson to send troops to Alabama.

As he introduced his proposed voting rights act to Congress on March 15, 1965, Johnson praised the protestors from across the nation, thousands of whom were not far from his doorstep at the time: "The real hero of this struggle is the American Negro. His actions and protests, his courage to risk safety and even to risk his life, have awakened the conscience of this nation. His demonstrations have been designed

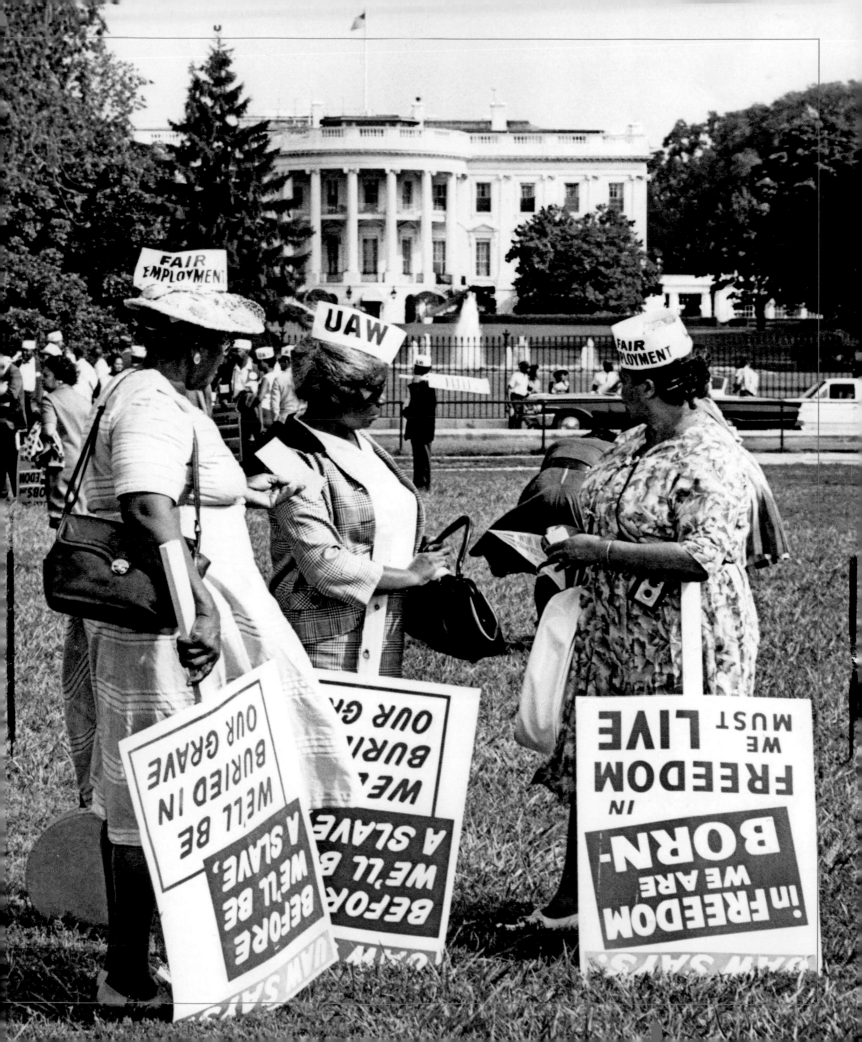

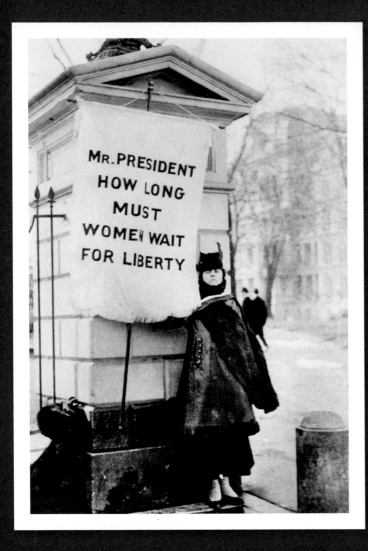

MR. PRESIDENT HOW LONG MUST WOMEN WAIT FOR LIBERTY

SILENT SENTINELS

The National Woman's Party established its headquarters on Jackson Place at Lafayette Park in 1916, and staged a series of pickets at the White House, called "Silent Sentinels." After a mob attacked and shredded the banners of two suffragists in 1917, the display of banners at the White House was prohibited. World War I intervened and, citing the service and sacrifice of women, Woodrow Wilson in 1918 announced his support for a constitutional amendment on women's suffrage, calling it "an act of right and justice to the women of the country and of the world." Women won the vote in August 1920, with ratification of the 19th Amendment.

Suffragist Alison Turnbull Hopkins holds a protest banner at the north-west gate of the White House, circa 1917.

to call attention to injustice, designed to provoke change, designed to stir reform." On August 6, 1965, the Voting Rights Act became law.

The Vietnam-era antiwar movement was one of the most pervasive displays of opposition to government policy in modern times. Protests raged across the country, but Washington was one of the most visible stages for this mass dissent. As early as January 1966, students staged silent vigils for peace talks in Vietnam in freezing temperatures and snow in the park. Protesters continued to use Lafayette Park as an integral element in bringing the government and the people within reach of each other.

The May Day Protest in 1971 is a prime example of how citizens used the nation's capital as the stage on which to signify their disapproval. Activists planned to shut down the city completely, handicapping the government and making it impossible for it to function. Protesters camped out on the edges of downtown Washington on May 2, 1971, so they were able to spread out along the entrances to the city as quickly as possible the next day. Traffic was stopped, at least for a few hours, and although it angered some commuters, no one could disregard the strength of the movement. CIA director Richard Helms remarked that May Day was "one of the things that was putting increasing pressure on the [Nixon] administration to try and find some way to get out of the war."

Constant Reminders

Lafayette Park has been a stage of choice for a small but steady stream of citizens concerned with the possibility of nuclear war. Periodically in the 1980s, larger groups frequented the park to protest the

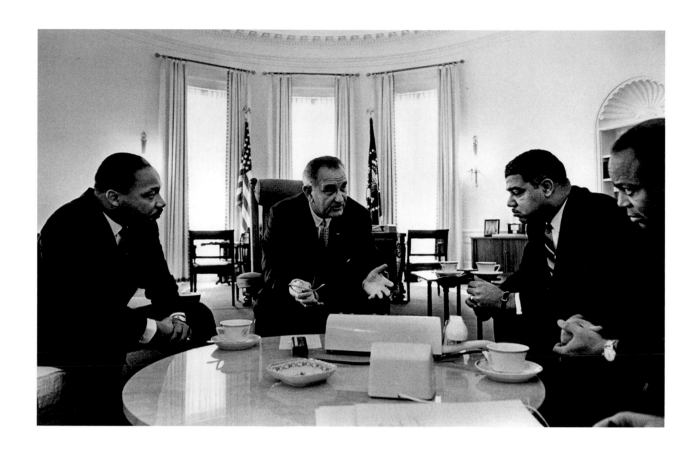

buildup of these weapons. The issue has also motivated long-term demonstrators. These citizens are not only constant reminders of the issues they represent, but also symbols to park visitors of America's tradition of protesting. In June 1981, antinuclear activist William Thomas Hallenback, Jr., launched a "peace vigil" whose supporters have maintained a continual presence in Lafayette Park ever since, even after Hallenback's death in 2009.

Before the Supreme Court's January 22, 1973, decision in *Roe* v. *Wade*, abortions were largely outlawed in most of the United States. In the mid-1960s, some states began to loosen those laws. By a 7-to-2 vote, the majority ruled that the U.S. Constitution protected the right of a woman to have an abortion through the second trimester of pregnancy. During the third trimester, the court proclaimed that states could outlaw abortions except in cases where the life or health of the woman is jeopardized.

Since *Roe* v. *Wade,* the issue has been one of the most polarizing in the United States. Abortion rights advocates and abortion rights opponents have come to Lafayette Park, the Supreme Court, and other areas in Washington to voice their opinions to the president, Congress, the court, and fellow citizens. The March for Women's Lives brought hundreds of thousands to the capital in April 2004. The March for Women's Lives is an annual event that coincides with the anniversary of *Roe* v. *Wade* in January.

To manage the many protests, giving the protestors full voice yet assuring peaceful conduct, a framework of rules has developed, including limits on the number of protesters allowed in Lafayette Park. Additionally, regulations on signs affect those who choose visual expression. Signs not carried by hand are to be no larger than four square feet on the sidewalk and must be attended by the demonstrator, but there is no limitation on hand-carried signs in Lafayette Park. This is to allow tourists a view of the White House and to permit a free flow for

pedestrians making their way through the park. For security reasons, structures, packages, and parcels cannot be placed on the sidewalk. There is a continuing effort to balance the beauty of the park, the safety of visitors, and the First Amendment rights of citizens.

Within these regulations, Lafayette Park still attracts those with views to express. On any day, there are likely to be protestors attempting to draw attention to causes that are important to them but may be unknown to the tourists who come to photograph the White House. Groups still assemble, but individual protestors also champion many issues.

Over the course of time, Lafayette Park has changed physically and demographically. The area, which was once largely residential and consisting of small row houses, is now surrounded by large government office buildings. Statues and monuments have been erected over time. On May 21, 1995, Pennsylvania Avenue in front of the White House was closed to all vehicular traffic, a response to the Oklahoma City bombing the previous month. In November 2004, the street became a new pedestrian-friendly civic space where people stroll and bicycle between the tree-shaded park and the White House fence.

Many who gaze through the fence upon the gorgeous and stately White House do not know many details of its storied presence. Those who come to stand, backs to the fence with families and friends posing for photos, enjoy the freedoms its presence and its occupants protect. Through over 200 years, the White House has stood through boom and bust, triumph and tribulation, one administration to the next. Its residents have each left marks in large and small ways, the resilient and singular staff have toiled toward a higher common good, and the White House remains one of our most hallowed and abiding emblems of freedom. ★

PORTRAITS of PRESIDENTS and FIRST LADIES

The portraits of the presidents and first ladies, many of which hang in the halls and rooms of the White House, honor the special people who have contributed to the evolution and growth of the nation and continue to inspire visitors and the house's occupants alike. Well into the 20th century, the commissioning and acquisition of portraits of presidents and first ladies for the White House collection was haphazard and dependent on gifts from families and friends of the first family. It was not until the founding of the White House Historical Association in 1961 and its commitment to fund the acquisition of life portraits of the presidents and first ladies that the paintings were consistently commissioned for the collection. Today, these works form a treasured official portrait gallery.

Four presidents—Thomas Jefferson, Andrew Jackson, Martin Van Buren, and Chester A. Arthur—entered office as widowers, and three—John Tyler, Benjamin Harrison, and Woodrow Wilson—became widowers while in office (Tyler and Wilson remarried while they were president). Two presidents—Grover Cleveland and James Buchanan—were bachelors when they became president. Illness prevented some presidential spouses from taking up demanding social duties of first lady.

This time line includes the portraits of presidents and their wives and in a few cases (indicated by an asterisk) the painting of a daughter or niece who served as official hostess. Although the role of "first lady" usually has been filled by the president's wife, throughout the history of the White House, daughters, sisters, nieces, and others have supported the president when a spouse was deceased or unwell or if the president was a bachelor.

1st 1789–1797

George Washington

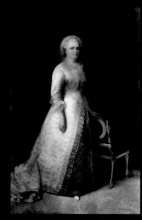
Martha Dandridge Washington

4th 1809–1817

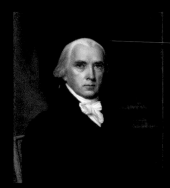
James Madison

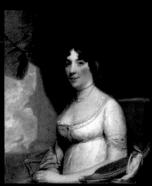
Dolley Payne Madison

7th 1829–1837

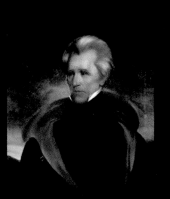
Andrew Jackson

Rachel Donelson Jackson

John Adams

Abigail Smith Adams

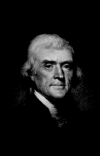

Thomas Jefferson

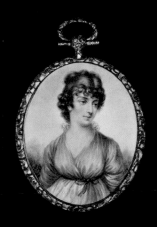

Martha (Patsy) Randolph*

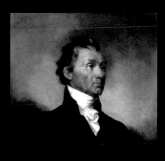

James Monroe

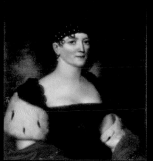

Elizabeth Kortright Monroe

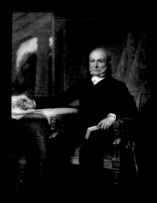

John Quincy Adams

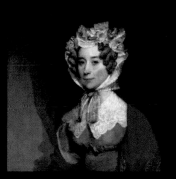

Louisa Catherine
Johnson Adams

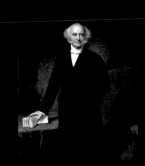

Martin Van Buren

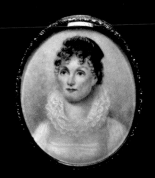

Hannah Hoes Van Buren

William Henry Harrison

Anna Symmes Harrison

10th 1841–1845

Not so many marriages can build themselves in the global proportions, and be consummated in the achievements, which characterize the relationship of Lou Henry and Herbert Hoover . . .

CHRISTIAN SCIENCE MONITOR, January 11, 1944

Letitia Christian Tyler

John Tyler

Julia Gardiner Tyler

13th 1850–1853

Millard Fillmore

Abigail Powers Fillmore

14th 1853–1857

Franklin Pierce

Jane Appleton Pierce

17th 1865–1869

Andrew Johnson

Eliza McCardle Johnson

18th 1869–1877

Ulysses S. Grant

Julia Dent Grant

11th 1845–1849

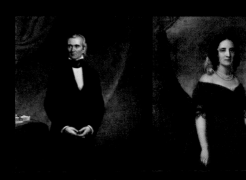

James K. Polk Sarah Childress Polk

12th 1849–1850

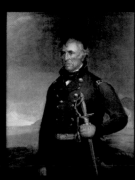

Zachary Taylor Betty Taylor Bliss*

15th 1857–1861

James Buchanan Harriet Lane*

16th 1861–1865

Abraham Lincoln Mary Todd Lincoln

19th 1877–1881

20th 1881–1881

James A. Garfield Lucretia Rudolph Garfield

Speaking from the advantage of my years,
I would say this: that a successful marriage,
I think, gets happier as the years go by.

PRESIDENT DWIGHT EISENHOWER, quoted in
"Successful Marriage Gets Happier With Years: Ike,"
Washington Post, July 2, 1959

21st **1881–1885**

Chester Alan Arthur Ellen Herndon Arthur

25th **1897–1901**

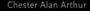

William McKinley Ida Saxton McKinley

26th **1901–1909**

Theodore Roosevelt Edith Carow Roosevelt

29th **1921–1923**

Warren G. Harding Florence Kling Harding

30th **1923–1929**

Calvin Coolidge Grace Goodhue Coolidge

22nd & 24th 1885–1889 & 1893–1897

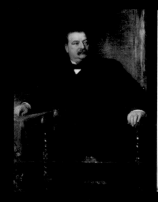

Grover Cleveland

Frances Folsom Cleveland

23rd 1889–1893

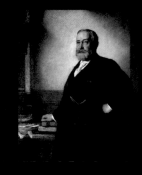

Benjamin Harrison

Caroline Lavinia Harrison

27th 1909–1913

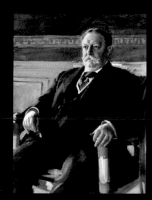

William Howard Taft

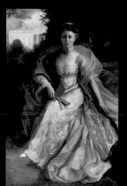

Helen Herron Taft

28th 1913–1921

Ellen Louise Axson Wilson

Woodrow Wilson

Edith Bolling Wilson

31st 1929–1933

Herbert Hoover

Lou Henry Hoover

32nd 1933–1945

Franklin D. Roosevelt

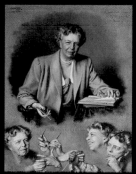

Anna Eleanor Roosevelt

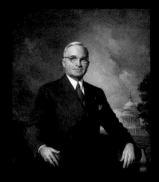
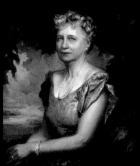

Harry S. Truman Elizabeth (Bess) Wallace Truman

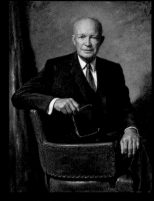
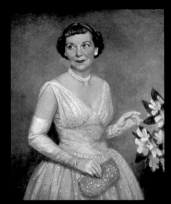

Dwight D. Eisenhower Mamie Doud Eisenhower

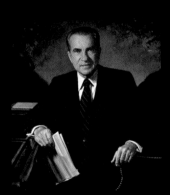
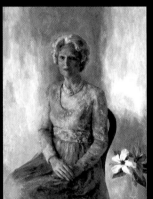

Richard M. Nixon Thelma (Pat) Ryan Nixon

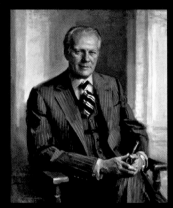
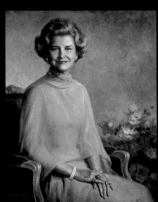

Gerald R. Ford Elizabeth Bloomer Ford

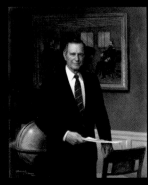
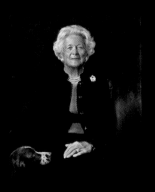

George H. W. Bush Barbara Pierce Bush

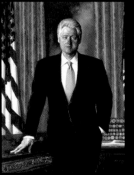
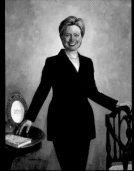

William J. Clinton Hillary Rodham Clinton

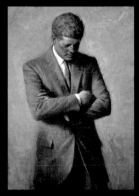
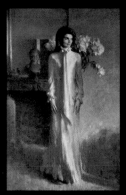

John F. Kennedy

Jacqueline Bouvier Kennedy

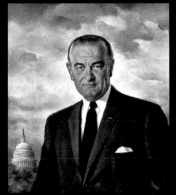
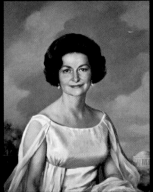

Lyndon B. Johnson

Claudia Taylor (Lady Bird) Johnson

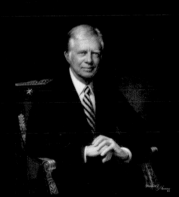
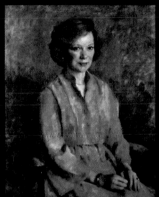

Jimmy Carter

Rosalynn Smith Carter

Ronald Reagan

Nancy Davis Reagan

George W. Bush

Laura Welch Bush

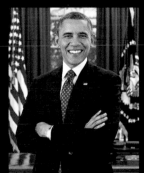

Barack Obama

Michelle Robinson Obama

FURTHER RESOURCES

The following sources provide further information about the topics covered briefly in this book. In addition, read the White House Historical Association's extensive history materials and source references for *Inside the White House* online at www.whitehousehistory.org.

General

Beschloss, Michael, and Hugh Sidey. *The Presidents of the United States of America,* 18th ed. Introduction by Barack Obama. Washington, DC: White House Historical Association, 2009.

Black, Allida M. *The First Ladies of the United States of America,* 12th ed. Introduction by Michelle Obama. Washington, DC: White House Historical Association, 2009.

Goldberg, Vicki. *The White House: The President's Home in Photographs and History.* Foreword by Mike McCurry. New York: Little, Brown, and Co., 2011.

Monkman, Betty C. *The Living White House,* 12th ed. Washington, DC: White House Historical Association, 2007.

Monkman, Betty C. *The White House: Its Historic Furnishings and First Families.* Principal photography by Bruce White. Washington, DC: White House Historical Association, 2000.

Seale, William. *The President's House: A History.* 2 vols. Washington, DC: White House Historical Association, 2008.

Sidey, Hugh, comp. and ed. *The White House Remembered: Volume I: Recollections by Presidents Richard M. Nixon, Gerald R. Ford, Jimmy Carter, and Ronald Reagan.* Washington, DC: White House Historical Association, 2005.

The White House: An Historic Guide, 23rd ed. Washington, DC: White House Historical Association, 2011.

First Ladies Biographies

Anthony, Carl Sferrazza. *First Ladies.* New York: William Morrow and Company, Inc., 1990.

Boller, Paul F., Jr. *Presidential Wives: An Anecdotal History.* New York: Oxford University Press, 1988.

Brown, Margaret W. *The Dresses of the First Ladies of the White House.* Washington, DC: Smithsonian Institution, 1952.

Caroli, Betty Boyd. *First Ladies.* New York: Oxford University Press, 1987.

Caroli, Betty Boyd. *America's First Ladies.* Garden City: Doubleday Direct, Inc., 1996.

Caroli, Betty Boyd. *First Ladies: Martha Washington to Michelle Obama.* New York: Madison Park Press, 2009.

Gutin, Myra G. *The President's Partner: The First Lady in the Twentieth Century.* New York: Greenwood Press, 1989.

Holloway, Laura Carter. *In the Home of the Presidents.* New York: United States Publishing Company, 1875.

Holloway, Laura Carter. *The Ladies of the White House.* New York: United States Publishing Company, 1870; Philadelphia: Bradley and Company, 1882.

Mayo, Edith P., and Denise D. Meringolo. *First Ladies: Political Role and Public Image.* Washington, DC: Smithsonian Press, 1994.

Mayo, Edith P. *The Smithsonian Book of the First Ladies: Their Lives, Times and Issues.* New York: Henry Holt & Co., 1996.

Smith, Nancy Kegan, ed. *Modern First Ladies.* Washington, DC: National Archives and Records Administration, 1989.

White House Architecture and Art

Abbott, James A., and Elaine M. Rice. *Designing Camelot: The Kennedy White House Restoration.* New York: Van Nostrand Reinhold, 1998.

Dietz, Ulysses Grant, and Sam Watters. *Dream House: The White House as an American Home.* New York: Acanthus Press, 2009.

Kloss, William. *Art in the White House: A Nation's Pride,* 2nd ed. Washington, DC: White House Historical Association, 2008.

Mellins, Thomas. *History of the White House Architecture.* New York: Acanthus Press, 2009.

Ryan, William, and Desmond Guinness. *The White House: An Architectural History.* New York: McGraw-Hill, Inc., 1980.

Seale, William. *The White House: The History of an American Idea,* 2nd ed. Washington, DC: The American Institute of Architects Press in association with the White House Historical Association, 2001.

White House China and Glassware

Klapthor, Margaret B. *Official White House China, 1789 to the Present,* 2nd ed. Additions and revisions by Betty C. Monkman, William G. Allman, and Susan Gray Detweiler. Photographs by Will Brown. New York: Harry N. Abrams, 1999.

Spillman, Jane Shadel. *White House Glassware: Two Centuries of Presidential Entertaining.* Washington, DC: White House Historical Association, 1989.

White House Children and Grandchildren

Angelo, Bonnie. *First Families: The Impact of the White House on Their Lives.* New York: Morrow, 2005.

Edwards, Susan. *White House Kids.* New York: Avon Books, 1999.

Quinn-Musgrove, Sandra L., and Sanford Kanter. *America's Royalty: All the Presidents' Children.* Westport, CT: Greenwood Press, 1995.

Reit, Seymour. *Growing Up in the White House.* New York: Crowell-Collier Press, 1968.

Rhatigan, Joe. *White House Kids: The Perks, Pleasures, Problems, and Pratfalls of the Presidents' Children.* Illustrations By Jay Shinn. Watertown, MA: Charlesbridge Publishers, 2012.

Wead, Doug. *All the Presidents' Children: Triumph and Tragedy in the Lives of America's First Families.* New York: Atria Books, 2003.

White House Christmas

Burke, Coleen Christian. *Christmas with the First Ladies: The White House Decorating Tradition from Jacqueline Kennedy to Michelle Obama.* Foreword by Deborah Norville. San Rafael, CA: Insight Editions, 2011.

Menendez, Albert. *Christmas in the White House.* Louisville, KY: Westminster John Knox Press, 1983.

Pickens, Jennifer Boswell. *Christmas at the White House.* Dallas, TX: Fife and Drum Press, 2009.

Rosenbaum, Alvin. *A White House Christmas.* Washington, DC: Preservation Press, National Trust for Historic Preservation, 1992.

Seeley, Mary Evans. *Season's Greetings from the White House.* New York: MasterMedia, 1996.

White House Staff Publications

Baldrige, Letitia. *Of Diamonds and Diplomats.* Boston: Houghton Mifflin Company, 1968.

Braisted, Rear Admiral William C., and Captain William Hemphill Bell. *The Life Story of Presley Marion Rixey Surgeon General, U.S. Navy 1902–1910.* Strasburg, Virginia: Shenandoah Publishing House, Inc., 1930.

Bruce, Preston, with Katharine Johnson, Patricia Hass, and Susan Hainey. *From the Door of the White House.* New York: Lothrop, Lee and Shepard, 1984.

Butt, Archie. *The Letter of Archie Butt,* ed. Lawrence F. Abbott. New York: Doubleday, Page & Company, 1924.

Butt, Archie. *Taft and Roosevelt: The Intimate Letters of Archie Butt, Military Aide.* New York: Doubleday, Doran & Company Inc., 1930, 2 vols.

Carpenter, Liz. *Ruffles and Flourishes.* New York: Doubleday and Co., Inc., 1970.

Crook, Colonel William H. *Memories of the White House.* Boston: Little, Brown and Co., 1911. [White House employee, 1865–1911]

Crook, Colonel William H. *Through Five Administrations,* ed. Margarita Spalding Gerry. New York: Harper & Brothers, 1910.

Fields, Alonzo. *My 21 Years in the White House.* New York: Coward-McCann, Inc., 1961.

Helm, Edith. *The Captains and the Kings.* New York: G. P. Putnam's Sons, 1954.

Hoover, Irwin Hood. *42 Years in the White House.* Boston: Houghton Mifflin Company, 1934.

Jaffray, Elizabeth. *Secrets of the White House.* New York: Cosmopolitan Book Corporation, 1927.

Keckley, Elizabeth. *Behind the Scenes.* New York: G. W. Carleton & Co., 1868.

Lincoln, Anne H. *The Kennedy White House Parties.* New York: The Viking Press, Inc., 1967.

McIntire, Vice-Admiral Ross T., and George Creel. *White House Physician.* New York: G. P. Putnam's Sons, 1946. [Physician for Franklin D. Roosevelt]

Nesbitt, Henrietta. *White House Diary.* New York: Doubleday and Co., Inc., 1948.

Parks, Lillian Rogers, and Frances Spatz Leighton. *My Thirty Years Backstairs at the White House.* New York: Fleet Publishing Corporation, 1961.

Pendel, Thomas F. *Thirty-Six Years in the White House.* Washington, DC: Neale Publishing Co., 1902.

Randolph, Mary. *Presidents and First Ladies.* New York: D. Appleton-Century Company, 1936.

Smith, Ira R. T., and Joe Alex Morris. *"Dear Mr. President . . ." The Story of Fifty Years in the White House Mail Room.* New York: Julian Messner, Inc., 1949.

Starling, Colonel Edmund W., and Thomas Sugrue. *Starling of the White House.* New York: Simon & Schuster, 1946.

West, J. B., and Mary Lynn Kotz. *Upstairs at the White House.* New York: Coward, McCann and Geoghegan, Inc., 1973.

White House Gardens and Grounds

Kramer, Frederick L. *The White House Gardens: A History and Pictorial Record.* New York: Great American Editions Ltd., 1973.

McEwan, Barbara. *White House Landscapes: Horticultural Achievements of American Presidents.* New York: Walker and Co., 1992.

Obama, Michelle. *American Grown: The Story of the White House Kitchen Garden and Gardens Across America.* New York: Crown Publishers, 2012.

Seale, William. *The White House Garden.* Washington, DC: White House Historical Association, 1996.

Temple, Dottie, and Stan Finegold. *Flowers, White House Style.* Senior writer, Leslie F. Cavalier; contemporary photography by Rob Cardillo; introduction and sidebars by William Seale. New York: Simon and Schuster, 2002.

White House Music

Kirk, Elise K. *Music at the White House: A History of the American Spirit.* Chicago: University of Illinois Press, 1986.

Kirk, Elise K. *Musical Highlights from the White House.* Malabar, FL: Krieger Publishing Company, 1992.

White House Pets

Bush, C. Fred. *C. Fred's Story: A Dog's Life,* edited slightly by Barbara Bush. Garden City, NY: Doubleday, 1984.

Bush, Barbara. *Millie's Book: As Dictated to Barbara Bush.* New York: William Morrow, 1990.

Clinton, Hillary Rodham. *Dear Socks, Dear Buddy: Kids' Letters to the First Pets.* Compiled, with a foreword, by Hillary Rodham Clinton. New York: Simon and Schuster, 1998.

Pickens, Jennifer Boswell. *Pets at the White House: 50 Years of Presidents and Their Pets.* Dallas, TX: Fife and Drum Press, 2012.

For Children

Arbelbide, Cindy Lea. *The White House Easter Egg Roll.* Illustrations by Barbara Leonard Gibson. Washington, DC: White House Historical Association, 1997.

Kurtz, Howard M. *Art and Color in the White House.* Washington, DC: White House Historical Association, 2010.

Kurtz, Howard M. *Eagles in the White House.* Washington, DC: White House Historical Association, 2010.

Kurtz, Howard M. *White House Colors.* Washington, DC: White House Historical Association, 2008.

Kurtz, Howard M. *White House Pets.* Washington, DC: White House Historical Association, 2008.

Trounstine, Connie Remlinger. *Fingerprints on the Table: The Story of the White House Treaty Table.* Illustrated by Kerry P. Talbott. Washington, DC: White House Historical Association, 2013.

White House Activity Book. Washington, DC: White House Historical Association.

DVDs

Where History Lives: A Tour of the White House. Washington, DC: White House Historical Association, 2004.

The People's President: Man, Myth, and the Media. Washington, DC: White House Historical Association, 2007.

ILLUSTRATIONS CREDITS

Abbreviations for terms appearing below:
Dwight D. Eisenhower Presidential Library and Museum (DDE), Franklin D. Roosevelt Presidential Library and Museum, Hyde Park, New York (FDR), George Bush Presidential Library and Museum (GB), George W. Bush Presidential Library (GWB), Gerald R. Ford Presidential Library (GRF), Harry S. Truman Presidential Library (HST), James K. Polk Memorial Association, Columbia, Tennessee (JKP), Jimmy Carter Presidential Library (JC), John F. Kennedy Presidential Library and Museum (JFK), Library of Congress Prints and Photographs Division (LOC), Lyndon Baines Johnson Library and Museum (LBJ), Official White House Photo (OWHP), Richard M. Nixon Presidential Library (RMN), Ronald Reagan Presidential Library and Museum (RR), Rutherford B. Hayes Presidential Center (RBH), Smithsonian Institution (SI), U.S. National Archives and Records Administration (NARA), White House Collection (WHC), White House Historical Association (WHHA), William J. Clinton Presidential Library (WJC).

Unless otherwise noted, all photographs courtesy of the WHHA.

Front Cover (composite image): (White House) Charles Kogod; (Sky) Vibrant Image Studio/Shutterstock.

Back cover (left to right): (UP) JFK; WJC; WHHA; (LO) WHHA; LOC; OWHP by Pete Souza.

Front Matter
1, WHHA (WHC); 2, OWHP by Pete Souza; 4, Erik Kvalsvik for the WHHA; 5, WHHA (WHC); 6, Photo by Eric Draper, Courtesy of the George W. Bush Presidential Library; 8-9, LOC; 11, Photo by Eric Draper, Courtesy of the George W. Bush Presidential Library.

The Building and Its Architecture
12-13, OWHP by Pete Souza; 14, WHHA (WHC); 16, LOC; 20, Courtesy of the Maryland Historical Society, Item ID # 1976.88.3; 21, WHC; 24-25, OWHP by Lawrence Jackson; 28 (UP), Erik Kvalsvik, The White House; 29, LOC, Frances Benjamin Johnson Collection; 32-33, LOC; 35 (UP), The White House; 35 (LO), LOC; 36, Abbie Rowe, NPS (HST); 37, Photo by Tina Hager, Courtesy of the George W. Bush Presidential Library & Museum; 39, HST; 40, Ed Clark/Time & Life Pictures/Getty Images; 41, Bruce White for the WHHA; 43, The White House.

The White House Gardens and Grounds
44-45, Courtesy of the Woodrow Wilson House, a National Trust Historic Site, Washington, DC; 48-49, The Huntington Library, San Marino CA; 51, (UP) Marjorie Egee for the WHHA; 51 (LO), Jack E Boucher, HABS/LOC; 53, LOC; 55, LOC; 56 (UPLE), Collection of Rachel Lambert Mellon/Oak Spring Garden Library/Upperville, Virginia; 56 (UPRT), The White House; 56 (LO), LOC; 57 (UP), NARA; 57 (LO), Frank Leslie's Illustrated Newspaper; 58 (LO), LOC; 59, Collection of Rachel Lambert Mellon/Oak Spring Garden Library/Upperville, Virginia; 60-61, LOC; 61, Bettmann Archive/Corbis; 64-65, OWHP by Pete Souza; 66, LOC; 67, AP Photo; 68, JC; 69 (UP), Office of the National Park Service Liaison to the White House; 70, OWHP by Chuck Kennedy; 71, GWB.

The West Wing
72-73, GWB; 74, Collection of Lloyd Ostendorf; 77 (UP), LOC; 77 (LO), JKP; 79, National Museum of American History/SI; 80 (UP), LOC; 80 (LO), LOC; 81, The White House; 82-83, OWHP by Paul Morse; 84, Nixon Presidential Materials/NARA; 85 (UP), Congressional

Medal of Honor Society; 85 (LO), LOC; 86, James Sorensen/NBC/Newsmakers/Getty Images; 87, RR; 90, William Seale Collection; 91, LBJ; 92-93, LOC; 94-95, Robert Knudsen/White House/JFK; 96, LOC; 97, OWHP by Pete Souza; 98-99, LOC; 101, NARA.

The First Lady
102-103, JFK; 104, RR; 106-107, The Daughters of the American Revolution Museum, Washington, DC. Gift of Mrs. W. H. Park; 107, WHHA (WHC); 108 (LE), Ralph E. Becker Collection of Political Americana/National Museum of American History, SI; 108 (RT), WHHA (WHC); 109 (RT), WHHA (WHC); 110, LOC; 112, GRF; 114 (UPLE), JKP; 114 (UPRT & LO), WHHA (WHC); 115 (All), WHHA (WHC); 116, WHHA (WHC); 117, Bruce White for the WHHA; 119 (UP), WHHA (WHC); 119 (LO), Mark Shaw/mptvimages.com; 120 (LE), LOC; 120 (RT), LOC; 122-123, GWB; 124, LOC; 126, Gilbert Stuart, Gift of Mrs. Robert Homans, Photograph © Board of Trustees, National Gallery of Art, Washington; 127, Bettmann/Corbis; 128, LOC; 129, AP Photo/Susan Walsh; 130, WJC; 131, Collection of the Hagnar Family.

The Working White House
134-135, OWHP by Pete Souza; 136, LOC; 138-139, WHC; 139, LOC; 140, GRF; 141, OWHP by Chuck Kennedy; 142, Photo by Bruce White for the WHHA; 144-145, LOC; 145, RBH; 146, GWB; 147, SI Traveling Exhibition Service/The Working White House (Lent by the White House); 148, LOC; 149 (LE), Mary E. Alexander; 149 (RT), Moorland-Spingarn Research Center, Howard University; 150, GWB; 151 (All), GWB; 152, Fleet Publishing; 153, AP Photo/Pablo Martinez Monsivais; 155, Photo by Roland Freeman, SI; 156, GB; 157, Mark Thiessen, NGS; 163, GWB; 164-165, OWHP by Chuck Kennedy; 166, LOC; 167, RBH; 168, OWHP by Pete Souza; 169, Conrad-McCann; 170-171, Brian Lanker Archives.

At Home in the White House
174, RR; 176, WJC; 178, LOC; 180, LOC; 181 (UP), DDE/NARA; 181 (LO), JC; 183, JFK; 184, LOC; 185, James Monroe Law Library, Fredericksburg, VA; 187 (LE), LOC; 187 (RT UP), Missouri History Museum, St. Louis; 188-189, WHC; 190, LBJ; 190-191, RMN; 192, NARA; 193, Behring Center/National Museum of American History/SI; 194, WHHA (WHC); 195, OWHP by Pete Souza; 196 (UP), GRF; 196 (LO), NARA; 197, NARA; 198-199, LOC; 200 (LE), OWHP by Chuck Kennedy; 200 (RT UP), LBJ; 200 (RT CTR), GB; 200 (RT LO), LOC; 202, LOC; 203 (UPLE & UPRT), LOC; 203 (LORT), LOC; 204, JFK; 205, WJC.

Entertaining, Celebrating, and the Holidays
206-207, RR; 208, RR; 211, WJC; 212 (UP) WHHA (WHC); 212 (LOLE), WHC; 212 (LORT), WHHA (WHC); 213 (UP), RR; 213 (LO), LOC; 214, OWHP by Pete Souza; 215, 560.51 1902-177/Theodore Roosevelt Collection/Houghton Library/Harvard University; 216-217, OWHP by Chuck Kennedy; 218 (UP), Courtesy of the FDR; 218 (LO), WHHA (WHC); 220-221, OWHP by Pete Souza; 222, Massachusetts Historical Society; 222 (INSET), WHHA (WHC); 223, FDR; 224-225, Sagamore Hill National Historic Site, National Park Service; 226 (UP), Courtesy of Barbara DePriest; 226 (LO), LOC; 227, LOC; 228-229, OWHP by Pete Souza; 230 (Both), LOC; 232 (UP), GRF; 232 (LO), Stephen Jaffe/AFP/Getty Images; 233, OWHP by Pete Souza; 234-235, Mark Shaw/mptvimages.com; 236, Fisk University, John Hope and Aurelia E. Franklin Library, Special Collections; 237, WJC.

Diplomacy, Ceremony, and Performance
238-239, GWB; 240, GB; 242, LOC; 243, LOC; 244, RBH; 244-245, Collection of the New York Historical Society; 245, Hulton-Deutsch Collection/Corbis; 246-247, DDE; 248, AP Photo; 251, WJC; 253, RR; 255, JC; 256-257, GRF; 260, JFK; 261, OWHP by Pete Souza; 262, United States Marine Band; 263, United States Marine Band; 264, JFK.

Innovations and Technology
266-267, OWHP by Pete Souza; 268, HST; 270-271, LOC; 271, Bruce White for the White House Historical Association; 272, Courtesy of the descendants of James M. McQueen/WHHA; 273, LOC, HABS DC, WASH,134—251; 274 (UP), OWHP by Samantha Appleton; 274 (LO), HST; 276-277, OWHP by Chuck Kennedy; 278 (UP), NARA; 278 (LO), WHC; 279 (UP), LOC; 280 (UP), OWHP by Lawrence Jackson; 280 (LO), OWHP by Pete Souza; 283, LOC; 284, LOC; 285, NARA; 286, LOC; 287 (Clockwise from up left): LOC, LOC, LBJ, JC; 290, DDE; 291 (Inset broadcast screen), Kenneth Garrett; 291 (Television frame), dreamerve/Shutterstock; 292-293, OWHP by Pete Souza.

Transition and Crisis
294-295, DoD photo by Senior Master Sgt. Thomas Meneguin, U.S. Air Force/Released; 296, Cecil Stoughton, LBJ; 298-299, The Granger Collection, NY; 300, LOC; 301 (UP), Louis S. Glanzman; 302, LOC; 303, GB; 304 (UP), Bettmann/Corbis; 304 (LO), LOC; 304-305, RR; 305, JC; 306, (Clockwise from top left): AP Photo/Pablo Martinez Monsivais; LOC; LOC; Division of Political History/National Museum of American History/SI; 307 (RT UP), LOC; 307 (LE), Division of Political History, National Museum of American History, SI; 308, National Museum of American History, SI; 309, Donald J. Crump/NGS; 310 (LE) LOC; 310 (RT), RBH; 311, National Museum of American History, SI; 312, LOC; 313, U.S. Navy, Official Photograph; 314, Bettmann/Corbis; 316-317, Kiplinger Washington Collection, Washington Historical Society; 317, LOC; 318 (UP), NARA; 318 (LO), LOC; 319, FDR; 321, GB; 322-323, RR; 324 (UP), U.S. Senate Collection; 324 (LO), Bettmann/Corbis; 325, LOC; 326, RMN; 327, JC; 329, Walter P. Reuther Library; 330, LOC; 331, LBJ; 332-333, AP Photo/Charles Tasnadi.

Back Matter
Unless otherwise noted, all presidential and first lady portraits are WHHA (WHC).

334 (Rachel Donelson Robards), The Hermitage: Home of President Andrew Jackson/Ladies' Hermitage Association; 335 (Abigail Smith), Gilbert Stuart, Gift of Mrs. Robert Homans, Photograph © Board of Trustees, National Gallery of Art, Washington; 335 (Martha Washington Jefferson Randolph), Diplomatic Reception Rooms, Department of State; 335 (Elizabeth Kortwright), Courtesy of the Edwards Family; 335 (Hannah Hoes), Martin Van Buren Columbia County Historical Society; 336 (Julia Gardiner), Courtesy of John Tyler Griffith; 336 (Jane Appleton), Courtesy of the Pierce Brigade; 336 (Eliza McCardle), National Museum of American History, SI; 336 (Julia Dent), LOC; 337 (Sarah Childress), JKP; 337 (Betty Taylor Bliss), National Museum of American History, SI; 337, (Harriet Lane), LOC; 337 (Lucretia Rudolph), LOC; 338 (Ellen Herndon), LOC; 339 (Ellen Axson), Courtesy of the Woodrow Wilson House, a National Trust Historic Site, Washington, DC; 341 (Barack Obama), OWHP by Pete Souza; 341 (Michelle Robinson), OWHP by Chuck Kennedy.

*PAGE NUMBERS IN **BOLD** INDICATE ILLUSTRATIONS.*

CELEBRATING
‹125›
YEARS

Inside the White House:
Stories From the World's Most Famous Residence
Noel Grove, with William B. Bushong and Joel D. Treese

Published by the National Geographic Society

John M. Fahey, Chairman of the Board and Chief Executive Officer
Declan Moore, Executive Vice President; President, Publishing and Travel
Melina Gerosa Bellows, Executive Vice President; Chief Creative Officer, Books, Kids, and Family

Prepared by the Book Division

Hector Sierra, Senior Vice President and General Manager
Janet Goldstein, Senior Vice President and Editorial Director
Jonathan Halling, Design Director, Books and Children's Publishing
Marianne R. Koszorus, Design Director, Books
Lisa Thomas, Senior Editor
R. Gary Colbert, Production Director
Jennifer A. Thornton, Director of Managing Editorial
Susan S. Blair, Director of Photography
Meredith C. Wilcox, Director, Administration and Rights Clearance

Staff for This Book

Susan Straight, Editor
Maryann Haggerty, Text Editor
Marty Ittner, Art Director
Charles Kogod, Illustrations Editor
Carl Mehler, Director of Maps
Marshall Kiker, Associate Managing Editor
Judith Klein, Production Editor
Mike Horenstein, Production Manager
Galen Young, Rights Clearance Specialist
Katie Olsen, Production Design Assistant
Erin Greenhalgh, Intern

WHHA Staff for This Book

Maria Downs, Director of Public Affairs
John Riley, Vice-President of Education and Scholarships
Courtney Speaker, Manager of Education Programs
Alexandra Lane, Rights and Reproductions Coordinator
Heidi Fancher, Media Specialist
Lawana Holland-Moore, Research Intern
Erin Vail, Research Intern

Production Services

Phillip L. Schlosser, Senior Vice President
Chris Brown, Vice President, NG Book Manufacturing
George Bounelis, Vice President, Production Services
Darrick McRae, Imaging Technician

The National Geographic Society is one of the world's largest nonprofit scientific and educational organizations. Its mission is to inspire people to care about the planet. Founded in 1888, the Society is member supported and offers a community for members to get closer to explorers, connect with other members, and help make a difference. The Society reaches more than 450 million people worldwide each month through *National Geographic* and other magazines; National Geographic Channel; television documentaries; music; radio; films; books; DVDs; maps; exhibitions; live events; school publishing programs; interactive media; and merchandise. National Geographic has funded more than 10,000 scientific research, conservation, and exploration projects and supports an education program promoting geographic literacy. For more information, visit www.nationalgeographic.com.

For more information, please call 1-800-NGS LINE (647-5463) or write to the following address:

National Geographic Society
1145 17th Street N.W.
Washington, D.C. 20036-4688 U.S.A.

For information about special discounts for bulk purchases, please contact National Geographic Books Special Sales: ngspecsales@ngs.org
For rights or permissions inquiries, please contact National Geographic Books Subsidiary Rights: ngbookrights@ngs.org

Library of Congress Cataloging-in-Publication Data

Grove, Noel.
Inside the White House : Stories from the World's Most Famous Residence / Noel Grove, with William B. Bushong and Joel D. Trees.
 p. cm.
Includes bibliographical references and index.
ISBN 978-1-4262-1177-5 (hardcover : alk. paper) -- ISBN 978-1-4262-1304-5 (hardcover (deluxe) : alk. paper)
1. White House (Washington, D.C.)--History. 2. Washington (D.C.)--Buildings, structures, etc. 3. Presidents--United States--History I. Title.
F204.W5G76 2013
975.3--dc23

2013029095

ISBN: 978-1-4262-1177-5
ISBN: 978-1-4262-1304-5 (deluxe)
Printed in the United States of America
13/CK-CML/1